D1452084

FROM PLYMOUTH TO PARLIAMENT

A RHETORICAL HISTORY OF NANCY ASTOR'S 1919 CAMPAIGN

Karen J. Musolf

St. Martin's Press
New York

ISBN 0-312-21364-6

Library of Congress Cataloging-in-Publication Data

Musolf, Karen J., 1937-
 From Plymouth to Parliament : a rhetorical history of Nancy
Astor's 1919 campaign / Karen J. Musolf.
 p. cm.
 Includes bibliographical references and index.
 ISBN 0-312-21364-6
 1. Astor, Nancy Witcher Langhorne Astor, Viscountess, 1879-1964.
2. Rhetoric—Political aspects—Great Britain—History—20th
century. 3. Great Britain—Politics and government—1910-1936.
4. Great Britain. Parliament—Elections, 1919. 5. Women
legislators—Great Britain—Biography. 6. Americans—Great Britain-
-Biography. 7. Nobility—Great Britain—Biography. I. Title.
DA574.A8M87 1998
941.082'092—dc21 98-41946
 CIP

For Bill, Beth, and David

CONTENTS

If this is the dawn of women in politics, then I say let us thank God that we made the great adventure.
John Davis, May 1922

Acknowledgements

In conducting research for this book, I utilized the resources of the University of Minnesota Wilson and Walter Libraries, the British Library, the British Newspaper Library, the British Library National Sound Archive, and most importantly, the University of Reading Library. I am grateful to the staff members of these libraries for their courtesies, diligence, and resourcefulness. I wish to thank especially Michael Bott, archivist at the University of Reading, who located the requested items, made special accommodations for me to work on them, and offered continuing support as the manuscript developed. I also appreciate the efforts of my son and research assistant, David Musolf, who made a number of trips to the New York City Public Library to gather materials for the concluding chapter.

Many reviewers have offered helpful comments and suggestions, most notably Robert L. Scott, J. Vernon Jensen, Ernest G. Bormann, Josef L. Altholz , Chris Anson, Adrienne E. Christiansen, Verna Corgan, Debra Petersen, Gregory Olson, Moya Ball, Patricia Sullivan, and family members, Bill Musolf and Elizabeth Reilly. Other helpful critiques were given by Kathleen Turner, Kathleen H. Jamieson, and Margaret Barnett, respondents at conference presentations.

Staff members of St. Martin's Scholarly and Reference Division have been gracious, patient, and helpful. Particular thanks go to Amy Reading, Rick Delaney, Ruth Mannes, Enid Stubin, Meg Weaver, and especially Maura Burnett, who believed in the work from the beginning.

RHETORICAL HISTORY

IN SPECIFIC TERMS, this book can be classified as a campaign history, a genre made popular by Theodore White's *The Making of the President* in 1960. And like other campaign histories, its aim is to "make an election comprehensible and enjoyable."[1] In general terms, the book is a rhetorical history, a blended form that joins historical description with rhetorical criticism.

Since rhetorical history is an emerging genre, more familiar to scholars in the field of communication than in other disciplines, some explanation is in order. The most succinct definition of rhetorical history is "the study of rhetorical processes in historical contexts." Thus, the authors of rhetorical histories look at both words and deeds. They recognize that "when something happens, it stirs up a hell of a lot of rhetoric." In turn, the stirred-up mass of rhetoric often influences what happens next. Rhetorical historians hold the view that rhetorical discourse is a shaping force of society, both past and present.[2]

Rhetorical histories are born in interdisciplinary study and share many features with other scholarly works. They are richly textured, melding descriptions of historically particular backgrounds, close speech analysis, and interpretation into a coherent narrative form. In brief, they can be called analytic narratives. Their authors "try to do two different things simultaneously, to swim with the stream of events and to analyze these events from the position of later, better-informed observers."[3]

Rhetorical histories are carefully researched. Their authors go beyond secondary sources to archival materials and contemporaneous accounts. They derive information from early manuscripts, speech drafts, printed

texts, contemporary press accounts, correspondence, memos, official documents, legislative proceedings, visual messages, recordings, oral histories, interviews, and other items that reveal rhetorical processes at work. As Ron Carpenter aptly put it, the thrust of a rhetorical historian's investigation is what is "pertinent and primary."[4]

Rhetorical histories aim for authenticity. Their authors "deal with subjects as faithfully and accurately and as impartially as the limitations of human nature and ordinary language allow."[5] At the same time, these authors also attempt to reconstruct the past in a manner meaningful to the modern reader. Lady Astor's campaign, for example, should not only stand as one of women's significant twentieth-century achievements but also serve as inspiration for those desiring a place in the political arena.

It should be noted also that rhetorical histories differ from other scholarly works in a number of respects. First of all, their authors take the term *rhetoric* seriously. They do not trash it as "empty," "a mark of falsehood," "mere embellishment," or "hot air." They appreciate rhetoric in both classical and modern terms. Today, Martin Medhurst calls rhetoric "symbolic inducement." Karlyn Kohrs Campbell defines it as "persuasive discourse, written or oral, that alters attitudes and actions." Not only do rhetorical historians take rhetoric seriously, but they also hold it in high regard. They agree that "people's words are our best evidence about human history."[6]

Rhetorical histories are pluralistic. They examine voices in the mainstream, especially contemporary and historical political participants. They also include discourses of those previously subject to "exclusion, domination or marginality."[7] Most notably, there is growing interest in those voices ignored in the past, especially those of women and minority populations.

Rhetorical histories are limited in scope. Their authors turn to the past not in grand sweeps but in focused encounters with specific eras, themes, events, or moments. The subject of a rhetorical history may be a political campaign, a series of speeches viewed from a different critical perspective, a debate, a policy decision, or even a single speech. Oftentimes, rhetorical historians will link their works to greater movements or trends. For example, Karlyn Kohrs Campbell's *Man Cannot Speak for Her* connects the woman's rights movements of the early nineteenth century to the rise of feminism in the latter part of the twentieth.[8] My work, the account of Lady Astor's entrance onto the parliamentary stage, can be seen as part of the long history detailing the expansion of voting rights in Britain.

Rhetorical histories may not offer specific judgments but will often imply them. Campaign histories usually tell the story of winners and give reasons for their success. However, results do not always measure success in

both campaign histories and the more general rhetorical histories. Rhetorical historians consider intrinsic merits as well, judging "whether the choices made by rhetors were skillful responses to the problems they confronted."[9]

Rhetorical histories may or may not have explicit theoretical underpinnings. Like those in microhistory, their authors "do not sacrifice knowledge of individual elements to wider generalization but in fact accentuate individual lives and events." More often than not, a rhetorical history either weakens or bolsters a current communication theory. The following analysis of Astor's campaign, like similar studies conducted by Cragan and Shields, certainly lends credence to symbolic convergence theory as proposed by E. G. Bormann.[10]

Overall, the rhetorical approach to the study of an historical event enriches our understanding of that event. New insights are gained when rhetorical acts and the responses to them are viewed in conjunction with one another. Examination of this dynamic interplay of voices often reveals rhetorical causes for historical actions just as important as those reasons deemed political, economic, or social. The reader will discover, as the author has, that Lady Astor's campaign success can be attributed not only to her political affiliation, her wealth, or her sex, but most importantly to her communicative skills—her ability to share rhetorically compelling visions with her voters.

The narrative begins with a biographical sketch of Nancy Astor. It is followed by a description of the rhetorical situation, the historical circumstance that prompted Lady Astor to act, both in deed and word.

NANCY ASTOR

To be loved in Virginia is enough to turn the strongest
head but to be worthy of her is enough to humble
the proudest heart.

—Lady Astor

ON MONDAY, 1 DECEMBER 1919, the titled Nancy Astor took her seat in
the House of Commons. As the first woman to do so, she heralded a new
era for women in the British political arena. She opened the door for those
seeking parliamentary service, cabinet positions, party leadership, and even
the highest rank, that of prime minister. Historians chronicling the twen-
tieth century, already marked by unparalleled achievements by women,
note her entrance into Commons as a pioneering event.[1]

Lady Astor's move into Parliament was highly unanticipated. Many
expected that the honor of first woman MP would go to an active suffragist
or even the first woman elected, Constance Markievicz. Markievicz was an
Irish Sinn Feiner who, with others of her party also elected in 1918, refused
to come to England or swear allegiance to the King. Unpredictable, she
could change her mind and take her seat. In Plymouth Sutton, soon to
become Lady Astor's home constituency, voters thought they would con-
tinue to be represented by Waldorf, her husband and their MP since 1910.[2]
Although some foresaw that he would be forced to ascend to the House of
Lords on his father's death, they did not think that he would call on his wife

to stand in his place. Never did they imagine that Lady Astor's first campaign for Parliament would become the most widely observed by-election in British history. And most likely, experienced politicians did not think she would win. Assessing her capabilities, they agreed that she had too many liabilities to be a successful candidate.

But win she did, not only in 1919 but in six subsequent elections, chalking up enough victories to give any historian pause and to prompt the obvious questions, "How did Lady Astor become the first woman in the House of Commons? How was she able to mount a successful campaign?"

Even though political and social reasons for Astor's success have been suggested in earlier biographies and histories, this book approaches Astor's campaign from a rhetorical perspective and attributes her victory to her communicative skills. Her 1919 campaign is examined as a series of rhetorical acts and responses, not only by the three contending candidates but by members of the electorate and press as well. Analysis of the dynamic interplay of voices provides new insight into this event.

AN UNLIKELY CANDIDATE

Nancy Astor was an unlikely candidate for the House of Commons, and had Waldorf not been compelled to move to the House of Lords, she would never have stood for Plymouth Sutton. Her decision to act as his substitute was taken with considerable risk because she was saddled with many more political liabilities than he was. First of all, she had to overcome the fact that she was not even British.

An American, she was born in Danville, Virginia, on 19 May 1879 and called "Nannie" after her mother, Nancy Witcher Keene Langhorne. Her father was Chiswell ("Chillie") Dabney Langhorne, a Civil War veteran. She spent her childhood in Danville and Richmond and moved to western Virginia during her early teens. She first visited England in 1904 for the foxhunting season but did not move there until her marriage to Waldorf two years later.[3]

Even though she had lived permanently in the country for over 13 years and had cultivated many English friends, she had never adopted their manners or self-restraint. At 40, she was as much the impetuous, impish, and brashly outspoken "daughter of Uncle Sam" as she was when she first appeared among those of the horsy set at Market Harborough when in her twenties.[4]

"America's daughter," however, preferred to identify herself as a Virginian. It was as if she never wanted to be confused with a Northern Yankee

but recognized instead as a child of the Confederacy, one who cherished her Southern heritage.[5]

The viewpoint was a natural one for her to take at that time. Danville, her birthplace, had been one of the last locations of the Confederate government. Her father, who had volunteered for the Confederate army at 17, never gave up his allegiance to the lost cause or his love for Virginia. In this respect, Nancy inherited his devotion. When very young, she shocked fellow passengers on a train ride to Chicago by calling, "Three cheers for Robert E. Lee!"[6] At 16, she applauded and cheered at a parade of Confederate veterans in Richmond. Her father's world appealed to her romantic sensibilities, and she adopted it as her own.

Her time was the era of Reconstruction, and in her early years she knew both poverty and good fortune as Chillie sought out different ways to support his family of eight: Nancy; her three brothers, Keene, Harry, and William; and her four sisters, Elizabeth, Irene, Phyllis, and Nora. He worked as a nightwatchman, a piano salesman, and a tobacco auctioneer.[7] He finally attained financial success in railroading because he was particularly adept at managing a black labor force.

Major money worries over, Chillie was able to purchase a small estate, Mirador, in Albermarle County, and as a result, he began to enjoy the life of a country gentleman.[8] It was here that Nancy became acquainted with the Virginia she fondly remembered, a world focused on horses and hospitality, yet a place unbridled by the social restraints of urban life.

Free to develop her own interests and skills, she chose to become a horsewoman, breaking yearlings and two-year-olds as well as riding in hunts and show events. She was a tomboy, unpolished and at times uncouth, compensating for her lack of refinement with good looks and an abundance of good cheer.

It was also at Mirador that she learned to hold her own in the rough and tumble of family life. Most likely, she chided her brothers for drinking on the sly and disapproved of her father's taste for whiskey and mint juleps.[9] She competed with her sisters for beaus. Acknowledging that Irene was the family beauty, she turned young men's attentions her way by clever conversation sparkled with repartee and *bon mots*. In family squabbles she sided with her mother, whose goodness she admired.

In the same household she picked up a patronizing attitude toward blacks. No doubt she often heard her father remark, "Only Yankees and niggers work," and at the same time, she noticed his patriarchal treatment of black servants in his employ. At the time, it was not an uncommon attitude

among Southern whites, but it was racist and probably led to her later propensity for other prejudices, especially in matters of religion.[10]

Even though Lady Astor deplored snobbery in others, she oftentimes failed to recognize a similar quality in herself. She often used her Virginia background as grounds for one-upmanship. Maurice Collis, one of her biographers, wrote that as a Virginian she considered herself "socially superior to most and the equal of any." Once she even went as far as to remark that a woman who married outside of Virginia married beneath herself.[11]

Thus Nancy Astor was not only an American but a provincial one as well. A rural Virginian, she stood in stark contrast to the typical postwar MP, a solid man of land, big business or finance, prone to either the silence of a Trappist monk or moderate speech "proper and germane to the subject at hand."[12] To those not amused by Nancy's brash ways, she could be insufferable.

A second factor in Lady Astor's disfavor was her lack of education. Unlike Waldorf who had a university degree, she had no more than second-ary schooling. As a child, she attended private academies in Richmond, the first operated by Miss Julia Lee and the second by Miss Jennie Ellett. At Miss Jennie's she developed a love for language and studied her dictionary, learning two new words per day. At the same time, she came to despise arithmetic. Struggling over her multiplication tables, she prayed that the schoolhouse would burn: "O God, please burn down the schoolhouse. Please burn down the schoolhouse entirely. Save Miss Jennie and Miss Jennie's mother, please God, but let the schoolhouse go. Burn down that house!"[13]

When Nancy was seventeen, her parents sent her to Miss Brown's Academy for Young Ladies, a finishing school in New York City. Not only did they think a stay there would prepare her for a "good marriage," but she would also have the opportunity to spend weekends and holidays with her sister, Irene, now married to the graphic artist, Charles Dana Gibson.[14]

Time spent with the Gibsons was the best part of her New York experience because Nancy intensely disliked Miss Brown's. Later, she claimed that she did not learn even manners there, and at the time, she was thoroughly disgusted by her classmates. She thought they were too con-cerned with money, clothes, and men. Furthermore, they treated her as a "country lass," one whose Virginia background was a mark of inferiority, a reason to keep her out of their social circles. She responded to their ostracism with characteristic boldness, playing up the assigned role of rural bumpkin. Exaggerating her drawl and dropping her g's more than ever, she told them that her father was a drunkard and her mother a washerwoman. Continuing

in her attempt to startle, she frequently dressed in outlandish clothes, favoring a blouse of clashing yellows, pinks, and greens.

Outwardly she gained the attention she sought, but inwardly she felt miserable. When her parents came for a visit and learned how unhappy she was, they allowed her to leave. She returned to Mirador for a round of summer activities and then asked to live with Irene. Even though her term at Miss Brown's had been a disaster, she had become enchanted by the glamorous and cosmopolitan features of New York in its Gilded Age.

Later, as a married woman in England, Nancy made several attempts to compensate for her poor education by cultivating friendships with those who possessed artistic and literary talents. She posed for John Singer Sargent and talked with writers at literary lunches held on Tuesdays. She met Rudyard Kipling, James Barrie, and Henry James, later developing a close friendship with George Bernard Shaw. Before World War I she paid considerable attention to the Anglo-French writer, Hilaire Belloc, who tried to impose on her both his ardent Catholicism and anti-Semitic views.

As Lady Astor began to move among those who were well-educated and made personal attempts to better herself, she demonstrated an interest in educational issues. At a 1917 meeting in Plymouth, she introduced H. A. L. Fisher, president of the Board of Education, with the comment, "I am very keen about education because I suffer from a lack of it."[15]

Another potential problem facing Lady Astor as a candidate was the fact that she was a divorced woman. Although divorce had come to be accepted in certain social circles, it was still perceived as a significant political drawback.[16] Lady Astor was fortunate that hers had occurred while she was in the United States and few in the British populace knew about it.

Nancy's first husband was Robert Gould Shaw II, a Bostonian of distinguished family, whom she met at a polo match during the time she was living with Irene. She was impressed with his horsemanship, and he said that he knew he wanted to marry her immediately. Shortly thereafter, they became engaged, broke it off, and became engaged again. Not yet eighteen, Nancy was flattered by Shaw's attentions but uneasy about marriage with him. She later wrote, "But in my heart, I was never sure."[17]

Her father also had his doubts and made a visit to Shaw's parents to make inquiries. He asked them if there was anything the Langhornes needed to know about Bob, and they told him that there was probably nothing to be concerned about. They said that he was just a young man sowing his wild oats and that after marriage to Nancy, he would settle down. What they failed to mention was that he had become an alcoholic and that they hoped Nancy would help him give up his heavy drinking. Even though reassured

by the Shaws, Chillie sensed that the marriage was not a good one for Nancy, and he and his wife advised against it.[18]

Displaying her usual contrariness and undoubtedly fancying herself in love, Nancy disregarded her parents' advice and chose to marry Shaw. They wed in the drawing room of Mirador in October 1897 and then departed for a honeymoon trip to Hot Springs, Virginia.

The honeymoon was certainly no romantic interlude. Nancy came home on the second night, probably appalled by sex or overcome with regret. Chillie tried to reassure her and sent her back to Shaw. Soon after, Shaw brought her back to Mirador because she was so miserable. Not too much later, they decided to give their marriage a second chance and moved to Boston. Matters did not improve and their relationship continued in a chaotic fashion for the next few years. When Nancy was with Bob, he drank and was physically abusive. She was frightened but at the same time unwilling to admit her mistake.[19] Furthermore, she was pregnant. Their son Bobbie (Robert Gould Shaw III) was born in 1898.

After his birth, Nancy went home to Mirador for six months, a separation suggested by her in-laws, who promised that they would try to straighten their son out during her absence. When she came back, she found that Bob was not only still drinking but also seeing another woman.[20] Chillie made an attempt to preserve the marriage by purchasing the couple a home near Mirador. Neither the Shaws nor the Langhornes helped for any length of time. Nancy and Bob permanently separated in 1901, and Nancy returned with Bobbie to her own family.

At Mirador she agonized over what she should do: file for a divorce or sign a deed of separation. As divorce was then anathema to her religious beliefs, she chose to sign the deed in October 1902, exactly five years after her marriage had begun. She told Chillie, "Your beautiful daughter is back again, unwanted, unsought, and part-widowed for life."[21]

Before the end of the year, she was to feel even worse. Bob Shaw's parents came to visit, specifically to implore her to begin divorce proceedings at once. Having told the other woman that he had been divorced from Nancy, their son had gone ahead and married her. Were she or her family to discover that he and Nancy were indeed not divorced, Shaw could be sent to prison for bigamy. Nancy now had no choice. She filed for divorce on grounds of adultery, and the matter was concluded in Charlottesville on 3 February 1903.

During the next three years, Nancy's fortunes began to turn for the better; in fact, her life acquired the romantic qualities of which legends are made. The same month she was divorced, she sailed to Europe accompanied

by her mother and a friend, Alice Babcock. In London they called upon some friends of the Gibsons. One was Mrs. John Jacob Astor IV, wife of the cousin of Nancy's future father-in-law.[22] Mrs. Astor was so pleased with the young women's company that she asked them to stay for another month. Although Nancy did not meet Waldorf at the time, she was introduced to the Edwardian society that would become a great part of her later life.

She went back to Virginia in the spring, and recalled, "knocking around in a shabby old riding habit most of the time." Near the end of summer, tragedy struck. On the day the family had gone to a horse show in Lynchburg, her mother died. Nancy later wrote, "That was sorrow such as I had never known or imagined. The light went out of my life. I was ill for months, in a wretched nameless fashion."[23]

For nearly the next year and a half, she stayed on at Mirador, attempting to take her mother's place in managing the household, caring for family and servants, housekeeping, and gardening. The adjustment was difficult for all concerned.[24]

In autumn 1904, Chillie asked her if she would like to return to England, this time for the hunting season. After some protest, she agreed, and in October she went abroad, this time bringing with her Bobbie, his nurse, her sister Phyllis, her two children, and their governess. The party settled in at Market Harborough. Nancy and Phyllis chased the hounds and raised some eyebrows among those in the horsy set. On her first day out, Nancy astounded a fellow rider with a stinging remark. Moving to remount her horse after it had thrown her in the mud, she told the man who offered to help, "Do you think I would be such an ass as to come out hunting if I couldn't mount from the ground?"[25]

Nancy also gathered a host of suitors from those in the same sporting crowd, men fascinated by the incongruity of her "hard-drivin'" horsemanship and her prudish ways, going to church and drinking nothing stronger than tea.[26] Their attentions and a trip to France kept her abroad until the following summer.

Nancy left for her third trip to England and second hunting season in December 1905. This time her father was her companion. On board ship, she met Waldorf Astor, who had sought her out. Like Nancy, Waldorf had been born in the United States and coincidentally on the same day as she.[27] Yet his upbringing had been quite different from hers.

Waldorf's father was William Waldorf Astor, heir to the vast fortune made by his great-grandfather, John Jacob Astor of fur-trading and Manhattan real estate fame. Unable to launch a political career in the United States, William had accepted a diplomatic appointment and moved to Rome when

Waldorf was three. When Waldorf was ten, his father chose the life of an expatriate and permanently settled in England. Here he was able to pursue his interests in art, architecture, and literature; acquire a newspaper, the *Pall Mall Gazette;* and bring up his family in a traditional, autocratic manner.[28]

William raised Waldorf like many an English boy of the upper classes. Waldorf attended Eton and then went to New College, Oxford. Although he did not excel academically, he earned his reputation as a sportsman by hunting, playing polo, rowing, and fencing. While still in school, he began to develop his racing stable, gaining expertise in genetics.[29]

At the time he met Nancy, he was unwell and no longer able to participate in the many physical activities he enjoyed.[30] Troubled with a weak heart, he had both angina and a tendency toward tuberculosis. Nevertheless, his poor health did not prevent him from charming Chillie, wooing Nancy, and making plans to see her again after their ship had docked.

Waldorf courted her all winter and they announced their engagement on 8 March 1906. Just short of two months later, 3 May 1906, they were married at All Souls, Langham Palace. The bishop of London had interviewed Nancy, and after hearing the details of her divorce had given permission for a full Anglican service. The Astors honeymooned in Italy and Switzerland, and this time Nancy did not run away.[31]

When they returned to England, the Astors moved to Cliveden, a country estate in Buckinghamshire, not too far from the royal residence at Windsor. One of the homes of William Waldorf Astor, Nancy's father-in-law, it was given to them as a wedding present. A magnificent structure, it was patterned after the Villa Albano in Rome and built by Sir Charles Barry, the greatest of Victorian architects. It sits surrounded by formal gardens, and from the terrace offers a view of the curving Thames River and adjoining wooded countryside.[32] One can imagine that as she returned from her European honeymoon and glanced up the long approach to the entrance, Nancy pinched herself. Not only had she captured the prince but she got the palace, too.

Within the next decade, the Astors acquired other homes: a London residence at 4 St. James Square, a golfing cottage at Sandwich called Rest Harrow, a sporting lodge on the island of Jura, and after Waldorf had been asked to stand for Plymouth, a home there at 3 Elliot Terrace.[33]

At Cliveden, Waldorf continued breeding and racing horses. He also began to make plans for a political career. He did not believe that the rich had any right to be idle; he thought that they owed their countrymen deeds of public service. He thought that his best role would be in using his wealth and influence to get things done. Unlike Nancy, who was often impulsive,

Waldorf thought matters through, and as a consequence, it took him some time before he made his first political move. He met with two friends, Lord Curzon and Arthur Balfour, and told them of his interest in becoming an MP. He was offered a safe Conservative seat but turned it down, preferring one that would require the challenge of a contest. The opportunity he sought did not come until 1910.

Nancy immediately plunged into her duties as mistress of a grand household, managing servants and entertaining a great variety of guests. Assisted by a professional housekeeper and a remarkable butler, she supervised a prewar staff that included "forty to fifty gardeners, ten to twelve stablemen, six housemaids and six laundrymen" in addition to valets, footmen, and other domestic servants. Some were still in livery, powdering their hair and wearing yellow stockings like Shakespeare's Malvolio.[34]

She excelled in her role as hostess, blending forms of Virginia hospitality with the riches she had acquired. She invited not only those in her new social set but visiting Americans, believing that the best way to improve Anglo-American relations was to bring those of each country together. Her parties gained a reputation for wonderful food, a blend of French cuisine and traditional Virginia fare such as corn bread and beaten biscuits. They were also known for great merriment, the latter often prompted by impersonations given by Nancy herself. Her neighbor, Julian Grenfell, once wrote her, "You will go to heaven for keeping people cheery."[35] And another neighbor, the affable King Edward VII, not wanting to be left out, invited himself from nearby Windsor.

One biographer, Christopher Sykes, commented that Cliveden soon became "a meeting place of the eminent, the famous, the distinguished, the privileged and the titled." And, as Waldorf turned to public service, it also became a gathering place for those with political interests: cabinet ministers, MPs, reformers, and newspaper editors. Harold Macmillan, prime minister from 1957 until 1963, said Nancy would be remembered as a "notable hostess, a lively character and a loyal friend."[36]

But entertaining was not enough. Waldorf and Nancy began a family of their own. Their son Bill (William Waldorf III) was born in 1907, followed by a daughter, Wissie (Phyllis), in 1909 and another son, David, in 1912. Two other sons, Michael and Jakie (another John Jacob), were born during the war years. "Babies," Nancy once laughingly remarked, "are my hobby." And for a woman well supplied with enough bedrooms and able to afford nannies and governesses, they were no burden.[37]

By the time Nancy was to stand for office, she had become the envy of many. Her social world was vastly different from that inhabited by those

of the working classes in Plymouth Sutton, poor families struggling for adequate housing and decent wages. She was certainly not one of their own. Her tremendous wealth, though a personal asset, could be a political liability. Lady Astor could easily be perceived as one of the idle rich, a person unsuited for Plymouth's poor. Constance Markievicz, herself the first woman elected to the House of Commons, certainly disapproved: "Lady Astor is not only a foreigner and a thoroughly unrepresentative woman, but she is of the aristocracy, the upper classes, out of touch completely with the problems and difficulties confronting the average woman. She is a carpetbagger."[38]

Wealthy, divorced, poorly educated, and foreign, Lady Astor had enough personal liabilities to make any thoughtful voter pause. Yet that was not all. An experienced politician would also notice that she had neither a following nor a comprehensive political ideology of her own.

Lady Astor's most likely following could be found among women. The Representation of the People Act of 1918 had granted the franchise to those over 30 and as a result, over eight million women had joined the British electorate. In Plymouth Sutton, 17,175 women were eligible to vote, holding a very slight majority over male voters.[39] Yet by the time she was to stand for Parliament, Lady Astor had done little to build their support.

Furthermore, she had not mixed with those active in the women's movement, suffragists and suffragettes who had sought, by both democratic and militant means, to gain political power for over 50 years.[40] While they had been meeting and marching, smashing and starving, she had been home at Cliveden tending to her babies and her other duties. She had also been ill, suffering from severe headaches and bouts of nervous exhaustion that sent her to bed for days. In 1914 she had two operations for an internal abscess, and her health did not begin to improve until after that. Even if she wanted to be part of a women's movement, her health would have limited her.

Lady Astor, then, could not be assured that women would lend her their support. She also had to wonder if she would be backed by members of Waldorf's party, the Conservative-Unionists. A diehard faction of the group had vigorously opposed women's suffrage. They were all the more dismayed when Parliament passed the Qualification of Women Bill, which permitted women as young as 21 to serve in the House of Commons.[41] They would certainly object to her taking Waldorf's place. Consequently, Lady Astor had to face the fact that some of those who had supported Waldorf would reject her simply because she was a woman.

Though a Conservative-Unionist, Waldorf was a liberal at heart. Finding himself within a party nearly split between "the last ditchers" and the "progressives," he sided with the latter, the faction forming the left wing of the party.[42]

In Parliament, he joined a forward-looking group known as the Unionist Social Reform Committee. As one of its more radical members, one motivated by the conditions he observed in Plymouth, he prompted a scandal when he crossed party lines and voted for Lloyd George's Health and Unemployment Insurance Bill in December 1911.[43] As a result of this vote, he became acquainted with Lloyd George and later, when Lloyd George became prime minister, served as part of his Coalition government.

At first, he spent six months as Lloyd George's parliamentary private secretary. Later, in the midst of World War I, he became a part of the "Garden Suburb," working out of hutments behind 10 Downing Street. After the war was over, he continued to support the Coalition; indeed, he was one of the couponed candidates in 1918. He liked the Coalition's proposals for postwar reconstruction and reform, especially in the areas of health and housing. As one who had earlier contributed to the development of the Ministry of Health, he hoped that he would succeed Christopher Addison in that position. Like Lloyd George, he hoped to see England become "a fit country for heroes to live in."[44]

During his early years in Parliament and later in wartime, some of Waldorf's closest associates were young Oxford men known as "Milner's Kindergarten." Many of them, but not all, had served as assistants to Lord Milner in South Africa after the Boer War. Like Milner and Cecil Rhodes before him, they had become "apostles of Empire," perceiving themselves as enlightened imperialists hoping to weld the British Empire together as they had forged union in South Africa.[45]

Now back in England, they started a publication, *The Round Table*, in 1910 to debate the desirability of Imperial Federation. They had many of their meetings, called "moots," at Cliveden, their fantasy Camelot. Nancy, their prudish and temperate Guinevere, served as hostess and paid some attention to their discussions.[46] They appealed to her because they believed in the unity of the English-speaking peoples and espoused romantic and idealistic hopes for creating a better world.

One of the group, Philip Kerr, editor and writer for *The Round Table*, became devoted to Nancy and she in turn to him. In time, he became her spiritual adviser, but in early years, he never offered too much in the way of political advice. He became her soulmate, not a political crony or a sexual partner. Certainly Waldorf and his associates influenced Nancy's political ideas, but not so much that one cannot discern some differences. Nancy's views veered away from theirs in subtle ways.

Nancy was even less a party person than Waldorf. She advocated "cooperation" among all parties for the common good. She cultivated friends

in all political groups: Coalition Liberals, Independent Liberals, Conservatives, and middle-of-the-road Labourites—backing off only from those on the extreme left of the Labour movement.

Essentially she was a centrist, a person willing to place cause above party loyalty. Her decisions were guided by the stirrings of her heart, her conscience, or her own intuitive sense of what was right. For example, she strongly believed in prohibition or at least strict control of the liquor trade. It was an opinion grounded neither in political nor religious thought but in painful personal experience. Once asked if she had come from a temperance family, she retorted, "No, a hard-drinkin' one."[47]

Like those in Milner's Kindergarten, she had an interest in international affairs but was too much of an American to be concerned with the building of Empire. Foreign policy, she thought, should be built around the League of Nations and friendship with the United States.

Brian Harrison, the British historian who studied Nancy Astor's years in Parliament, said she "had no inclination or talent for elaborating a political philosophy."[48] Those voters who inquired into her political views often found them vague and undefined—good reason for not offering her their support, especially in a country that had a long history of party affiliation and political orientation.

A WOMAN OF PROMISE

Though troublesome, Lady Astor's political liabilities were not so numerous as to make her candidacy an impossibility. Her assets were also worthy and, if used to advantage, could at least balance the factors against her. On the plus side, she had the courage of her religious convictions, a strong record of community and national service, and rhetorical gifts yet to be exploited.

Maddeningly vague in expounding her political ideology, Lady Astor was quite clear in presenting her religious views. Those who met her had no trouble recognizing that she was a woman of faith, the embodiment of religious principle and morality.

During her Virginia childhood, she attended church at St. Paul's Episcopal in Richmond and participated in family prayers and Bible readings, making her way through all of the books of the Bible by the time she was twelve.[49] Both her mother and her nurse, Liza Piatt, influenced her developing spirituality. Years later, she told a radio audience:

I can never remember the time I didn't pray. I had a blind faith in God. And I believed in goodness, and I saw it—so much—around about me—first the unselfish goodness of my mother and then the goodness of my old black nanny who had intimate experience with Jesus. She was always talking to Mr. Jesus. She was one of the best that ever lived.[50]

When she was fourteen, Nancy met Archdeacon Frederick Neve, minister at St. Paul's Church in Ivy, not too far from Mirador. An Englishman, he had come to Virginia to be a missionary among the farmers in the Blue Ridge Mountains. He told Nancy about his work with the destitute, the sick, and the illiterate and took her with him on visits to the Sheltering Arms, a home for the disabled. She was so inspired by his work that she, too, considered becoming a missionary.[51] She never forgot those poorer than herself, and prompted by social conscience, she engaged in many acts of private charity.

By 1919 she had become an ardent Christian Scientist. In 1913 she had read Mary Baker Eddy's *Science and Health with Key to the Scriptures* during a period of spiritual restlessness but did not become a convert until after her first operation in March 1914. While recuperating, she was visited by her sister, Phyllis, who arranged for a Christian Science practitioner, Maud Bull, to see her. Mrs. Bull suggested *Science and Health,* and this time, as Nancy reviewed the book, she found the first chapter on prayer astoundingly meaningful: "It was just like the conversion of St. Paul. Here I found the answer to all my questions, and all I had been looking for."[52]

Christian Science soon became a part of Nancy's daily life. She sandwiched in lessons and Bible readings between her daily exercises and her bath. On Wednesdays she attended the Testimony meeting and on Sunday the regular service. She became a proselytizer, but not always an effective one.[53] She learned that she could not force her opinions upon others and that an overreaching attitude could antagonize.

Privately she preached the gospel according to Mary Baker Eddy, but publicly she referred to basic Christian tenets, frequently quoting "Love one another." One of her favorite comments was: "You cannot take your politics into religion, but you can take your religion into politics."[54] Her religious views, if presented without offense, could be one of her valuable political assets.

Contrary to Constance Markievicz's opinion that Lady Astor was out of touch, Nancy was well known in Plymouth. She had established a considerable record of community and national service, another factor in

her favor. Unlike other MPs, the Astors resided in the area they represented. Undoubtedly, their decision to do so was a carryover from American political life with which they were familiar. Living in Plymouth, they came to know the needs of its citizens and whenever possible helped out with community social programs.

Nancy showed particular interest in children's welfare, "establishing maternity centres and creches in the poorer parts of town." Specifically she founded Wissie Wee Cot, a home for invalid children in Dousland, and the Francis Astor Creche, a haven for homeless children in Plymouth. She provided the quarters for the Victory Club for Girls and supported the Civic Guild of Help and the Three Towns Nursing Association.[55]

During the war, both Astors contributed wherever needed in Plymouth or in London. Waldorf, most unhappy that his heart condition prevented him from active service, asked for the most unpleasant job on the home front and was given the task of reducing army waste. In Plymouth he built YMCA huts for servicemen, and Nancy spent some time doing hospital work.

Their major effort, however, was at Cliveden. They turned much of it over to the Canadian Red Cross for use as a hospital. It opened in February 1915 with beds for 110 but later was expanded to 600 beds. In the next four years, over 24,000 wounded received medical help there. Reconciling her Christian Science beliefs with her conscience, Nancy ministered to them by daily visits. Consoling by cajoling, she described her service as "my not too tender care."[56]

Her favorite story concerned a young man named Saunders. Colonel Newbourne, head of the hospital, turned him over to Nancy as someone who had given up. As she recalled the incident, Saunders had told her, "I'm going to die." And then she said:

> Yes, Saunders, you're going to die. You're going to die because you have no guts. If you were a Cockney, or a Scot, or a Yank, you'd live. But you're just a Canadian, so you'll lie down and die! I'll have them send you up a good supper for your last meal and I bet you this wrist watch you'll be dead this time tomorrow. You can keep it 'till then. I'll get it back when you're gone.

She then concluded the story with the comment, "He ate the supper I sent him, and he still has the watch."[57]

Not all recovered as well as Saunders, and for those who did die, the Astors prepared a cemetery on the grounds, now holding the graves of forty Canadian soldiers and two nursing sisters. Bertram MacKennal, an Australian

sculptor, designed a statue, a female figure symbolizing Canada, as the primary ornament. A literary friend from Oxford, Sir Walter Raleigh, suggested the inscription: "They are at peace. God proved them and found them worthy for Himself."[58]

Lady Astor also possessed rhetorical gifts that if developed, could enable her to survive a tough campaign. The art of persuasion was her hidden weapon, not yet fully deployed in public.

She discovered her ability to captivate an audience on board ship crossing from the United States to England in September 1906. Never a good sailor, she had skipped dinner and gone out on deck to catch the ocean breeze. Shortly thereafter, one or two seamen joined her and then as many as "eight or ten." She recalled that they "argued about this and that and discussed things in general." She added, "They told me their troubles and I told them mine."[59]

Soon after, those who had finished dinner joined the lively group, and Nancy found herself the center of their attention as well. She overheard one observer, a parson, remark, "I would give my life to be able to do what that girl is doing." She said that, at that moment, she realized that she "could do it."[60]

Before discovering she could do well with a larger audience, she learned that she could succeed in the give and take of interpersonal conversation. She frequently saw the humor in most situations and often grasped the opportunity to engage in repartee—whether with the dockers of Plymouth or the dignitaries of London.

On one of her earlier hunting trips, she was introduced to the Cunards. Mrs. Cunard, hardly masking her suspicion, remarked to Nancy, " I suppose you have come over here to get one of our husbands." Without a second's hesitation, Nancy responded, "If you knew the trouble I've had gettin' rid of mine, you'd know I don't want yours." The retort broke the chill, and Mrs. Cunard warmed to Nancy, becoming a lifelong friend.[61]

In such exchanges, Nancy did not lose many rounds. One, in which Winston Churchill bested her, has been long remembered. The most reliable account comes from the memoirs of Consuelo Vanderbilt Balsan. She stated that Lady Astor and Churchill, who never really liked each other, accidentally met at Blenheim and entered into a trivial but heated argument:

> Nancy, with a fervor whose sincerity could not be doubted, shouted, "If I were your wife I would put poison in your coffee." Whereupon Winston with equal heat and sincerity answered, "And if I were your husband I would drink it."[62]

This exchange is one of the few in which Lady Astor was not the victor.

Lady Astor also demonstrated a dramatic flair that was often displayed in spontaneous exhibitions for her family and guests. She embellished her remarks with mimicry, animating narratives by acting. When telling stories to children, she "cited every part with her voice, making her characters sound lazy and confiding, boastful or frightened."[63]

At her dinner parties, she delighted her guests by doing impersonations, choosing from characters in her considerable repertoire. Some were stereotypical: a Tsarist Russian émigré, a Jewish businessman, an English lady of the horsy set, a clergyman and his wife. Others were of well-known public figures: Margot Asquith, Charlie Chaplin, and Winston Churchill. She also poked fun at herself. Lord Riddell mentioned in his diary that she played out her entrance into Commons by sashaying down an aisle to "The Missouri Waltz." A natural and uninhibited performer, Nancy might have had a life upon the stage had she not thought it such a wicked place.

Lady Astor was familiar with the rhetorical requirements imposed upon campaigners. In both 1910 elections and again in 1918, she had canvassed Plymouth voters on Waldorf's behalf. She went door-to-door so often that one of her biographers, John Grigg, concluded that she "might well have been called the inventor of the walkabout."[65]

She greeted those she met with a standard spiel: "I am Mrs. Astor. My husband is standing for Parliament. Will you vote for him?" She found that most "listened intelligently," responsive to her message. The experience verified her long-held notion that "if you go out to people in a friendly spirit, that is how they will receive and listen to you."[66]

Although Lady Astor's liabilities were certainly numerous, the strength of her assets could work to her advantage. If she could capitalize on her religious views, her record of community and national service, and her rhetorical gifts, then she could overcome both her personal weaknesses and the challenges posed by an uncertain campaign. The unlikely candidate, the woman of promise, could become the woman elected.

ENTERING THE ARENA

> It's my husband who started me on this downward
> career—from the home to the House.
> —Lady Astor

THE FIRST VISCOUNT ASTOR, William Waldorf, liked his status as peer of the realm, a member of the greater nobility and the House of Lords. Although many in Britain characterized him as an arrogant American who thought money could buy anything, he still pompously paraded in his nobleman's robes and came to be remembered for his attire: a coronet, a pair of boots, and an ordinary gray business suit and a red tie peeking out from under a peer's resplendent robe.[1]

Neither the attire nor the title fit well with his son Waldorf, who, upon his father's death in October 1919, found himself in a terrible quandary and "in complete shock." By law, he would have to give up his seat in the House of Commons, a move accomplished by accepting the Exchequer's appointment to be Steward and Bailiff of the Three Hundreds of Chiltern.[2] Then, as heir to his father's title, he would be summoned to the House of Lords—for a lifetime of service on the fringes of government. The destiny was not only his but would fall to his eldest son Bill and in turn to other generations of Astor males. The new Lord Astor thought of a way out and explored his options.

First of all, he could acquiesce, surrender to his fate and his father's fantasies, and at the same time abandon his own hopes for a distinguished

Commons career, perhaps even a ministerial appointment. On the other hand, he could challenge the Constitution with an attempt to change the law so that the eldest sons of peers could divest themselves of their titles. Such an act would then permit those presently serving in the House of Commons to remain there. Previous attempts had not been successful, and, as he had learned in his ten years as MP for Plymouth, the parliamentary process could be exceedingly slow. If he were to refuse the dictum, "Once a peer always a peer," then he would need some support, not only parliamentary democrats to propose the measure but also a stand-in for himself until the matter was settled. Actually, he needed more than a stand-in; he needed someone who could stand up to the opposition and someone willing to stand down when he became eligible to regain his seat.[3]

There were not very many who could step into his shoes under these circumstances. His brother, Captain John Jacob Astor V, had been severely wounded late in the war (September 1918); in fact, he was disabled and not up to the rigors of a campaign. And then there was his wife, Nancy. Legally, she could stand as a candidate. The Qualification of Women Bill, passed as a supplement to the law granting the franchise to certain women, allowed that. Furthermore, the fact that she was a peeress would not preclude her entrance to Commons. The same law established equality among women whether their husbands were "dustmen or dukes," and as a result permitted peeresses, though not allowed in the House of Lords, to sit in the Commons. However, she still needed the blessings of the local selection committee for the Coalition-Unionists. Already there had been talk in Waldorf's constituency that Alderman Lionel Jacobs would be asked "to stand as an Independent Conservative." Additionally, there were other factors to consider: Nancy's assets, her liabilities, her other duties, and her willingness to undertake such a venture. But yet, he also knew it would break her heart to leave Plymouth. He did not know if she would stand in for him; he did not know if she should be asked. Engulfed by all the ambiguities of his situation and unable to resolve the difficulties of his predicament, Lord Astor announced that there would be no decision until after his father's funeral.[4]

During those autumn days, writers in both the provincial and national press offered their own speculations concerning the required Plymouth by-election. They discussed the likelihood of Lady Astor's candidacy, profiled her accomplishments, and recalled the electioneering tactics she demonstrated in Waldorf's earlier campaigns. They considered the Labour candidate, William T. Gay, Waldorf's 1918 opponent, and wondered if the non-Coalition Liberals would enter the contest. A writer for the *Evening News* hinted that Mr. Isaac Foot, two-time candidate in Southeast Cornwall and

native of Plymouth, "may be invited to stand." He reported that a number of letters to the paper sought the re-entry of Mr. Asquith, the former prime minister who had lost his parliamentary seat in the 1918 election. Not only did the members of the press speculate about the candidates, but they also pondered the outcomes of both a two-way and a three-way race. The *Western Mercury* commentator predicted that the Coalition candidate, someone in favor with both the Conservative-Unionists and the Lloyd George Liberals, would fare best in a three-way contest. At the same time, however, he reasoned that the Coalition favorite would not do so well in a two-way event on the grounds that the Labour candidate would pick up votes from the Independent Liberal supporters who were unhappy with the postwar Coalition government. In short, he thought that a Liberal-Labour combination could win the day.[5]

On Wednesday, 22 October, the day of William Waldorf's funeral, reporters started to trade rumor for some solid information. The *Evening News* carried four articles devoted to the Plymouth election; one of them mentioned that Mr. Frank Hawker, the Conservative chairman for Plymouth, had gone to London "at Major Astor's request." Over the next two days press accounts reported that Hawker had announced that the Central Executive Committee of the Plymouth Conservative and Unionist Association had invited Lady Astor to stand for the Sutton division. He added that if she were to refuse, the committee would then ask Lord Astor's brother, John Jacob Astor V.[6]

Lady Astor, who was at Cliveden, received the bid on Saturday and wired the *Daily Express* that she had made no decision. Lord Astor told a reporter for the *Sunday Herald* that she would reply on Monday, 27 October. In Plymouth, party organizers for all three parties, Conservative-Unionists, Labour, and Liberal, announced an agreement declaring the time from 25 October-3 November as a "truce week" in the upcoming by-election campaign as they all had enough to do preparing for the municipal elections previously scheduled.[7] For a brief time, those entangled in the parliamentary affair could relax.

Some Sunday papers returned to their earlier speculations; a few discussed other pending by-elections. One, the *Sunday Express*, related that Asquith had been informally approached but that he would not enter a three-way contest. It went on to say that the Liberals were now considering a coalition with the Labourites in order to obtain "a fighting chance." It is not clear whether or not these new developments affected Lady Astor's decision. What is clear is that when Lady Astor did respond, there was no Liberal candidate. On Sunday evening, she wired Hawker and the Unionist

Association of Plymouth: "Fully conscious of great honour and grave responsibility, I accept the invitation to stand for Plymouth."[8]

The next day more than thirty British papers published stories announcing her acceptance. Many of them presented her in a favorable light and hinted that she had a good chance to win the election. They based their predictions not only on her merits as a candidate but on their feelings that the time had now come for women to serve in Parliament. A writer for one of the local papers, the *Western Morning News*, said, "People [were] beginning to see that if a woman can do good work on Boards of Guardians and other public bodies, she can do equally valuable service in Parliament."[9]

Nevertheless, there were some negative press accounts. The most critical was the *Morning Post* whose editorial writer attacked the Unionist party for abandoning its earlier stand against the enfranchisement of women and their election to Parliament. He also turned on Lady Astor for failing to abide by the Unionist party. Bluntly, he challenged her to define her Unionist principles "for at the moment we cannot call to mind in what they consist." Other writers indicated that Lady Astor had some problems in that she was an "American by birth." One thought that her abundance of gaiety and good spirits might also detract from her legitimacy as a candidate: "Lady Astor is quite unaffected, a shrewd and sympathetic woman, though she so often seems to be living in a light wind, so to speak."[10]

Overall, the immediate response to Lady Astor's candidacy was a mixed one, neither positive enough to promote overconfidence nor negative enough to dishearten. She would have to enter the campaign as a fighting woman, ready for the risks and challenges ahead. Realistically, she needed to face up to the imperatives of her situation. First of all, she needed to create an identifiable political persona; second, she needed to build a solid base of support; and third, she needed to fend off her opponents—all tasks that would require the best of rhetorical skills.

THE PROBLEM OF PRIOR PERSONAS

Lady Astor entered the campaign encumbered with a number of prior personas. Some of these would need to be cast off; others would need to be refashioned. A new image had to be created—one compatible with her own character and attractive to the Sutton electorate. As the opening of the campaign rapidly approached, Lady Astor found that the press had already cast her into several distinct types: "Gibson Girl," "Pussyfoot," "Lady Bountiful," "Warming Pan," and the "Hustler."[11]

The Gibson Girl was the creation of Charles Dana Gibson (1867-1944), an American illustrator whose pen-and-ink drawings of elegant, graceful, but active and animated young women with wasp waists and deep bosoms captivated worldwide audiences and propelled him into the top circles of New York and London society. His work became so popular that eventually he was "credited with creating a second age of chivalry in the American male of the period and with creating a new freedom for women who patterned themselves on the model he had fashioned."[12]

His primary model was the statuesque Irene Langhorne Gibson, his wife and Nancy Astor's older sister. Others in the family may have inspired him as well. The *Liverpool Post* spoke of the "four beautiful American sisters," and *Lloyd's News* referred to "Virginia beauties" and headlined one of its stories, "A Gibson Girl M.P.?" Other papers portrayed Lady Astor as a sportswoman, adept in driving, riding, golfing, swimming, and cycling—all distinguishing attributes of the Gibson Girl.[13] Lady Astor, at least in the public view, was one.

Identification as a Gibson Girl could have some impact upon Astor's campaign. There is no doubt many would have easily recognized that she was more a contemporary of those females of voting age than the flapper then bursting onto the scene. It is even possible that the freedom she symbolized might carry on over from the playing fields to Parliament. On the other hand, the Gibson Girl was a prewar figure, part of a glittering society now sobered by the trials of war. Her elegance seemed out of place for the time and especially so for the poor women of Sutton. Not only was she inappropriate for the situation, but she now seemed incongruous with Astor's personal circumstances. She was much too youthful for a 40-year-old mother of six.[14]

Astor's identification as a Pussyfoot can be traced to her outspoken views on drink and the travels of William E. ("Pussyfoot") Johnson, an American representative of the Anti-Saloon League. The *Daily Express* linked the two in an article headlined, "'Pussyfoot' Woman M.P.?" The writer commented that it would "be of interest to Plymouth voters that Lady Astor is an open and avowed 'Pussyfoot.' She believes that prohibition is the one thing for Plymouth and England." The remark would not do Astor any good; in fact, it might prove fatal to her campaign. American states had just ratified the Eighteenth Amendment, and there were many in Britain who feared that a similar measure might be passed there. Johnson, who had been quietly explaining the benefits of American prohibition while on an extended speaking tour, had drawn considerable press attention. Although his soft-spoken and mild-mannered approach

may not have warranted such a scathing response, he was nevertheless "ridiculed into eminence," stereotyped as "a meddlesome Yankee," and used as a scapegoat for other anti-American sentiments. Although Lady Astor personally opposed intoxicating beverages and hoped for the day prohibition would come to Britain, she did not deem it wise to impose her views on others. Association with Johnson would mark her as an extremist and contradict the view that the Astors were champions of moderate opinion. Additionally, it could kindle strong opposition from "the trade" and members of the "wet" press. Undoubtedly, it would also fire up the working men of Sutton. And finally, it could set the stage for Astor to be called another interfering American, sticking her nose in the business of others.[15]

Far less troublesome than the Pussyfoot persona was the press typification that Lady Astor was the local Lady Bountiful. The label was used in two press accounts, the *South Wales Daily News* and the *Evening Standard,* and implied in many others. The term linked Lady Astor to a long line of goodly and godly women who had befriended the unfortunate for many years. Originally used in connection with the personal ministerial efforts of the women of the nineteenth-century landed gentry and aristocracy, the name "Lady Bountiful" had expanded to encompass those women engaged in urban philanthropic work and, in Astor's time, service in local government. Charged with maintaining social order and "expected to devote their lives to others," the Ladies Bountiful had nursed the sick, cheered the elderly, and visited the destitute. They had taught Sunday school, conducted mothers' meetings, and encouraged cleanliness, industry, and thrift. In meeting immediate needs, they had dispensed soap, delivered bedding, and doled out clothing, coals, and castor oil. Later, they turned their interests to institutional endeavors: nurseries, organizations for women and children, savings clubs, and nursing associations. From 1914 to 1919, they supported the war effort; in postwar times, they moved dramatically into the public sphere, taking part on school boards, poor-law boards, and borough councils, where they focused their attention on issues concerning education and health, particularly matters relating to infant mortality, housing, and unemployment.[16]

Astor's role as one of the Ladies Bountiful who had "won the heart of the West country" began in 1911 and may be attributed as much to Waldorf's dedication to constituency service as to Lady Astor's own charitable sympathies. At any rate, press accounts carefully cited her many civic endeavors. They noted that she had been involved in maternity work and child welfare.[17]

During the war, she had helped build the Plymouth War Hospital Supply Depot, visited war hospitals, provided entertainment and country drives for the convalescents, and served as the "life and soul of many

movements" designed to bring benefits to families of servicemen and the working classes. Her home on the Hoe not only served as a social club for officers but was open to men of the lower deck and their wives. Even though reporters highlighted her work on behalf of those in Plymouth, they also made special mention of the care she had provided at the Canadian Red Cross hospital at Cliveden.[18]

Life as Lady Bountiful had provided Lady Astor with an admirable track record and a kindly persona. Nevertheless, continuation in the role could prove bothersome. There were some, especially those in the Labour party and others in the poorer classes, who resented the Ladies Bountiful, perceiving them as intrusive, insulting, self-indulgent busybodies motivated by class guilt. J. J. Moses, who seconded the nomination for Astor's ILP opponent, William Gay, revealed such negative feelings when he said, "The male relieving officer is lost to Sutton, and the Tories are trying to provide a female relieving officer. But Sutton does not want anybody to give away blankets and coals . . ." On the other hand, Lady Astor had apparently come across to others in an acceptable way. The *Daily Telegraph* reported that "her social welfare schemes and her unobtrusive help" had not only been well received but "cherished." The local paper, the *Western Morning News,* said that "acts of undemonstrative kindness and real constructive work [were] characteristic of her."[19] Lady Bountiful she was; she must remain known as the best of the type.

One of the more difficult perceptions Lady Astor had to deal with was the view that she would be a Warming Pan, simply a stand-in, for Waldorf. As soon as she had announced her willingness to stand, rumors began to circulate that she would be "deputizing for her husband." In its election story of 28 October, the *Western Morning News* subtly reported that the "suggestion" had been made that her "candidature was to be regarded as a temporary measure" while Lord Astor attempted to divest himself of his title. The reporter stated that to ask an outside candidate to stand for the by-election and then later "to ask him to stand down would be extremely unjust." He implied that it would not be so for Lady Astor because "the intention is to revert to representation by Lord Astor if this is at all possible."[20]

Although such an announcement might appease the Tories who were lukewarm at best about a female candidate and, should his attempt prove successful, smooth the road for Waldorf's easy return to Commons, it posed a dilemma for Nancy's own campaign. If she were to act as a Warming Pan, then she made herself vulnerable to all the charges her opponents could bring against Waldorf and the Lloyd George Coalition government he represented. Additionally, she might lose the support of the new female

electorate because the term Warming Pan was just another reminder of woman's subordinate role and could weaken her position with many of the Sutton voters. Were she to deny the Warming Pan role, then she placed both Waldorf and herself in a potentially embarrassing future position and fostered speculation concerning their domestic bliss. But at the same time she could strengthen her own campaign, open the way to an independent political view, and provide inspiration for future female candidates.[21] She would have to choose between her private and public roles. And rhetorically, she would have to do some fast-talking, both at home and on the platform.

Fast-talking would not be a problem, for the Hustler was Lady Astor's most well-known persona. Although recognized by family and friends for her captivating and amusing speech, Lady Astor did not share her talents publicly until Waldorf stood for Plymouth in 1910 and in 1918. On those occasions, she vigorously campaigned on his behalf, particularly in December 1918, when he was often kept away by governmental duties. Her efforts then not only captured considerable attention but also garnered enough votes that Waldorf topped the poll with a clear majority of nearly 12,000 votes. As her own campaign began, reporters recalled the earlier election-eering tactics she had used and predicted that Plymouth might be in for more of the same. Repeatedly, they drew attention to her style, her deft handling of hecklers, and her good humor.[22]

By style, the reporters meant both Astor's language choice and her delivery. In talking about it, the term they used most frequently was "unconventional." They said Astor persisted "in maintaining a hearty con-tempt for the ordinary rules of correct speech" and then referred to her most informal manner, questionable word choices, and wild comparisons. For example, they often seemed to recall Astor's penchant for the word *ass*: "I am not one of those *asses* who tell you you're going to have a new heaven on earth." They also liked to quote Astor's defense of Lloyd George by putting down his opponents as incompetents who "could not manage a tripe shop." They noticed that she was a highly animated speaker, one who preferred to deliver her speeches by standing or sitting on tabletops.[23] In selecting the words to describe her manner of speaking, they chose *bright, breezy, clever, captivating, amusing, racy, bantering, witty,* and *decidedly fresh.*

They had been particularly impressed with her skill in handling hecklers and liked to tell how she had quieted a few rowdies who had interrupted one of Waldorf's campaign meetings with a lusty "Shut up, you villains!" They also pointed out that she was a practiced heckler herself. They recounted the times she had pulled her carriage up to the open-air meetings

of Waldorf's opponents and joined in with her own disapproving remarks, "syncopated jibes and rapier-like thrusts."[24]

As easily as Astor turned the laugh on her opponents, she turned the joke on herself—much to the delight of her audience and the reporters who trailed her. They relished her self-deprecating humor and often repeated the anecdotes that illustrated it. A favorite was one of her war stories, the account she gave of a young invalid soldier recuperating at Cliveden. One day she took him up to her home and showed him the John Singer Sargent portrait of her placed in the great hall. Making the comparison between the lady before him and the one beside, he had remarked, "It must have been taken a long time ago, ma'am!" The reporters said she told the story with considerable "glee."[25]

Those who described her speechmaking talents evaluated them with high praise. They said she was an "excellent" and "very forceful" speaker, "fluent" on the platform. The *Pall Mall Gazette* said that "as an electioneer she has probably no superior." Lady Astor had, it appeared, already grasped the art of politics, exhibiting the gift of amusing the people—all on behalf of her husband Waldorf.[26] Could she do as well for herself? As the Hustler, could she achieve all that would be expected of her?

With each passing day, Lady Astor found that the expectations were mounting. Not only would she have to deal with the issue of her prior personas, but she also had to consider other complications arising in her campaign. The same day the announcement of her acceptance hit the press, Isaac Foot consented to be the Liberal candidate after receiving approval from party members in Southeast Cornwall, where he had stood in the two previous elections. Additionally, the rumor persisted that Mr. Lionel Jacobs might come forth as a fourth candidate, an Independent Conservative backed by "the trade."[27] Even one additional candidate could draw votes away from her. The time had now come for rhetorical actions, some damage control before either her previous personas or her new opponents blocked the way to a successful campaign effort.

Rhetorical theorists would say that she was in the middle of a consciousness-creating and consciousness-raising situation, compelled to "break up the old foundations and pour in the truth." In breaking up the old foundations, she needed to slough off those aspects of her political personality that could do her harm and to refurbish those that could do her good. In pouring in the truth, she needed to fashion a new look befitting the occasion. There were several means at her disposal. Initially, she chose to write letters to the press, grant interviews, and prepare an Adoption Day

speech. Analysis of these early efforts reveals that she used each to define who she was not, who she was, and who she was to be.[28]

Lady Astor's first move was to deny the charge that she was a Pussyfoot. Wiring Hawker and the Plymouth Unionist Association and at the same time releasing a copy of her statement to the press, she said, "I have never been asked to stand as a Pussyfoot candidate, nor have I any intention of doing so. It seems to me that I detect the claws of some other sort of envious cat in this misleading suggestion." The denial was clear and the wit characteristic. She extended the cat metaphor in order to deflect attention from her own prohibitionist views and turn it on the character of her accusers. She implied that they were not only distillers of misleading information but ungentlemanly as well; indeed, they acted like envious, clawing cats with whom she dissociated herself. In reviewing Astor's reply, the *Eastern Daily Press* predicted that it would become "classic."[29]

In an interview with the *Observer,* she repeated her disavowal of the Pussyfoot charge by explaining that she did not believe in forced prohibition. Yet she went on to point out that she did think the drinking problem needed to be tackled, and she expressed her opinion that progress had been made in wartime:

> It would be a national calamity, as serious as the loss of a battle, if we were to drift back into pre-war conditions, with all its unnecessary poverty, loss of efficiency, and mortality, which we now know were due to an excessive consumption of alcohol.[30]

Other occasions in the campaign afforded Astor the opportunity to expound on the problem of drink, but overall, her need to disavow the Pussyfoot accusation disappeared once the other candidates emerged. Both Isaac Foot and William Gay were teetotalers, and eventually the rumor that a fourth candidate would come forth was dispelled.[31]

Even though Astor emphatically denied the Pussyfoot charge, she equivocated when considering the Warming Pan role. The closest she came to admitting as much was when she stood before the selection committee for the Plymouth Unionist Association, whose members needed reassurance that she would be a good replacement for Waldorf. Even then she did not offer a direct comment but approached the issue obliquely and with a touch of humor. In one breath, she said that she was not there as a Warming Pan but in the next promised her "word of honour" that if Waldorf were able to stand in the next election, she would not run against him.[32]

Other times, she skirted the question of her surrogate role by qualifying her support of the Coalition government with whom Waldorf had been so closely associated. She often stated that she was for Lloyd George—as long as he was right—and that she was "a general supporter of the Coalition," but not "bound to it head and foot." Additionally, she opened the way for a more independent course by speaking in terms of "separate spheres." She stated that her mission was "to prove that women can serve the country in Parliament, and to convince electors in general that there is a great sphere in Parliament for women."[33] She hoped that within this sphere she would be able to present a new point of view. Conversing with a reporter from the *Observer*, she said:

> . . . it seems to me that the work of Parliament, and many of the issues it will have to solve might be assisted by a somewhat new point of view. . . . Women now constitute one-third of the electorate, and surely they are entitled to a representative of their own sex in Parliament. Don't you think the reason why the world is so lopsided is because women have no proper share in control? No woman would dream of trusting her baby with a man. . . . Why should she trust entirely to man so many questions which touch, on every side, herself and her baby?[34]

In essence, Astor coped with the Warming Pan dilemma by admitting that she would be a stand-in for Waldorf. In fulfilling the role, she would continue to represent the electors of Plymouth, but in a most significant addition, she would reflect the views of the country's women and children, operate in the sphere closed to him.[35]

In these first attempts to deal with the negative features of two of her prior personas, Astor denied some traditional female trappings. She did not want to be perceived as an "old woman" temperance advocate or as a supportive wife incapable of a mind of her own.[36] Neither did she wish to be corseted by other stereotypes.

She was especially eager to free herself from the commonplace rhetorical attributes of her sex, which she listed in a series of somewhat disjointed remarks during her first interview. She said that, if she were elected, there would not be "any screaming in the House" if she were not satisfied with parliamentary progress; she said she would not "weep over disappointments" nor would she ask "foolish questions." Neither, she added, would she be "a silent member." By contrast, she would "plod along at Westminster," protesting "earnestly," and "stand[ing] up for the British men and women."[37]

As far as her campaign was concerned, she pledged herself to a fair fight, commenting that "The whole of England is looking at us, and I would be ashamed of us all if we got back-biting and bat-slinging. They would say, 'That's a woman's way.'" Apparently, when it came to speaking either on the platform or in Parliament, Astor thought it better to do so in what was then perceived of as a man's way.[38]

Although she attempted to divest herself of the unappealing aspects of some of her prior personas, Astor did retain the best of her popular roles, updating them for the present circumstances. She kept parts of Lady Bountiful by emphasizing her interest in women and children and frequently referring to her wartime hospital work at Cliveden. She stressed her wartime service record to underscore her patriotism, dedication, and compassion. She pointed out that she had also been one of the first ladies who "went through the streets at the request of Mr. Lloyd George when he called for women munitions workers in the perilous stage of the war." And when the war was over, she had visited both the battle and burial fields in France.[39] For the most part, she spoke of her accomplishments in a general way, implying that her past record was already well-known by those in the community.

The term "Lady Bountiful," as mentioned earlier, was a typification used by the press. Lady Astor's own version was "Mother," a figure verified by her own six children and a nurturing persona expanded to mean agent for children and later agent for humankind.[40] Astor presented herself most clearly in her Adoption Day speech in two closely connected remarks:

> I have heard women say, "Why should a woman who has got children go into the House of Commons?" I feel that somebody ought to be looking after the more unfortunate children. My children are among the fortunate ones. That steels me to go into the House of Commons to fight my best not only for the men and women but for the children.[41]

And then, as if it were an afterthought to a discussion of her wartime service, she said: "When I went to France and saw those little crosses over there, I prayed hard that never would I let my personal consideration come between me and what I thought my duty to mankind."[42]

In refashioning Lady Bountiful into Mother, Astor surmounted some of her earlier problems and increased her opportunities to better identify with the Sutton electorate. Mother bridged the class difference that Lady Bountiful, in the eyes of some, had accentuated. Mother also brought to mind the expression "Mother of Parliaments" and encouraged the association

"mother in the Mother of Parliaments." Furthermore, in locating her spiritual rebirth, her prayerful dedication to mankind, among the crosses in France, Astor transcended the temporal ties of her own family, community, and nation to ascend to a universal role, "Mother for many." Rhetorical critic Roderick Hart would say that she had created a construct around which all could rally.[43]

Lady Astor also promised the Hustler that Plymouth voters had seen in her campaigns for Waldorf, assuring them that she was indeed very much a competitor. She said, for example, that she was "keen to contest the seat," "full of confidence and with a determination to win." She added that she feared nothing, that she could take care of herself, and that she was entering the political fight with zeal and earnestness. And then, as if for special emphasis, she remarked, "I have always been like that."[44]

Yet she was very careful in differentiating between the part she played when working on Waldorf's behalf and the role she was compelled to fulfill when campaigning for herself: "But remember there is a wide gulf between assisting my husband in electioneering work among people I know and being a candidate myself. . . . Now I am in a very different position and have to undertake a new and more responsible role." The key word here is *responsible*, and it was one she often repeated or alluded to when talking about her campaign and future work in Parliament. In her second statement to the press, she began, "The first thing I want to make quite clear is that I do not look upon this contest as a joy ride, nor do I enter upon it in any spirit of flippancy." In her official letter to the electors, she underscored a picture of her unsmiling face with the comment, "I hesitated long before consenting to stand . . . as I was overwhelmed by the special *responsibility* which under the circumstances would rest upon me as regards Plymouth, womankind, and my husband's past work." On the eve of her adoption by the Unionist Association, she stood before her audience dressed in black and couched her opening line in the phrase, "Although I am one of the most serious-minded women in Britain today . . ."[45]

Analysis of these repeated phrases in Astor's initial remarks, especially when contrasted to those of the earlier Hustler known for her humor, informality, and deft handling of hecklers, reveals that Lady Astor made an effort to shift from the humorous mode of discourse to the serious mode. By doing so, she sent a signal to the electorate that this time around the Hustler was not out to amuse the people but to take their concerns seriously. It was an attempt to set the tone for her campaign. By moving to the Serious Hustler, Lady Astor also revealed that she, in turn, wanted to be taken seriously, to receive the acclamation and the votes of Plymouth

Sutton. Additionally, a shift to the serious mode granted her greater control over the campaign as such a mode rests on the assumption of "a social world in common with the people around us"; that is, a single reality that has a unitary effect.[46] It was one way she could come to terms with the considerable novelty of her unorthodox situation and find common ground with the electorate.

As the campaign commenced, Astor revamped her prior personas and gave birth to a new one which she nurtured, not only in the days ahead, but also throughout her political career. This child of Astor's imagination came to be known alternatively as Pathfinder, Pioneer, and Pilgrim, but eventually emerged as Pilgrim, and it bore links to both the Pilgrim ancestors and Astor's role as first woman in Parliament. It was through the Pilgrim forebears that Astor justified her place in Plymouth and provided herself with a cover for the fact that she was an American by birth. She presented herself as a kind of Returning Pilgrim, a descendent of those who had left England for America centuries earlier. She stated that "if ever I had to choose a constituency it would be the Sutton division. I love Plymouth; it reminds me so much of my home in America. It reminds me of America and also makes me proud of my Cornish ancestry." Additionally, she identified with the "spiritual faith of the Pilgrim fathers," implying that if they had had the faith to set forth across the Atlantic, then she, too, would have the faith to undertake the pilgrimage to Parliament.[47]

By going to Parliament, she then would become the first woman to take a seat there, undertaking not only the constituency duties but assuming a role as agent for womankind. She saw her future as a symbolic one: "My hope is that I may pave the way for other women who aspire to enter Parliament." She felt it was her mission "to establish the right of enfranchised women not only to vote, but to sit in Parliament with lasting advantage to the nation."[48] Like Mother, Pilgrim was also a transcendent figure, another inclusive construct around which many could rally.

In the restructuring of her persona, Astor broke through the barriers that separated her from her supporters. She traded in the girlish Gibson Girl and the sometimes unwelcome Lady Bountiful for the Mother. She moved out of the narrow ways of the Pussyfoot to undertake the journey of the Pilgrim. In short, she exchanged those aspects of her persona that could divide her from her electorate for favorable features with which they both could identify. And then she covered her new political identity with the mantle of manhood.

Like Shakespeare's Viola, who found it necessary to don male disguise as she made her way in Illyria, Lady Astor also turned to manly trappings as

she made her own entrance onto the political stage. Specifically, she linked herself to her husband Waldorf and to Plymouth's hero, Sir Francis Drake.

Although she did not want to be perceived as a Warming Pan for Waldorf, she did want to hold on to all the benefits her association with him could bring. The most obvious advantage was that until he was called to the Lords, he was the incumbent. By taking on the role as his heir apparent, Lady Astor could advance as a frontrunner, capitalize on name recognition, and legitimize her efforts. As for the rough and tumble of the campaign itself, she could use him as a kind of shield—not only as a protector but also as a front for some of the bat-slinging she might be drawn into. As it turned out, it was Waldorf who started some of the early dirty work in the campaign by disparaging Lady Astor's ILP opponent, William Gay.[49]

Lady Astor also tied herself to Sir Francis Drake, the national and local hero best known for his part in the defeat of the Spanish Armada. She implied that he was her model for "heart" and "courage," and drew her audience into making the comparison between them, sending her to Parliament as he had been sent on his many adventures at sea.[50]

Contemporary wartime heroes with whom Astor identified were Tommy, Jack tar, and the Sergeant-major. They seemed to serve a triple purpose. Like Drake, they each exemplified courage, especially Tommy, who, Astor said, could laugh when "go[ing] over the top." Also, because these heroes came from the lower ranks of the military, Astor's identification with them helped her again bridge the gap stemming from class differences. Most interestingly, their speech patterns and ungenteel style, either the "mirth of the Tommy" or the "manners of the sergeant-major" helped her justify her own direct, frank, and fresh manner of speaking. In a way, such "Tommy talk" could also ease the shock of those discovering for the first time that she was not a duplicate of Waldorf, "urbanity itself."[51]

Lady Astor prepared herself for the political arena by overhauling her prior personas, discarding some, reshaping others, adding new features, and loosely disguising all in male trappings. She wanted to come forth as a serious Pilgrim Mother who would not pussyfoot but would follow her husband's way into Parliament to represent the men, women, and children of Plymouth by undertaking the work waiting not only for women but for humankind. The most distinguishing feature of Astor's new political persona was its male equivalency. She not only tried to cast off negative features of her own sex but made a conscientious effort to add the perceived attractive features of the male gender. Her situation was an extremely vulnerable one. Even though women had been granted the right to take a seat in Commons, gender was still very much an issue.

Lady Astor made her formal debut before the Sutton Division Con-
servative and Unionist Council on Monday, 3 November 1919, in the
Masonic Hall. Waldorf introduced Nancy after his own touching farewell.
"I have tried in the past to give you my best," he said, and then, turning the
platform over to Nancy, announced, "Today I again offer you my best."[52]

The reporter for the *Evening Standard* said that as Lady Astor rose, "her
audience rose with her." Then, when matters had quieted, she began "to read
her speech" from typed sheets that then "became an embarrassment." He
said, "She put them aside and with sparkling eyes set her audience, cheering,
laughing, and, sometimes solemnly hushed." He then quoted extensively
from the speech and gave it high praise. He said that it was "one of the most
remarkable political speeches ever delivered by a woman." He added that it
was the kind of speech that would leave "even the most hardened political
campaigner spellbound." And as if trying to explain her power, he said that
it was "artless self-revelation and a homely intonation" that were "part of the
secret of Lady Astor's oratorical success."[53] Self-revelation, the presentation
of an identifiable political persona, was certainly a part of Astor's success,
but the reporter's claim that it was "artless" may be open to question. What
he may have seen was a very carefully constructed persona artfully presented.

After Lady Astor's performance, a formal resolution to adopt her was
proposed. No questions were asked, and "the resolution was carried unani-
mously."[54] One of the most difficult hurdles for any candidate, the approval
of the selection committee, had just been cleared. Lady Astor then turned
her attention to the electorate.

FROM CONSTITUENCY TO COMMUNITY

> It makes no difference what the men do; the women
> are going to elect me.
>
> —Lady Astor

PRIOR TO 1917 two MPs had represented voters in Plymouth, but in that year parliamentary boundaries were redrawn and the area was divided into three divisions, West, Central and East. Waldorf and the other MP, Shirley Benn, thought the names undistinguished and pressed for them to be changed to Devonport, Drake, and Sutton. Each division was to have a single representative and Waldorf's was the East division, Plymouth Sutton. The entire community was divided into twenty wards, seven in Waldorf's division: Vintry, Sutton, Laira, Friary, Charles, Compton, and St. Andrews. The restructuring of boundaries, as often happens, changed the political complexion of each division and, in Waldorf's case, provided some uncertainty as potential voters in Sutton were now less likely to be Unionist than those in his former constituency. Laira ward, in particular, seemed to be a hotbed for Labour unrest.[1]

In the 1918 general election, called quickly by Lloyd George in order to capitalize on his wartime victory, Waldorf had done well, defeating both

Colonel Ransome, an Asquithian Liberal, and William Gay, the Labour candidate, with a majority of 11,757. However, in the following year, numerous voters began to voice their growing dissatisfaction with the ruling Coalition, and there was a rise of interest in the Labour party. The municipal elections in Plymouth held just prior to the by-election revealed this shift in voter preference. For all twenty wards, Labour led by a margin of 3,500 votes, but in Sutton it trailed slightly behind the Conservatives, who held on with a 600-vote margin.[2] Although the voters were not always the same in municipal elections and general elections, municipal elections were often watched for trends possibly predictive for the next general election. The results from this particular municipal election indicated that Lady Astor would face a stronger opposition than Waldorf did in 1918.

On the other hand, such opposition could be met were she to receive the support of the women voters. Eligible resident voters for the by-election included 17,175 women and 16,986 men. In addition, there were 4,518 absentee voters, usually servicemen still stationed overseas. Yet it was much too early to predict female electoral support, and Lady Astor did not know what the "buxom and solid women of Devon" who had "not yet quite got used to their votes" were going to do.[3] It was as likely that they would support a male representative of their class as a female representative of their sex.

The most distinguishing feature of the Sutton division was that it contained a large working-class population. These workers lived in the oldest part of town, known for both its historic features and its slums. There were railwaymen, fishermen, servicemen, and chemical workers. During wartime there were a great number of dockyard workers, but in the transition to a peacetime economy, 6,000 of them had been laid off and were now unemployed. At the time of the by-election, they were waiting to hear of plans for the future of the dockyards and concerned about the talk that those still employed were to be asked to take a cutback in their working hours. The Sutton community also housed old-age pensioners and, apparently, a great number of children. Members of the press repeatedly described some of the dwellings as the "worst slums," and Lady Astor commented that one dwelling was "just like Wypers."[4]

A reporter for the *Daily Telegraph* called Sutton a mixed constituency with an unpredictable electorate. He knew, for example, that Labour would increase its vote, but was uncertain if that increase would be enough to win. He had no idea what the women would do; he thought it unlikely that they would support a millionairess promising social reforms, and at the same time, he doubted if they would buy into the "gorgeous visions and dreams, which

make the stock-pot of Socialist outpourings."[5] In short, Plymouth Sutton, a fairly safe seat for Waldorf in 1918, could now be considered marginal.

If she were to win Sutton, Lady Astor would have to build a solid base of support. Politically, she would have to go beyond party appeals and seek continued support for the Coalition government that had sustained Britain in wartime and fostered the return of Lloyd George shortly thereafter. Lady Astor would have to draw votes not only from the Conservative-Unionists but also from the moderate members of the Liberal and Labour parties. Rhetorically, she would need to participate in some consciousness-raising activities, engaging her audiences with her campaign by helping them identify their common hopes, dreams, aspirations, and concerns.[6] Eventually, she took on the challenge of wooing the entire constituency, but she started her campaign by focusing on the women, the majority of the resident electorate and the audience most likely to be receptive.

WOMEN'S MEETINGS

Lady Astor moved quickly to garner the women's vote. Her campaign committee immediately booked many of the public rooms and scheduled a series of women's meetings for every weekday afternoon until polling day. She held the first in Pitt's Memorial Hall on Tuesday, 4 November 1919, the day after her formal adoption. She scheduled the last for the Guildhall, Plymouth's largest public forum. Other meeting sites were scattered about the various wards but were usually parish halls or schoolrooms. As Astor's crowds grew, she and her supporters held overflow meetings in adjacent areas, courtyards, schoolgrounds, and even among the gravestones in parish churchyards.[7]

The meetings usually started at 3:30 P.M., but some began as late as 5:00 P.M. The timing seemed convenient as it allowed Astor to attract women who were out and about anyway, either doing the family marketing, taking their babies for a daily outing, or picking up their older children after school. But most important, it was a time when she could talk to the women when they were apart from men. A reporter for the *Liverpool Courier* noticed, for example, that a women's meeting permitted Lady Astor to be on her own, to act as her own chair, to give a speech, and to ask for a vote of confidence. Additionally, it gave her the opportunity to set aside her mantle of manhood and reveal the best of her own feminine persona. Similarly, the women in her audience were not encumbered by the often-intimidating presence of men, and when the climate was right, they, too, were free to speak, to discuss

the issues that mattered to them. The result, as the *Courier* recorded, was a number of women's meetings "more lively than those called for men."[8]

The meetings were popular and Astor had no trouble in attracting an audience—not only the invited women but their bawling babies and cheering children as well. The meetings held in various ward locations were often overcrowded, a physical condition that often led to lighthearted complaints, especially when a mother attempted to squeeze herself, baby, and market basket into a schooldesk designed for primary children. The *Daily Chronicle* reported that Astor's first meeting attracted 500 women. Her last, held at the Guildhall on Friday, 14 November, gathered, with the exception of her final rally, the biggest crowd in the campaign. The *Western Morning News* stated that "several thousand" waited to get in, and the *Globe* reported that of the two queues, one was "a quarter of a mile long."[9]

As mentioned, Lady Astor herself was the featured attraction at her women's meetings. Occasionally, she would bring along another speaker or have one fill in for her if she had another engagement. Some of these speakers were from the local area or were members of her family. Other guests had received national recognition; the most distinguished of the latter were Mrs. Alfred Lyttelton, Mrs. Oliver Strachey, and Mrs. Lloyd George. Mrs. Lyttelton, a good friend of Lady Astor's, was the widow of a former Colonial Secretary and a leading feminist of the day. Mrs. Oliver (Ray) Strachey was also a feminist who had distinguished herself in the women's suffrage movement. Later she served as a parliamentary assistant to Lady Astor.[10] Mrs. Lloyd George, of course, was the wife of the prime minister.

The meetings for women shared features in common, and a comparative critical analysis of the rhetorical activities that took place in each reveals a characteristic pattern. The discussion that follows describes the pattern in terms of a community-building activity. It notes those rhetorical strategies that Lady Astor employed in establishing the boundaries, both in determining who was to be excluded and in fostering identification with those who were to be on the inside.[11]

As is obvious, Astor's afternoon meetings were for women, and men were neither invited nor expected. She made the message clear in the announcements that were issued in advance. Handbills for the women's gatherings were labeled "A Meeting of Women," and those aimed at gathering a mixed crowd were marked "A Public Meeting" or "Open-Air Meeting." Sometimes other gender designators appeared on the handbills as well. For example, the call to the meeting at Palace Street Schools said, "If you vote against/Astor/You Vote against Lloyd George/who gave Women Maternity Benefit." Several others commanded, "Sutton Women! Vote for Lady Astor."[12]

The "Sutton Women" appeal revealed another exclusionary feature; the meetings were not for nonvoters in the division. Female hecklers working on behalf of Gay were especially unwelcome. An incident that occurred at the meeting of women at Laira Green Schools, 7 November 1919, illustrates this well. During the question-and-answer part of the meeting, one woman took an exceedingly long time to come to the point of her question, prefacing it with a tirade against the Lloyd George Coalition. Lady Astor interrupted her to ask if she were a voter in the constituency, and if so, from which ward. The woman evaded her, continued her attack, and shouted, "What did the Government do at Woking?" This time Astor shot back, "I thought so; you're not a voter. I am talking to the electors of Plymouth and not to agitators from Woking. I am not going to answer any more of your questions." And then, in the ensuing disorder, she said, "Please take that woman out."[13]

A few days later, she explained to the women gathered at Palace Street Schools that those who had abused her and told lies about her were "imports" brought in by her opponents. "They were not," she said, "West country people."[14]

Astor also used her women's meetings to dismiss her opponents and the competitive politics that she said they represented. She frequently relied upon the elimination technique as the structuring device for her short speeches. Usually, she would begin with an attempt to put away William Gay, either by creating a negative persona for him or directly challenging the policies of his Independent Labour party. Then, albeit in a milder manner, she would dispose of Isaac Foot in similar fashion. By eliminating both from consideration by members of her audience, she then created a situation in which she would become their only choice. Should they have any doubts, she explicitly stated the matter: "You have not got much of a choice if you do not elect me." She would then present herself as a cooperative soul who was standing as a Coalition candidate. She would explain that even though the Coalition government had not yet achieved all its goals, it was still the best choice for the postwar period: "You must understand that I stand as a Coalition candidate, and that Coalition means the best of Unionists, Liberals and Labour are working together in co-operation and real co-partnership."[15]

In her earlier meetings, she transcended her political stance to present herself as a follower of Christ. Speaking with her first group at Pitt's Memorial Hall, she implied that Gay was a mere rhetorician when he had spoken of "the brotherhood of man and down with the classes." She said that, by contrast, "there had never been but one Socialist in the world, and

we women know who that was." She echoed the same thoughts the next day at St. Jude's Church Room when she repeated, "There never was but one Socialist, and he said, 'Love thy neighbor as thyself.'" Thus she again cut off Gay from consideration by associating him with false doctrine and establishing herself as a true believer. She also implied that those in attendance shared her religious ideology when she noted that "women had spiritual insight; they had always been foremost in spiritual things."[16]

Referring to an assumed common spirituality was one way Astor fostered identification with those women who were to be on the inside. She also employed other rhetorical means in her attempt to gather them together in a community of support. The next section examines those strategies Astor used in further distinguishing the "ins" from the "outs." Specifically, it discusses the format for her meetings, the prevalent style of discourse, and the linkages Astor made with the members of her audience by noting shared roles and values.

As Lady Astor was usually on her own in the women's meetings, she was able to establish the rhetorical agenda. She opened with an unusually short speech—so spontaneous in nature that one reporter called it "animated conversation."[17] The purpose was threefold: to downgrade the opposition, to set forth her own policy, often as a defense of the Coalition, and to enhance her own persona or develop other means of identification.

In talking about policy, she did so in bits and snatches, never elaborating upon it in full. Usually, she would clarify some stance taken by the Coalition or outline some of its postwar reconstructive acts. Occasionally, she would focus upon those acts specifically relevant to women: "Women in particular should be grateful to Mr. Lloyd George's Coalition, which gave them votes, which passed the Maternity and Child Welfare Act, and many other measures which would directly improve social conditions."[18]

There were many ways in which Astor attempted to enhance her own persona. One of them was to point out that she was not just another politician. She would justify her Warming Pan role by explaining that she was a candidate until Waldorf could get out of the House of Lords. But then, she would go on to claim "that women had the fullest right to representation in the House of Commons." She differed from the other candidates in that she did not want to make a political career. Not only that, she said that she was not going to make any election pledges that she could not keep.[19]

Astor often began her speeches *in medias res*, usually as if she were continuing the conversation from a previous meeting, responding to a morning press report, or had just received a penny for her thought. She would then jump to some statements in line with her purposes and then come to a rather

abrupt stop. Next, she would turn her attention to her audience and ask for questions, and more than that. The reporter for the *Western Evening Herald* said, "She not merely asked for questions, but practically coaxed her audience to ask them." Then, after Astor received her first question or comment, the meeting really began. It was as if she needed impetus from the audience to get her started. Although audience members were initially reluctant to enter a discussion, they did respond, usually with concerns related to local issues. For example, they questioned her about housing, pensions, pay for soldiers, strikes, and discharges at the dockyards. They shied away from many personal questions but frequently asked about her American birth, testing whether or not she was English enough to represent them in Parliament.[20] In giving her replies, Astor would then expand upon her initial remarks or lapse into a narrative that she thought would be apropos.

Overall, the pattern for the women's meetings can be described as an interactive format, one quite familiar to those acquainted with modern-day speaking situations. In Astor's time though, such interaction was quite unusual for a women's gathering. As a matter of fact, one of the speakers on her behalf had said that "as recently as five years ago," if anyone had "dared to say" that such an assembly "called to support a woman's candidature for Parliament was possible, the world would have rocked with laughter."[21] What is significant then about the format is not that it promulgated a great amount of substantive discourse but that it permitted women to speak up. It gave both Astor and the members of her audience the opportunity to enact women's participation in the political process. The fact that they were speaking and taking part in the political arena far outweighed what was said. Each meeting then was a social statement in itself, a joint enterprise by both Astor and her audience.

As the interactive format brought Astor's audience closer to her, her informal speaking style brought her closer to them. Drawing upon her previous contacts, Astor spoke comfortably with the women in her constituency as one familiar with her audience. Reporters covering the meetings noted that her speeches were *frank, earnest, homely,* and *vivacious.* One commented that they were "heart-to-heart talks." Another said they were "a tonic for jaded politicians." They had noted what was an intimate quality to her talk.[22] It implied closeness with her audience. Analysis of her rhetorical activity reveals that Astor fostered this sense of intimacy by the use of personal terms, easy body movement, and considerable self-disclosure.

Lady Astor avoided the impersonal and the indirect. She spoke of herself as "I" and her audience as "you," but most often she linked the two together as "we" or "we women." She called her opponents by name, "Mr.

Foot" and "Mr. Gay," turning to other references such as "one of my opponents" when she sought variety or thought it a safer way to attack them.

Furthermore, she moved easily when in contact with her audience. She would stop for a short personal exchange with several as she came and left her meetings; she would take babies into her arms or find chairs for their mothers.[23] She reached out to her women followers and made every effort to accommodate them. At Laira Green School, for example, she kept changing her position as conditions warranted:

> The candidate commenced by speaking from the floor. Still more women pressed in, and she stood on a chair. The crowd was even more tightly packed by further arrivals, and she got up on the table, holding a paper between her face and the electric light, which was about three inches from her nose.[24]

Self-assured and trusting to the goodwill of her audience, she freely disclosed to them the problems she had been encountering during her campaign. At the meeting at St. Augustine's School, she told them of the difficulties she had with the press, revealing that she really did not know how to cope with the matter. She said that the "newspapers were terrifying," rushing to take her from her "quiet, respectable life" and shooting her "into the very forefront of the women of England." At another meeting she said that it was "a terrible ordeal to go to Parliament."[25] She also confessed—with her usual self-deprecating humor—that her audiences were not always receptive.

> "I remember trying to practice a speech on my little boy," she told her audience. "Oh! Mummy, I am asleep," he complained. "Pet," she postulated, "Can't you keep awake until I tell you my speech?" "Send for the watchman," he replied, "he is deaf."[26]

In making such self-disclosing remarks, Lady Astor gambled, risking her image as a competent candidate, one able to cope with the press and to prepare an effective campaign speech. On the other hand, she stood to gain if her self-disclosure elicited reciprocal behavior by her audience. As she had trusted them with her campaign tribulations, they, too, could trust her with their concerns in Parliament.[27]

Astor also gave her women's audience moments of mirth, as if with them the necessity of maintaining a serious tone was not so compelling as with a male or mixed audience. She related or dramatized amusing personal anecdotes, cast out witty one-liners, and frequently engaged in ready repar-

tee. Her humor was never of the canned variety but arose spontaneously from the situation at hand.[28] She herself was often the victim, but, as the campaign progressed, men in general, her opponents and their supporters felt the lash of her tongue. One story, "Lady Astor and a Sailor," proved popular with members of the press and several of Astor's later biographers. In replying to a question relating to the street arrests of women thought to be soliciting for prostitution, Astor said:

> Let me tell you something awfully funny that happened to me. I saw a young American sailor looking at the outside of the House of Commons. I said to him, "Would you like to go in?" He answered, "You are the sort of woman my mother told me to avoid." I went to Admiral Sims that night and said to him, "Admiral, you have one perfectly upright young man in the American Navy." We have got to take risks. You know, nothing risked, nothing won.[29]

Here the joke was on the American sailor—and the American navy. The sailor had come up with two cases of mistaken identity, thinking Astor was a prostitute and the House of Commons a house of prostitution. And then the American navy got the jab for having *one* perfectly upright young man. The anecdote served Astor in several ways. First, it eased the concern of the woman who questioned her by assuring her that being mistaken for a prostitute had happened to Astor, too. Second, it placed Astor on the side of the English, an insider who not only knew what the House of Commons was but who was also capable of laughing at the American navy, thus easing fears about her own American heritage. Third, it opened the way to Astor's ambiguous follow-up comment, "We have got to take risks. You know, nothing risked, nothing won." Did she simply mean that women took their chances when walking alone? Or was she also implying that the sailor missed out on his opportunity to visit Commons by not taking the risk of following her? Could parallels be drawn between his case and that of the skeptical voter? Whatever the analysis here might be, Astor's story brought lightheartedness to the instant and drew her audience close to her in a bond of shared laughter.[30]

The incident that may have had even greater appeal than Astor's story about the American sailor occurred on Wednesday, 5 November 1919. While departing from St. Jude's Church Room, Astor stopped to speak to an overflow gathering "clustered around the graves in the old churchyard," a site more conducive to final rites than a political appeal. Responding to the solemnity of the scene, Astor stated, "If you elect me, I will behave with dignity," as she "drew herself up to full height." And,

"then with a smile, she added, 'And I promise not to pull the leg of the House of Commons any oftener than I can help.'" She moved on her way, but the reporter for the *Daily Chronicle* noted, "At that the women laughed until they had to hold their sides." In a most ladylike speech, Lady Astor had just conjured a vision of most unladylike behavior. No wonder the *Western Morning News* commented that she would "impart new life into the dead bones of politics."[31]

Astor's informal style and humor helped her cross some of the class and cultural barriers that stood between her and the women in her audience. She attempted to foster further identification with them by recognizing the commonalties inherent in shared life roles and values. She perceived that many in her audience were mothers, and, in turn, spoke in a way that further developed her own Lady Bountiful/Mother persona.

Essentially, Lady Astor saw herself as a caregiver. It was a role she played in her own family as wife, mother, and hostess to many. In wartime, she had expanded the part in ministering to those who passed through Cliveden and other war hospitals. The latter was an experience that had touched her deeply, and she alluded to it on several occasions. The story she shared with the women featured both "Tommy" and "Fritzie." She used it to illustrate her point that women cannot hate . . . that "man or woman" could not "consistently hate anybody for any length of time."[32] She said:

> When I was helping in a war hospital a "Fritzie" was brought in. The poor boy was very ill. I took grapes to English "Tommies," and I took "Fritzie" some. English "Tommies" asked me how I could do it. I asked them what they would think if one of them was in a German hospital and a German woman did not take any notice of them. Then, when Christmas time came round, every one of those British "Tommies" had a present for "Fritzie."[33]

She did not anticipate any change in her role in the future, but she thought that caregiving would be her parliamentary duty. In speaking with the women at Palace Street Schools on 10 November 1919, she told them that was what she was all about: "You ought to think of what I stand for. Unless I cared tremendously about the things which affect the women and children of England I could not, I would not, want to go into the House of Commons. But I do care tremendously." Astor saw the women in her audience as caregivers, too, and as a result, she constructed a second persona for them that was similar to her own.[34] She then saddled them both with responsibility for men:

We all know they are only grown-up boys. If men have failed us, it is
our own fault. Women have a great parliamentary vision. And now they
must go out and fight for it. Men think they have to help us; but it is a
great mistake—it is really we who have to help them.[35]

The caregiver role, part of the Mother persona, linked Astor with the
women in her audience. Identifying the men they cared for as "grown-up
boys" was also an interesting strategic move, for it placed men in a
subordinate position, implying that they were the ones who should listen
to their mothers, wives, and sisters when it came time to vote. Thus the
caregiver role could free both Astor and her audience for independent
political action.

Astor also assumed that she and members of her women's audience
shared common values, particularly esteem for peace, cooperation, and
unselfishness. All were part of her emerging postwar vision that was domi-
nated by the idea of sacrifice. Astor's work in war hospitals, her visits to
burial sites in France, and the development of the Canadian cemetery at
Cliveden had brought her into constant contact with the reality of war and
prompted a kind of conversion experience or at least a rededication of life
purpose. The servicemen's wartime efforts and their "spirit of glorious
selflessness and principle and fearlessness" that they had given "so freely for
this country" had profoundly impressed her. Similarly, she had been touched
by the sacrifices made by those left behind, "the mothers who have lost their
sons and women who have lost their husbands." She thought that the fitting
response, for both herself and others, was "to give up . . . selfishness:"

If every one of us does what we ought to be glad to do, we can "make
good" for the boys and men who will never come back. We owe to
them such a duty, and I want to see every thing they wished for come
about. I long to see their generosity and their goodness come out in
our lives.[36]

The view was certainly not Astor's alone but one held by many in the
aftermath of World War I. It was most clearly echoed by Archdeacon
Perowne, who reiterated similar thoughts in his Armistice Day address at St.
Andrew's Church. He reminded his local audience "of the sacrifice the
10,000 men of Plymouth " had made in "four terrible years." He said that
their wartime mission had "become a crusade against war itself" and that their
"call from the grave is a call to us to see that the Great War shall be the last
war, to eradicate the spirit of greed and egotism in which war is bred."[37]

Not only did Astor and Perowne mention sacrifice, but, as Robert Blythe in his book *The Age of Illusion* notes, it was etched onto every war memorial in Britain. He states that a million names were carved in stone, each representative of a life "that had been given and not taken."[38]

The reminders of wartime sacrifice and the call to unselfishness also brought to mind the Christian story, a prototype for unselfish love and supreme sacrifice: "For God so loved the world, that he gave his only begotten Son, that whosoever should believe in him should not perish, but have everlasting life." The story is a master narrative or an archetypal drama familiar to many. By alluding to it, Astor reminded her audience that whatever their differences, they were linked together by the same myth and were thus part of the same community. Furthermore, she gave her audience members the opportunity to identify with God, the supreme caregiver, and thus created for them a second persona that was hard to resist.[39]

Although Astor's speeches at the women's meetings were viewed by some to be rather insubstantial, a close comparative analysis of them reveals that Astor did employ a great variety of rhetorical strategies conducive to a community-building activity.[40] Her aim was to prompt political action among women. She separated them from the men and made every attempt to draw them together as one. She entered their circle by breaking down class and other barriers in introducing an interactive format, by speaking in an informal manner, and by recognizing and bringing to the forefront their common roles and values.

She perceived that their response to her was a positive one—so positive that by the end of the first week, she boldly prophesied, "It makes no difference what the men do; the women are going to elect me."[41]

However, Astor did not wish to "slip in or slide in" to Parliament "with a nasty, stingy little majority" but to "bound in," and as a result, she also aimed her campaign at male and mixed audiences.[42] No potential vote would be overlooked.

Even though her chances of capturing the vote of the male electorate were not as good as those in garnering female support, Astor enthusiastically campaigned whenever and wherever she could. She spent most of her mornings and early afternoons out and about the constituency, either canvassing for votes, making appearances, or addressing open-air meetings. Evenings she set aside for public gatherings at which she shared the platform with others who spoke on her behalf. Her daily excursions, including the open-air meetings, were even more informal than the meetings with the women. Her evening meetings, on the other hand, tended to be more formal until she opened the floor for questions. The energy

that she put into her campaign astounded one reporter so much that he complained, "She is here, there, and everywhere. To accompany her at all her meetings would cost a small fortune in petrol, and you would have to get a good car to stand the strain."[43]

Many others of the press did follow her, however, and a synthesis of their numerous and diversified reports permits a look at Astor's effort to build an electoral base beyond the women she specifically targeted. The next section examines Astor's work beyond the women's meetings. It begins with a summary of Astor's public appearances and moves on to a discussion of her traveling show and a brief examination of her invasions into enemy territory and friendly strongholds.[44]

CONSTITUENCY TOURS

Recognizing that visibility could be as important as the spoken word, Astor made every effort to appear in public. She went where she was invited; she went where she was expected, and she went where she had a good chance to be seen. During the dozen days of her campaign, she made nearly all large gatherings in Plymouth, a joint speaking appearance with the other candidates at a Guildhall meeting in support of the League of Nations, a Saturday football match, the mayor-choosing ceremonies, Armistice Day services at St. Andrew's Church, and meetings in the marketplace. She concentrated upon the poor, pensioners in almshouses and slum dwellers in the Barbican, but also appealed to those of greater means, particularly Plymouth businessmen and their wives. She targeted audiences of workingmen and those in the service, moving in their midst near the dockyards, beside the gas works, by the wharves, or in their shops or mess. She visited with wives, widows, and children, stopping in at organizational meetings (such as the Day Nurseries Committee of the Civic Guild of Hope), a church bazaar, and a party at a boys and girls club. She investigated street gatherings, observed her opponents' rallies, and called out to passers-by.

Astor did not just make her presence known, but on quite a few occasions made an unusual effort to draw attention to herself. As she had done in Waldorf's earlier campaigns, she turned to Churchward for assistance in putting her traveling show on the road. Churchward was a driver for a Plymouth livery stable who assumed the role of either master of ceremonies or campaign manager for Astor's daytime excursions. Dressed in a silk hat and wearing a large rosette fashioned in the red, white, and blue Coalition colors, he would bring around a landau and a pair of similarly beribboned sorrels for

either Lady Astor or Lady Astor and her traveling companion. Together, they would set out for visits and speaking engagements in Sutton, trailed by photographers and reporters and those picked up along the way. When Churchward spotted a good place to stop, he would halt the procession, and Astor would deliver an impromptu talk to her audience or engage in lively conversation with some members of it. Sometimes, Astor spoke from the open carriage; other times she moved out into the crowd. When it appeared as if she had finished or the attention of the audience was waning, Churchward signaled to Lady Astor, "Time's up, get in."[45]

Early on in the campaign, Astor's wayside meetings reveal that she attempted to establish good rapport with her potential voters. The bantering that went on was friendly, and Astor kept her good humor. For example, in a meeting with some fishermen on Saturday, 8 November 1919, she told them that "Fishermen have played a glorious part in this war, though I'm not here to flatter you."[46]

The line led to a rhetorical hook that left the men with no choice but acceptance. If they resisted her "I'm not here to flatter you," then they left themselves out of her praise, "Fishermen have played a glorious part in this war." However, if they took her at her word, then, in order to identify with her compliment, they also had to accept her remarks as sincere. Thus it was that she lured them into recognizing both personas—glorious fishermen and sincere politician.

She then spoke in general terms about the Unionist party's support for the navy and said she thought "there ought to be a Ministry of Fisheries alone." Her comments directed at her opponents were mild, and she avoided confrontation by telling those with whom she disagreed, "Don't vote for me; I will not represent you."[47] The purpose of the meeting was not to present a program but to establish a relationship.

Later that same day Lady Astor took her public relations efforts to the Victory Club, a children's welfare institution, where she danced with the children and played blind man's bluff and ring o' roses. The children chanted, "She is one to have a bit of fun," and all had such a good time that Astor was "extremely late for dinner." The *Daily Express* indicated that at such a time, politics was forgotten, but that may not have been so at all. Astor had frequently said that she intended to represent children, and meeting with them certainly gave her the opportunity to reinforce her credibility on that point.[48]

Astor also tried to expand her electoral base, or at least prevent inroads into her own, by invading enemy territory. On 11 November she directed her cavalcade to Coxside, where she tried to engage the attention of Gay's supporters, employees of the gas works. It may be that she wanted to tell

more about herself as parliamentary agent for women, children, and the workingman or that she hoped to break up the foundations of Gay's ILP party with a frontal attack or that she needed to further vindicate Lloyd George's Coalition government. She got through her opening phrase, "Ladies and Gentlemen, I want just to talk to you and show you—," and then encountered so many interruptions that she ended up defending her right to speak. Facing such a highly antagonistic audience, she dropped the familiar jocularity of her earlier open-air meetings and responded to her challengers bluntly and directly, coming back as a fighting woman. Repeatedly she told them to either "Be quiet," "Shut up," or "Yap" when she was finished. Occasionally, she met momentary success, but finally had to shout for order by crying out, "I am not here for a beano!" When her audience began to quiet down, she explained that she was "not out to serve" herself, but just "out to do my bit." She then implied a comparison with those servicemen who had "done their bit in the war, not on the quay."[49] Touched by her appeal or perhaps recalling that it was indeed Armistice Day, her audience then gave her some room to speak her piece.

Undaunted by the taunts on the eleventh, Astor returned to Coxside on 13 November, this time planning to speak to a group of workingmen at Notte Street. She opened by asking her audience to ignore the requests of the Labour whips and to "exercise their intelligence and vote as they thought best." Shortly thereafter she introduced J. A. Seddon, MP, a member of the Labour party whom she had brought along to speak on her behalf.[50] By toning down her own comments and by having Seddon with her, she had hoped to defuse some of the hostility she had experienced before.

Her strategy backfired, and Seddon became the target for the jibes and insults of the workingmen. They called him a "Traitor" and a "Black-leg" for supporting Astor and interrupted him so many times that he, like Astor on 11 November, found himself struggling for his right to speak. Astor, who had thus tried to break into Gay's strength by forging a Labour split, ended up in retreat, returning to a defense of the Coalition government. Later she tried to hold her own by defending her American birth, her campaign manners, and Lord Astor.[51]

The most interesting remark in the exchange occurred when Astor rebuffed an unemployed ex-soldier who had claimed that he was going to vote for the Labour party. Astounded, Astor said, "You ought to be ashamed of yourself to side with those pacifists." The soldier responded by saying that Lloyd George had "promised us a land fit for heroes when we came back." Astor then said, "Oh! no, he didn't. He promised to try to make the land fit for heroes, and no one is doing more than he is to achieve that end."[52]

Even though this second daytime excursion into Gay's territory ended a shade better than her first, Astor's moves to gain support away from her Labour opponent cannot be deemed outwardly successful. The value of her effort lay not in her ability to solicit more votes but in her willingness to demonstrate that she could enter the political fray, take the heat, and reveal that she was not fainthearted. Again, her strategy was enactment, living proof of her frequent claim that "women should be in politics."

Unable to detect many signs of support among the workingmen and unemployed in Plymouth Sutton, Astor took her campaign to the servicemen in hopes that she might find a more favorable response. She visited the marine barracks on 12 November and the headquarters of the Royal Garrison Artillery on the thirteenth, each time speaking to "sergeants in their messes." On the fourteenth, just before her final rally, she met with those of the lower deck of the British navy.[53]

The first meeting began with some moments of tension because neither Astor nor the sergeants knew quite what to do in such a novel situation. Astor and her small entourage had invaded the sergeants' territory while they were drinking stout, and their half-finished glasses were still on the tables. Astor was not sure what, if anything, she should say about that. The men did not know whether to drink or not to drink. Neither did they know whether to stand or to sit. Finally, one sergeant offered some chairs to the visitors, and those who had accompanied Astor sat while she stood at the end of a long table and addressed the men who stood "at ease"—rather "ill-at-ease."[54]

As in her meetings with women, she opened with a short talk and then opened the floor for questions. One of the men boldly asked what it was that Lady Astor had done for the navy, wondering aloud why her supporters kept referring to her past efforts on behalf of the lower deck. Caught off guard by his question, she opted not to give a public reply but to answer him privately. The two of them then stepped over to a window where Astor divulged her secret—later rumored to be the account of a special trip she had taken to see Lloyd George in order to plea for an increase in sailors' pay.[55]

She then planned to leave the meeting, but on her way out, remarked, "Good-bye, boys, I know you want to get back to your beer and smoking; unless, of course, you would like me to give a temperance lecture." One of the "boys" thought that might be a bit of fun, so he took her up on her offer. Accepting his challenge, she then gave such a straightforward reply regarding various governmental policy options related to the drink question that he and others in her audience wondered if she were indeed a Pussyfoot.[56]

Astor's meetings with other servicemen were not covered by members of the press as carefully as was her first meeting with the marines. However,

there is evidence that indicates that Astor had indeed been capturing the support of those in the navy. A letter from Waldorf to the Earl of Selborne, former first lord of the Admiralty, indicates as much. Waldorf had asked Selborne to come to Plymouth to speak on Lady Astor's behalf. Selborne had sent his regrets, explaining that he could not take time off from his parliamentary duties, but then offered his support for Lady Astor. Waldorf, in a second letter to Selborne, then asked if he could publish "an extract" from Selborne's first letter. Waldorf then wrote, "My wife is getting wonderful support from the lower deck and the man in the street, but there are some men, e.g. some of the officers, naval and military, who were in the past totally opposed to suffrage, and who are now not quite certain about supporting a woman."[57]

Later on, Lady Astor credited the men in the navy for their help. In a postelection article written for Universal Service, she explained, "I believe it was the wonderful, touching support from the navy lower deck men which steadied and rallied the waverers, overcame the doubters." And according to one press report, the children of Plymouth certainly knew of the navy's support for Lady Astor. In addition to their "She is one to have a bit of fun," they also chanted:

> Yankee Doodle had a son
> They said, "Now, who's your fancy?"
> He said, "I'm off the lower deck,
> And so I'll vote for 'Nancy'"[58]

Astor's public appearances, open-air gatherings, and meetings with the servicemen, though highly varied, do reveal some common patterns and characteristics that link them together as rhetorical events. First of all, there were so many of them. Second, each was short. Third, many offered the opportunity for dramatic confrontation, and finally, they were colorful. None of them gave Astor the opportunity to expand upon her program, discuss the issues, or even develop her persona to any great extent. They were Astor's attention-getting devices—her ballyhoo, perhaps. They were designed to bring out the potential voter, at first to come to the late afternoon women's or evening meetings and later to the polls. They also attracted the press.[59]

And because they attracted the press, they also bear an extremely close resemblance to what in today's electronic age one now calls "media events." Actually, they *were* media events, but in 1919, the major medium was the newspaper. Today's candidates aim for spots on the evening television news,

speak in sound bites, and stir up interest by creating matters that will distinguish them favorably from their opponents. Astor's daytime excursions from one spot to another usually led to a reporter's evening dateline and a place in the next day's morning news, either in the local or the national press. The clever phrases, called "Astorisms," were really first cousins to today's sound bites; they were short, pithy comments perfectly suitable for headlines. Romps with children, parading around with Churchward, and shaking her finger at suspected "Bolshies—all provided photo opportunities, not only for the press photographers but for newsreel makers as well. Her confrontations with hecklers and the dramatic and comic moments provided by such an adversarial situation are the very stuff of storymaking. Astor, then, by creating and participating in imaginative, theatrical campaign events became the talk of Plymouth and the story the reporters wrote home about. She was, as Fisher contends we all are, *homo narrans*, a storytelling person. But her daytime excursions reveal she was more than that. She was a storymaking person as well.[60]

EVENING MEETINGS

Lady Astor continued her quest for electoral support in the Sutton division by appearing at a series of evening meetings held for mixed audiences. These meetings, all scheduled for 8:00 P.M. from 4 November through 14 November, were held in schoolrooms or parish halls within the various wards. The final rally on 14 November, like her final women's meeting, was held in the Plymouth Guildhall. Astor's campaign committee often arranged for concurrent meetings, switching Astor's spot on the platform back and forth with others who spoke on her behalf. For example, on Thursday, 6 November, she was to appear at Palace Street Schools and Embankment Road Schools following a joint appearance with her opponents at a meeting on behalf of the League of Nations. At the same time, Oswald Mosley, one of her supporters, was to speak for her both at the Baptist School and Lower Compton School. Although such a schedule allowed Astor maximum audience exposure, she was often late to her meetings and had to push her way through the crowds in order to address them.[61]

The meetings were all well advertised, announced in both morning press reports and a series of handbills distributed by Astor's campaign committee under the supervision of her election agent, C. G. Briggs. The handbills, printed on both sides of colored newsprint, followed a standard pattern. On one side, the words, "A Public Meeting," would appear, followed

by location, date, time, and a list of "other speakers" in addition to Lady Astor. On the flip side, a variety of slogans promoted Astor's candidacy. During the first week of the campaign, the following two appeared: "Make history and the first lady M.P." and

> A woman for economy
> A lady for Parliament
> Astor for Plymouth[62]

During the last week of the campaign, the reverse side indicated that Lady Astor would assume the incumbent's role. One handbill simply stated, "Astor Once Again." Another linked Lady Astor's present campaign with those Waldorf had conducted earlier:

> Election Results
> Astor first in 1910
> Astor first in 1918
> Astor first in 1919[63]

Although Lady Astor was certainly the featured attraction at the evening meetings, she was not always the featured speaker or one of the featured speakers. Campaign talk came from her entourage of male supporters, her husband, Waldorf, her brother-in-law, Colonel Spender Clay, MP, and other members of Parliament who thought she would be a welcome addition to the House of Commons. One speaker, Sir Henry Jones, was Professor of Moral Philosophy at Glasgow University. Another, J. A. Seddon, had been a Labour leader early in the war years. A third, also an MP, Oswald Mosley had served in the Ministry of Munitions and the Foreign Office. At the time of Astor's campaign, he was known as an outstanding public speaker, a member of the "smart set," and a representative of a younger generation for "whom the war had sown doubts about traditional creeds and line-ups." Many of the speakers had been contacted by Waldorf through Hughes Gibb, his secretary at the Ministry of Health. He selected some because they were personal friends, some because they supported women's suffrage, and some for their ability to represent the encompassing nature of Lloyd George's Coalition government. The most notable feature was that they were not all Conservative-Unionists but Coalition Liberals, independent Liberals, and Labourites as well.[64]

When it was Lady Astor's turn to appear on an evening platform, she often gave a short speech and then opened the floor for interactive sessions

with members of her audience. Again, by inviting audience participation she also opened the way for confrontations with her opponents, subjecting herself to heckling and verbal abuse. Yet at the same time she gave herself the opportunity to come back, to reveal her strengths in witty repartee.

Astor and her supporters spoke about a variety of topics and responded to a number of questions relating to both domestic and foreign matters. Press reports indicated that audience members were interested in pensions, premium bonds, franchise reform, the League of Nations, and governmental views on Russia. Many more were concerned with the fate of the dockyards, the most pressing problem in Plymouth. As mentioned earlier, 6,000 workers had been released since the war, and at the time of the by-election, 200 a week (another 1,200) could expect to be discharged by Christmas. Their concerns had been taken on by the Labour party, and those in the Coalition had to consider a rapid change in policy or face the probability of losing power. Astor contended that she had been involved in the matter even before she decided to stand for office:

> I felt so much about the dockyard . . . before I thought I was going to
> stand as a candidate that I went to the people in authority in London
> and told them, "You must do something about Plymouth Dockyard.
> The very life of the place depends on it."[65]

Even though she was concerned as any Labourite about the dockyard issue, Astor did not support Gay's view that "complete socialization of industry" was the solution to the problem.[66] Thus it was that in addition to speaking about the dockyards, Astor also devoted a considerable portion of her time during the evening meetings attacking her opponents and defending Lloyd George's Coalition government and her own candidacy.

As in her other meetings, she insisted that Gay was not a true Socialist, but a dangerous fellow associated with the ILP and the Bolsheviks whom she felt it was her duty to "keep out of power." And with the exception of her speech regarding British policy with Russia, she rarely mentioned Isaac Foot. She followed the remarks of her supporters by seconding their defenses of the Coalition government and extolling its extension into peacetime. For example, she mentioned the progress made in such areas as housing, health care, pensions, army and navy pay, and peace with Germany and Austria. Often she referred to the League of Nations, the world's best hope against war:

> Leagues are no good unless people accept them, believe in them, and
> try to live up to them. Some day the world will be perfect, and there

will be a real League of Nations, but there is only one way of reaching
that, the Christ way.[67]

Astor also had to hold her own against attacks that she was a wealthy
American insensitive to the needs of the Sutton working class. When told,
"Go back to America," she retorted, "I am pleased to do my duty in the State
which it has pleased God to call me." On other occasions, she often repeated,
"I am of Virginian blood and come of good old Anglo-Saxon fighting stock."
When faced with implied charges about her wealth, she would often turn
the tables, asking the inquirer, "Would you be doing what I am doing if you
had what I have?" She also snapped, "I represent the working man. My
husband was not elected by 17,000 millionaires living on the Hoe." Emphat-
ically, she then announced, "I would rather be MP from Plymouth than first
Duchess of Europe."[68]

Astor's evening meetings can be compared and contrasted with her
daytime meetings in terms of rhetorical strategies and other characteristic
patterns. As in her women's meetings, Astor often began *in medias res*, a habit
that forces her modern-day reader to wonder if she ever stopped talking. It
seems as if she was always continuing on, making remarkable connections
to the scene at hand. She would follow up on the remarks of the previous
speaker, refer back to a meeting earlier in the day, latch on to a press report,
or allude to a comment by one of her opponents.[69] As will be seen in a later
discussion of the 10 November speech at Prince Rock Schools, her state-
ments then can be traced to an earlier address by Lloyd George, a critical
charge by her opponent Isaac Foot, and an ongoing national conversation
concerning postwar British foreign policy.

In her evening appearances, she again relied upon humor and narrative
to gain and keep the attention of her audience. She also demonstrated her
gifts of mimicry—delighting her audiences by acting out her stories, taking
on the personas of her opponents whoever they might be. Mocking one of
those who had made a disparaging remark about her wealth, she told her
audience at St. Jude's Mission Hall a story she had overheard:

> One thing I heard today I must tell you. "We know Lady Astor," they
> say. "She comes among us and then goes into her big house, calls a maid,
> and says, 'Remove my gloves, I have shaken hands with a Tommy!'"[70]

The reporter then added that she mimicked herself in "mincing accents."[71]

She played politics, but preferred to downplay her future role as a
politician in order to emphasize her role as a caregiver. Often, she denied

that she ever intended to be a politician; instead she was a caregiver, willing to attend to the needs not only of the women and children but also those of the workingman, the serviceman, and the pensioner. References to this role then enhanced the development of her Lady Bountiful/Mother persona.

However, it must also be noted that even though she downplayed her potential role as a parliamentary politician, she did not forgo some of her electioneering tactics. She demonstrated the "hustle" that her audiences had come to expect. She often made audacious comments to open her evening's remarks. At her 10 November meeting at Laira Green Schools, she pushed her way forward in "an enemy stronghold," climbed on a tabletop and "carried its garrison off their feet" by announcing:

> At the present rate of promises . . . I shall get 3,000 more votes than my "late lamented" husband, so, instead of having a poor little majority of only 11,000, if they all do their duty I expect to romp in with 14,000.[72]

In relating the incident, the reporter for the *Manchester Chronicle* then commented that Astor's opening assertion had so astounded the opposition ("which had been expected to create something more than a little liveliness") that it "completely took its breath away" [so] "that it had not recovered by the end of the meeting and a vote of confidence in Lady Astor was carried by a large majority."[73]

As mentioned, she relied upon the interactive format, turning immediately to her audience or doing so after a short series of introductory remarks. She answered questions and, when challenged by those who opposed her, engaged in dramatic confrontations with them. As the campaign progressed, she seemed to grow bolder. She either grew in confidence or trusted in the chivalrous inclinations of her male entourage or audience members. For example, she accepted the gallantry of a railwayman who befriended her at an outdoor overflow meeting after her night meetings at Prince Rock and Laira Green Schools. Touched by the scene, the reporter of *The Daily Telegraph* closed his account of the happenings with the following:

> Against a poor exhibition of ill manners let me record the act of a railwayman who took off his heavy coat to shield Lady Astor against the cold night air at the overflow and effectively squashed the rudeness of an interrupter.[74]

The evening meetings differed from her daytime women's meetings and street excursions in several respects. First of all, they were more formal

in structure, organized according to a pattern that seemed at the time to be standard campaign procedure. Usually a chairperson opened the meetings and then introduced the speakers on Astor's behalf.[75] When she appeared, she would give a short talk and answer questions from the audience. After she finished, someone would call for a vote of confidence; the vote would be given and Astor would respond with a grateful thank you. During these events, Astor usually spoke for a short time and then moved on to the overflow meeting or the next event. The structure inhibited Astor somewhat, and as a result, the evening meetings, though lively, lacked the intimacy prevalent in the women's meetings and the color characteristic of her daytime excursions with Churchward.

Second, Astor's evening meetings were more political than her meetings with women. The overall focus seemed to be more on the issues at hand, the ability of the Coalition government to deal with them, and the dangers that might arise should an opponent gain the seat. Astor seemed a bit trapped in the immediacy of the event and less inclined to move forward with her visions of progress.[76] She, for example, did not make as many biblical references in her evening meetings, talk of spiritual matters, or turn to transcendence as a rhetorical device.

Third, she sometimes took a back seat to her entourage of surrounding males. Often, she allowed them to do most of the speaking, relying upon their expertise as MPs to deal with matters regarding the government. Frequently she deferred to Waldorf, who assisted by speaking for the Coalition, confirming his support for her candidacy, and, on occasion, prompting answers to the questions she received.[77] Overall, turning night-time matters over to the men may have enhanced Astor's campaign. The move revealed that she had male support and endorsement. It demonstrated that, contrary to her statement that she was "no Warming Pan" for Waldorf, she was willing to continue his work in Parliament. It assured the potential voters that in undertaking the dramatic and historic move of sending a woman to Parliament, they would have Astor's promise that the representation of their interests would not change all that much.

Astor's evening meetings, like those held in the late afternoon for women and the noon-hour ones held in the open air, did attract interest. She drew large crowds and often had to speak to overflow meetings. One reporter wrote, "Old hands say they have never known a by-election at which a candidate has attracted such huge audiences." Another, comparing an Astor event to one held by Foot, complained, "A visit to the Liberal candidate's meeting after this was like watching the fizzling of a damp squib after a brilliant fireworks display."[78]

The evening meetings that attracted the most press attention were those held at the beginning of the second week of the campaign. They followed a weekend of Labour rallies and several other significant events. They were held at Prince Rock Schools and Laira Green Schools. An analysis and discussion of Astor's speech at Prince Rock follows.

Speech At Prince Rock

When Astor entered the halls reserved for her evening meetings, she frequently had to work her way to the front, rubbing elbows with those in the crowd. Reaching the platform, she would find it necessary to pick up on the discussion that was underway and to elaborate upon the topics already presented.[79]

On several occasions she discovered that she was expected to speak on matters of war and peace. On 10 November, she anticipated audience interests and came prepared to discuss the proposed changes regarding Britain's relationship with Soviet Russia.

Initially, Lloyd George's wartime government did not think the Bolshevik regime would last, and as a result, it did not adjust rapidly to the changes ushered in by the Russian Revolution. When it became apparent that the Bolsheviks were willing to plea for a separate peace with Germany, Britain, fearing the disintegration of the eastern front, gave her support to the Whites, a conglomeration of Russians held together by the desire to continue the war. After a peace had been negotiated, Britain and other allies continued their support of the Whites as they became the counterrevolutionary forces opposing the Reds in the ensuing Russian Civil War. A first concern was to protect war goods, piled in northern and southern ports, from falling into German or Bolshevik hands. The British sent 40,000 troops and later delivered additional supplies, including tanks, for General A. I. Denikin, the commander of the White army. They upheld a local anti-Soviet movement in Archangel. At the time of Astor's 1919 campaign, they were in the midst of a blockade.[80]

The tide, however, was not turning in favor of either the Whites or those intervening on their behalf. The Reds, "on the defence everywhere at the beginning of the year," now "had control on all fronts." In October, Denikin had been checked 250 miles from Moscow; another White general, Yudenich, had been turned back on the edge of Petrograd. The Reds held the center of the country; foreign interveners could not penetrate beyond the fringes. There was little hope for a military victory.[81]

Neither was there much interest in continuing the intervention. The allies themselves had negotiated a peace with Germany, and many no longer wished to keep war-weary troops abroad or to fund their activities. In Britain, several points of view emerged. The Labour party opposed intervention. Churchill, then Secretary for War, did not want to pull back. Asquithian Liberals, concerned with postwar problems, thought intervention much too costly.[82] On 8 November, two days before Astor's Prince Rock speech, Lloyd George had announced what was to be a major shift in Coalition policy.

Speaking to those assembled for the annual Lord Mayor's banquet, Lloyd George reviewed the activities of the previous year. He first turned to the past, reminding his audience that on that night in 1918 he had announced the abdication of the Kaiser and the end of the German Empire. He discussed the progress that had been made during subsequent peacemaking and then turned to the present to outline the problems that still needed to be resolved. He said, "Quite frankly, I do not like the outlook in Russia." He described the present situation, the setbacks to the White cause, and predicted an "interminable series of swaying campaigns" until the warring factions themselves sought peace. He justified the support Britain had given in the past by claiming it was an obligation "to the gallant men in Russia who helped us fight the Germans when the Bolshevik leaders were betraying the Allies on the front." He said:

> We have sent one hundred millions' worth of material and of support in every form, and not a penny of it do I regret in spite of the heavy burdens which are cast upon us. It was a debt of honor, and we had to discharge it.[83]

But then he looked to the future and announced that Britain could not, "of course, afford to continue so costly an intervention in an interminable civil war." He added that the "troops are out of Russia," that Russia was "a quicksand," and that he hoped winter would offer an opportunity for "the Great Powers of the world to promote peace and concord in that great country."[84] British intervention would end.

Shortly thereafter, the Labour party passed "a resolution welcoming the Prime Minister's statement." The Liberals grudgingly called it "a wise if all too tardy proposal." In Plymouth, Astor's Liberal opponent, Isaac Foot, responded to Lloyd George's remarks by chastising him for spending so much on the Russian intervention. In a speech at Grenville Road Hall, he commented:

> But they were not his millions. They happen to be our millions, and we do regret them. A hundred millions would furnish us with 150,000 houses, which could have been let rent free in perpetuity to disabled soldiers.[85]

And on the same occasion, he threw down the gauntlet to Lady Astor by telling his listeners, "Frankly, I don't know where she stands on matters of vital importance."[86] That night she accepted his challenge. When she pushed her way through the crowd at Prince Rock, she was armed with a ready response to the Russian question. After first astonishing those present by predicting a healthy majority, she then turned on Foot and others critical of Lloyd George's policy.

She said that "one of her rivals" had "suggested there were no houses because of the money thrown away in Russia." She asserted that Asquith's figure, £115,000,000, was in error and that "of the total spent, £27,000,000 represented the value of useless stores, guns, and tanks." She then queried, "Did Mr. Foot want to give every mother a cannon, or did Mr. Gay want the people to sleep in tanks?" Noting that her sarcasm produced laughter, she attacked again. First, she explained that the money had been used to remove troops and stores from Russia and to transport friendly Russians out of danger, and then she posed, "Would Mr. Foot or Mr. Gay have left those men there?" Having smacked both her opponents, she reviewed and justified the Coalition stance, echoing Lloyd George's comments and adding her own: "We want peace in Russia, but we are determined not to have Bolshevism in England." She linked Bolshevism in Russia to the ILP in England and took pains to point out that Labour leaders Ramsay MacDonald and Philip Snowden had advocated that Britain take a neutral stance in the early days of the war. She contended that members of the ILP shirked "while England was bleeding at every pore." She clinched her accusations by intimating that one of the Labour party's leaders had told her "they were only waiting until the end of the war when our men came home with their grievances to have a revolution." She opened the floor to questions and followed the direction of her audience in switching to financial issues relating to reconstruction. She caused a stir when she declared herself against the capital levy, Labour's controversial plan to expunge the war debt by calling for "a severe sacrifice of wealth on the part of the very rich." One heckler sneered, "You look after your own interests at any rate, my good woman," but she turned the tables and asked, "Do you think if any members of the ILP had what Major Astor and I have they would spend time working the way we do?"[87] Satisfied that her audience understood whose interests she really had at heart, she then

responded to a question regarding premium bonds, another postwar financial scheme.

Unsure of her position here, she said she had not yet made up her mind but would do so. When pressed further, she said that she was not a politician and would not make any promises. Backed against the wall by the question, "Don't you think such bonds would encourage the gambling spirit?" she made light of the matter by noting that few were betting on Astor's horses, Winkipop and Buchan, again drawing laughter from the crowd—all on her side.[88]

As she had done in the past, Astor used the elimination technique in dealing with her opponents. She knocked off Foot by *reductio ad absurdum* argument, conjuring up images of people sleeping in tanks and women with cannons; she put Gay in his place by linking him with an unpatriotic, revolutionary band that she dubbed "the shirkers." She filled the gap by bolstering Coalition views and offering herself as a fighting woman for Parliament. At one point, she even implied that she was so tough that the ILP "would rather see the devil with the red tail than me."[89] When challenged by members of her audience, she gave a direct response, turned the tables, or eased the tension with a lighthearted remark. Although Astor's employment of such devices might keep her opponents at bay, those concerned with meritorious critical standards would question their use. Rhetorical critics would be more pleased to note that in supporting her own arguments, Astor came prepared for the meeting at Prince Rock with exact figures, direct quotations, and historical facts. She shielded the Coalition view with the best of strategies but used "huff and puff" to buffalo her way past the opposition.

In the evening meetings, she demonstrated, as she had in the meetings for women and her daytime excursions, that she could hold her own in the political fray. She could discuss even the most volatile issues at hand. She could fully participate in the ongoing conversations of her time.[90]

COMPLICATIONS

It takes opponents to get me gingered up.
—Lady Astor

LADY ASTOR RELIED HEAVILY UPON HER OWN RHETORICAL SKILLS in carrying her campaign forward. At the same time, she was able to depend upon the support of others who diligently worked for her. The section that follows discusses her campaign organization but focuses upon the assistance given by her husband, Waldorf.

THE SUPPORTING CAST

As the candidate adopted by the Plymouth Conservative and Unionist Association, Lady Astor had the resources of the local party organization available to her and as a result, could turn to its president, Frank W. Hawker, and its secretary and election agent, C. G. Briggs, when arranging many details. For example, they scheduled meeting rooms for the speaking engagements and established fourteen (two in each polling district) committee rooms for canvassers to gather. Central headquarters for party workers and other volunteers were at 17 Lockyer Street, but another hub of activity operated out of Astor's home, 3 Elliot Terrace. Correspondence in Waldorf Astor's files reveals that Briggs worked with

Hughes Gibb, Waldorf's secretary at the Ministry of Health, in soliciting and scheduling visiting speakers. Additionally, Briggs passed on important releases to the local press, kept in touch with neighboring Unionist associations, and drafted some of the letters aimed at target audiences. He also supervised the tedious task of putting out major campaign mailings, letters to absentee voters, circulars, and polling cards—an effort dispatched by the Plymouth Habitation of the Primrose League, whose members prepared 77,000 pieces for the post.[1]

Moving beyond the party organization, Lady Astor also sought volunteer workers among women in the area. As mentioned earlier, her sister-in-law, Mrs. Spender Clay, invited them to help during the first women's meeting on 4 November. The same day, Astor published a letter to the editor in the *Western Daily Mercury* that made the same request:

> I know that there are many women in Plymouth who wish us to remain here, and who, I feel, would be willing to help at this election. I have offers of help from Unionist, Liberal, Labour, and Co-operative women. May I ask all ladies who are now already working in some organization, and who are willing to help me, either to send their names and addresses to my sister-in-law, Mrs. Spender Clay, or to come here on Tuesday morning to see us?

She signed the letter "Nancy Astor" and gave her home address.[2]

Waldorf served as the connecting link between the local party organization and the home circle as well as the primary liaison between Astor's campaign and members of the press and others in position to influence the course of the campaign. Although no longer in the limelight, he still played a very active part in Lady Astor's effort, frequently serving as her stage manager.[3] Specifically, he solicited coupons and speakers on her behalf, prepared some pieces of her campaign literature, guided Lady Astor in her press interviews, responded to letters from special interest groups, scouted her opponents, resolved conflicts, and spoke at her evening meetings—often offering the opening and closing remarks.

A "coupon" is a party leader's letter of endorsement for an electoral candidate. Former Prime Minister Herbert Asquith coined the term during the 1918 general election, sneering at Lloyd George, Coalition Liberal, and Bonar Law, Coalition Unionist, for working together and jointly recommending candidates whom they both "considered reliable." Law and Lloyd George also agreed that neither of their parties would oppose the "couponed" candidates in each constituency. The deal ensured "an overwhelming

majority of seats for the government" but often left other Liberals and independent Conservative-Unionists out in the cold. In effect, the coupon split both parties, but it was later thought to damage the Liberal party the most. In time, the term came to mean any letter of endorsement from a person of power and influence, but the 1918 election, known thereafter as the Coupon Election, carried a negative connotation that lingers to this day. Although Law and Lloyd George saw their work as a continuing contract for national unity, others came to think of it as a great betrayal of party principles and a step towards the destruction of Parliament itself.[4]

As Coalition supporters, the Astors viewed the Coupon Election positively and actively sought endorsements for Nancy wherever they could find them. They were so active in this regard that one reporter said that Lady Astor was the "most thoroughly couponed candidate that the Coalition has ever put forward." The record indicates that Astor received at least ten "testimonials" favoring her entry into Parliament and that Waldorf probably solicited most of them.[5]

Complimentary responses came from George J. Wardle, MP and Parliamentary Secretary to the Ministry of Labour, former Prime Minister Arthur J. Balfour, and Robert Cecil, MP. Of course, the coupon that attracted the most interest was the official blessing conferred by the Liberal Prime Minister David Lloyd George, head of the Coalition government. There is no correspondence that indicates that Waldorf solicited Lloyd George's endorsement, but one of Astor's biographers reports that it was probably drafted by Philip Kerr, aide to Lloyd George and long-time friend of both Astors.[6] However prompted, Lloyd George sent the letter on 7 November, and the next day Astor's secretary directed copies to be sent for both the Sunday and local papers.

Lloyd George said that he was glad to hear that Lady Astor had been nominated "to contest Plymouth as a Coalition Unionist." He felt that women should be in Parliament "in order to present the woman's point of view" and thought they could assist in matters "in regard to housing, child welfare, food, drink, and prices . . ." He then struck a patriotic note and praised Astor for her "hard, devoted and unselfish work which she had done during the war on behalf of the wounded." He offered his own testimony to her efforts and concluded with his recommendation.[7]

As in 1918, the coupon was used to endorse a candidate backing the Coalition majority. And again, it left other Liberals and Conservatives without party support. No one was more hurt than Astor's opponent Isaac Foot, candidate for Southeast Cornwall in 1918, who now found himself—for the second time—seeking office without support from the Liberal leader.[8]

He also might have found himself drowning in a flood of campaign literature. According to the *New York Times*, "Posters on all the billboards and almost every other available space announce that 'Lady Astor is the only Lloyd George candidate' or appeal to the voters to 'make history and elect the first woman member of Parliament.'"[9]

Waldorf's files also contain evidence that the Astors deluged the community with the written word as well as the spoken. Artifacts include election cards, an address to the voters, meeting announcements, a letter to campaign workers, a letter to absentee voters, a letter to the wives of businessmen, lists of supporters, summaries of the accomplishments of the Coalition government, handbills, and doorknob hangers. In content they ranged from the general to the specific, but none was very complex. Overall, they reiterated three themes. The first was that Lady Astor had the support of those in all parties, not only those in the Coalition, but also those in Labour and independent organizations. Those on her bandwagon included men of national prominence, but perhaps even more important, women and men known and respected in Plymouth and the West country. For example, Astor's list of electors mentioned Dr. Mabel Ramsay (Liberal), chairman of the Plymouth Citizens' League; Mrs. Daymond (Liberal), member of the Plymouth Town Council; Admiral Sir George Egerton, former admiral commanding at Devonport; C. Knight, chairman of the Lower Deck Benevolent Associations; and Colonel F. B. Mildmay, Unionist MP for Totnes who had defeated Isaac Foot in the 1910 (January) election.[10]

The second theme, discussed earlier in connection with Lady Astor's Warming Pan role, implied that Lady Astor was either the incumbent, or, for those in the know, would carry on Waldorf's work. The key phrase, repeated in handbills, small 12-by-12-inch posters and 2-by-3-foot signs, was "Astor—Once Again."[11]

The third theme indicated that Astor was a social reformer determined to carry out the plans presented in the early 1918 Coalition manifesto and undertaken in the first nine months of postwar activity. She particularly identified herself with improvements made, or to be made, in areas relating to housing, profiteering, unemployment pay, army and navy pay, pensions, health, and international endeavors such as peace and the League of Nations. She also linked herself with the major concern in Plymouth and put out a special handbill relating to the dockyards:

THE DOCKYARDS.
Who went to see LLOYD GEORGE about the Dockyards?
ASTOR DID.

Who, before there was any question of an Election, went
and worried the Admiralty, Board of Trade, and
Ministry of Transport about Devonport Dockyard?
ASTOR DID.
VOTE FOR LADY ASTOR
If you want to get things done for the Dockyard
Please turn over.

On the overleaf, "Vote for Lady Astor" appeared.[12]

Although it is not clear that Waldorf assisted in preparation of all of Nancy's literature, there is evidence that he had a hand in drafting some of her campaign letters. C. G. Briggs, Astor's election agent, specifically asked for Waldorf's help in drafting a letter to the wives of those men who had business premises in Sutton and as a result were entitled to vote whether they resided there or not. Waldorf responded by making many alterations, revealing that he liked to exercise a heavy editorial hand.[13]

Waldorf also supplemented Lady Astor's campaign rhetoric by elaborating upon, explaining, and justifying her positions—which most often coincided with his own. The *Globe* photo published on 15 November shows Lord Astor helping Lady Astor with her correspondence, and the letters in his files reveal that he did respond to many inquiries from special interest groups. Writers were interested in a great variety of issues, and Waldorf took pains to clarify Lady Astor's views as best he could. His replies were usually straightforward, courteous, and succinct. For example, he replied to a letter from the Comrades of the Great War by stating, "I feel justified in claiming that I will do everything that lies in my power, if returned to Parliament, to advance and uphold all just causes of ex-servicemen." Similarly, he offered encouragement to those asking Lady Astor's views concerning old-age pensions, state aid for children, and expanded health care. He also sent out a positive response to those whose interests specifically matched his own. In a letter to a horse breeders group, he stated, "In the interests of a national industry—horse breeding, I am not in sympathy with attacks upon horse-racing."[14]

Waldorf was highly concerned with the way matters appeared in print. He assisted Lady Astor in her meetings with the press—often to the chagrin of the reporter hoping to capture Lady Astor in her own words. In her interview with the *Morning Post* on 4 November, the opening day of the campaign, Nancy found Waldorf constantly at her side. The *Post's* correspondent stated that "it was a disjointed sort of interview. . . , for Lord Astor, who was present, switched his wife off when any dangerous or difficult topic

was broached, but Lady Astor nevertheless managed to express opinions on a variety of subjects of general interest." The reporter then went on to record that Waldorf "intervened" when Lady Astor was asked about devolution for Ireland. He said, "Don't you go into details. Wiser heads have failed. You stick to general principles." He also "interposed" comments relating to the League of Nations and "incidentally remarked that the war had altered the attitude of the nation toward women." He closed the interview by disclosing his plan to divest himself of his title, and, if that were to fail, to "go into the House of Lords and work there to the best of my ability."[15]

When Lady Astor did have her say, she expressed opinions relating to the British navy, free trade, prohibition, woman's point of view, and her Virginia background. She also vehemently expressed her mind in denouncing war profiteering—taking on those governed by greed and hurling charges at Asquith for failing to take action against profiteers when the matter was brought to his attention in 1914.[16]

Waldorf's promptings did not go unnoticed by Lady Astor's Labour opponents, and as a result they laid plans to cut her off from his help whenever possible. They decided to forgo "written interrogatories" and to have her "heckled" and "compelled to give immediate answers on special points." As one "labour organizer explained, 'Lord Astor can't help her when she is in a meeting.'"[17]

However, Astor could help her by scouting her Labour opposition, and his records show that he played a part in that activity. He gathered materials from Gay's campaign, not only a copy of his platform, but handbills and posters, too—no doubt noting the slam against Lady Astor and himself in:

> For the
> Idle Rich
> 'PALACES'
> for the workers
> 'wood huts.'[18]

He also conducted some investigative work into Gay's connection with the ILP, especially his relationship with its left-wing and pacifist members. An unsigned memo in his files states that the ILP was sending Ben Spoor, Mrs. Snowden, Richard Wallhead of Coventry, Ernest Bevin, James Wignall, and Arthur Henderson, "who hopes to be accompanied by Thomas," to speak on Gay's behalf. Behind the memo were some brief scouting reports for Snowden, Spoor, Bevin, and Wallhead—confirming, to an extent, that Gay's supporters were ILP radicals. In this context, Bevin fared the best and

Wallhead the worst. Only one of these reports indicated its source; the commentary on Mrs. Ethel Snowden was sent to Hughes Gibb by a Sir B. Thomsen with the note, "This is a rather bold precis of Mrs. Snowden's activities, but I daresay it will suffice." It is possible that "Sir B. Thomsen" may have been Basil Thompson, the man Kenneth Morgan identified as the "head of the Special Branch in the Home Office Directorate of Intelligence" who, since the summer of 1919, was responsible for reporting on "revolutionary activities in various parts of the British Isles."[19]

Waldorf's work in this regard may have been in vain as press reports concerning Gay's campaign revealed that Bevin, then leader of the Dockers' Union, was the only speaker "investigated" who later became worthy of press attention. Of the other speakers supposedly gathering for Gay, others did not show or were not noticed by the press when they campaigned for him.[20]

Waldorf also took on some of the unpleasant chores of the campaign, either bailing Nancy out of trouble or dispatching unwanted help. His first major rescue effort came early in the campaign after Nancy had strongly stated that she favored "a vigourous censorship of motion pictures." She prophesied, "They can be the greatest curse or the greatest blessing for England," and then went on to explain, "It is not a small question; it affects thousands. I was a girl not so long ago and I know how those lurid love scenes have affected me." Her remark did not go unnoticed by Mr. C. Rundle of the Elite Picture House, who was so upset that he threatened "to have slides prepared to be thrown on every screen to the effect that Lady Astor is desirous of closing Picture Houses and inviting the audience to vote against her." Initially, Rundle's complaint was sent to Briggs who then passed it on to Lady Astor's secretary, Miss Beningfield, who apparently turned it over to Waldorf for the mollifying reply.[21]

Waldorf also contended with the tensions that arose within the campaign organization, keeping control over the overall operation. At times he had to turn down offers of help, often on the grounds that the campaign could not pick up the expenses of those volunteering. On one occasion, he had to get rid of a worker who blocked progress. Miss Goring Thomas, organizing secretary of the Women's Branch of the National Unionist Association, sent a Miss Taylor to Plymouth to help with the organizing she thought might be needed. Waldorf thought Taylor got in the way and wrote Miss Thomas, "We are already organized," and added that the campaign needed canvassers. Subsequently, Miss Taylor went off to London.[22]

As mentioned earlier, Waldorf and his secretary Hughes Gibb made the arrangements for many of Lady Astor's outside speakers. Waldorf often joined them on the platform during Nancy's evening meetings, either

endorsing her or providing appropriate introductory or closing remarks. Some reports indicate that, on some occasions, he also tried to prompt her while she was speaking. All of these activities tempted one biographer to conclude, "Waldorf directed the show in which Nancy starred." He went on to assert, "He also wrote the script," but then qualified the statement by adding, "although no one could prevent Nancy from ad-libbing with certain unpredictable regularity."[23]

The notion that Waldorf "wrote the script" leads to speculation that, among all his other activities, he also served as the ghostwriter for her campaign speeches. The present investigation argues that Lady Astor generally prepared her own work because evidence indicating that she did not is insufficient.[24] Certainly Waldorf did many things to help Lady Astor, but writing her campaign speeches was not one of them.

Unlike Lady Astor's later parliamentary speeches and other addresses, few notes or manuscript texts remain for her campaign talks. None appeared in her files, and only five of the numerous ones given appeared in Waldorf's papers. Of these, one indicates a date, "a Monday night." Another definitely reveals that it was to be for Nancy. Two others could be hers. Phrases in a text referring to British policy in Russia closely match with her reported remarks at Prince Rock. Another promises that the speaker will complete the work of the Coalition and pass bills reflecting an active social program— similar to the one mentioned in Lady Astor's literature, interviews with the press, and other public statements.[25] It is possible that the two remaining scripts could have been for Waldorf's own speeches.

Articles in the provincial, national, and international press also indicate that Lady Astor often ignored Waldorf's promptings, set her notes aside, delivered her speeches extemporaneously, and engaged her audiences by turning to an interactive format. A reporter for the *Yorkshire Observer* noted that Waldorf had said that he is often "a little worried on his wife's account, as he never knows what she is going to say or do next" and that he had confessed "to desperate attempts to catch her eye—generally unavailing ones." Overall, Lady Astor demonstrated many of the earmarks of an empathic communicator.[26]

In addition, a brief comparative analysis of some of Lady Astor's and Waldorf's other speeches revealed some very noticeable stylistic differences. Waldorf's speeches were usually quite lengthy in contrast to Nancy's, whose remarks were unusually brief. His speeches contain transitional phrases; hers seem to jump from one idea to another. His texts employ different kinds of supporting data; hers often reflect a preference for narrative and pithy statements. He seems to like historical references; she prefers biblical

allusions or, when she does turn to history, looks to Plymouth's own figures, Drake and the pilgrims. Their differences are so distinct that if he had ghosted a speech or two for her, it is easy to imagine that she would have remarked, "It's just not me, dear."[27]

Lady Astor's supporting cast, managed and directed under the watchful eyes of Waldorf, complemented her rhetorical showmanship with a very significant amount of behind-the-scenes work. They certainly deserve credit for helping her rally the support of the Sutton electorate. Yet all their efforts did not guarantee a sure victory. As the campaign progressed, all needed to turn their attention to the obstacles Lady Astor faced: challenges from her opponents, Isaac Foot and William Gay, an unruly press, and an even more unruly band of hecklers. The following sections look into these obstacles and the strategies Lady Astor employed in her attempt to overcome them.

LADY ASTOR VS. ISAAC FOOT

At the time of the 1919 campaign, Isaac Foot, Lady Astor's Liberal opponent, was a well-known and respected native son. He was a solicitor in partnership with Edgar Bowden in what was becoming a very prosperous law practice. During the war, Foot had specialized in defending conscientious objectors and had been so successful at it that one biographer said that his efforts had made him "wealthy."[28] Of course, he could not match the Astors' money but had enough of his own so that he, too, was vulnerable to attack by those claiming to represent the poorer classes.

However, like Lady Astor, he was also dedicated to community service. In 1908, the same year he entered into partnership with Bowden, he was elected to the Plymouth Town Council, where he served in a variety of capacities: vice-chair of the Education Committee and chair of its Elementary Sub-Committee, chair of the Cemeteries Committee, and vice-chair of the Free Library Committee. He had "founded the League of Young Liberals in Plymouth" and was recognized as the "leader of the Liberal Party" in the town council. Members of the press, who seemed less interested in his persona than Astor's, treated him as a progressive who held "advanced views on social and political subjects." They also noted his work in establishing the "Save the Children Fund," his long-term service to the Wesleyan Connexion, and the fact that he had just recently been elected president of the Plymouth Shakespeare Society.[29]

Unlike the situations of many candidates surfacing in present-day political arenas, there was little in Foot's personal background that could

give him any trouble. He had married the woman he had met at a Wesleyan outing and together they had seven children, four of whom went on to distinguished political careers. Neither did he drink nor was he said to be easily tempted by other women. As a matter of fact, he joked that even though he thought Lady Astor was charming, he was the "only man who can stand against her blandishments." A letter endorsing his candidacy by the Liberals of the Bodmin Division, Southeast Cornwall, said that he was a person of "high character" and a "sterling and fearless exponent of Liberalism."[30]

Prior to standing for Plymouth, he had made three other unsuccessful ventures into national politics. In the first 1910 election, he opposed Colonel F. B. Mildmay, the entrenched Unionist for Totnes. Later that same year, in the second election, he lost by only 41 votes to General Pole-Carew in the Bodmin Division, Southeast Cornwall. During the war, Pole-Carew was succeeded by Sir Charles Hanson, ex-Lord Mayor of London. It was Hanson then whom Foot stood against in 1918. Losing again in the division he came so close to representing earlier, Foot blamed his loss on "the coupon and a combination of other circumstances."[31]

A man of many talents, Foot was particularly praised as a public speaker and man of letters. A champion of Nonconformity, he had been a Methodist lay preacher for twenty years. Steeped in biblical knowledge and capable of reciting most of the book by heart, he thoroughly prepared his sermons and tested them out on his family before presenting them to his chapel congregations. In later years, his son Michael, also a gifted speaker, commented that he had "learnt his first oratory from listening to his father preach."[32]

Foot was equally comfortable on the public platform and, like Lady Astor, had already earned a reputation as an electioneer. The *Western Morning News* stated that Foot was the "most fluent of speakers" whose "remarks are enforced by pungent wit and sparkling epigram." Additionally, it remarked that the "heckler has no terror" for him as "opposition immediately brings into play his fighting qualities, and the interrupter must indeed be well-versed in his subject and reinforced with facts if he would hold his own in verbal combat." One anecdote from the Foot family history has it that one of Isaac's replies to a heckler's questions was, "My dear man, I can answer your questions, but I can't give you the brains to understand." It seemed that he was seldom on the defensive and put off his opponents by initially capturing audiences with "a full hour, maybe, of rollicking humour and invective, fifteen minutes of passionate argument, and a peroration to take the roof off." His good fortune with hecklers prevailed in the Plymouth campaign, and he was so "immune" to their antagonism that by the end of

the first week, he could praise "the serious demeanor of his questioners" and declare that "everything in the garden is looking lovely."[33]

In his private life he surrounded himself with the giants of history and literature, gorging himself on Macaulay, Cromwell, Lincoln, Burke, Shelley, Keats, Coleridge, Shakespeare, and Milton and then spewing forth long passages from their works as he commuted to and from work. Books, he thought, "were weapons, the most beloved and sharpest," and he was never unarmed.[34] If their match had been confined to rhetorical skills, he would have been Lady Astor's most formidable opponent.

As it turned out, he became the least of her campaign worries. One reason that he did not seem to stand in her way stems from the fact that he was somewhat of a latecomer to the contest. Even though the *Evening News* speculated as early as 22 October that Foot might be the Liberal candidate, no official announcement came until five days later. Neither the Plymouth Liberal Association nor Foot seemed to be in any hurry. Perhaps they were caught in the municipal campaign or deliberating the options before them. As mentioned previously, several letters to the papers suggested that former Prime Minister Herbert Asquith should be called to stand. Other papers rumored that a Liberal-Labour combination might be possible. Foot himself hesitated, wanting to make sure that returning to his home constituency would in no way offend those in the Bodmin division, Southeast Cornwall. He said that "he had no wish to do anything which might be regarded as ungracious or inconsiderate to his host of friends in that constituency." And as a result, he did not accept his invitation to stand for Plymouth until he received word that he had the approval of the Liberals in Southeast Cornwall. By the time all these activities transpired, it was Monday night. Lady Astor's acceptance had already captured the day's headlines, and Foot's decision to enter the contest had to wait for the Tuesday press. Thus, by the time he surfaced, he looked as if he were the Liberals' third choice, and Lady Astor was already refashioning her Pussyfoot persona.[35]

Another reason he did not seem to disturb Astor's campaign to any great extent was that he chose to forgo his usual Tory-baiting in order to focus on his own quarrels with Lloyd George and his small band of Liberal supporters. He did not like the idea of Coalition government, many aspects of its postwar policies, or Lloyd George's relationship with the Conservatives. He saw the whole contest as a matter of confidence: "Are the electors going to give the Government a vote of confidence?" Astor, he perceived, would be a supporter of continuation; he, as he often expressed, would initiate change—that is, restore government based on solid principles. As Astor was officially a Conservative-Unionist, she could not get too disturbed

by what she may have felt was intraparty strife. Within the framework of partisan politics, Foot was not very potent.[36]

Rhetorically, however, he had the potential to be dangerous, and as a result, Lady Astor and members of her campaign paid close attention to his charges against the Lloyd George government. More than likely, her campaign leaflet "Deeds Not Words" was a direct response to his implication that the Coalition had failed to meet the needs of postwar Britain. Similarly, his denunciation of the Coalition's Russian policy set Lady Astor scurrying for her facts and figures.[37]

Foot set forth most of his themes in his Adoption Day address on 3 November. He spent some time on local issues, first commenting on the municipal elections. He then pointed out that because of its special circumstances in postwar times, Plymouth needed to be represented by someone from the area. He suggested that the dockyards be used to restore the mercantile navy. He then moved on to matters of national priority—presenting a counterstatement to the programs and policies of the government. Using one example after another, he catalogued its troubles: corrupt election practices in 1918, financial mismanagement, an inconclusive peace, starving children, freedom from opposition, inconsistent ministers, unproductive and expensive intervention in Russia, continued conscription, and disorder in Ireland. After having created the impression of total failure and depravity, he then offered his listeners a message of hope, calling for "the restoration of Parliamentary government" and a return to the "old principles of Peace, Retrenchment and Reform" without "any hedging, trimming or compromise." He concluded by urging them to "conduct a good fight" and "bring Plymouth back to the cause of Liberalism." Later, he reiterated these ideas many times throughout his campaign, particularly in his speech at Grenville Road Hall on 11 November and in his letter to the electors.[38]

His Adoption Day speech, in contrast to Lady Astor's, was superbly organized, integrating several techniques to aid the listener. At times Foot used chronological order, moving from past to present; at other times he expanded the scope by going from local to national to international issues. Primarily, he relied upon a modified jeremiad—cataloguing the sins of the Coalition and calling for repentance in asking all to return to or keep the tenets of Liberalism.[39]

The speech also revealed Foot's literary background and penchant for the apt quotation. Having just delivered the presidential address at the Shakespeare Society, he opened his remarks to the Liberals with "Once more unto the breach, dear friends, once more." Surveying their response, he added, "I see you stand like greyhounds in the slips," and followed with his

assurance, "The game's afoot." He then moved his audience into the twentieth century and concluded his introduction by stating that he didn't know for sure how many opponents he would face, but "Let 'em all come!"[40]

Afterwards, Mr. Solomon Stephens, chair of the Liberals' Election Committee, commented that Foot's speech was "that of a statesman. Its tone was high, and it contained both a trenchant criticism of the Government, and a concise and impressive outline of the principles which the electors will be called upon to endorse." In sum, Foot left his followers feeling that once again it was time to "Fight the good fight and keep the faith."[41]

As his campaign progressed, it became apparent that in opposing Lady Astor, he certainly kept the Liberal faith, but was reluctant to fight her much at all. It was not that he was unaware of her vulnerabilities. In an interview with a reporter for the *Boston Globe*, he agreed with her Labour opponent that her American birth, her wealth, her attitude regarding prohibition, and the fact that she was a woman were points on which she could and would be "attacked."[42] Yet Foot refrained from doing so and by contrast treated her for most of the campaign with remarkable kindness. His approach to her candidacy was so unusually gentle that an examination into the reasons for such a tactic is in order.

One probability is that his own ethical stance prevented him from taking the offensive. In his Adoption Day speech, he had called for a fair campaign:

> I ask . . . that this election shall be distinct from all other elections by a complete absence of personalities. We want to put it upon a higher level than any fight we have had before. It is too serious for personalities. I have no time for them; they are detestable to me, and I intend to follow the practice I adopted at the last election to say nothing about a opposing candidate that I would not say if that candidate were sitting in the front seat at a meeting. I want to make it a point of honour, not even in private or while canvassing, to say anything to which an opponent could object if he or she heard it.[43]

After creating such an idealistic view and following it with his upright personal pledge, he would have had difficulty extricating himself from the entanglement he had created.

A second reason he may have held back is that he was not really sure what Astor's party or program was. Although endorsed by the Conservative-Unionists, she really was not a Tory. And even if she defended the Coalition, she qualified her support for Lloyd George. Used to a party system and

longing for its return, Foot did not know what to do with an opponent who demonstrated a strongly independent streak. Neither could he find a program to attack and on 6 November called for her to present one. On the tenth—after outlining the proposals in his own program—he again commented that as far as Lady Astor was concerned, he did not know where she stood on "matters of vital importance."[44]

Third, he may have had difficulty in opposing her because in several ways he identified with the Astors and was capable of recognizing and appreciating their commonalties. On the most humane level, he respected their grief and early on offered his condolences on the death of Waldorf's father: "I deplore the circumstance which has given rise to the election, and in common with all Liberals throughout the division sympathize sincerely with Viscount and Lady Astor in their bereavement." With Nancy he shared common spiritual values, exemplified by a through knowledge of the Bible, belief in prayer, and the desire to be morally good. These views then spilled over into practices promoting sobriety and social welfare work.[45]

Personally, Foot and Lady Astor could both be termed romantics who shared a love for drama and good humor. Both also admired and called upon Plymouth's seafaring heroes in their discourse. Lady Astor preferred Sir Francis Drake and the Pilgrim fathers, but Foot could turn sentimental over them all: "Humphrey Gilbert, Sir John Hawkins, Sir Francis Drake, Martin Frobisher, Sir Walter Ralegh, Admiral Robert Blake . . . Captain Cook and Admiral Nelson." They also saw themselves as "life's champions of the underdog."[46]

In addition, situational humor delighted them both. They enjoyed give and take with their audiences and with each other. Several newspaper reporters commented that they looked in on each other's meetings and when they did meet, stopped for some bantering. For example, on 14 November they both met at a daytime meeting at the engineering works. Listening to Foot substantiate his claim regarding his concern for the "interests of women and children" by stating, "I am a better authority than Lady Astor; I have seven children and she has six," she interrupted with, "But I haven't finished yet." To which he then replied, "Neither have I."[47]

Foot may not have come to terms with how he would respond to her womanhood. In principle, he expounded a progressive view towards women, demonstrating his belief that many of the barriers that prevented their full participation in society should be removed. In response to a series of questions posed by the Plymouth Citizens' Association, he stated that he subscribed to an "equal moral standard for men and women, further extension of the franchise to women lowering the age limit and making

the qualifications the same as for men, equal guardianship of children of both parents" and "full professional and industrial freedom of opportunity for women."[48]

In practice, he held to a traditional view bordering upon "old fogey-ism." Members of his inner circle reported that he was "in favour of votes for women, but within a world where women stayed at home." Like his wife Eva, he felt that "women should be self-effacing and supportive to their men."[49]

Lady Astor then placed him in a dilemma. On the one hand, he could disapprove of her entrance into the political arena because she was going beyond her right to vote; on the other hand, he had to take note that, in doing so, in becoming a Warming Pan for Waldorf, she was certainly a supportive wife.

Lady Astor's womanhood also posed a problem for Foot in his dealing with her as a candidate. The boxing metaphor had guided his previous contests where he "fought with the gloves off." He liked to say, "Let the best man win" and then "slug it out man to man." He really could not do that this time around and as a result, must have felt the need to refashion his platform behavior. He implied as much in his Adoption Day remarks when he quipped that he could not say "'Let the best man win' because that would be prejudiced." And then after the laughter had subsided, he rephrased the line to "Let the best candidate win."[50]

Overall, Foot's campaign behavior indicates that he took flight from any serious confrontation with Lady Astor. Instead, he came at her obliquely by first using the entire Lloyd George Coalition as surrogate opponent and, second, by bolstering his own program. He framed his quarrel with the government and used his speeches to point out the discrepancies "between the promises and performances of the Coalition." In contrast to Coalition policy, he offered his own remedy, a nine-plank program whose aims were 1) honesty in government; 2) restoration of the authority of Parliament; 3) sound finance; 4) a clear European and Russian policy; 5) abolition of conscription; 6) unfettered trade; 7) abolition of scandalous mismanage-ment, waste, and extravagance; 8) self-government for Ireland; and 9) social reform. Then, in his letter to the electors, he said they had two choices:

> If you approve the record and policy of the Government you will, of course, vote for the Government candidate and add one more to the huge majority in the House of Commons. If however you disapprove that policy and record and you wish to restore sound finance and honest government I ask you to vote for me thus strengthening the Opposition whose numerical weakness is a danger to the State.[51]

As will be discussed in a later chapter, he then turned to a direct attack upon Lloyd George, the Coalition leader.

He bolstered his own campaign, as did both Astor and Gay, by seeking and printing letters of endorsement, obtaining others to speak on his behalf, and relying on press support. For example, the *Westminster Gazette* endorsed his effort and sent out the call for other Liberals to rally around. Recognizing the Foot had "a very hard furrow to plough," its correspondent still felt that Foot had captured the "leading Liberals" of Plymouth and attracted a strong following among "women" and those in "the working-class." He predicted that if Foot had the assistance of Liberals outside the constituency, if the Plymouth electors could hear "Liberal policy expounded," then Foot would garner the needed vote.[52]

It was not until the end of the campaign that Foot turned upon Lady Astor with a devastating remark—then he did so indirectly. According to the *Western Morning News* on the fourteenth, Foot commented that Lady Astor's speeches reminded him "of the picture called 'Bubbles'—they looked very pretty, but they didn't last very long and achieved nothing." The obvious implication here is that Astor's words were inconsequential stuff—holding little substance or power—and as a result, she was not worth listening to or voting for. Her speeches—and she herself—should just be dismissed. It was a powerful way to discredit her—to use a popular image to call forth the longstanding notion that woman's "pretty speech" was ornamental, decorative, but not to be taken as seriously as men's. It was a way of evoking a cultural stereotype, the bringing into the consciousness of the electorate the long-held view that "effeminate discourse pleases," but "manly discourse persuades." Her words were for the parlor; his were for Parliament.[53] Yet again, Foot was slow to draw and missed the thrust when it could have done the most harm. By the time he tagged her "Bubbles," she had already made her mark and had turned her attention to her final rally.

Like Foot, Lady Astor called for fairness in the campaign, but unlike him, did not practice it as often. Slipping into the "yah-boo" of politics, she used naming in an attempt to tarnish his image as a progressive young Liberal. She frequently referred to him as a "tired old Asquithian" or simply as "Asquithian." On one occasion she told him he was "far too progressive a man to be identified with the Asquith Ancient Mariner Party." Often she would hedge her remarks by describing Foot as a "good fellow" or state, "I like Mr. Foot better than his leader."[54]

She also implied that he was an ineffective man of talk, not a person of action. In her Adoption Day speech, for example, she linked him with a

popular image of lawyers and said, "I am not a lawyer. . . . You won't get long reasoned speeches from me. If you expect 'em, you won't get 'em. . . . But it doesn't mean I can't get the things they are talking about better than they can." Later on in the same speech, she told her listeners that "if they wanted a lawyer, they must not elect her." She said she'd heard complaints that there were too many lawyers in the House of Commons and that they should "look out" and not "put another one there."[55]

Additionally, she tried to discredit Foot by knocking his politics and, as mentioned earlier, ridiculing his views on British Russian policy. She frequently contrasted his partisanship with her cooperative spirit. And on the last day she attacked him for using scare tactics, "shouting bankruptcy and belittling our national efforts."[56]

Lady Astor's negative portrayals of Foot, scattered here and there in her campaign remarks, tried to establish an unattractive persona for Foot as candidate—someone who had already had his day and was out of step with the times. As far as their personal relationship was concerned, she probably did like him and enjoyed meeting with him during the campaign. The final impression of their entanglement should be close to the one presented by the *Westminster Gazette* on 8 November 1919:

> One of the notable features of the election is the friendship that exists between Mr. Isaac Foot, the Liberal candidate, and Lady Astor. They have met several times during the contest, and the fact that they are now opponents had not been allowed to interfere with the happy relations that were the result of pre-election collaboration in social and educational activities in the town.[57]

LADY ASTOR VS. WILLIAM GAY

By contrast, Lady Astor's relationship was not nearly so pleasant with William Gay, whom she saw as a tough and challenging Labour opponent capable of not only breaking up the Coalition but also damaging parliamentary democracy itself. While she often ignored Foot, she looked upon Gay as a central figure in the contest.

At 45, Gay was the oldest of the candidates and, like Isaac Foot, had been born in Plymouth. At the time of the election he was a member of the Co-operative Society and manager of its boot factory. He had never taken part in municipal government, but he had pursued studies in economics and revealed interests in social reform. He ventured into the political arena in

1918 when he stood against Waldorf Astor, the couponed candidate for the Coalition. Although Gay had lost, members of the local Labour group thought he had done well enough in the polls to be asked to stand again— long before it became necessary for a by-election.[58]

When he learned of William Astor's death and Waldorf's promotion to the House of Lords, he had some doubts as to his own status as a candidate. He contacted the Labour Executive and mentioned that he was willing to stand down should its members prefer a "National candidate with parliamentary experience." He also got in touch with Arthur Henderson and, according to the *Daily Herald*, other prominent Labourites. After receiving their blessings, he then turned back to local party affiliates for reaffirmation as their candidate. Before his formal adoption on 4 November, he picked up resolutions of support from the Labour and Co-operative Representation Association and the Trade Unionists. By 25 October, the day before Lady Astor entered the contest, he was able to announce that Labour would enter the race—whoever the opponent might be.[59]

As the Labour candidate, Gay posed some difficulty for Astor, Foot, the press, and the electorate as they did not know how to sort out his political views within the party that was developing as rapidly as the Liberal one was disintegrating. At the beginning of the campaign, the *Western Morning News* introduced him as a Socialist for 25 years, first as a member of the Social Democratic Federation founded by H. M. Hyndman and since 1905 a member of the Independent Labour Party. The report then stated that he was interested in housing but had devoted his political energies to "propaganda" and had distinguished himself "as a student and debater."[60]

In an early speech at the Newton Abbot Labour Club on 27 October, he confirmed the foregoing description of his leftist leanings by defining postwar conditions in terms of a class struggle and expressing the disillusion and discontent of the laboring classes. He said that in wartime the "brotherhood of the trenches" had fostered a "different spirit" . . . between the capitalist and the worker," but that it had not prevailed at home. Now he lamented that "Far from there being a new spirit, the feeling was much more bitter than in prewar days." He went on to say that "The capitalists were now looking about to see what they could do to squeeze the worker a little more, to bring him back to the prewar standard of existence."[61]

Later on in the campaign there were occasions when his tone became strident and the substance of his discourse even more revolutionary. Foot, for example, when learning that Gay was in favor of direct action, denounced him by stating:

The man who stands for direct action is, in my opinion, an enemy of the commonwealth, and traitor to Parliament. . . . I cannot understand his seeking to enter Parliament, and holding at the same time and opinion which undermines Parliament itself.[62]

Similarly, the *Birmingham Post* noted that "Mr. Gay is tainted with all the beliefs of the extreme wing of the Labour party."[63]

Yet, when questioned about his views by the *Morning Post*, he "shied" when the reporter "mentioned Bolshevism, declaring he did not know what the term meant." A few days later the writer for the *South Wales Echo* commented that "I have not yet heard Mr. Gay make any reference to the ILP, though from every platform he is accused of being a member of it." This reporter then concluded that Gay was a member of the ILP and implied that he had been evasive about the matter because he did not want to lose the support of Labour moderates.[64]

Although Gay dodged some questions concerning his ideology, he was willing to be more specific in outlining his program. An analysis of his opening round of speeches from 27 October to 4 November 1919, his letter to the electors, and other campaign remarks reveals that he highlighted local issues and repeated many of the proposals presented in the Labour Manifesto for the 1918 campaign.[65]

Recognizing the unemployment problems arising from discharges at the dockyards, he stated that maintenance of the dockyards would be the first plank in his platform. He said that he wanted them to become a "'real collectivist institution' building State mercantile shipping as well as fulfilling the Royal Navy's requirements." He thought that a joint committee of government representatives and workmen could institute the transformation, but that eventually the industry would come under Labour control. He tempted his audiences with a vision of Plymouth as a "hive of collectivist activity" with "thousands" employed and capsulated it in the rhyme, "The Dockyardie to stay/ if you vote for Gay."[66]

Early on, the writer for the *Daily Telegraph*, who had observed that Labour recruited among dockyard workers, remarked that the Gay campaign had "fastened upon" the issue "like leeches." Later, the *Telegraph* again reported that Gay was "making the most of the dockyard question." With this emphasis, it is not surprising that Ernest Bevin, prominent labor leader and then national organizer of the Dockers (longshoremen), became the featured speaker at a major rally.[67]

Other aspects of Gay's plan called for a capital levy, a "once for all" tax to reduce the national debt, and nationalization, particularly of "routine

industries such as Mines and Railways." He believed that "nationalisation" was "the basic principle upon which the social edifice of the future" was to be built. Additionally, he called for stronger controls on war profiteers and the end of secret diplomacy, intervention in Russia, and conscription. He declared himself a "foe of Imperialism" and called for, "sooner or later," self-government in Ireland and India. All of these proposals were in keeping with the postwar national Labour program. He differed in that he omitted some of Labour's general views regarding the rights of women, but still recognized them in advocating pensions for mothers.[68]

Unlike Astor and Foot who best expounded their views from the platform, Gay presented his program most clearly in a lengthy letter to the electors, indicating perhaps a preference for the written word. An examination of the letter reveals several persuasive features. One of them occurs in his introduction when he declared that "the tide has started to flow against a Government that promised to 'Hang the Kaiser,' 'Make Germany Pay,' 'Abolish Conscription' and 'Make the World Fit for Heroes to Live In.'" He characterized these slogans as a "glib indulgence in rhetorical phrases" and contrasted them with a "crop of serious problems" that he then outlined and described in some detail.[69]

In cataloguing these difficulties of the time, he used an effective organizational pattern that broke the monotony usually associated with a listing arrangement. As he briefly discussed each problem, he then followed it with an explication of Labour's remedy—a common problem-solution format but one emphasizing solutions. Beyond that, he arranged each problem-solution item in an alternating sequence that can roughly be described as "for the poor" and "against the rich." The switching back and forth, a kind of antithesis, kept the reader's interest and intensified the view that Gay would support the working class, his targeted audience.[70] Indeed, he implied he was to be their champion—if not as a romantic hero, at least as a reasonable man.

In sum, his program flowed from both Socialist values and the facts at hand; it was designed to appeal to a broad segment of Labour interests.

His political persona, as revealed in his written work and platform appearances, was that of the stereotypical conservative: somber, serious, self-disciplined, self-reliant. His campaign photo enhanced the image by showing him in his "Sunday best"—black suit, stiffly starched white shirt with rounded collar, perfectly knotted dark tie spattered with polka dots neither too large nor too small.[71] Today his photo looks as if it might be of anybody's generic "Uncle Bill," one of those unidentified fellows who shows up in family albums but has been long forgotten.

Many press reporters who followed his campaign chose to describe him in terms of his speaking style. The writer for the *Western Evening Herald* was the first to note Gay's preference for statistical evidence and cited his comments on the government's profiteering bill, which he claimed was insufficient because it restricted small retailers but let the "real profiteers" go.[72] Gay supported his view with figures relating to profits that he thought excessive:

> 113 brewery companies made £7,366,000 or 22 1/2% interest on their capital; 88 iron, coal and steel companies made £10,947,000 or 24%; 14 oil companies profited by £12,577,000 or 22%; 31 shipping companies took in £5,851,000 or 22%.[73]

He then qualified the numbers by stating that these were "only the declared profits" and "did not include amounts in secret reserves or bonuses." Later on, the *Times* reported on a speech in which Gay compared cost of living figures in 1914 with those in 1919. He used them to support his argument that the Admiralty's "short time" proposal for dockyard workers would lead to "worse" than "prewar conditions."[74]

When describing Gay's speeches midway through the campaign, the *Western Daily Mercury* referred to his "more closely reasoned style" and noticed, and remarked upon, those occasions when he deviated from it. The *Western Morning News*, a local paper that later endorsed Astor, inferred that he was also "adroit and ingenious" in "spinning imaginary paradises," but that he repeated what he had "culled from political textbooks." Similarly, but in milder terms, the *Westminster Gazette* said that his fault—"if it can be so described"—was that "he is a little inclined to get above his audience. He is, in fact, a far better debater than a platform speaker."[75]

Only the *Daily Herald*, the Labour paper strongly supporting his campaign, portrayed him in colorful terms. A headline proclaimed "Gay to Victory." Articles indicated that he was a confident frontrunner striding ahead with increasing momentum—taking advantage of the move to Labour generated by gains in the municipal elections. One *Herald* reporter found him to be "a man of exceptional attainments, and an arresting speaker."[76]

As mentioned, Gay's program had been geared to appeal to Labour interests. His persona, it now appears, was crafted for the general electorate. Certainly such a reasonable man would not be viewed as a serious threat to anyone.

Except Lady Astor. She saw him as the major obstacle to her success and from the beginning of the campaign set out to portray him in terms

differing from his own. In a special interview granted to the family-owned *Observer* printed on 2 November, she casually identified Gay as a member of the ILP who was not needed in Parliament—especially since she would be the one to present a new point of view. The reporter then implied that Gay was also a loser because Labour and Liberals had tried to get their leaders who were currently out of office to stand, but they would not as they thought their chances against Lady Astor were slim.[77]

Beginning with a soft touch, Lady Astor revealed her "claws" the next day. In her Adoption Day remarks, she characterized Gay as even more to the left by labeling him a "Socialist" and then "a supporter of Bolshevism," linking him with Snowden and MacDonald, who were viewed by members of the Coalition as revolutionaries. As Snowden and MacDonald were also pacifists, Astor then reasoned that Gay, too, was one and labeled him as such. Placing him among those who had opposed the war, she was then able to present herself as an attractive alternative—compatible with those who shared patriotic feelings still prevalent in postwar Plymouth. In her typical succinct manner, she said, "If you can't get a fighting man, get a fighting woman."[78] In brief, her initial strategy was to create a negative persona for Gay, evoking what is now called the "wimp factor."

Gay, however, had a few things in mind for her. As mentioned in the previous discussion of Foot, Gay told a writer for the *Boston Globe* that he thought Lady Astor's vulnerable points were her wealth, her American birth, her sex, and her views regarding prohibition.[79] Although he seldom mentioned her personal wealth, wealth or capital became the target for his attacks, and by implication she served as the personification of it. Thus, Gay enabled himself to place Astor into his schema of life as a class struggle—an ongoing tension between capital and labor.

A few days later, he also noticed that she had been speaking in general terms—"a weakness in her equipment"—and made plans to have her heckled and "compelled to give immediate answers on specific points." The negative persona he conjured, at least initially, was a hybrid—a cross between a "rich bitch" and a "dumb broad."[80]

In his classic poem "To a Mouse," Robert Burns observes that "The best-laid schemes o' mice an' men, /Gang aft agley." The same can be said for political campaigns. Soon after Astor and Gay outlined their strategies for the campaign, their supporters veered off course, and some of the earlier plans went awry. Trouble started in Gay's quarters. On Sunday, 2 November, the night Gay received support from the Trade Unionists, J. J. Moses, who seconded Gay's nomination, took a stab at the Astors' wealth by implying Lady Astor was bribing children to stand with her for photo opportunities. He said

that the "capitalistic press was gathering children of the Barbican as background for Mrs. Astor's winning smile," but that "Sutton did not want their children photographed at a 'tanner' a time." He added that the people of Sutton were "going to see through and beyond the clamour of American millions."[81]

The next night Lady Astor's key supporter, Waldorf, came back with a remark—perhaps inadvertent—that was viewed as damaging to Gay. When introducing Lady Astor just before her own Adoption Day address, he took a few moments to discuss her opponents. He said:

> Let's look who else is in the field. There is a young man who I am told, has not been a great success as a manager in the Co-op. He is an extremist belonging to the Bolshevist circle of the Labour Party, and if he and his friends had had their way we should have lost the war.[82]

Labourites who learned of Waldorf's comments were incensed—not so much that Waldorf labeled Gay a Bolshevist, pacifist, and extremist, but that he indicated that Gay was not "a great success" in the boot factory. On 4 November, the evening of Gay's official endorsement, Dan Hillman sprung to the Labour platform ready for a rhetorical brawl:

> The attack upon Mr. Gay in his business capacity is dirty, mean and dastardly. I am going to say that up to now I thought the Major was a bigger sport than that. If he throws mud about, by God we will come and throw cartloads about. He won't have it all his way. I don't want to go into individual characters, but if they touch friend Gay they will hear something they won't like from me.[83]

Other Labourites expressed their resentment and discussed the possibility of slander action. Gay added that he would be the "last to stoop to such a dirty trick as that," but tried to tone down the furor by stating that he wanted to "fight clean" and that he and Foot "were going to fight on principles."[84]

Within a few days, it became apparent that Gay would also fight continuously. He announced weekend and second week plans that included a mass meeting with a torchlight procession, daily dinner hour meetings, gatherings for women nearly every afternoon, and about eight meetings every evening. Predicting a "perfect oratorical orgy," the *Evening Standard* reported that Gay had said "a hundred gatherings."[85]

At first Lady Astor responded to Gay's intensified opposition by staying with her original strategy—labeling him a Socialist, a member of the ILP, a Bolshevist, and a pacifist. As the campaign progressed, she began to flesh out

these skeleton terms with additional descriptive detail. She defined the ILP as the "most poisonous section of the Labour party" and linked it with its pacifistic element by also referring to it as "the unpatriotic section of Labour." She said that Gay, as a member of the ILP, "posed as a conscientious objector," but that he really was affiliated with "those long-haired wild-eyed men" who never worked but hung out on the North Quay "while your sons, husbands, brothers and fathers were fighting in France." While they were serving their country, Gay and those like him "preached revolution and class hatred" and advocated "untried and wild schemes." She encapsulated the view in the assonating line, "Mr. Gay, the Labour candidate, represents the shirking classes, but I represent the working classes." She repeated these dramatizations of Gay as a hobgoblin-devil figure and by the campaign's end used him to personify some of the major evils in her world vision. In her speech at the citadel on 13 November, she told the sergeants that "on the other side, they had the Bolshevism, pacifism, pessimism, Communism, and all the other isms." In this same turn, she transformed these words into devil terms by using onomatopoeia and cacophony to create resemblance to a hissing snake, the popular satanic image. If audience members were able to track these movements of Lady Astor's associative mind, they would note that she equated Gay with the "isms" of the day: from Bolshevism to pessimism. At the time, the sounds of these words reminded her of a hissing snake, which, if grasped by her audience, would in turn remind them of the devil, the figure with whom she wished to link Gay.[86]

In depicting Gay as a Bolshevist, Astor was not only presenting her own view but also sharing one held by many in the Coalition. A year earlier, Astor's good friend Philip Kerr had written that "the Labour Party consisted of those 'who have always been for fraternization with the enemy and a compromise peace, and who are now really Bolsheviks and doing all they can to condemn this country to class hatred and social strife, ending in Bolshevist ruin.'" Similarly, both Churchill and Lloyd George feared Bolshevist backing of Labour and evoked the "Red bogey" when confronted with discontent by the working classes.[87]

In addition, it is likely that Lady Astor was responding to a serious contemporary concern, the news of Red agitation and a subsequent crackdown in several centers of activity in the United States. On 10 November, the *Guardian* reported that the United States government had raided "the headquarters of the Russian Soviet in New York" and in 17 other cities. Over 200 had been arrested and numerous items (including five tons of radical literature) confiscated. Among them were some membership books whose preambles revealed that "violent social revolution" was the organizational aim.[88]

An electorate just recovering from a war, Astor figured, did not need a revolution. She took advantage of those fearing one and used this appeal to counter Gay.

Astor also met Gay's opposition by attempting to drive a wedge between the various factions of the Labour party. In particular, she tried to accentuate the existing tensions between the Trade Unionists and those in the ILP: "I draw a distinction between the old Trade Unionists and the ILP." A few days later, she elaborated by describing "the old Trade Unionists as splendid men," quite different from "the intellectuals of the I.L.P. who had never done a day's work" and who "were the craziest lot she had ever known."[89]

Astor also drew a distinction between those Labourites who were "in," or had been so, with the Coalition and those who, usually by their own choice, were "out." Those in favor included James H. Thomas, general secretary of the National Union of Railways; G. N. Barnes, Minister without Portfolio; J. A. Seddon, MP and former president of the Trades Union Congress; and George J. Wardle, Parliamentary Secretary to the Ministry of Labour. She favored Thomas and went so far as to say that "if he were down at Plymouth," she would vote for him herself. Later, on 10 November, she said, "I'll bet . . . if Mr. Thomas were here he would vote for me." Philip Snowden and J. Ramsay MacDonald, Labour leaders who had opposed the war and subsequently lost in the 1918 election, were frequent objects of attack—a clear sign that Astor was out to divide the Labour members who supported the war from those who had not, those who were in government from those who were not.[90]

She also made some attempts to persuade Labour women that they had more to gain by supporting her than Gay. A letter to the editor in the *Western Daily Mercury* on 6 November revealed her intention. Signed "A Labourite," but similar to other messages from Astor's own campaign, the letter stated:

> It is a fact that Labour women (or women who have hitherto voted in the Labour interest) are supporting Lady Astor simply because she is a woman. We feel that no matter how good a man and his programme is, he lacks the sympathetic understanding of the wants and needs of women electors and their children. So in that sense he is not representative.[91]

The writer then continued by saying Lady Astor would be an "ideal and fearless pioneer" for women in Parliament and that she would have at least one vote from Labour.[92]

Gay, in turn, tried to see that Astor did not get any more Labour votes and defended himself against her charges and characterizations in several different ways. Indirectly countering her accusations that he was an extremist, he evaded questions concerning his attraction to Bolshevism and affiliation with the ILP. He made other efforts to bring his campaign into the mainstream by asking for support from both those in the Trades Unions and those representing Labour interests in Parliament. He asked Astor's friend J. H. Thomas to speak on his behalf as well as Ernest Bevin, Arthur Henderson, J. R. Clynes, and James Wignall.[93] Thomas sent his regrets but followed with a letter of endorsement for Gay in which he asked "every railwayman in Plymouth to throw himself into the fight against the forces of privilege" and to return "Gay at the head of the poll . . ." Neither Henderson nor Clynes appeared in Plymouth, but Bevin and Wignall spoke at major Labour rallies on the weekend, 8 and 9 November.[94]

By chance, Gay also gained the support of a Mrs. Evans, an American identified as "a friend of Jane Addams and president of the Women's Labour League in Boston." Apparently, she was visiting in England and according to press reports, had decided to join in the activities in Plymouth as a Gay supporter. When asked why she was not supporting Lady Astor, she commented, "Oh, I place the Labour cause before sex . . . I hold that as a secondary consideration." For Gay, her remark was a nice counterpunch to the Labourite who had written that Astor was gaining support "simply because she is a woman."[95]

For the most part, Gay conducted himself in a manner that sharply contrasted with the impression Astor was trying to convey—demonstrating for all to see that he was not the man she said he was. The correspondent for the Liberal *Westminster Gazette* noticed the contrast and on 8 November, commented, "She [Astor] is very severe in her treatment of Mr. Gay. He is a pacifist, a Socialist, a Bolshevik; and any stranger might be led to suppose that he is anything but the well-read, even cultured Labour man that he is."[96]

As the campaign neared its finish, Gay moved from indirection and enactment to straight denial of Astor's charges against him. On 11 November, he "repudiated" the "rumour" that he "was a conscientious objector" during the war by explaining that he had gone for a medical examination but was placed in "a low category." As a consequence, he said, "I was not called and I did not go." The next day, Mrs. Anderson, National Women's Organizer of the Labour Party, told those gathered for a Labour meeting by the Dockyard Gates that she wanted to clear up some "misrepresentations" made about Gay by "Lady Astor's lieutenants." One of these misrepresentations, she said, was that "Mr. Gay was an I.L.P. candidate." She emphasized

that "he was not. He was the candidate of the National Labour Party and had the support of the whole Labour movement and was not the nominee of any section of it."[97]

Gay did more than defend himself against the unflattering charges brought against him. He and his campaign followers also organized a two-pronged counterattack on the Astors. They first turned upon Waldorf, but soon after diverted their attention to Nancy.

Gay's initial response to Waldorf's line that he had "not been a great success as a manager in the Co-op" was to forgive him his trespasses. He said that he was not in favor of any legal action and thought that Waldorf's remark was "foreign to" his character and "probably attributable to the fact that the new peer is still suffering a personal loss." Nevertheless, he went along with his supporters who decided to pursue the matter as far as they could. On 4 November, the day after Lord Astor's remarks, Gay's election agent, James Turner, wrote a letter of complaint, pointing out that his statement had been "without foundation . . . unjustifiable, and calculated not only to injure Mr. Gay in his candidature, but in his business capacity." That evening the Plymouth Cooperative Society passed a resolution repudiating Astor's statement about Gay by stating that Gay "had been a successful manager."[98]

On 5 November, Waldorf replied to Turner, stating that he had "no wish to injure Mr. Gay's business prospects" and that he was "quite prepared to accept the majority resolution" of the Cooperative. That evening, while responding to a question at one of Lady Astor's evening meetings, he publicly apologized: "If Mr. Gay thinks that what I said injures his business prospects, I regret that I said it. I am quite prepared to accept the opinion of the majority of his Co-operative Executive that he is a suitable manager." The next morning the London *Times* reported that, in Labour circles, there had been "talk" of a "writ for slander" against Waldorf, but it was "understood now that the matter will be allowed to drop."[99]

Waldorf, too, thought the matter had been "clearly and honourably settled," and he was no doubt surprised to then receive a letter from Messrs. Bond and Pearce, solicitors for Gay, with "threat of an action." He had expected that both his letter and Turner's would have been published and that the exchange would have corrected the misunderstanding. This time he not only wrote a detailed letter of reply to Bond and Pearce but also saw to its publication. He outlined the history of the matter, published the exchange between Turner and himself, again withdrew his statement about Gay, expressed his regrets, and concluded by hinting that he, too, had grounds for legal action:

For instance, I might just as well take action against Mr. Gay's chairman, Mr. Moses, for having suggested from Mr. Gay's platform that my wife and I had bribed electors in the past with coal and blankets, and had paid children to be photographed. I was surprised that Mr. Gay's chairman should have insulted the people of Plymouth by suggesting they had been, or could be, bribed. I had too high an opinion of Mr. Moses to believe that he meant literally what he said.[100]

Moral superiority prevailed. After Lord Astor repeated his apology and expressed his willingness to forgive Moses, the matter was dropped.[101]

LADY ASTOR VS. THE HECKLERS

Lady Astor did not fare as well as Waldorf. Not only did she have to contend with her two opponents, Foot and Gay, but she also had to be continuously on her guard against the numerous challenges posed by a band of hecklers who appeared nearly every place she went. Most frequently, they cropped up in what was regarded as hostile territory, Laira Ward, Coxside, and the Victoria Wharves. Many of the hecklers were affiliated with either Gay's campaign or some other Labour interest. Although they seldom used tactics so extreme as to interfere genuinely with Astor's right to speak, they were disruptive enough to provide an element of discontinuity to every Astor gathering. Some were sporting, entangling Astor in order to capture a quick laugh, but most of them easily qualified as bona fide hecklers—those "apparently hostile listeners" who orally interrupt a public address for a variety of reasons.[102] They wish to silence or discredit the speaker, to express their own view, to force discussion of a controversial issue, to capture media attention, or to provoke the speaker to an act of self-destruction.

In Astor's case, ILP/Labour hecklers clearly stated their motives early on. As mentioned previously, the *New York Times* reported that Gay's intent was to create a situation in which Astor, heckled and forced "to give immediate answers on specific points," would reveal that without Waldorf's help, she was incompetent.[103] They were also hopeful that she would not be able to defend Coalition policies or reveal herself as an appropriate and representative candidate for the Sutton electorate.

Other observers quickly discerned the organized nature of the heckling incidents and commented upon them. A correspondent for the *South Wales Echo* noticed that the same hecklers often appeared at different meetings and that they presented a new question to Astor each evening. Further-

more, it was the same question at every meeting. He added that this question was "not always nicely put," but often delivered "in a tone which is rude." The writer for the *Manchester Guardian* related that the "most persistent hecklers" were women. The local reporter for the *Western Morning News* speculated that the hecklers intended to "cause annoyance" and "provoke disorder." These commentators and others seldom mentioned heckling incidents at either Gay's or Foot's meetings, and as a result, one can assume that these gatherings proceeded with few disturbances. The *Devon Express* accounted for the differences among various candidates' meetings by stating that Foot and Gay attracted their own supporters and offered few interesting features whereas "everybody goes to hear Nancy—not knowing what to expect, but feeling sure that it "will be something new."[104]

The questions the hecklers posed covered a wide variety of topics but most often fell into two categories, the political and the personal. Hecklers asked about Coalition policies and practices, positions Waldorf had taken while he was in the Commons, or turned to larger ideological matters separating labor and capital. They frequently zeroed in on economic issues and related concerns that personally affected those in the constituency: old-age and servicemen's pensions and measures to accommodate a return to a peacetime economy, particularly the problem of unemployment in the dockyards. Not only did they ask Astor what her government would be willing to spend, but they also wanted to know where it would obtain the revenue. They taunted her with questions related to income taxes, super taxes, taxes on wartime profits, the proposed capital levy, and the merits of premium bonds. On occasion, they asked about such social concerns as drink and divorce reform in order to test her credibility in the areas in which she was known to be vulnerable. In particular, they wanted to know if she favored Sunday pub closings and easy divorces.[105] Other times they posed questions about Waldorf's efforts to obtain pay increases for soldiers, bring about women's suffrage, or revive sugar refining in Plymouth. Sometimes they turned from the concrete to the abstract in an attempt to highlight philosophical differences dividing Conservative-Unionists from Labourites. Taken together, the political questions reveal a conscious attempt to divert each audience's attention from Astor's discourse to the Labour program.

Hecklers targeted their other remarks to Astor herself. They baited her with comments disparaging her American birth, her wealth, and her campaign manners. Although some of them, like the woman from Woking, were outside agitators, they liked to paint Astor as even more of an outsider by pointing out that she was not an Englishwoman. Hecklers also made snide remarks and innuendoes referring to her money and class, and the *New York*

Times said that the Astor millions were the "favorite target of Plymouth street orators." Ironically, the hecklers who criticized Astor for being rich also chastised her for not acting like a lady. They tried to further discredit her by pointing to the times when she had demonstrated poor campaign manners. On one occasion, an "old friend," Astor's term for a planted heckler, chastised her for saying "that the children here had all dirty faces."[106] Another time, she was called to account for inappropriate name-calling, and at least for a second, felt compelled to apologize.

The latter incident occurred late in the campaign on 13 November. Astor, out and about during one of her daytime excursions, had asked a street corner crowd, "Now, are you going to vote for me—early, late, long, and loud?"[107]

A woman, described as a "brawny Devon . . . Liberal of the respectable working class," then moved forward in order to face Astor and announce, "No vote of mine will go to you." She then asked Astor to recall the first meeting "you ever addressed in Plymouth" and told how at that time—ten years earlier—she had shouted, "Three Cheers for Lloyd George," and Lady Astor had called her a "virago." Astor, who was reported to be "skipping up and down to keep herself warm," then ventured, "Perhaps you are."[108]

To this, the *Liverpool Courier* noted, the woman "retorted," "You are no lady; you do not behave as one."[109]

Not willing to be publicly spanked, Astor came back with, "That is right . . . I am just an ordinary working woman, but you cannot persuade the women of Plymouth that I am rude, for though I have had insults hurled at me, I have not been rude to anyone. I apologize for calling you a virago."[110]

Even though Astor revealed her willingness to demonstrate ladylike behavior, the woman did not accept her apology. Astor's final attempt at some sort of reconciliation turned to transcendence. Evoking the well-known petition in the Lord's Prayer, she asked the woman, "You will not forgive me?" Receiving no hopeful sign, she then warned, "Wait until you want to be forgiven for your sins."[111]

In confronting Lady Astor, her hecklers used several different tactics. In the case just discussed, the woman moved closer to Astor, perhaps in a threatening way, and then she contradicted her—asserting "No" when Astor obviously expected a positive response to her rhetorical question. During several evening meetings, other hecklers bombarded her with statistical information and then asked specific questions referring to it. Sometimes they tried to unsettle her by offering running commentaries during the time she was to have the floor. Refusing to play listener roles, they talked among themselves or argued with her supporters. According to the *Evening Standard*,

Astor had to deal with this problem at her first evening meeting—standing on a table and calling out, "Now, none of your sass," to a heckler who talked while Lord Astor tried to introduce her. Later in the campaign, the *Telegraph* reporter talked about Astor's "sundry street harangues" and an evening meeting where the "wrangle . . . on the floor . . . must have been highly diverting to the platform."[112] Most often, hecklers interrupted Astor in mid-speech, interjecting sarcastic comments, tossing out insulting remarks, or shouting imperatives. The favorite was "Go back to America."

Taking the point of view of those in Gay's campaign, one can say that there was some merit in choosing heckling as a rhetorical tactic. By introducing heckling into Astor's campaign events, Gay's supporters thought they would be able to disrupt Astor's plans and in their place develop a new reality in which she would then disclose her weaknesses. Thrust into this new scene, audience members would then be invited to contrast Astor's behavior with that of Gay who could now emerge as the stronger candidate in the transformed situation. In this process of change, audience members would come to see Astor as a woman who did not know what she was talking about—or what they were concerned about. In short, she would reveal herself as out of touch with the issues of the day, incapable of dealing with the economic matters pressing upon the electorate. Recognizing these inadequacies in Astor, audience members would become all the more receptive to Gay whose campaign messages emphasized his economic expertise.[113]

Although never overtly stated, it is also possible that Gay's supporters considered provocative persuasive tactics that force an opponent into an inappropriate emotional display indicative of character or mood which is deemed unacceptable. According to F. G. Bailey in *The Tactical Uses of Passion*, such strategies, supported by the cultural assumption that we live in a reasonable world, follow the principle of abomination, a notion that "cool heads" are expected to prevail and that the abominable act is to become distracted, rattled, overexcited or angry. Bailey remarks, "If a person can be provoked to display emotion, he has lost the capacity to exercise reason and so conduct a winning campaign."[114] Thus, if Gay's hecklers could prompt emotional outbursts by Lady Astor, she would either self-destruct or invite considerable contrast with Gay whose "reasonable" persona was frequently displayed. If successful, the tactic could tempt members of the electorate into recognizing that Lady Astor was just another emotional woman, or if gender were not a discriminating factor, one very capable of "making an ass of herself." In brief, if all went well, heckling Astor could work to Gay's advantage; it would be a rhetorical device that highlighted her weaknesses and his strengths.

However, in Astor's case, heckling was not the wisest rhetorical decision to be made by Gay and his supporters. In fact, heckling played right into her hand. She was not discomfited to any great extent and readily accepted the process as part of the political game. Neither did heckling compel Astor to reveal a self unfamiliar to her audience. Even though it did detract from her attempts to come across as Pilgrim Mother, it also prompted a ready revivification of the old Hustler persona exhibited in prior campaigns. It allowed Astor to play a familiar role—one in which she was known to revel and often excel. One of the first to notice the comeback was the correspondent for the *Evening Standard* who, in reporting heckling incidents during Astor's first evening meeting, stated that she "scored every time." He then commented, "She is better under fire than when no political bullets come whizzing back at her." Oswald Mosley, who spoke for Astor during the campaign, later told one of her biographers, John Grigg, that "She was much better when she was interrupted. She must have prayed for hecklers and interrupters." Similarly, Lady Astor's son Michael recorded that she loved a contest: "My mother only felt happy when she had to struggle to achieve something difficult or something new." Lady Astor herself remarked, "It takes opponents to get me gingered up."[115]

Heckling did not put any clamps on Astor's campaign talk. Instead, it provided her with the opportunity for a virtuoso performance—a tour de force of rhetorical invention. The following discussion explores, analyzes, and evaluates the numerous strategies Astor employed while coping with the hecklers. These responses include norm development, evasion, positive identification, entrapment, repartee, persona transformation, refutation, insults, disassociation, silencing, bravado, admonishment, and resolution.

Although informal, Astor's meetings operated within a framework of clearly established boundaries derived from the principle of reciprocity. Her choice of the interactive format signaled to both questioners and hecklers that they would have their turns to speak. Furthermore, her own readiness to keep her remarks brief indicated that she wanted to hear what her audience had to say. As the campaign intensified and her hecklers grew testy, she took time to clarify the rules. She reminded them that they were the listeners, that she should speak first, that she had the right to finish, that afterwards they could speak, but that she "was not going to be insulted." As she often had to bring forth these reminders in the midst of a disintegrating situation, she did so bluntly: "Keep your mouths shut until I have finished and then yap as much as you like." In the roughest days of the campaign, she also took insults, attempting to dissuade her hecklers by an appeal to conscience, "You can insult me, and I won't insult you in return," and a picture

of martyrdom, "I will take it all. I am getting immune to it."[116] Bringing forth the rules was a conventional response, and Astor knew that such an act would probably have little effect upon those intent upon breaking them.

Evasion was a second tactic in her repertoire. It permitted Astor to "keep face" when she did not know the answer, prevented her from taking the bait offered by the heckler, and at the same time allowed her to keep open the dialogue with her audience. One of her favorite choices was to turn attention from the question to the questioner/heckler and simultaneously make a move to diminish the apparent hostility by fashioning a second persona for her heckler that was much more to her liking. On 6 November, for example, when Astor finished her remarks to a women's gathering at Laira Green Schools, her heckler opened the question-and-answer period with "Why don't you go work in America?" Astor cleverly quipped that she wanted to better herself. But then, she turned directly to the heckler and said, "You have just had that question put into your head by people who want to be nasty. I can look into your face and see you have not a nasty thought in you."[117]

A few days earlier, a 66-year-old woman asked about old-age pensions, specifically wanting to know if Astor would make the government pay pensions to people of 65. Not answering the question, Astor replied that the woman "was far too young to trouble about such a matter." Later, she totally averted a question by turning to her challenger, smiling, and stating, "Now then, you know that as well as I do—and you have such a nice face."[118]

Sometimes she turned hecklers away from their questions by inviting them to be empathic, or, in the terms of her day, " to put the shoe on the other foot." At an evening meeting on 11 November, again in "an enemy stronghold in the Laira district," a woman asked, "Would you like to live on two pounds a week?" "No," replied Lady Astor, "but would you do what I am doing if you had what I have?" Or, on occasion, she would reveal her empathy by stating that if the roles were reversed, she would not blame the heckler as the heckler was blaming her.[119]

Additionally, she turned hecklers in on themselves by indicating a familiarity incompatible with a hostile question. During one of her street-corner gatherings, a man asked her, "What has your husband done for us?" Recognizing him, Astor called him by name, "Charlie," and then warmly charged, "You old liar; you know quite well what he has done."[120] She turned attention his way even more by then posing for a photograph with him.

Although evading questions by looking to those who asked them was a popular choice with Astor, it was not her only one. She also liked to change the question or redefine the terms. For example, when another older woman,

a mother of a serviceman, asked if Lord Astor had refused a shilling extra for soldiers' pay, Lady Astor stated that she was not sure of the fact but that the woman should ask the "opinion of the lower deck about Lord Astor," thus diverting a question about army pay to navy pay. As for terms, she was quick to spin "prohibition," "cooperative," and "Socialist" to her advantage. "Prohibition" became "state purchase and local option." "Cooperative" became the "true spirit of brotherhood." "Socialist," which she claimed to be "at heart," became "the most beautiful creed on earth." In twisting "Socialist" to appease her Labour detractors, she did such a good job that she ended up antagonizing the right wing of her own party whose spokesman, Lionel Jacobs, said, "People resent very much her Socialistic tendencies."[121]

Other evasive tactics included moving attention away from the question by turning to a third party, either her opponents or all men whom she said could be blamed for the ills of the world because they had been in charge. Occasionally she would dismiss a question by implying that it was irrelevant. When stumped, she would then confess that she did not know but rationalize her ignorance by saying she was not "a paid politician," and therefore could "afford to speak the truth."[122]

A popular strategy that Astor relied upon was a kind of crossover technique; that is, instead of playing an adversarial role in meeting her hecklers, she would attempt to positively identify with them. She made honest efforts to bend, to listen, and even to defend their right to challenge her. This was her choice when she encountered her first hecklers at the opening women's meeting on 4 November. During the question-and-answer period, a young woman identified as a Socialist told Lady Astor that she did not think it right that Astor should put down Labour before it was given a chance and pointed out to Lady Astor that she was not in tune with her own party: "But all your own party do not think as you do." Astor then defended the Coalition and "thanked the heckler for her question [comment]." This unanticipated response, thanking a heckler, brought forth giggles from Astor's audience. At this point, according to the *Daily Chronicle*, Lady Astor raised "her hand in protest" and said, "I admire her for sticking up for her party. I respect her. I want women to think."[123]

A few days later, she employed the same approach when responding to "a burly mechanic" who interrupted to comment, "Even if we sent a block of wood to Parliament, it would be a protest against the Coalition policy as to the dockyards." She readily agreed that something had to be done and told him how she had already taken active steps.[124]

Near the end of the campaign, she took the same stance when bringing her daytime cavalcade to hostile territory, an alley filled with Plymouth's

worst slums. Before she even began her remarks or hecklers threatened to chase her away, she stated, "I am for you; don't think I am against you."[125]

Although Astor was often sincere when siding with those who challenged her, she was not always so. She employed the same technique to catch her hecklers off guard and entrap them in a situation in which she could either deliver a counterpunch or turn the tables completely. Seeking common ground with one of her interrupters at Coxside, she evaded his question by coming back with one of her own: "Are you a sportsman?" When he said, "Yes," she snapped, "Then shut your mouth until I have finished." Her expressions of solidarity, those either straightforward or deceptive, were not strictly verbal but enhanced nonverbally as well. The most memorable anecdote from the campaign, Astor's encounter with the woman who asked about divorce reform, illustrates this well. The incident occurred at an evening meeting on Tuesday, 11 November. Lady Astor had been subjected to considerable heckling but had taken an unusual amount of abuse from one noisy lady who "repeatedly interrupted." Astor asked her to wait with her questions, but the woman continued making remarks that the *Devon Express* described as "not always in the best of taste." Patient, Astor "bore with her" but offered a "look in [her] eye . . . which boded ill for her tormentor." Then, the woman, indirectly alluding to Astor's previous marriage and divorce and raising a matter not yet brought forth for public scrutiny, asked, "Are you in favour of a Bill to make divorce in England as easy as it is in America?" And then the reporter noted that she "set her jaw as though to say 'That's one you can't answer.'" This time, Astor seemed to be caught speechless, and she did not reply immediately. It may be that she was waiting for a prompt from Waldorf or was thoroughly taken aback. She then moved forward to the front of the platform, closing the distance between herself and the heckler, adopted "her most sympathetic attitude," and said, "Madam, I am sorry you are in trouble." Others in the audience "simply yelled with merriment," and the woman, according to the *Express*, "certainly got it where the chicken got the ax."[126]

Other retorts were not so staggering but fell into repartee, a witty exchange that kept Astor from siding with her heckler but at the same time allowed her to keep open the relationship by indicating that she was willing to play the political game—or at least transfer it to the comic mode. One instance is interesting as it reveals Astor's familiarity with adages other than her own. Astor gave this quick reply midway through the first week of her campaign. Facing Labour opposition at an evening meeting at Mutley, she displayed a bit too much self-assurance for one of her hecklers. He interrupted her to say, "A confident person never wins." Without an intervening pause, she retorted, "Never mind . . . a faint-hearted man never got there."[127]

When she had trouble converting or upstaging her hecklers, Astor would try yet another ploy. Chameleonlike, she would change herself, transforming her own persona into one more to the heckler's liking. Most often, she used this device when confronted with derogatory remarks or questions relating to either her wealth or American birth. As mentioned before, she modified her American background by noting that her ancestors were West Country folk, her husband was an English citizen, and that far from being an ordinary Yankee, she was a Virginian. When taken on for not being an Englishwoman, she agreed, stating that "there were many . . . better qualified . . . to sit in the Commons," but then added that "she doubted if any were better qualified to represent Plymouth."[128]

Questions or remarks referring to her wealth brought forth several distinctive replies. Sometimes she tried to modify the view by indicating that even though the Astors were wealthy, they were not guilty of the wrongs often associated with those in their class. For example, Lady Astor took pains to point out that they were not *idle* rich but workers, or representatives of the working class. Neither were they concerned with class distinctions but "interested in all classes." Also, when specifically asked about slum owners being Conservatives, she denied that the Astors had any such links.[129]

If such modifications seemed inappropriate for the situation, Astor would then turn to self-deprecating humor—thus transforming the idle-rich-woman target of her heckler into a comic figure whom none could take seriously. She would ridicule herself and her detractors, drawing upon her skills in mimicry to exaggerate the characters, distort the scene, and thus amuse her audience. One time, she anticipated her hecklers' shots and jumped the gun on them before they could fire. Taking an insider's approach with her audience, she began her remarks with the following:

> I must tell you this, which was said about me last night, or I am afraid you won't hear it: "Lady Astor will kiss your babies today, and splash them with mud tomorrow!" The speaker did not live in Plymouth or he would know better.[130]

Similarly, she bantered with the marines who told her that they would vote for Gay. "No," she said, "don't you vote for me. I would not represent you."[131] Then in a mocking manner, she went on to explain:

> I am one of the idle people; I am one of the idle rich. I want to grind down the faces of the poor. I want you to work harder and harder, so

that I can live in a palace. But Plymouth people know me too well, and that is the last thing they will believe.[132]

Astor's first choice when confronted by hecklers was to turn the other cheek. She greeted her adversaries with cheerfulness, tried to reduce tensions, and attempted to transform a potentially hostile scene to one infused with good spirits. The *Daily Telegraph* reporter, in reflecting upon her approach, praised the way she would "share her buoyant spirits" and remarked that such actions were "not out of place in public life but the salt of it."[133] However, Astor's winning and wooing ways did not always succeed, and she would then have to turn to other options in her repertoire.

One of these was not to evade her hecklers' questions and remarks but to meet them head on, either refuting the charge by the heckler or offering a response that clarified her position. Early on, she stated her views opposing direct action, the Labour policy supported by Gay. One of Gay's followers told her that a "worker couldn't get money without strikes." "Oh yes, they can," she returned, adding, "and remember this, that all strikes stop the manufacture of goods."[134]

On another occasion, she quickly came to Waldorf's defense when several in a hostile crowd said that in an earlier election Waldorf had promised to revive sugar refining in Plymouth. Lady Astor disagreed, "He never said it in his life. Do stick to facts. Why, it would be bribery and corruption. There is not a word of truth in it. He has denied it, and Major Astor's word is as good as yours."[135]

She was at her best when dealing with questions relating to her views on drink. However, these questions were of little apparent interest to her hecklers, either because they knew she could offer satisfactory answers or because, as mentioned, Gay himself was a teetotaler. Those who were disturbed belonged either to the Trade or the right wing of her own party. They did not bother her at meetings, but instead took their complaints to *The Morning Post* that served as an outlet for them to air their discontents.[136]

Even though Astor said she would try not to insult those who insulted her and prayed that she would not be rude, she did succumb to the temptation to trade insults with her hecklers. She then would give as good as she got—often responding to the ugliness of her heckler's remark by referring to the ugliness of his or her appearance. The time one of her "old friends" reprimanded her for saying Plymouth's children "had all dirty faces," she first told him to "Shut up," but when he persisted in bothering her, she then hurled, "I am sorry for your wife when I look at your face." But since he was an "old friend," she then softened the blow by winking at him.[137]

She was not so charitable with a Mrs. Simson who, according to Maurice Collis's biography of Astor, had told Lady Astor "that her face was pretty but that was all one could say for her." Astor replied, "I'm sorry I can't return the compliment as an honest woman. Perhaps if I had been in politics a bit longer I could have managed it."[138]

Many of the strategies Astor used while coping with her hecklers can be categorized as inclusive rhetoric, attempts to mend the differences between them, and bring both together within a single fold. When compelled, she also employed exclusive rhetoric to bring about the opposite relationship—a clear separation of the heckler from herself. Here she used the tactic of disassociation, encapsulated in her countersuggestive injunction, "Don't vote for me."[139] As a matter of fact, she used this phrase so often that a waggish observer of her campaign meetings could have remarked, "She asked as many not to vote for her as she asked to vote for her."

Oftentimes Astor's efforts to displace her hecklers were swift—taking no more than a line or two. When dealing with doubters, she said, "If you don't think me honest, capable and sincere, I implore you not to vote for me." When dumping an ILP Gay supporter who had said he believed in Soviets, she evoked fear as well: "Don't vote for me. I won't represent you." And then, turning the attention of the audience to her outcast, she went on, "Anyone who wants bloodshed, revolution and starvation must support that gentleman."[140]

On one occasion, she met a formidable heckler and as a result, she had to explore several possibilities in her attempt to confound him. The *Western Morning News* gave the best account of the incident that occurred at an open-air meeting in Notte Street near the end of the campaign:

> A man shouted to Lady Astor: "You go back to America and look after the miners there."—Lady Astor: "You go back to Lancashire, old boy. You don't come from down here or you would not speak like that."—The Man: "No, I'm an Irishman."—Lady Astor: "I knew you were imported."—The Man: "If I was imported like you I would go and drown myself."—Lady Astor: "Perhaps you would drown yourself in drink if you had what I have."—The Man: "I never tasted a drop in my life."—Lady Astor: "Then go and do so. Perhaps it would sweeten you."[141]

Here one sees that Astor first tried to mark the "old boy" as an alien when she said that he was from Lancashire. When he said he was not, but that he was Irish, she said he was still an import. But then, tit for tat, he pointed out that so was she; thus, they were not separated but in the same boat. He then set her up for the next round in the exchange by saying that

if he were she, he would drown himself. Refusing to be counted among the dead, she picked up his "if I were you" and extended the remark to indicate that indeed if he were she, he would drown himself in drink. Here she was hoping to knock him out as a drunken Irishman. But again he foiled her. He told her that he did not drink. This was a move that again put them in the same league. He was going to be hard to get rid of, especially since everyone present was familiar with Astor's stand regarding the evils of alcohol. To score, to succeed in trumping him, she would have to change her tactic. She retreated and did the unthinkable; she told him to go have a drink. And then she added the devastating, "Perhaps it would sweeten you."[142] Finally, she was able to expel him as an old grump.

Simultaneously, by introducing the perspective of incongruity, which in this case was her own compromise on the matter of drink, she surprised her audience and propelled them, at least momentarily, into the comic mode.[143] She revealed that, in contrast to the "old boy," she was a cheerful sort, a "good old girl" willing to join them in the joke—both on him and herself.

By the time the campaign closed, Astor had tried to include many on her side, but, by using tactics of disassociation, she had excluded nonresidents, conscientious objectors, Bolshevists, Marxists, pacifists, shirkers, drunkards, and disagreeable folk—and the hecklers among them.

Although Astor willingly engaged with many of her challengers, she increasingly used disassociation and other more extreme measures with planted hecklers as the campaign progressed. She sarcastically referred to them as her "loving friends," but then made efforts to cut them off. She told one man that he was a professional heckler and that she would not listen to him. Other times, she made unmistakable moves to silence them without mincing or wasting a word: "Be quiet." "Get out." "Shut up."[144]

Once, she took an indirect approach, relying upon the authority embedded in the words of Labour's own Margaret Bondfield. After Astor's own pointed "Stop yapping there" did not work, she tried one of Bondfield's insults, encasing it in a narrative which she though would capture their attention:

> Margaret Bondfield . . . was addressing a meeting of you united Labour folk, and the people were yapping away just as you are, when Miss Bondfield turned on them and said, "You who are quarreling and criticizing the Government are not fit to run a tripe shop." That is what Labour leaders say to people who yap.[145]

The implication here is that yapping or interrupting is not only rude, but, in Miss Bondfield's view, un-Labour-like as well.

When these efforts appeared to fail, Lady Astor would act as chair and call for order or turn to others for assistance in gaining silence. At the women's meetings held in schoolrooms, someone would help out by ringing the teacher's bell or blowing a whistle. At curbside meetings, Churchward, her driver, would move to her rescue. Most often, her supporters or others in the audience would eventually turn upon those who were disruptive, either gaining silence or at times entering the rhetorical brawl themselves.[146]

Although Lady Astor was certainly irritated by her hecklers, she seldom gave any indication that she was afraid of them. Instead of forcing her to back down, they produced a contrary response and prompted a display of bravado very much in keeping with her "fighting woman" image. First of all, she did not skirt dangerous territory but sought it out in every area of the Sutton division; she even canvassed in those "hostile" neighborhoods Waldorf had avoided in his campaign the year before. She recognized her own responsibility in the troubles that occurred, knowing well that "Come on now. Who will take me on?" would inspire more than a straightforward answer. She exaggerated her strengths—audaciously telling her audiences that she would not only capture more votes than her opponents but also best Waldorf's previous record. She offered "to throw every capitalist off the Hoe" if the ILP could guarantee a better world. Drawing upon a domestic simile, she told one audience that if she "were to descend to personalities, I could beat Gay like a pancake." In the latter instance, she was bested. Alluding to Waldorf's earlier slur on Gay, the respondent in her audience drawled, "And you might have to apologize."[147]

Switching to her Mother persona was another way Astor dealt with her hecklers. Acting as if they were naughty children, Astor would admonish them for their bad manners. She told one heckler, "Please do not call me 'Nancy.' It is not polite to call a married woman by her Christian name. One of Mr. Gay's conscientious objector friends from Dartmoor started it." Another time (again with those in the unruly group gathered for an open-air meeting in Notte Street), she noticed that the man whom she had invited forward to speak with her kept talking with a cigarette in his mouth. When she pointed this out to him, he said that "he would please himself about it." When the women in her audience misbehaved, she would accuse them of being "as bad as the men," sarcastically remind them that they were "Ladies," or wonder in dismay, "Ladies, sometimes I doubt whether we ought to have the vote." She was often brusque, showing less patience with adult children than those with genuine qualifications. She stated to one, "If you don't want to hear me, go away." To another, she was rougher yet, "If you don't want an answer, then what in thunder did you ask a question for?"[148]

Astor did not always employ a single technique in meeting the challenges posed by her hecklers, but she sometimes overwhelmed them with a complete battery of retorts, leaving them awestruck or at least confused. Analysis of one particular incident revealed that she came back to the interruption, "If there were no capitalists there would be no slums," with a lengthy reply in which she redefined the problem, asked for proof, expressed bravado, shifted the focus to her opponents, transformed her own persona, and then disassociated her interrupter before moving on with her comments.[149] It is easy to imagine her recalling the scene in plain terms: "I threw everything at 'em includin' the kitchen sink."

In overwhelming her hecklers, admonishing them, or brashly making the initial move, Astor revealed familiarity with assertive rhetoric and an understanding of the maxim, "The best defense is a good offense." As a result, she often did not find herself in a defensive position. Yet, when she did get into such situations, she either presented her own good deeds or simply held her ground. It was easy for those in her audiences to recall the remark she made in her opening address, "I may have my faults, but even my opponents will admit that feebleness is not one of them." Similarly they learned more about her resolve when she polished off a "windy skirmish" with some Labourites with "If I don't win I'll fight till I'm sixty-five." Grigg, one of her biographers, said, "Nerve was a primary ingredient."[150] It is obvious that she did not give in easily or noticeably flinch when battered by hecklers' questions or remarks.

However, it must also be noted that she did not allow herself to be subjected to excessive abuse. When matters did get beyond control, she simply stopped talking. Once, early on in the campaign, she even left a meeting muttering, "Hang it all," but most often she just moved on to the overflow meeting or the next engagement. She acted upon the advice of her father-in-law, William Waldorf, who had been known to say, "Take the tricks whenever you can and go on with the game."[151]

In dealing with the hecklers who followed her, Lady Astor demonstrated remarkable versatility in meeting the challenges they posed. She revealed that she had a comprehensive awareness of the rhetorical choices before her and an uncanny knack for selecting a fitting response. An ancient would say that she did possess "the faculty of observing in any given case the available means of persuasion." A modern would remark that she was competent, capable of assessing the situation and adapting. Moreover, he would note that her competence seemed to operate at an unconscious level—without deliberation or scripting. Instead, it came through as intuitive, spontaneous, and unusually quick. Gwladys Jones, correspondent for

the *Daily Chronicle*, repeatedly remarked how Astor came back to her hecklers "in a moment" or at most, "in a minute." She implied that Astor could instantaneously make "ordinary political barriers go down like ninepins" or sweep a "meeting along with her on a tide of jollity." And then she said, "Sometimes she won by sheer ability to grasp the question in a flash, array the facts in a line, and pick out the favourable one for her answer."[152]

When considered individually, one sees that Astor's responses to her hecklers were timely and most adequate in helping her keep or regain control of the meetings in which she appeared. When considered collectively, one perceives that the responses reveal patterns compatible with Astor's other rhetorical acts. They fit into the community building that was the primary thrust of her campaign activity.

Although Astor often turned the tables on her hecklers, she really did not want to turn them out. Most often, her first moves were to charm them to her side or convert them to her cause. Defending and representing a Coalition government, she attempted to sustain its power by keeping and bringing as many as possible into the fold. Thus, in countering her hecklers, she relied upon a shifting rhetorical pattern that moved from the inclusive to the exclusive. It was a pattern similar to the one followed by small groups when dealing with deviant members, and it incorporated many of the persuasive strategies common to that situation. One is restating the norms. Another is drawing attention to the deviant and his or her "disturbing activity." Also, group members turn to humor in an attempt to cajole the deviant into changing his or her ways and at the same time release the tension that has developed. When, however, the nonconformist does not change, or, as in Astor's case, the heckler persists, then the group members turn to exclusionary tactics such as ridicule, direct and serious confrontation, and finally, when all else fails, rejection and isolation.[153]

Analysis of the prevalent patterns imbedded in the wide and diversified range of rhetorical activity stirred up by Astor's confrontation with her hecklers reveals that she initially perceived them not as outsiders but as members of the community who had strayed and needed to be brought back. If that could not be done, then she had to let them go. In brief, she approached and reproached hecklers by being both positive and pragmatic. In the process, she let her audiences see that she was capable of holding her own in the political fray—fit for the campaign and ready for Parliament.

Even though Astor scored in most rounds with her hecklers, she did not come through each confrontation unscathed. Their persistent interruptions did damage her campaign—at least in two respects. First of all, they blocked some of her moves to develop the serious, responsible Pilgrim

Mother persona that she brought forth in early press interviews and her Adoption Day remarks. They succeeded in reviving the Hustler, known better for her ability to amuse than to reform. More often than Astor wished, the hecklers prompted a shift from the serious mode of discourse to the comic. Second, Astor's bouts with the hecklers, far more interesting than her opponents' speeches to their own followers, captured an unusual amount of press attention and coverage, which detracted from her attempts to seriously discuss matters of importance with the Sutton electorate. Failing to get her own messages across as she had hoped, she then had to take on members of the press in an additional skirmish.

The next section discusses the obstacles Astor had to overcome in dealing with an unruly press whose rhetorical choices were not in her control and not always to her liking.

LADY ASTOR AND THE PRESS

When Lady Astor moved down from Cliveden to Plymouth on 29 October, she brought with her a following of press photographers and reporters. It is not exactly clear how many were in the pack, but there were enough that they often commented upon each other in terms indicative of quantity. The *Chicago News*, for example, reported that more than "a score" followed her. Another U.S. paper, the *Boston Globe*, said she was trailed by a "battery of press photographers," and the *New York Times* mentioned that the "taxicabs [were] loaded with newspaper men and photographers." Those in the British press commented that the campaign was "attended by crowds of photographers and journalists" and noted that they "awaited" her daily comings and goings and "swarmed" around as she moved among those in the electorate. A count of a selected sample of press reports indicates that at least 21 different papers assigned their own correspondent or special representative to track her activities.[154]

These reporters and photographers came from numerous places. As could be expected, the local press covered Astor and her rivals extensively. All three Plymouth papers—the *Western Morning News*, the *Western Mercury*, and the *Western Evening Herald*—featured the campaign as the lead story throughout its duration. Each seemed unusually fair in presenting campaign news and withheld judgments on the candidates until the close of the campaign.

The provincial press from other parts of England also took an interest in Astor's campaign. Reporters from the *Birmingham Gazette*, the *Birmingham*

Post, the *Express and Echo* (Exeter), the *Liverpool Courier*, the *Liverpool Post*, the *Manchester Daily Despatch*, the *Manchester Evening Chronicle*, the *Manchester Guardian*, the *Yorkshire Observer* (Bradford), and *Yorkshire Post* (Leeds) followed her frequently as did those from the *Glasgow Herald*, the *Scotsman* (Edinburgh), and the Welsh papers, particularly the *South Wales Daily News* (Cardiff) and the *Western Mail* (Cardiff). The *Birmingham Post* and the *Manchester Guardian* took sides in the contest—with the *Post* favoring Astor and the *Guardian* favoring Foot.[155]

The reporter for Plymouth's *Western Morning News* also noticed a large following by the metropolitan papers, "which usually dismiss such contests in a paragraph."[156] Those representing the London contingent included correspondents from the dailies, the *Daily Chronicle*, the *Daily Express*, the *Daily Mail*, the *Daily Mirror*, the *Daily Telegraph*, the *Evening Standard*, the *Globe*, the *Morning Post*, the *Pall Mall Gazette*, the *Times*, the *Westminster Gazette*, and the Sunday papers, *Lloyd's Weekly News*, the *Observer*, and several pictorials.

Another observant reporter, this time from the *Liverpool Courier*, found that Astor's campaign captured "worldwide interest" and drew attention to the fact that representatives from American and European papers were also present, most notably the *Boston Globe* and the *New York Times*. Astor's own records indicate that Hearst, Universal Service, and the Associated Press provided wire service coverage as well.[157]

Since other concurrent by-elections did not generate so much print, it is reasonable to ask, "Why Astor's campaign?" Credible answers, beyond the phenomenon of pack journalism, might be that her attempt was politically important and socially significant.[158] The "kinship factor" may have played a role—as well as the fact that Astor offered the promise of bright copy and thus an increase in newspaper sales.

Political Importance

From the perspective of those in the British quality press, the Plymouth by-election, even though a small part of the democratic scene, was still politically important and worthy of attention. At this time in history, political news was the primary function of the British press—its *raison d'être*. Charles H. Grasty, writing about "British and American Newspapers" in the November 1919 *Atlantic Monthly*, said that in Britain, "Government by public opinion is very real," adding that "Parliament is the agent of the people; they have the power of enforcing their views at any moment." Because this is the case, he inferred, "Matter about the government is 'hot stuff,' to describe it in journalese."[159]

Campaign coverage was "politics as usual" for the press; in Sutton it was also "politics as unusual"—a situation brought about by the convergence of several factors including redistricting, a newly enfranchised electorate, a female candidate, and a reluctant Lord. Some uncertainty prevailed about the Astors themselves, not only whether Nancy would win, but also what would happen if she did. If she were to capture the Commons seat and Waldorf were to stay in the House of Lords, then the country faced the prospect of having the "first couple" in Parliament.[160] If, however, Waldorf were to successfully rid himself of his title and regain his Commons seat, and if Nancy were to turn to other concerns, then there would be some Constitutional consequences affecting the composition of Parliament itself.

More important than speculation about life after an Astor victory, the press found the campaign attractive because its members already saw the election itself as unpredictable. The struggle in Plymouth would be a new test for Lloyd George's Coalition, far less popular than it had been a year earlier when the coupon had been its return ticket. Lloyd George, "the Man Who Won the War," now faced a period of turmoil at home: unrest in the armed forces and police and serious challenges from organized labor. The Conservative-Unionists had the numbers to get along without him, and the Liberals wondered about the color of his banner. The man who had reached the pinnacle of political power was, as Wrigley points out, "at the top of the greasy pole" and had begun to slide. How long his Coalition government would last was already a matter of discussion. In Plymouth, Lionel Jacobs, who had considered entering the contest as an Independent Unionist but then changed his mind, explained himself by telling the *Western Mercury* that he "honestly believed that the present Parliament could not last long and a general election was not far off."[161]

Should Jacobs be correct, then the press certainly did not want to miss out—either in following what could be the bellwether election or in influencing its outcome. Unlike the U.S. press that at the time was more restrained in expressing its political views, the British press was highly partisan. Its members could use the Sutton by-election as a vehicle to express their own alignment. Distinctive voices could be heard from all parts of the political spectrum. The *Daily Herald* strongly supported Gay, the cause of Labour, and continuously found fault with Astor and her Establishment backers. Foot found his press support in the Asquithian *Westminster Gazette* and, as mentioned, the trusted and respected *Manchester Guardian*, both critical of the Lloyd George Coalition. The *Morning Post*, "the 'stand-pat' paper that hates and wards off everything that is progressive," looked upon Lady Astor with extreme skepticism and often criticized her as sharply as

did the papers to the political left. Pro-Astor papers included the *Daily Chronicle*, purchased by Lloyd George supporters in September 1918, those that were Astor-owned, the *Pall Mall Gazette* and the *Observer*, and *Lloyd's Weekly News*, which gave her editorial support as early as 2 November. Other papers took a moderate, positive approach but withheld expressing strong opinions as the campaign progressed. The *Daily Telegraph* confessed that it could not call the election because it was so novel and predicted that, come polling day, there would be a lot of abstentions.[162]

Social Significance

In addition to a certain amount of political importance, Lady Astor's campaign garnered press attention because it was socially significant. Should she be elected, Lady Astor would become the first woman to enter the House of Commons, ushering in changes not only for her own time but years to come. Her entrance would be a "mark on the forest," a milestone event in the history of women's attempts to participate in the governance of their lives.[163] She would be granted the role that, up until that time, either eluded or had been forbidden to others.

The Representation of the People Act of 1918 granted the franchise to women over the age of thirty, and a follow-up measure, the Qualification of Women Bill, allowed them to serve in the House of Commons. The latter measure, passed just twenty-three days before the 1918 polling day, tempted seventeen women to stand, but not one in England was elected. The sole winner was an Irishwoman, Constance Markievicz.[164]

A revolutionary, Constance Markievicz, had been chosen by the Sinn Fein to stand for St. Patrick's division in Dublin. She easily won her seat and subsequent recognition as the first woman elected to the British House of Commons. Yet she did not go—could not go. At the time of her election, she was being held in the Holloway Jail in England as a political prisoner for suspected involvement in an Irish-German plot deemed detrimental to the war effort.[165]

Even though she was later released in March 1919 and was free to serve in Commons, she spurned the opportunity and joined other Sinn Feiners in the Dail Eireann, the parliament of the renegade Irish Republic—emphatically sharing their opposition to the British, now characterized by militancy in the Anglo-Irish War.[166]

As part of this struggle, Markievicz repudiated all things British, and in June she was arrested for a seditious speech she gave at a prohibited meeting

earlier in May. Alarmed by her remark, "Burn everything British except its coal," the judge sentenced her to four months in the Cork women's prison in Ireland.[167]

While she was there, IRA attacks upon the police intensified and prompted additional British attempts to reassert control of affairs in Ireland. When Markievicz got out in October, she re-entered an Ireland in which "the Dail had been declared illegal" and Sinn Fein had been "proscribed." A member of both, she was "under constant threat of re-arrest" for what was deemed, in British eyes, participation in highly subversive activities.[168] Thus, when Astor's campaign began early in November, Constance Markievicz was on the run—disinclined to show up either in the House of Commons or near any British authority.

With no indications that her female rival would appear, the path was then clear for Lady Astor to become the second woman elected but the first to take her seat. If the voters of Plymouth Sutton did not find gender an issue or prefer one of her opponents, then she stood a good chance of seizing the parliamentary honor. Unlike Markievicz, she had the support of the government in power, and unlike her female predecessors in the 1918 general election, she had the official endorsement of both the Conservative-Unionists and the Coalition Liberals.[169] From the point of view of many in the press corps, the time for a woman's election and entry into the House of Commons had arrived. They did not want to miss out on what could become an historic event.

Kinship Factor

Another reason Lady Astor picked up an unusual press following could be the kinship factor. Reporters saw her as one of their own. As Waldorf's wife, she too was associated with that large press family that included proprietors, editors, and journalists. Certainly her press connections were well-known. Waldorf owned both the *Pall Mall Gazette* and the Sunday *Observer* and hobnobbed with other giants in the industry, Lords Northcliffe, Rothermere, and Beaverbrook. Top editors J. L. Garvin (*Observer*) and Geoffrey Dawson (*Times*) not only visited Cliveden but also corresponded with Nancy when away. A goodly number of Waldorf's fellow MPs had had a press connection, either as proprietors or journalists. It is likely that several writers may have been would-be Parliamentarians, eager to participate in the activities they had observed so often.[170]

Similarly, those in her following who were American also saw and claimed her as one of theirs and delighted in reporting back to their U.S.

papers accounts of her captivating ways. Many of the U.S. reports focused upon the pageantry of her daytime excursions. They dwelt at some length upon Astor's physical appearance—as if she were Cinderella on the way to the ball. They recalled her past as a Virginia beauty, a Southern belle, and pointed out that she was "still beautiful," a "pretty girl." They attributed her good looks to her vivaciousness and told how "every now and then she stomps a foot or makes an animated signal with her hand." They were also fascinated by her coachman, Churchward, whose ruddy face, bulk, silk hat, and commanding manner they described, as well as the horses he held in hand "with bridles decorated with red, white and blue rosettes."[171]

Drawn to these fairy-tale characters, the American press dramatized the event in which they acted. They talked about the fact that it was unprecedented and perhaps exaggerated its importance by claiming that the campaign was the "most novel and vigorously fought parliamentary battle in Plymouth's history."[172]

American reporters also drew attention to the exchanges Astor had with hecklers and members of her audience. They termed her comments "sassy" and indicated that her quick wit was an American characteristic. The writer for *Outlook* described Astor as a woman "with an American 'snap' and 'edge' which the English, of all others, like, one reason being that they often lack these qualities." Later, he talked about her "flashing courage, quips and sallies which we like to think peculiarly our own." These reporters remarked upon her "loyalty to America in general." They praised her for standing by her countrywomen in making "it an invariable rule to speak no disparagement" of them, never snubbing those like herself. And, most often, they cheered when she defended her American birth, repeating her comment, "Do not think for one moment that I am ashamed of my Virginia blood."[173]

At times they became so caught up in their subject that they indulged themselves in ethnocentric and self-congratulatory prose. The *New York Times*, for example, said that Lady Astor warmed American hearts by "letting the staid old Britishers know that, English peeress as she is, she had not forgotten her American traditions, and is not ashamed of them." It then quoted an effusive friend of hers who had stated, "Nancy Langhorne is a character of whom we Americans might well be proud."[174]

Eventually, U.S. reporters overworked the American kinship link and came to see their reports perceived as overblown. Indeed, those in the leftist and more radically inclined press thought their work "snobbery and adulation of the 'parasitic' classes." When the campaign was over, a commentator for the *Cleveland Citizen* heaved a sigh of relief, thankful that there would be

an end to the "daily slush" brought forth by "snobocratic news purveyors employed in disposing of tommyrot."[175]

Even though U.S. journalists warmed more to Astor's charms than the British, both probably chose to follow her because she made good copy. In his book, *Politics and the Mass Media in Britain*, Ralph Negrine describes the journalistic conventions that influence the selection of news items and discusses some of the criteria employed in determining stories of newsworthy value. A comparison of the factors he cites with elements in Astor's campaign reveals that she proved herself attractive copy to the press in three important ways. She was, first of all, a member of the social elite. Second, she could be expected to perform, to act in consonance with journalistic predictions. And third, she offered them the opportunity to provide a striking contrast to the long series of war and recovery reports that had dominated the papers for the previous five years.[176]

Even before she became "Lady," Nancy Astor was a socially prominent woman, known both in England and North America for her wealth, beauty, and gracious hospitality—particularly in her role as a political hostess at Cliveden and at 4 St. James, London. The *New York Times* placed its stories of her campaign in the society pages among birth, engagement, wedding, and death notices. On one occasion, the reporter commented that she was perceived to have "personal feminine power in influential circles,"and could be counted upon to "drop word in the right quarter for the good of Plymouth." An American news digest, *Current Opinion*, stated that she had been studied by the English society papers for fifteen years and her "peculiarity and charm reside chiefly in her manner of knowing everybody and being known by everybody." Years later, her son, Michael Astor, noted that, "My mother was a famous person . . . as much a household word as Mrs. Roosevelt, Greta Garbo, Marilyn Monroe."[177]

Known to the press and already portrayed as a Gibson Girl, Pussyfoot, Lady Bountiful, Warming Pan, or Hustler, Lady Astor could also be expected to act out her old roles or develop a new one of equal interest. Thus, she would either vindicate press predictions or offer a performance as good as she gave in the past. Members of the press corps followed because they figured she would give them what they wanted: memorable phrases, good stories, and enough unpredictability to keep their stories fresh. And in this respect, she did not let them down. She spoke in memorable quotable terms. Her epigrammatic style, evident in both her short speeches and replies to her hecklers, delighted the reporters who passed them on as "Astorisms"—culled from context and juxtaposed one beside the other. One favorite, repeatedly mentioned, was 'There is a difference between the working classes and the shirking classes."[178]

Astor also gave the reporters ready-made stories to tell by illustrating her speeches with personal anecdotes enlivened with dialogue and embellished with detail. Often she made the private public and disclosed incidents others of her class would have kept quiet. She seemed to have "no need of revealing her true nature by degrees but burst upon the stranger's consciousness with all her lights going." She not only told stories about herself but also offered interesting tidbits of information about other elite contemporaries. One such narrative, again reflecting Astor's self-deprecating humor, revealed that as a hostess she sometimes made mistakes. Hoping to achieve a diverse mix of guests at her dinner table, she had seated political enemies Lord Curzon and Herbert Asquith side by side. She soon discovered that her assumption that they would be civil to each other was false: "Instead of eating my salad, they threatened to eat one another."[179]

Even though Astor repeated herself from meeting to meeting and reiterated her campaign themes, she added enough fresh material to her daily fare that the reporters always had something new to report and often found themselves taken by surprise on several occasions. This element of unpredictability brought forth praise from the *Daily Telegraph* representative, who said:

> [She is] as clear as a brook, with a musical voice and features wonderfully responsive to her varying moods. Yet at any moment there flashes out some sentence that overwhelms you with surprise—some daring utterance coming quite unexpectedly, a quaint turn of phrase, a colloquial expression that leaves you in wonderment.[180]

Not only did Lady Astor provide reporters with fresh stories, but she also gave them bright copy and thus the opportunity for their papers to balance the kinds of stories printed. War news had filled the papers from August 1914, and, except for the euphoric days in November 1918, domestic troubles in times thereafter. Astor's campaign, often spoken of in light metaphors, provided a welcome contrast in a world where death still loomed. In recalling the time, Astor's niece, Alice Winn, who had visited her shortly after the election, said, "It was at this time that she walked onto the world stage, for the Press from every nation followed her ascendancy. She was a new luminous shooting star." Years later, George Seldes, reporter for the *New York Tribune* who had covered the campaign, recalled that "it exceeded everyone's dreams, expectations."[181]

Although awed and somewhat amused by the size of her press following, Lady Astor started her campaign by positively responding to it. In fact, she was remarkably cooperative.

Astor-Press Relationship: The First Stage

In the uncertain days after William Waldorf's death when the decision as to whether she would stand was still pending, she told the press that she had made no decision but that one would be forthcoming. Although perplexed by the abrupt changes in his life, Waldorf immediately took upon the role as her press liaison, fronting for her and making direct contact with the press in response to reporters' requests. Very early, Lady Astor granted interviews; the first, even before she arrived in Plymouth, was given to the *Western Morning News*. She granted other exclusives to the Sundays, *Lloyd's Weekly News* and the *Observer*. She also spoke with the reporter for the ultra-Conservative *Morning Post* on two occasions, once to answer numerous questions on a variety of issues and again to detail her specific views on drink. The latter interview, as mentioned before, helped dispel the Pussyfoot persona and reassure jittery members of the Trade that even though she personally preferred prohibition, politically she endorsed local option and full compensation for pub owners should they lose their businesses.[182]

In addition to graciously responding to press requests, the Astors also initiated a series of press-related activities. They sent out press releases, early copies of Nancy's Electioneering Address, and the letters of endorsement (coupons) as they came in. At least one secretary, Miss Cundy, attended to the task in Plymouth, and it is likely that another, Miss Kindersley, dealt with similar matters at 4 St. James in London. They tracked press activity by using Woolgar and Roberts' clipping service and filed the clips in large scrapbooks. Sometime during the campaign, the Astors employed a news agent, a W. T. Cranfield, who helped them in contacts with the provincial papers. Locally they used the letters column to make announcements or present support for Lady Astor's positions.[183] Thus in the very early days of the campaign there was every indication that the Astors intended to foster a favorable relationship with the press, mutually beneficial to both parties.

Yet as the campaign unfolded Nancy began to show an uncooperative side by occasionally withdrawing from press requests and complaining about their reports. Her reaction is understandable as the press was demanding, especially photographers who continuously begged her to pose. On the first day out, she said to them, "Why can't you let us have our little election down here in Devonshire?" And then to the Plymothians in the crowd, she commented, "Aren't these foreigners awful persons?" Later on, when pushed for a portrait with a fisherman on his schooner, she snapped, "I'm not an actress," but she made the most of the situation by soliciting the fisherman's vote.[184]

Her bantering and jibes did not deter her press following, and they besieged her all the more. Another time she looked upon them and cried, "Spare me," and later she appealed, "Men of Devon, come and help me!"[185]

The constant physical presence of the press corps, though annoying, did not bother Lady Astor as much as the fact that they were not reporting what she wanted. She pointed out this concern during her second interview with the *Morning Post* when, in admitting she was a prohibitionist, she said, "It is surely best to be quite honest. All I ask is that people of education and intelligence will not snap up one sentence or even half a one, without taking the trouble to understand what I have stated quite clearly." The same day, the *Liverpool Post* reported that she had asked the press representatives "not to follow her remarks too closely" and had "laughingly exclaimed, 'The reporters simply do for me, I cannot enjoy myself.'" And a week later, she still complained that the papers, "never report her speeches at length."[186]

Astor-Press Relationship: The Second Stage

Lady Astor's trials with her press contingent eventually led to an explosive encounter on Friday, 7 November, Nomination Day. The previous evening, the reporter for the *Westminster Gazette*, the independent Liberal paper, had commented that Lady Astor's meetings were "regarded as a great 'stunt.'" Apparently, Lady Astor had read the report and was upset by it. Friday morning, when she arrived at the municipal buildings to turn in her papers and election deposit, she found that again she was met by her large press gathering. After handing in her twenty-five nomination papers, she then turned upon those swarming nearby and let burst a surprising tirade in which she accused them of "making a 'stunt' of her candidature." She then threatened:

> When I get to the House of Commons, I intend to expose every one of the newspapers that have been making stunts. I do not blame the reporters; I believe they act decently. I have a very good case, but the papers are making fun of it. I have principles and ideals, but they are turning me into a stunt, and they would even make fun of the dead. They would do anything for 5 pence.[187]

Still perturbed, she departed a few minutes later directing Churchward to drive on because she did not want her picture taken: "You may like to have your photo taken. I don't." The *South Wales Daily News* later reported that she had spent the rest of the afternoon indoors.[188]

It could be that this was the time when she granted an interview to the writer for *Lloyd's Weekly News* as the same feelings were echoed in its publication in the following Sunday's edition. When asked by the *Lloyd's* reporter how she was enjoying her fight, she had replied that she was not. She went on to clarify her remark by stating, "I certainly regard one feature of it—the publicity—as a penalty and not a pleasure. Some organs of the Press are trying to convert this into a stunt election. It isn't. I wouldn't be here if it was." She then added, "The main principle . . . is the maintenance of spirit and cooperation and Coalition which alone can meet peace dangers as it met war dangers" and went on to explain aspects of her policy.[189]

On Monday morning, 10 November, it was Waldorf who first stepped forth from Elliot Terrace to greet the battalion of tagging reporters. He recalled Friday's incident at the municipal buildings and subtly announced, in terms of a polite request, that Lady Astor would grant no more interviews. He justified the action by explaining that she needed the time for other matters, telling the press that:

> There is a great deal of preparatory work to be done, and the task of keeping thoroughly informed on both local and national topics, as Lady Astor endeavors to do, is no light one, whist the fresh and stimulating character of all her speeches is ample evidence of careful thought and study.[190]

Diplomatically, he concluded his statement by advising the press on its future course. The *Western Mail* recorded:

> His lordship would be glad if more prominence could be given to those portions of his wife's public utterances in which her principles are set forth, and a little less devoted to those which, on the whole, are more lively and diverting, but perhaps less informing.[191]

Astor-Press Relationship: The Third Stage

Thus rebuked by both Astors—perhaps hurt by their response—the press momentarily drew back and fell to quibbling among themselves in a series of postmortem reviews. In the process, they oftentimes overlooked their own complicity in the fray and indulged themselves in critiquing Astor's rhetorical efforts and offering their evaluations. The *Daily News*, seeing Astor as the instigator of her own stunts, was condescending. It put down

Lady Astor and her women followers in the curt: "Women especially flock to her meetings and derive amusement from her naive speeches and her replies to questions." The offending *Westminster Gazette* blamed Astor for her troubles by saying that she "invites this kind of thing" by her campaigning methods and ways of dealing with her hecklers. The *Liverpool Post* agreed, implying that her approach was wrong, that it lacked dignity. The representative said that her "political methods do not appeal to me strongly . . . that a little less facetiousness, a shade less playing to the gallery in her would-be constituency and in the Press, would more entirely please the Briton in me." The *Morning Post* also faulted her. It said that she had a "butterfly method of dealing with anything she alighted on" and that she was "delightfully inconsequential in her utterances." Her "unconventional manner and address," it concluded, provided "material for such light writing."[192]

Other papers—the *Times*, the *Liverpool Express*, the *Birmingham Post*, the *Daily Telegraph* and the *Express and Echo*—came to her defense. The *Daily Telegraph* replied directly to the *Morning Post*, which had said she had a "butterfly method." Introducing a direct quotation from an Astor speech, the *Telegraph* representative began, "Lest there should be any who still believe that Lady Astor is only a butterfly in politics, I give the closing passage of her speech." The *Times* said that "it would be quite a mistake to suppose that Lady Astor and her supporters do not take her candidature seriously" and that she was "by no means the frivolous creature which some of the reports suggest." The *Birmingham Post* went so far as to attack others in the press as "superficial observers" who misunderstood her "buoyancy of spirit" and failed to take account of the fact that she was "taking both herself and championship of the Unionist cause in deadly earnest."[193]

The obvious non-participant was the *Daily Herald*, the Labour paper clearly supporting Gay. It stayed aloof from the entire event but disdainfully intimated that Lady Astor's press retinue was her own kind, representative of the Coalition press, which it said locals had dubbed the "Astor Circus."[194]

Astor-Press Relationship: The Outcome

In a few days, the squabble played itself out, and the press turned its primary attention elsewhere. Lady Astor carried on with direct work with her constituents by relying upon personal contact in canvassing and meetings, both public and private. In working out her relationship with the press, Lady Astor learned she could not control what they reported, and the press

learned that she had her own story to tell. Both, to a degree, asserted their independence. Like an actress who had received mixed reviews from her critics, Astor went on to play for her audience—those potential voters who continued to pack the meeting halls and cluster about her in the streets. The press be damned; direct access would be her preferred venue for working with the electorate.

DRAMATIC DEVELOPMENTS— CONTROVERSY, CLIMAX, AND RESOLUTION

If you can't get a fighting man, get a fighting woman.

—Lady Astor

BY THE TIME LADY ASTOR TURNED IN HER NOMINATION PAPERS and completed a packed week of campaigning, she had made some progress in refashioning her public persona, in building a solid base of womanly support, and in holding off those against her. Although still vulnerable to the vagaries of a testy and uncertain electorate, she was in a strong position to move forward in the final week. No one would say she was ready to be proclaimed a champion, but many would declare that she was a contender. She had demonstrated the fighting spirit she admired; she was "man enough for the job."

Undaunted by her early trials, she was prepared for another campaign round that promised both an increased pace and heightened dramatic tension. Her advance schedules, as well as those for the other candidates, indicated that the electorate could expect a series of frenetic activities. Isaac Foot, for example, announced 60 meetings, 24 on Monday. Astor's Coali-

tion campaign matched his 60 and Labour proclaimed 100. The high numbers included both candidate appearances and those meetings and rallies conducted on their behalf by their supporters. A typical day's program for each candidate usually included two dinner-hour meetings, one afternoon meeting for women, at least four evening meetings, often with overflows, numerous impromptu street gatherings, and quite often an appearance at a community event. One observer noted that "Plymouth's capacity for electioneering is extraordinary. It seems to grow as polling day approaches."[1]

Members of the press did their best to keep pace with the candidates, but after the confrontation with Lady Astor on 7 November, turned some of their attention away from her. This response may have been in compliance with the Astors' requests, may have been an attempt to restore balance in coverage, or it may have been an acknowledgement of the fact that Astor's opponents were indeed making significant gains. It also may have been a deliberate move to create a sense of drama and thus prompt intensified interest in the campaign.[2]

Football and fireworks dominated the weekend. Plymouth Argyle defeated Merthyr Town by three on Saturday afternoon, and that evening Gay's campaign made a major move to entice the electorate to his side by sponsoring a torchlight procession and a mass meeting. As the procession snaked its way through Sutton division's main streets, spectators noticed that it was headed by several figures holding aloft a large sack, a symbol indicating that the time had come to "Sack the Coalition." Behind them followed a large body of marchers who filled the crisp night air with music and the sounds of cries and tramping feet. Some carried Chinese lanterns, and at least two hundred held torches that eerily illuminated two headsmen's axes, presumably one for the execution of Lady Astor and the other for Isaac Foot.[3]

The procession ended at the Cosmopolitan Gymnasium, a large arena usually host to boxing matches, where participants joined five to six thousand others for a Labour mass meeting. The primary speaker was Ernest Bevin, a national organizer for the Dockers' Union, who was growing in importance as a trade-union official and Labour leader. In the 1918 general election, he stood for Central Bristol. He strongly identified with the working class population and was a popular speaker with them. Although "not . . . a great orator," he projected "a raw strength which compelled conviction." Speaking for Gay, he "rose to great heights of eloquence and at the end of his speech the audience rose en masse and cheered him again and again." Gay also spoke and in the process, abandoned "his more closely reasoned style" and developed "an oratorical power which carried his supporters into the higher levels." Others talked "Labour all the time," frequently

asking for money from either "wealthy capitalists" or "munificent million-aires" or taking up collections for the "fighting fund" from their own. The reporter for the *Daily Telegraph* found the event exciting and commented that a "Labour mass meeting has something infectious about it." Writers for the *Birmingham Post* and the *Northamptonshire Evening Telegraph* took a negative view, remarking that Gay had "too much of a revolutionary" tone, reflective of "the beliefs of the extreme wing of the Labour party." They were alarmed that he had suggested direct action to secure Labour demands and accused him of threatening the community with "tumult, disorder and bloodshed."[4]

The enthusiasm among Gay's followers spilled over to Sunday. They gathered on the North Quay to hear Bevin again and Mr. James Wignall, Labour MP, also affiliated with the Dockers. Lady Astor, the *Telegraph* reported, listened from the sidelines as a Coalition gathering had no chance. She was not unnoticed, however, as Gay's followers presented her with his leaflets and even asked her to "assist the collection."[5] The weekend, indeed, was Labour's.

During the early part of the next week, the focus of attention turned to an exchange of letters between Isaac Foot and Prime Minister Lloyd George that highlighted intraparty strife and produced some of the more eloquent lines in the campaign. The controversy began when Lloyd George issued a coupon on Lady Astor's behalf. The letter came out from 10 Downing Street and was dated 7 November 1919. Miss Cundy, Astor's secretary, passed it on for press release, and it appeared in the Monday papers, 10 November 1919. Lloyd George's letter not only offered the customary best wishes but also cited Astor's good deeds and social concerns. These details, used to justify Lloyd George's endorsement, also enhanced Lady Astor's motherly Lady Bountiful persona by referring to her wartime work:

> I further know the hard, devoted and unselfish work which you did . . . on behalf of the wounded, and how your house became a home for thousands of men stricken on the field of battle. I have seen many of the wounded who passed through Cliveden hospital and know the feelings of gratitude and affection which they feel for the tenderness and cheer which you brought them.[6]

He then followed these lines with the official blessing: "I, therefore, cordially recommend your candidature to the electors of Plymouth and trust they will return you at the head of the poll."[7]

The next evening, 11 November 1919, Isaac Foot fired off a reprimand to Lloyd George, apparently as an open letter designed for press publication.

The *Birmingham Post* said Foot's letter had been prompted by increasing Liberal support for Lady Astor and the fear that a deluge of coupons from all parties would sway the electorate to her side.[8] An examination of the letter shows that Foot was also highly agitated by the discovery that he had failed to receive the prime minister's approval for the second time.

Foot began his epistle by drawing attention to the letter Lloyd George had written for Lady Astor, and he specifically quoted Lloyd George's lines of endorsement. In what one headline writer called "A Significant Reminder," he then referred Lloyd George back to the words George had spoken to a Liberal gathering a year before—a proclamation in which Lloyd George had reconfirmed his Liberal faith:

> From the old leaders of Liberalism I learnt my faith. Even if I had the desire, I am too old now to change. I cannot leave Liberalism. I would quit this place tomorrow if I could not obtain the support of Liberals. Now is the great opportunity for Liberalism.[9]

In the succeeding paragraph, Foot emphasized how he, too, had preached the same Liberal doctrine and had "stood up" for Lloyd George when he had been "assailed . . . by those who are your present associates." But now, he said, when Lloyd George could "return" the favor, he urged "the electors to vote for the Unionist candidate."[10]

Challenging Lloyd George's behavior, Foot asked "whether you still regard yourself as a member of the Liberal party?" and reinforced the question with the echo: "We younger Liberals want to know where you stand with us? We have work to do and cannot wait." He concluded the letter with an allusion to Robert Browning's poem "The Lost Leader" and an affirmation of his own devotion to Liberalism:

> If you are with us, let us push on together; if you are not with us, we will read Browning's "Lost Leader" once again, and give ourselves with more devotion to the cause which is happily greater than any one man and more enduring than a single generation.[11]

The allusion to "The Lost Leader" (for those who read it "once again") brought to light the anger, bitterness, and regret Foot felt at the lack of loyalty on Lloyd George's part—indeed, it revealed him as a man betrayed. Betrayed he was, but not beaten. In his own testimonial to Liberalism that immediately followed, Foot led the reader to compare and contrast his statements with Lloyd George's pronouncements, both for Liberalism and

Astor. This act, in turn, drew the reader to the conclusion that Lloyd George, failing to practice what he preached, was a charlatan, someone whose name could indeed be crossed from the books: "Blot out his name then, record one lost soul more." In sum, Foot's letter glaringly exposed the division within the Liberal party, championed traditional party principles, and denounced Lloyd George.[12]

Lloyd George responded to Foot's letter immediately—but not directly—sending off his reply to the press as he said that was the manner Foot had chosen to address him. Dated 12 November, the letter was sent in time for the evening papers, but appeared more often in those published on the thirteenth. Lloyd George opened by saying that he had read Foot's letter "in regard to my Liberal principles" in the newspapers and then scolded Foot for being discourteous in not sending him a copy. Next, he plunged into a justification for continuing a unified and cooperative National government. He argued that a Coalition was best for the "disturbance consequent on the war" and that "renewing party strife . . . would be entirely contrary, alike to Liberal principles and to national interests." He supported his "deliberate judgment" by stating that the same view was taken by the Allies, France, and Italy, and "endorsed . . . by a majority of Liberals" in the 1918 election.[13]

After this defense, he turned his attention to Foot. He said that Foot, holding a contrary "opinion, . . . stood for the policy of renewal of party strife." He went on to refute Foot's charge that he'd been unfaithful to the Liberal party by making an analogous countercharge:

> You have no more justification for holding me unfaithful . . . because I believed that national unity could best be served by continuance of a National Government than I would have the right to deem you a traitor because you believed that the immediate renewal of party strife was more important than national unity.[14]

He ended his letter extolling the legislative program of his government and taking a closing shot at Foot: "Inasmuch as your letter came to me through the medium of the Press, I am communicating this reply to the newspapers."[15] Remarkably, Lloyd George defended his Coalition, his Liberalism, and himself without once referring to his coupon for Lady Astor, the precipitator of the uproar in the first place.[16]

Lady Astor noted the developing controversy between Foot and Lloyd George and commented upon it on the afternoon of 13 November when she addressed a women's meeting at St. James-the-Less Mission Hall. She said that she thought that Foot's taking on Lloyd George was "a reckless thing

to do" and supported Lloyd George's response to Foot—again asserting her belief that the work of reconstruction should be carried on by the Coalition "partnership" and stating that she was not "ashamed to stand as a representative of the government." She declared that "all except fools or prejudiced critics must admit that the Government's record of things actually done was magnificent." But then she qualified her remarks by noting that "their work was not yet finished," that "it took time to get back from war to peace conditions."[17]

This same viewpoint was reiterated by Mr. Cecil Beck, a prominent member of the Liberal party, who spoke for Lady Astor that evening. He contended that "under the Coalition," he had seen "reforms carried into law which he had never expected to see if he lived to be 80 under a system of party government." As evidence he cited one Coalition accomplishment after another but elaborated upon the Education Act and the extension of the franchise.[18]

United, Beck and Astor rallied around Lloyd George and bolstered his argument for the continuance of the Coalition. In doing so, they demonstrated that they thought he was no "Lost Leader" to the nation.

Foot, however, was adamant. He retaliated with a second letter to Lloyd George, rushing it to print in the *Western Evening Herald* on 12 November and passing out copies of it to the electorate on the thirteenth. He began by thanking Lloyd George for his reply and stating that he had not intended a "discourtesy" in "reading to the electors of Plymouth the letter I had already despatched to you." And then, implying a discourtesy on Lloyd George's part, he stated, "You have not replied to the questions I respectfully put to you."[19]

In the next paragraph, Foot attacked Lloyd George by commenting that the prime minister's references to France and Italy had been "disingenuous." The fact of the matter, he proceeded to point out, was that the French prime minister did not consider an election "until all the electors, particularly those who won the war, were in a position properly to exercise the franchise." Second, he insinuated that in calling for the 1918 election during the days of postwar euphoria, Lloyd George had not demonstrated statesmanlike behavior. He backed this comment by quoting Hammond's book on Charles James Fox: "A true statesman uses the sober moods of the people to guard against the hour of delirium." By contrast, he said, Lloyd George had "deliberately used the hour of delirium to obtain your docile majority and in so doing struck down many of your truest friends."[20]

Foot then switched to a defensive posture and denied Lloyd George's "misleading" charge that he was fostering party strife. He countered by stating that he was renewing the principles of Parliament that he thought

were corrupted when "indiscriminate support" was given to "all ministers." He reasserted his view that Coalition government weakens Parliament and strengthens "unwittingly perhaps, the advocates of direct action."[21]

He closed his letter by recalling the Liberal watchwords, "Peace, Retrenchment and Reform," and sarcastically reminding Lloyd George that when George had uttered them, he was not taken seriously by either Liberals or Conservatives: "You will, no doubt, remember quoting these old watchwords a few days ago, amidst the derisive amusement of your temporary friends."[22]

By using an alternating pattern of attack and defense as the primary rhetorical strategy in this second letter, Foot attempted to reestablish himself as a worthy young leader of the Liberals—certainly one more deserving of the Liberal vote than the Conservative-Unionist Lady Astor championed by the Coalitionist Lloyd George.

There is no indication that Lloyd George penned another reply to Foot, but Mrs. Lloyd George, who perhaps enacted his last word on the matter, alluded to the controversy when she spoke at Lady Astor's rallies on the final day of the campaign.[23]

Even though the Foot-Lloyd George controversy became the featured attraction early in the second week, Astor's activities did receive a fair share of press attention, but not all of it was favorable. There was much ado about her bouts with the hecklers and in addition, some accounts devoted to the troubles within her own party. As mentioned previously, Astor had some rough experiences at an open-air meeting at Coxside and at an evening meeting at Laira Green. Although she often scored against her hecklers at these events, the fact that she received so many interruptions probably prompted doubts among many potential voters. She also encountered outright hostility when she toured the constituency with Labour MP J. A. Seddon on 13 November. Seddon ran into constant interruptions which he described as "Leninism and Trotskyism in excelsis because it amounted to preventing him from exercising his right of free speech."[24]

At the same time Astor met fierce opposition from Labour, she also felt the nips of some backbiting from her own party. Ultra-Conservative Lionel Jacobs, who had considered running against her, complained that she was not the party's first choice but thrust upon them against their wishes: "I understand that the chairman . . . went to London for the purpose of asking Lord Astor's brother to stand. Instead of doing that he brought back Lady Astor without having invited Lord Astor's brother at all." Another Conservative thought she was not an appropriate candidate: "We say that neither a kind heart nor a coronet fits a woman to take her place in Parliament. And

from what we know of Lady Astor, she is more unfitted than most of her sex." A third party member unabashedly denounced her by repeating the leading tenet of "old fogeyism": "I cannot conceive of any circumstances under which I would vote for a woman to go to Parliament, and that I know to be the feeling of many of us."[25]

The cumulative effect of Gay's rallies, Foot's exchanges with Lloyd George, and Lady Astor's troubles with her hecklers and those in her own party was that she was losing ground while her opponents were gaining. Gay, obviously buoyed by the apparent turn of events in his favor, felt that his support was great enough that he predicted victory as early as 11 November. He even went so far as to forecast the results: Gay—12,300; Astor—10,150; Foot—7,020. The same day, Foot, who was much more cautious, ventured that "Saturday will bring a surprise." He based his judgment on successful meetings with dockers and fishermen in the Barbican and "the fact that I was born in the locality."[26]

The majority of the press, too, contributed to the sense of reversal in Astor's fortunes by turning from one scenario to another in describing the campaign.[27] At first, they had presented Astor as a front runner, capitalizing on her political opportunities and setting the pace for a vigorous campaign. Second, noting such problems as Lord Astor's gaffe and Lady Astor's confrontations, they moved to a drama in which she was portrayed as the faltering front runner, a candidate capable of being overtaken by either opponent or sprinting forth to regain the lead. By midweek they were dallying with the questions: "Will the front runner regain the lead?" " Will one of the underdogs pull ahead?"

Signs of a comeback in Astor's campaign began to appear on Wednesday, 12 November, came forth even more on the thirteenth, and were readily apparent on the final day of campaigning, the fourteenth. The writer for the *Express and Echo* reported that Astor "never had a doubt about being returned" and speculated that Gay's predictions would be wrong. He thought that "the lady candidate is gaining ground" and based his view upon her successes as a speaker: "Even among the most brilliant of the suffragettes in their most palmy days I never heard a woman speaker so capable of taking her own part on the platform."[28]

The reporter for the *Liverpool Courier* concurred. He thought that Gay and his Labour supporters were overly optimistic and had "deceived even themselves" in believing that victory was at hand. He said that "Lady Astor, despite the handicap of her sex," was "more than their match" and would "retain the seat for the Coalition against determined attacks both of Labour and Liberalism." And on the final day, the *Western Morning News* gave Lady

Astor editorial support. It appealed to Unionist voters not to abstain "on no better ground than that she is a woman" and warned that were Gay to be returned, constitutional government itself would be subverted and "the whole country" would be subjected "to the despotism of a disloyal trade union clique."[29]

When the last full day of campaigning arrived, Astor gave no indication that she was anything but confident. The woman who wanted to bound into Parliament had regained her stride. Certainly there was no one who would say it was a chagrined or weakened Lady Astor who spoke to packed houses at her two closing rallies.

AFTERNOON MEETING FOR WOMEN

Lady Astor held her last meeting for women at the Guildhall on Friday afternoon, 14 November. Even though the Guildhall was a large building, it was not big enough to accommodate the numbers who wished to attend. Those unable to get into the hall crushed into one of the two overflow meetings held in the courtyard by Lady Astor's supporters and waited to catch a few words from her upon her arrival and departure. In his attempt to assess the size of the crowd, the *Globe* reporter speculated that "every woman in Plymouth was there or in the neighborhood." The meeting, which probably did not last very long, had four distinct segments: 1) an introductory disturbance, 2) a short address by Lady Astor, 3) a series of complementing talks by her supporters, and 4) Lady Astor's response to a vote of confidence.[30]

Dr. Mabel Ramsay, a prominent Plymouth citizen known for her concerns with suffrage issues, chaired the meeting. After calling the gathering to order, she opened with the line, "We are going . . . to put in the first woman member of Parliament," and before she could catch her next breath, was interrupted by "a shrill voice" shouting "Never!" Unflustered, Dr. Ramsay waited for the resulting cacophony to die down and proceeded as before. She repeated that "they were going to send the first woman MP of England" and launched into her introduction of Lady Astor by setting the scene for concerted action. She told how they were all connected to each other. For example, she said that Lady Astor and she were linked by "ten years" service to Plymouth—Lady Astor by her participation in community charitable activities and she in "fighting for the women's vote." She commended Waldorf for his support of women's suffrage and recognized Mrs. Daymond, the Liberal who had just been elected to the Plymouth Town Council. She

felt that women now had an unexpected chance to send one of their own to Parliament and stated that they "should be ready to seize it." [31]

Lady Astor spoke next, but she faced an audience even more difficult than had Dr. Ramsay. At first, the women cheered "and cheered again," but as they quieted down, "several women burst out with loud cries of dissent" including the distinct "You're not going in!" from "one standing in the centre of an aisle and waving her hands in futile exasperation . . . " Others joined the shouting match, some agreeing with the opposing voices but more calling for the hecklers "to be put out." Astor kept a smile as she observed the erupting fracas and waited bravely for a second of calm. She then tried to break the tension with an ironic admonishment: "I sometimes think there are certain women who ought not to have the vote."[32]

Caught up short, audience members momentarily remembered their manners and all came together and cheered. Then, Lady Astor firmly began her reply to her challengers, "I hope . . . that every woman in this room understands I am going—" but was interrupted for the second time. And as before, her detractors were set upon by those who were for her.[33]

Another pause occurred and she tried again, "Oh, yes, I am going—" but was unable to complete her sentence as, for the third time, she was drowned out by "shouts of opposition and counter-cheers."[34]

On her fourth try—with great determination—she broke through the tumult: "Yes, I—*am*—going to the House of Commons." The audience then quieted and she delivered "her short speech in peace."[35]

Her remarks, bearing all the earmarks of impromptu speech, seemed unusually rambling and disordered. However, for those in the audience who knew of her past work or who were familiar with the rhetoric of the present campaign, her few words were a strong dose of the standard fare. She gave what was expected, reinforcing the persona she had been developing all along.

She said that going to the House of Commons was "a grave responsibility" and then attempted to relieve the remaining tension with a touch of humor. She quipped that she was "not going there as a sex candidate" and clarified her comment by adding, "We have had enough sex candidates, and they have all been the wrong sex." Then switching from the comic mode back to the serious, she reversed herself somewhat and stated that she thought women have not always "been quite fair to the men." She explained that men would reveal their best if women set high ideals and standards for them to follow. She reassured her audience that she intended to represent the "best in both men and women." She could not say that she would make Commons "a perfect House," but pointed out to her following that her presence there "would make a good deal of difference to legislation."[36]

She then jumped to take on those who had criticized her for her apparent frivolity. Relying upon the strategy of differentiation, she said that her "cheerfulness" had been misunderstood and expressed her own feeling that "she would not give twopence for a man or woman who could not be cheerful when on the right thing." She echoed earlier remarks in repeating that she "had had to give up a good deal to stand for Parliament," but figured that she was needed there because she was a "fearless" fighter for the "best." She concluded by guaranteeing her audience that even if she made mistakes, "her purpose was honest and ideals were high."[37]

Audience members applauded her three times during the speech and, as she finished, gave her another round of cheers. Afterwards, there were four other talks on her behalf—two from the featured speakers, Mrs. Lloyd George and Mrs. Alfred Lyttelton, and two from others in the area, Mr. Meadows, a South Wales miner, and Mrs. Barlow, a former prisoner of war. Each offered a number of good reasons for voting for Lady Astor.[38]

Mrs. Lloyd George spoke first. She began by recognizing her audience in favorable terms, recasting its members in a positive light after their trespasses during Ramsay's and Astor's opening lines. She said that "their presence . . . showed they appreciated the vote given them and were going to use it in a proper manner." She alluded to their shared purpose, "to return Lady Astor to the House of Commons with a big majority," and justified her support for Lady Astor in general terms. She argued that Parliament would better serve the nation if it had "a few women sprinkled amongst the men." She thought that they would be most useful in "shaping laws" relating to housing, education, and children. She expanded upon her thoughts concerning women in Parliament by setting forth her criteria for those who would serve: "A woman for Parliament must be first a wife, then a mother, and then a politician." She then stated the obvious—that Astor met these three essential qualifications. Approaching the end of her speech, she adopted a slightly warmer tone and told her audience that, "from personal knowledge," she "could assure them . . . that Lady Astor was a woman of clear and strong convictions and deep and sincere sympathy." She rounded off her address by referring to the Lloyd George-Isaac Foot controversy and repeated Lloyd George's line that it was not a time for party strife. She concluded by assessing all three candidates: "One was a good man, and the other one better, but Lady Astor was the best of all."[39]

After Mrs. Lloyd George had spoken, Mrs. Lyttelton, a close friend of Lady Astor, made her contribution. She, too, offered reasons why Lady Astor should be sent to Parliament. Her primary argument was that the present Coalition government, "now facing the tremendous and overwhelming

difficulties of the peace," needed the continuing support of the electorate. She then chastised those "of the old Liberal party" who had nothing to offer but "carping criticism." Kinder to those in the Labour party, she appealed for their vote by stating that Lady Astor would help carry out some of the best Labour schemes. She noted that Lady Astor had a "strong and passionate feeling" regarding the question of housing and would, when in Parliament, speak up for what women wanted.[40]

Mr. Meadows and Mrs. Barlow, whose brief addresses were not recorded, followed, and then Mrs. F. B. Wyatt "moved a vote of confidence." Mrs. Daymond, the new Liberal member of the Plymouth Town Council, seconded, expressing her hope that Lady Astor would not only be the first woman in Commons but also "the first woman Prime Minister of England."[41]

Lady Astor "rose to reply" to the vote of confidence but was again interrupted by a heckler who apparently badgered her about her American birth. As a result, Astor directed her response to her instead of to those in the general assembly. She repeated, as she had on numerous other occasions, that she was "not ashamed of my Virginia blood" and added that she had "the best British, and it is fighting British blood, too." Turning again to bravado as a rhetorical strategy, she went on to say that she was not "afraid of Mr. Gay or the whole Independent Labour Party." As a matter of fact, she "would meet the whole of the Independent Labour Party on Salisbury Plain because they cannot fight." Furthermore she thought the ILP stood "for personal abuse and class hatred"; they represented the "shirking classes," not "the working classes." Having squelched her last heckler for the afternoon, Lady Astor then left the Guildhall with Mrs. Lloyd George, guided by policemen through the overflow crowds in the courtyard who offered "cries of goodwill." The overall impression that lingered behind was of a fearless, courageous woman capable of meeting the trials of the moment and very much ready for those ahead.[42]

Over the dinner hour she attended a special meeting held by the men of the lower deck of the British navy. Shortly after 8:00 P.M. she returned to the Guildhall for the final public rally. By then, she was "hoarse with the efforts of the day," but did not give in to fatigue or exhaustion nor lose the smile "which had seldom come off during her strenuous campaign."[43]

FINAL RALLY

Entering the Guildhall, Lady Astor again found a large crowd waiting for her, filling "every corner, blocking the aisles and exits, overflowing into the

large courtyard." Her entourage included Lord Astor, her brother-in-law, Captain J. J. Astor, Mrs. Alfred Lyttlelton, and Lady Cynthia Curzon. Others who had come earlier to speak for her were Mr. Frank Hawker, chairman of the Plymouth Conservative and Unionist Association; Mrs. Lloyd George; F. G. Kelloway, Liberal MP; Lieutenant Commander C. Williams, MP; and Mr. Oswald Mosley, MP. Hawker presided at the meeting, and prior to Lady Astor's arrival, both Mrs. Lloyd George and F. G. Kelloway had spoken for her and on behalf of the Coalition government. Oswald Mosley was taking his turn when Lady Astor appeared, but he did not finish his remarks as the audience's attention immediately turned to her.[44]

Less faltering than in her afternoon appearance, Lady Astor opened with "I'm going in!" and did not receive any heckling but instead an overwhelming positive response. The *Globe* reporter said she spoke "amid loud rolling cheers" and that her audience "jumped to their feet and waved handkerchiefs and hands till the large hall was a sea of boisterous arms and waving hands."[45]

She then received a bouquet of flowers and began her remarks with the customary thank you. She said that she was grateful for the "friendships she had made at Plymouth" and then explained that she had not realized "what the joy of service was until she came to Plymouth," but that those there had "shown" her "the great heart of the West," adding again, "and for that I am grateful."

After praising her audience, she then shifted her focus to herself. Picking up on the verb "to see," she commented that "she had seen the tragedies of the poor and the difficulties of the middle classes" and that "she wanted to help." She then restated that she "was not out for a career." She reminded her audience, as she had before, that her motives were different from those of her opponents. She referred to her past record of wartime service and stated that in the future "she wanted to go to Parliament to fight the battle of the distressed." She qualified her remark by adding that "she did not over-estimate her ability," but then went on to earnestly assure her audience that "she had a good cause," that she was a "good fighter," and that she felt "confident they were going to victory."[46]

After her introductory remarks, Astor detailed her vision of victory as "another historic occasion for Plymouth." She developed her glimpse into the future by an extended nautical metaphor. First, she reminded her audience, that in another grand moment, Plymouth had "sent out Drake to fight for freedom." Then, in an analogy, she said that Plymouth was "now going to send out a woman to a great terrifying place called the House of Commons."[47] She implied that she felt as if she were a seafarer about "to sail

into the unknown sea." Though the House of Commons would be terrifying and the outcome of her journey there uncertain, she felt "prepared" for the adventure—supported by her audience's confidence and trust, divine help and guidance, and "above all" her own determination "to be a credit to the people of Plymouth."

She rounded off her sea reference by alluding to the men of the lower deck with whom she had met at the dinner-hour gathering held in her honor. They had applauded her for her wartime service, an effort that she said, "Any other woman in the audience would like to have done if she had had the chance."[48]

Astor's choice of the nautical metaphor was an appropriate one for the situation. It was consistent with her other views, and it allowed her to align herself with the fighting men in the navy. At the same time, it excluded Isaac Foot, the "Ancient Mariner," and William Gay, "the shirker" who hung out with the wild, longhaired radicals on the North Quay.[49]

Astor's employment of the archetypal nautical metaphor is also interesting because it combined the classical and romantic views of the sea, offering an outlook that was normally separated by traditional rhetoricians. On the one hand, Astor reflected the ancients' perception of the sea as a dangerous and threatening place. This classical view was best expressed by W. H. Auden: "[The sea represents] that state of barbaric vagueness and disorder out of which civilization has emerged and into which unless saved by gods and men, it is always liable to relapse."[50] Astor saw the House of Commons as "a great terrifying place" and perceived her move there as a "sail into the unknown sea." It would be a fearful journey, a venture that she did not feel she could embark upon alone. Thus she turned to God for "help and guidance" and to men for their "trust" and "confidence."

On the other hand, the romantic view also swept into Astor's metaphor. One notes, for example, that her reference to Drake was not to his struggles with natural phenomena but to his encounter with the Spanish Armada. Similarly, she admired those on the lower deck of the navy for their efforts in World War I. In Astor's conception, the sea's primary obstacles were manmade. They could be overcome with determination and courage. This view ties in with those medieval, Elizabethan, and later Romantic poets who saw the sea as a frightening place but nevertheless found themselves highly attracted to its challenges. They felt a strong individual, a heroic persona, was capable of surmounting the risks.[51]

Astor's combination, a melding of the classical and romantic, seems to be a characteristic one for those harbor folk who confront the sea on a daily basis and look upon it with both "enchantment" and "dread."[52] The citizens

of Plymouth, though certainly wary of the sea, had not yet given in to its perils. Astor, as she had said, wanted to be worthy of her adopted heritage.

Astor closed her speech by returning to her purpose and her audience. She repeated that she wanted "to go to Parliament to fight the battle of the oppressed." Next she mentioned that she hoped she had absorbed "a little of the courage and unselfishness and beauty which the men and women of England had shown in the last five years." And then, perhaps again thinking of the sacrifices they had made, she ended with several lines of prayer. She asked God for the Spirit of sacrifice so that she could serve "you, the people of Plymouth."[53]

After Lady Astor had finished, Lord Astor gave a short speech. As he had done on the night of Lady Astor's party Adoption speech, he said that he was giving of his best. But then, implying that Lady Astor would be playing the Warming Pan role, he explained that he wanted "to do away with the law" that prevented peers from standing for the House of Commons and expressed the hope that "by the next election" he would be able to come and reclaim his seat from his wife. Alluding to Lady Astor's afternoon remark, "We have had enough sex candidates, and they have all been the wrong sex," he wittily retorted, "I am in favour of abolishing sex qualifications. I am out to fight for the rights of my sex." Turning to a more serious mode, as Lady Astor had done in her reference to Drake, he linked the present moment to an historic occasion: "In the past Plymouth sent out the Pilgrim Fathers. Tomorrow I believe Plymouth is going to send in the first Pilgrim Mother."[54]

The final rally served as an all-encompassing consciousness-sustaining event. Lady Astor presented the various facets of her persona that had appealed to her audience throughout the campaign. In particular, one saw traces of both Lady Bountiful and the adventurous fighter who appeared when Astor shrouded herself in the mantle of manhood. Waldorf encapsulated the figure best when he called her "Pilgrim Mother." In the process of presenting her persona, Lady Astor also clearly revealed her values, letting her audience know that she was not tempted by political ambition but motivated instead by the desire for transcendence. She wanted to serve the people of Plymouth with "that Spirit which was willing to lay down its life for others."[55]

By offering this election-eve review of her best qualities, Lady Astor broadened her opportunity to identify with those in her audience whom she perceived as possessing great hearts, courage, unselfishness, and beauty— values that she either shared or hoped to share.

She then placed this community of like souls into a scene that linked the present moment with an historic past and a significant future. Over the

years Plymouth had witnessed the heroic deeds of Sir Francis Drake and the departure of the Pilgrims to the United States. Within the last five years, her citizens had taken part in the Great War. Now Plymouth would see a new pilgrim filled with the spirit of sacrifice who would devote herself to a noble cause in keeping with Plymouth's traditions. Astor responded to her vote of confidence at the end of the rally with the line, "We have got the right spirit, and we have the right cause, and if we do right tomorrow we shall be worthy of the men [sic] of Plymouth."[56]

The strength of Astor's final rally was that it brought together many of the important aspects of the campaign that preceded it. Astor was able to establish a new vision for the electorate by drawing upon and extending those mythic elements that had long been part of Plymouth's heritage. If attracted to it, then they would be willing to embrace her as their own and send her to Parliament. If the goal of a political rally is, as Cragan and Shields maintain, "to highlight the heroic persona of the candidate and pinpoint the important fantasy themes of the candidate's rhetoric," then Astor scored well on both counts.[57]

POLLING DAY

Saturday, 15 November, was an intensely cold day in Plymouth, but not cold enough to interfere with either polling day plans or activities. Lady Astor voted for herself at 9:00 A.M. and then set out to tour the division. Riding about in an open carriage driven by Churchward and accompanied by Lord Astor, she stopped to meet with those in street corner crowds and to encourage them to vote. Her women supporters not only expressed their good wishes, but showered her with offerings of good luck: "flowers, laurel wreaths, teddy bears, lucky black cat mascots, and silver horseshoes." She was trailed by the usual retinue of journalists and reporters and assisted by a "large number of workers and carriages and cars."[58]

Along the way, she met Isaac Foot who was touring in a carriage with three of his children. More than likely, Lady Astor also came across William Gay whose appearances were announced by J. J. Moses, the prospective Labour candidate for Devonport, who moved about Sutton's streets ringing a large bell and acting as a crier for him.[59]

The polls were open for twelve hours, and there were forty booths scattered about the fourteen districts. The *Daily Chronicle* reported that more women voted during the day, but predicted that "Labour's strength" would "be more apparent" that night "after the football matches." The *Daily Express*

reporter also noted a strong contingent of women voters and forecast a heavy poll with a 70 percent return. The *Guardian* writer said the "polling became more brisk at two," and "from four there was a steady and increasing flow." He thought the final result would be "abnormally heavy." Similarly, the *Times* calculated a 75 percent turnout.[60]

After the polls closed at eight, each candidate met briefly with gatherings of supporters. Foot, in coming close to a concession to Lady Astor, said that she "might be found at the top of the poll." He added that he "hoped Liberal principles had triumphed over the forces of reaction on the one side and semi-revolution on the other." William Gay, still extremely confident, told his followers that he felt "the support given to Labour . . . was without parallel in the west of England." Lady Astor proclaimed, "We have won the day!" And then, as she departed for her home on the Hoe, she shot out: "Now, my dears, I'm going back to one of my beautiful palaces to sit down in my coronet and do nothing, and when I roll forth in my car I'll splash you all with mud and look the other way."[61]

No one took her seriously; no one was supposed to do so. For Astor, the parting quip was a characteristic shift in mode and another plunge into self-deprecating humor. Though the outcome of the election was up in the air, and Astor could not be absolutely sure she would have the last laugh on her opponents, she typically chose to have one on herself.

Her remark was also an inside joke—a triple topical allusion to previous comments or slogans made during the course of the campaign. Astor's line, "I'm going back to one of my beautiful palaces" refers to one of Gay's handbills that had been plastered in public places around Plymouth:

> For the
> Idle Rich
> 'PALACES'
> for the workers
> 'wood huts'[62]

The idea that she would sit around in her coronet and "do nothing," picks up on the "Idle Rich" persona in Gay's depiction and also refers to the comment of the ultra-Conservative who had said that "neither a kind heart nor a coronet fits a woman to take her place in Parliament." Astor's assertion that in the future she would "roll forth in my car" and "splash you all with mud and look the other way" looks back to something she had heard at Gay's Labour rally on Sunday, 9 November, and had previously commented upon on the tenth. Then she had said, "I must tell you what was said about me last night. 'Lady Astor will kiss your

babies today, and splash them with mud tomorrow!"[63] If her ridicule here proved effective, that is, if her audience members caught on to her elliptical lines, then Astor's final witticism would eliminate her detractors as absurd and bind her supporters even closer together in this uncertain moment.

The reporter for the *London Mail* was hopeful. He filed his election night story as an epigram: "The Lady candidate for Plymouth aspires to be one feminine star of the Parliamentary stage and the electors seem ready to take the Astor-risk."[64]

INTERLUDE

Unlike present day elections when one learns the results immediately after closing of the polls, the 1919 Plymouth by-election required a waiting period of nearly two weeks. This was not an unusual circumstance as the same recess occurred in the other by-elections. The delay was caused by the need to wait for the ballots containing the servicemen's votes.[65] During this interim period, both those in the press and Parliament speculated anew about the impact Lady Astor might have were she to be elected. The Astors, too, made plans for the future.

The *Daily Sketch*, presenting a long-term view, was not very positive. The writer did not think that Lady Astor would make "a lot of difference" to the women's cause. He said that it had needed a boosting since it had secured the right to vote and, at present, suffered with "no leaders, no programme, no party fund, no press."[66] He did not believe Lady Astor capable of providing the leadership required.

He lamented that it was "a thousand pities" because he felt woman's voice could be a "driving power for reforms" in areas relating to "the absolute equality of the sexes, the improved status of married women, the endowment of mother-hood, housing and domestic service [and] education." Instead of Lady Astor, he thought a "thrifty housewife" whom he idealized could better serve Parliament:

> Her power of economy, of making ends meet; her home-making instincts and her knowledge of children; her gentleness and forgive-ness; her horror of violence; her love of peace, of an ordered, steady, settled life; the maid's idealism and the mother's vision—is it not the balm that shall heal the wounds of a world sore-stricken?[67]

When he did offer some hope for Lady Astor, he remarked that she might succeed in breaking down "the prejudice that so far kept women out of Parliament."[68]

Many others considered the immediate effect of an Astor victory and foresaw impending doom. They feared that Astor's entrance would upset the tradition of Parliament as a "men's only" institution. Some declared that it would be an outright intrusion. They quivered at the thought she might step into the downstairs smoking room. Others quaked at the constraints she might place upon their rhetorical choices. Reporters observed that MPs were "revising" their story collections in "view of her arrival" and already glancing "warily around before telling that latest yarn from the golf club." Some others wondered what would happen to the ordinary terms of address and tried to figure out what the King would say during his annual speech to Parliament. His usual opening, "My lords and gentlemen of the House of Commons," would have to be altered. And Lord Hugh Cecil, although Astor's friend, "made no secret of the fact" that he felt she would deliver "a destructive blow . . . against parliamentary oratory," remarking that "the eloquence of Pitt, Sheridan, Burke, Gladstone and Disraeli was not intended for women."[69]

But most of all, politicians and pressmen fretted about the fate of the parliamentary hat. They not only wondered about what kind of head covering Lady Astor might choose but which hat rules would or would not apply to her within the House of Commons. Men had usually worn silk top hats, but in recent years, several ventured to try other toppings. John Burns, for example, had introduced a soft hat and Will Crooks had shocked everyone by wearing "a sort of sombrero."[70]

Parliamentary customs regarding the hat required that upon entering the House of Commons, the MP was to take off his hat and remain hatless until seated. If the MP then wished to make a motion or raise a point of order, he then put on his hat because parliamentary rule required him to be "sitting and covered." If, however, he chose to rise and speak to the motion, he was again to remove his hat.[71]

Astor's possible move into the House of Commons posed a problem because, at the time, a woman's hat was designed to be held securely in place with a hat pin—not to be easily doffed at will.[72] No doubt Lady Astor would be inconvenienced; similarly, other MPs would find a brief delay in parliamentary proceedings.

The British press and MPs fussed about the matter until the Speaker of the House Lowther ruled "that all the complicated hat protocol was to be waived for women members." An American reporter, Hayden Church of the *Buffalo Express*, remarked that after the ruling, "a weight, approximately that of the houses of parliament themselves, was removed from the fevered brain of the nation."[73]

At the same time speculators imagined life in the House of Commons after a female invasion, Waldorf Astor imagined it after his own return. He took steps to follow through on an attempt to change the law so that the sons of peers sitting in the House of Commons would not have to vacate their seats when succeeding to the title. He had mentioned his plan several times before the campaign began and spoke about it with considerable feeling when he endorsed Lady Astor on 4 November. Then, he had said that "he was going to do all he could to try to get back . . . perhaps at the next general election." He added that he did not want titles and that he would "rather be Mr. Astor" and take his "chance of being . . . a representative in the House of Commons than have a safe seat in the House of Lords." The following week he again mentioned his effort to change the ruling, this time at Plymouth's Lord Mayor's Banquet. Replying to Isaac Foot's toast, "Some men are born to peerages, some achieve peerages, and some have peerages thrust upon them," Waldorf snapped that there was a fourth class—"those who were trying to get rid of them."[74]

On 13 November, just as Lady Astor's campaign was drawing to a close, he announced that a Private Member's Bill that would obviate the necessity of his taking his seat in the House of Lords, would be brought to the Commons by Sir Joseph Davies (Liberal) and J. H. Thomas (Labour). The fact that the bill would be brought in by J. H. Thomas, leader of the railwaymen (NUR), caused some surprise as championing a lord seemed incongruous with his normal political role. Yet, his sponsorship did not seem so unusual since he was a good friend of both Astors and even lived in a cottage on their Cliveden estate.[75]

The debate (First Reading) in the House of Commons began around 4:00 P.M. on Wednesday, 26 November 1919. Mr. Thomas asked to introduce a "Bill to empower his Majesty to accept a surrender of any Peerage." He discussed the historical background of the measure and mentioned several test cases. He presented part of his proposal (Clause 1) and pointed out that it differed from the 1895 bill brought forth by Lord Selborne. Selborne's bill had allowed peers to sit in the House of Commons but did not take away other privileges. Thomas's Peerage (Surrender) Bill, by contrast, required that a peer surrender all of his rights and "privileges attaching" to membership of "the other House" and prevented him from having "the best of both worlds."[76]

Thomas briefly argued for his bill on the grounds that it did not force one into the Lords nor did it deprive a constituency of a trusted representative. He closed by saying that his bill would give a peer "the ordinary

privileges of humble citizenship" and allow him "to serve his country . . . in the manner he thinks best to do so."[77]

Edward Wood (the future Lord Halifax) opposed. He opened by expressing his own reluctance to speak out. He said that he did not want to oppose Thomas and wryly commented that he hoped Thomas would "go down to posterity as a constitutional lawyer and as a protector of peers." He explained that his own circumstances were the same as Waldorf's had been and that he had "every personal ground for trying to take the opposite view . . ."[78]

He then moved into his argument against J. H. Thomas's proposal. He claimed that the Peerage (Surrender) Bill would be harmful because it would weaken the House of Lords. Furthermore, he thought that at the moment it was not an appropriate move for the House to consider because it was not right to discuss a constitutional issue under the guise of a personal case or to do so in piecemeal fashion. When he had finished, the House voted against Thomas's bill, dividing "Ayes: 56; Noes: 169." The whole matter was settled in about ten minutes.[79]

Lady Astor's activities were not extensively covered at this time. She returned to Cliveden on 16 November, the Sunday after Polling Day. She rested, spent time with her children, and made plans for a round of holiday gatherings and entertainments. Perhaps she even gave some thought to her parliamentary attire.

COUNTING DAY

Two days after she learned that Waldorf would indeed be serving in the House of Lords, Lady Astor returned to Plymouth to find out what her own fortunes would be. Waldorf and their oldest son, William Waldorf (Bill), age twelve, accompanied her.[80]

The counting of the ballots took place at the Guildhall under the supervision of the Town Clerk, Mr. Fittall. The process was open to view as press reports indicated that scrutineers for each candidate and some members of the press were able to observe. After an initial sorting, the tellers divided the ballots among three tables and, even before an announcement was made, one could see by "the mountain of ballot papers" on the first table that Lady Astor would be the victor.[81]

Lady Astor arrived with Waldorf and Bill shortly before noon. She carried "a large bouquet of roses and chrysanthemums," a gift from the

women in the Primrose League, and received "a horseshoe mascot decorated with the Coalition tricolor" (red, white, and blue) from Lady Cynthia Curzon who had acted as one of her scrutineers. While the counting continued, she paced about and visited with Isaac Foot and William Gay.[82]

About an hour later, Waldorf quietly told her, "You have a majority over the other two." More demonstrative than his father, Bill gave his mother a "hearty kiss of congratulation" and then, in a somewhat surprising, but not unnatural, move, pulled some "sandwiches from his pocket" and told her that he had been saving his lunch until he knew she was in. Others congratulated her and asked, "How does it feel to be an MP?" She replied, "I feel that I have been over the top, and it was not so bad when I got there."[83]

The Town Clerk then gathered the candidates together and announced the results. All moved on outside to hear him make a public statement to the vast crowd waiting in the square in front of the Guildhall:

Viscountess Astor (Coalition Unionist) ———	14,495
Mr. W. T. Gay (Labour)———————	9,292
Mr. Isaac Foot (Liberal) —————————	4,139
Majority ————————————————	5,203

He then followed with, "I have, therefore, to declare Viscountess Astor duly elected as Member of Parliament for the Sutton division of Plymouth."[84]

At the moment, a ten-year old boy from Cornwall was riding in a tramcar down Old Town Street. Years later he recalled that he and the other passengers heard, above the noise of the tram itself, a "roll of cheering ahead," and remembered that the conductor had exclaimed, "She's in!" The multitude cheered not only for Astor but also in response to her calls for cheers for her opponents.[85]

When the clamor subsided, the Astors moved through the throng to their carriage for a trip to the Unionist Club. Jubilant supporters, "unharnessed the horses and dragged" the carriage themselves. At the Unionist Club, the Astors were greeted by more well-wishers both inside and outside. Lady Astor gave short speeches to both. She repeated her intent to serve women and children and ended with a reference to her own family: "I ought to feel sorry for Mr. Foot and Mr. Gay, but I don't. The only one I feel sorry for is the poor old Viscount here." The *Daily Express* reported that Bill also stepped forward on the balcony to say a few words, his own debut into the political arena: "I saw you elect Daddy. Now I have seen you elect Mother, and I want to thank you for both." The Astors then

toured the constituency—a triumphal journey that lasted until ten that evening.[86]

Before the day's end, both Lord and Lady Astor spoke with a reporter for the *Daily Express*. Lady Astor told him that the Speaker of the House had said she could do as she liked as far as a hat was concerned. She added that she intended to "dress most simply in the House of Commons" and would "never wear evening dress there." She explained that she felt "strongly on this subject, unimportant though it seems," as she was thinking ahead to the "other women who will follow me to the House—working women, perhaps, who are dependent on their 400 pounds a year." She did "not want to make it difficult" for others "to come after" her. Lord Astor mentioned that their plans were to return to town over the weekend and that Prime Minister Lloyd George and ex-Prime Minister Arthur Balfour would introduce her to the House on Monday, 1 December.[87]

On Saturday, Lady Astor spoke to a large gathering of dockyard employees in the neighboring division of Devonport. She urged them to accept a shortened week while the government tried to establish new work for the dockyards. She argued that a request for full employment for some would bring discharges for others and as a result, force hardships upon women and children and stir revolutionary discontent among those unemployed.[88]

On Sunday, 30 November, the Astors departed for Cliveden and two more spontaneous celebrations of victory that occurred along the way. Even though she and Waldorf had kept their arrival and departure times secret, there was a crowd of women, mostly "old suffragettes and their young admirers," waiting to meet them at London's Paddington Station where they changed trains to go on to Cliveden. One of the women, an earlier champion for women's rights who may have been among those arrested, imprisoned, and forcibly fed during a hunger strike, gave her a badge. She then told Lady Astor, "It is the beginning of our era. I am glad I have suffered for this." Lady Astor then clasped her weathered hands into her own, and the bond was made. Although this ceremonious moment was without pageantry, the ritual marked Astor's formal adoption by those female activists who had preceded her in a long struggle for political recognition.[89]

A short while later, the Astors, coming by car from the local train station, pulled into the driveway at Cliveden and were stopped by a crowd of tenants, gardeners, and servants. They persuaded them to get out of their automobile and climb into an "old Victoria carriage" which the men yoked to themselves for the ride up the driveway—past bonfires blazing in the cold November air.[90]

THE HOUSE OF COMMONS

The news of Astor's victory prompted a flurry of activity in London. Constance Markievicz was in town over the weekend, and her visit aroused speculation that she would upstage Astor's entrance by taking her own seat in the House of Commons. She further alarmed MPs who thought she would upset parliamentary balance by bringing the troop of Irish MPs with her. On Sunday she allayed their fears by departing for Manchester to address a Sinn Fein meeting. There was also a rush for gallery tickets for Monday's parliamentary session with the demand far exceeding the supply.[91] Women, especially, wanted to be on hand for what promised to be a milestone event.

As it turned out, Lady Astor's debut filled all the nonmember galleries. Witnesses included "a score or two of peers"; the U.S. ambassador; Waldorf; three of Nancy's children, Bobbie Shaw, Bill, and David; her sisters Phyllis and Nora; members of the press, adding, for the first time, two women journalists; and "as many ladies as could be accommodated in their own and the ordinary galleries." A *Guardian* reporter, in surveying the scene, also noted, "last and decidedly least a favoured minority of the once privileged sex."[92]

However, the announcement of Lady Astor's appearance did not pack the House with MPs, and it was described as "full, yet far from overflowing." As far as many of them were concerned, the principal item on the agenda was the debate on Horatio Bottomley's bill on premium bonds. It was a scheme for government finance that many felt was akin to gambling. His proposal was vigorously opposed by Chancellor of the Exchequer Austen Chamberlain, and a division on the bill would come that day.[93]

Lady Astor, having come down from Cliveden to 4 St. James, her London residence, went over to the House of Commons around 10:00 A.M., well before the 2:30 P.M. session would begin. Waldorf accompanied her and introduced her to the Sergeant of Arms who helped her select her seat. Waldorf probably coached her on the afternoon's procedure and helped her with a brief rehearsal. Reporters noted that when she did enter the House, she seemed poised and self-assured while her escorts, Lloyd George and Arthur Balfour, were seen to be "distinctly self-conscious and the least bit schoolboyish about it all."[94] After the morning visit, the Astors left.

In the afternoon, Lady Astor avoided the waiting crowds by returning about 3:00 P.M. and slipped in through the Members' entrance. Those who did happen to catch a glimpse of her noticed that she was wearing a black coat and skirt with a white blouse open at the collar and with white cuffs on the sleeves. She carried no handbag but held a small blue piece of paper, her election writ, in one of her white-gloved hands. Her hat, fitted neatly on her

head, was "a crown-shaped toque of black velvet." One of her biographers, Christopher Sykes, said that her clothes, though simple, were "beautifully cut." However, a contemporary, Genevieve Parkhurst, writing for the *Ladies Home Journal,* said it was a surprise to many "that she was so very plainly gowned. There was nothing smart about her attire. Her suit had seen wear and it did not look as if it had come from a fashionable tailor." Whether tacky or tailored, she was neat, trim, and obviously pretty. Certainly she was a pleasant contrast to the "blatant and bloomered" figure the cartoonist Linley Sambourne had imagined as Parliament's first woman thirty-five years previous.[95]

A half hour later, Lady Astor called at the Government Whip's Room and then crossed to the door of the House. Conservative members Commander Eyres Monsell and her brother-in-law, Colonel Spender Clay, accompanied her. They stayed in the antechamber until the end of question time, awaiting the call from the Speaker of the House: "Members desirous of taking their seats will come to the table." Her turn would be second as Sir Allen Smith, winner of the by-election at Croydon, would precede her.[96] Her escorts, Lloyd George and Arthur Balfour, joined her at 3:45 P.M.

When the moment arrived for their promenade down the center aisle to the table, Lloyd George took his place on Astor's left and Balfour on her right. Without waiting for the others, Lloyd George forged ahead and then had to step back—a false start that drew a laugh from observing MPs. A few seconds later, he brought forth additional smiles and titters when he missed a cue on one of the three required bows to the Speaker, and Lady Astor audibly remarked, "George, you forgot to bow."[97]

Laughter gave way to "Hear! Hear!" when the three were halfway up the floor. The *Guardian* reporter said that the applause lacked its usual sound of "one-sided party triumph," but was instead "sustained on a note of single-toned cordiality which might have been designed as a greeting to the new age."[98]

Lloyd George and Arthur Balfour continued to escort Astor to the table where the Clerk of the House, Sir Courtney Ilbert, met her. Then they stepped back to the Front Bench. Astor in turn gave her election writ to the Clerk, who administered the oath.[99]

The next step was to sign the roll, and there was a pause while Sir Ilbert readied the book. During this brief moment, Lady Astor turned for a word with her friends in the Front Bench, Lloyd George, Bonar Law, and Austen Chamberlain. A Labour MP then called out to Lloyd George that he might be next to "lose his job." Others feared that Astor might go down and greet all those on the Front Bench—bringing even more informality to the occasion, but the clerk then intervened and had her sign the roll. Astor next followed protocol and moved to shake hands with the Speaker. She went

out the exit behind his chair and was met by Robert Cecil, the MP who, a year earlier, had moved the resolution permitting women to sit in the House of Commons.[100]

Lady Astor then returned by a side entrance and took a corner seat on the second bench below the gangway on the Opposition side. It was normally occupied by William Joynson Hicks, who at the time was in India. The *Manchester Guardian* identified it as "Mr. Healy's old corner place." Mrs. Lloyd George revealed that the seat had also been occupied by her husband: "Congratulations!!! You did splendidly. I tried to wave at you but I don't think you saw me. You sat in my husband's old seat. He sat there for 16 years. Good luck and love."[101]

The first woman to take her seat in the British House of Commons did not sit still very long. She soon turned to converse with those near her, Mr. Devlin, Mr. MacVeagh, and Mr. J. H. Thomas. Occasionally she listened to Mr. Bottomley who stood before her arguing in favor of his bill promoting premium bonds. But Lady Astor's mind was already made up, and when the House divided, she voted with Chamberlain against him.[102]

That evening she gave a dinner party in the House of Commons. She invited "Lloyd George and his ministers, the leaders of the opposition," and other guests. Afterwards she did not go into the smoking room but returned to House before the end of the day's session. On her way out, she stopped to chat with Sir John Rees before stepping over the bar. She was called to order by the Speaker, but did not recognize that his "Order! Order!" was intended for her and kept on with her conversation.[103] When she was called to order a second time, Sir John explained to her that "to stop on the floor of the House and converse on the sanctified side of the bar during a session was a grave offense." She then skipped over the line and out the door. It was the first time Lady Astor was to be called to order by the Speaker—and far from the last.

REFLECTIONS

Lady Astor entered a Parliament faced with the challenges of reconstruction after five years of a war that had devastated the lives of many and led to considerable social upheaval. Therefore, it was not surprising that her mailbag contained numerous requests for help—estimated at 500 letters every day during December and dropping to 200 daily by mid-February. She summarized their contents by stating that her correspondents had asked her to take up over twenty social crusades. She said that most of these

crusades related to domestic concerns, many related to women and children. Her list, printed in both the *Daily Mirror* and *Daily News* contained the following matters.

> (1)Adoption of Children, 2) Care of the Blind, 3) Infant Welfare and Maternity, 4) Labour Conditions of Women, 5) Divorce Law Reform, 6) Drink, 7) Education, 8) Food Prices, 9) Equal Guardianship of Children, 10) Health and Sanitation, 11) Housing, 12) Hospitals, 13) Illegitimate Children and Their Mothers, 14) Income Tax Hardships, 15) Marriage Laws, 16) Endowment of Motherhood, 17) Penal Reform, 18) Pension Hardships, 20) Social Purity, 21) Tuberculosis, 22) Unemployment, 23) International politics, including Ireland, Poland, India and the League of Nations.[104]

The main proposal, brought forth to other MPs as well as Astor, was to extend the "female franchise from 30 to 21 so as to equalise the privilege for both sexes." Similarly, many MPs found themselves bombarded with demands "affecting the position of women before the law" and their desires for "equal opportunity of employment."[105]

In a speech to large and enthusiastic audience on 10 February 1920, Lady Astor implied that she had received so many requests for assistance because these matters of concern had been neglected for so long. She said that women were needed in Parliament and "should be" there because "men cannot realize the human side." And then, posing and answering her rhetorical question, she added, "Why should they? From the day they are born we women try to protect them, and quite rightly, because they are the weaker sex."[106]

Lady Astor's mailbag also contained an extraordinary number of congratulatory messages—not only from those who knew her personally but also from those who had canvassed on her behalf or identified themselves as strangers to her. These notes and letters expressed the hopes and satisfactions of Lady Astor's well-wishers and gave her an excellent opportunity to reflect upon her campaign successes.[107] However, before a discussion of these letters takes place, it is appropriate at this point to backtrack and look at several other assessments of the campaign.

Lady Astor herself had given some thought to her achievements. She stated that her victory began with the "spadework" of ten years' community service while living in Plymouth. She also felt that those in the electorate wanted Waldorf's good works and those of the Coalition to continue. She stated that the electors did "not want to go back to the old party labels

and party politics." She thought that they seconded her support of the Coalition but understood her independence, her refusal to be "tied to anybody's apron strings."[108]

Turning to some of the proposals brought forth in her campaign, she thought the electorate had been impressed by her overall commitment to "progress without waste," and her particular stands relating to "improved maternity services, better education, better factory conditions and better homes." In addition, she believed that her voters saw her as one who represented a hopeful future. They felt she would present the "woman's viewpoint" and promote programs beneficial to women and children. They thought she would tend to the "practical national housekeeping" that needed to be done, particularly the needs to "reconstitute . . . industrial organization," to "increase . . . exports," to "re-establish a sense of security," and to "bring down the cost of living." She implied that the electorate may have also been attracted to some of her personal qualities. Identifying with all women and using the inclusive "we," she focused upon women's spiri- tuality, their practical nature, their abundance of "common sense," and their willingness to confess a mistake. She said women are "the first to acknowledge when we are wrong" and, citing the Bible, referred to Eve as the "precedent."[109]

In singling out a particular body of supporters, Astor pointed to the "men of the lower deck" as those who probably contributed most to her victory in Plymouth Sutton:

> I had to contend against the prejudice which undoubtedly exists among many of the opposite sex. I believe it was the wonderful, touching support from the navy lower deck which steadied and rallied the waverers, overcame the doubters and brought me victory.[110]

Mrs. Alfred Lyttelton, Astor's great friend, reinforced some of Lady Astor's views in an article she wrote sometime after the election. She, too, thought those "men of the lower deck" had been an important group in helping Lady Astor achieve victory. She talked about the tribute these men had paid to Nancy, thanking her "for what she had done to help them in getting their grievances before the public."[111]

Lyttelton also stated that Astor's spadework had been an important factor in her appeal to the voters. She wrote:

> Nancy Astor got in for Sutton Division of Plymouth because she is loved there, because during ten years she has worked for the good of

the town and the people, and the people know her heart. That is why they elected her.[112]

Finally she summarized Astor's campaign effort in her own words of appreciation: "Nancy Astor has got back from Plymouth what she has given to it. That is the explanation of her election."[113]

Even though Lady Astor's and Mrs. Lyttelton's comments upon the campaign were perceptive, the letters Lady Astor received at the beginning of her parliamentary career were even more revealing. These letters demonstrated that Astor had struck a responsive chord among voters and observers in a variety of ways. They showed that the rhetorical strategies Astor had used in her campaign had proved to be unusually effective, particularly in developing an identifiable political persona and in building a community of support among women and their sympathizers.[114]

A prior section of this work, "The Problem of Prior Personas," discussed the various problems Lady Astor had with the Gibson Girl, Pussyfoot, Warming Pan, Lady Bountiful, and Hustler, and pointed out how Lady Astor revamped these personas in order to emerge as Pilgrim Mother: a universal archetype more venturesome and less meddlesome than her predecessor Lady Bountiful. An analysis of a sample of Lady Astor's congratulatory letters disclosed that her correspondents were highly receptive to this figure. Nearly thirty percent of those who wrote indicated that they were attracted to Astor as a combination Lady Bountiful Mother figure. They saw her as a nurturing soul caring for children, nursing the wounded, championing the poor and oppressed. For example, C. R. Davis wrote, "Once more the truth is brought home to us that 'the hand that rocks the cradle rules the world.'" In another case, S. Annie Evans, a young widow, told that she "eagerly" followed Astor's campaign and made "quite a rush for the daily papers" to look for her photographs and speeches. Her interest, she said, had been sparked by her brother, Harry Coggins, who, before he died, had "simply worshipped" Astor while a patient at Cliveden hospital.[115]

Ruth D. Hansard, who identified herself as the granddaughter-in-law of the printer of 'Hansard' (House of Commons Debates), congratulated Astor on her "undertaking" and expressed hope that she would "not find it disagreeable." She added that "We sadly want some one to look into the gov't of my poor country." She talked about her own service in two wars and that formerly given by her deceased husband. She complained about her limited pension and lamented that her country did not give back to those who had aided it.[116]

Other heartfelt letters came from Plymouth residents thanking Lady Astor for her personal kindnesses and charities.

Fourteen percent of those correspondents sampled indicated that they had been drawn to Lady Astor because she was a Pilgrim. Mary Collins, for example, addressed Astor as "Plymouth Mother," but identified them both as "pioneers":

> Another reason why I feel I must write to you sympathetically is that I am also a woman pioneer in my own way and know something of the effort which pioneering costs. I am one of the first two women students at New College, Hampstead, which is one of the Theological Colleges of London University and we are qualifying for the ordained ministry of the Congregational Church.[117]

She then went on to express the hope that Lady Astor would "do a great deal for the Kingdom of God," devoting herself to the "causes of Peace in the world and of the Christian home, the fount of true morality everywhere."[118]

Several other writers felt that Astor, as Pilgrim, would also usher in a new age. "The Fathers," the shop stewards of the composing and reading staffs of the *Observer*, wrote: "You have achieved a notable triumph in the political world, but you have done more, you have heralded the dawn of a brighter day in our island history." Similarly Amy Goddard stated, "Your entry into Parliament will herald a new Era in our country."[119]

One-fifth of Astor's writers responded with great joy to her promise that she would represent the woman's point of view. Most of these identified themselves as "old suffragettes," "suffragists," or "former suffrage workers," and proclaimed in one way or another that Astor was a dream fulfilled.[120] They believed that her entrance into the House of Commons was the day they had longed for, battled for, suffered for.

Most touching was a letter from Mrs. Letherbrow of Moorbeck Buxton who, at 89, said she was "the oldest suffragette in England." She told Astor how she became interested in women's rights as "an unhappy and romantic girl of 19," but had been "pronounced insane by a jury of matrons" who had told her "a woman's sphere was the kitchen and nursery." She felt that now, 70 years later, Astor had won "the fight" and that with her arrival in Parliament, she would "do something for us." She concluded by saying that this hope was "the earnest prayer of an old suffragette."[121]

Additional writers, comprising smaller percentages of the total sampled, disclosed what they thought were other appealing aspects of Astor's persona: her reflection of Christian values, her fighting spirit, and her

straight talk, especially that employed in toppling hecklers. Mrs. Clibborn told Lady Astor that she recalled "your speeches with much interest and admired your candour and plain speaking with your audiences." Florence Bateman, who had worked as a canvasser for Lady Astor, wrote that she thought Lady Astor had been "a brave soul to give smiles for curses as it were." Arthur Lisk said that he would remember "the way in which you stopped you carriage 'dead' at Gay's Committee Room . . . on Polling night, waved the colours and shouted: 'Work for the workers and not the shirkers.'" He then exclaimed, "What grit you had and in the hotbed of Labour."[122]

All of the letters subjected to analysis indicated that the correspondents had taken Astor most seriously. Only two writers seemed somewhat lighthearted in tone. One person wrote to say that she had found Lady Astor to be a "charmingly clever woman," but indicated that such qualities were political assets, not liabilities. Another, also serious, took to rhyme in expressing her thoughts, penning a poem titled "America's Daughter."[123]

The letters Astor received also provided sufficient and clear evidence that she had built a strong community of support among women and those males in sympathy with them. Of those who wrote and clearly signed their names or positively identified themselves, 64 percent were women. Of all correspondents sampled, 63 percent subscribed to one female vision, Pilgrim Mother, or the other, suffragist. As one vision was perceived to be more traditional than the other, the interesting fact here is that Lady Astor bridged the gap between them.[124] Even more interesting is that a large number of letters came from those who lived outside the boundaries of Plymouth Sutton—an indication, perhaps, that Astor had been building or was building upon a second constituency of women.

Overall, Astor's collection of congratulatory mail testified to the power of her rhetorical endeavors. These letters show that, in spite of frequent attempts by the press to pick up on the cleverness of her "Astorisms," the drama of her confrontational episodes with her opponents and hecklers, and later moves by antifeminists and frightened MPs to trivialize her efforts, Lady Astor had a tremendous impact upon women and those males in sympathy with them. During her campaign, she was successful in sustaining the consciousness among older suffragists, raising the consciousness of many in the electorate, both in her division and outside it, and in creating a consciousness among female aspirants willing to follow in her footsteps. She was fully aware that she would be setting a precedent, that as trailblazer, pioneer, pilgrim, she had to lead so it would be possible for others to follow. She proclaimed, "I've got to make good!"[125]

Indeed, Lady Astor did "make good" in her first campaign in Plymouth Sutton, November 1919. Although she had political and economic advantages, her primary strength lay in her rhetorical skills, which she effectively utilized. She developed an identifiable public persona; she created a supporting community of followers; she overcame the challenges posed by her opponents, an unruly band of hecklers, and a demanding press.

Not only did she win in 1919, but she went on to claim victory in six more elections. Her winning campaign formula brought her to success in November 1922, December 1923, October 1924, May 1929, October 1931, and November 1935. Taking her place on the backbenches of the House of Commons, she served under Prime Ministers David Lloyd George (Liberal/ Coalition), Bonar Law (Conservative), Stanley Baldwin (Conservative), Ramsay MacDonald (Labour/National), Neville Chamberlain (National), and Winston Churchill (National). She represented Plymouth Sutton for 25 years.

WOMAN
IN THE HOUSE

When ladies seek to be M.P.s
And in the House to frisk
They may be 'stars,' but still it is
A kind of Astor-risk[1]
—Winning Post

LADY ASTOR'S COMMUNICATIVE SKILLS proved to be a tremendous asset during her first campaign and those that followed, but they did not always lead to her success when she spoke in different settings or faced audiences other than those in Plymouth Sutton. In her first term of office, she had trouble adapting to her House of Commons audience and they in turn to her. She did much better when facing female audiences or those mixed audiences in a wider arena, especially those in her home country, the United States. In later years, her rhetorical powers declined both within Parliament and without.

She had considerable problems in dealing with matters of foreign policy and often found herself on the controversial side of an issue and subject to criticism by both colleagues and members of the press. In the end, the only way she could extricate herself from personal scandal was by enactment, moving from words to deeds.

THE FIRST TERM (1919-1922)

Much to everyone's surprise, Lady Astor's initial weeks in Parliament were relatively quiet. She kept to the room assigned to her or the Chamber and carefully avoided the bar, smoking room, and dining areas frequented by the male MPs.[2] She made a few interjections but not enough to foreshadow what was to come.

Before she first spoke in Commons, she presented her views in several speeches given for various large groups. In late January, she spoke at Albert Hall in London on behalf of the League of Nations, expressing hope that her home country, in spite of its reservations, would join. To a crowd at Queen's Hall two weeks later, she outlined 24 social crusades, most of them relating to the needs of women. A few days later, she told the Primrose League that when necessary, she would act independently of party affiliation. She stated:

> I know we must have team work in the House of Commons as well as outside, but there are a lot of questions on which people ought to be free to vote as they think best. Women especially have not yet acquired that narrow party sense and I think they will do their best work in Parliament if they keep themselves free to support sound human legislation from whatever party it comes.[3]

Lady Astor gave her maiden speech opposing the removal of wartime restrictions imposed by the Liquor Control Board, much to the consternation of her supporters who feared she would resurrect her Pussyfoot persona and fall flat on her face.[4] But attacking drink was one of her favorite topics and she made a special effort to construct a reasonable argument for the retention of the wartime measures.

The debate on the motion was set for 24 February 1920. Astor was scheduled to follow Sir John Rees, who, with great mirth, had supported the measure, becoming a delightful advocate for the return of unrestricted drink. Though she had planned to begin in a most serious way, she was drawn into the hilarity of the moment. Rees concluded his speech by referring to her in most flirtatious manner: "I know what is coming to me from the next speaker. Not only shall I accept the chastisement with resignation, but I shall be ready to kiss the rod." Astor, no doubt anxious about her upcoming remarks, looked at Rees and replied, " I shall consider the Honourable Member's offer—after his conversion."[5]

After turning the tables on him, she delivered the introduction that she had labored over for hours—lines that revealed Plymouth's MP to be a

courageous soul: "I know it is very difficult for some honourable members to receive a woman, but I assure you it was difficult for a woman to come in. To address you now on the vexed question of drink is harder still. It takes a bit of courage to dare to do it. But I do dare."[6]

She then launched her main argument, contending that wartime restrictions on drink had been a great boon to the country. She supported many of her points with statistical evidence and illustrations. One example proved to be a masterful touch as it contradicted what might have been expected. Astor presented not the image of a drunken man but of a woman. Relating a personal experience, Astor told how she came across a child waiting outside a pub for his mother. She said, "Presently" the mother "reeled out" the pub door, and "the child went forward to her, but it soon retreated, and the oaths and curses of that poor woman and the shrieks of that child as it fled from her—that is not an easy thing to forget and that is what goes on when you have drunkenness among women." Near the end of the speech, she faltered—overemphasizing and repeating points unnecessarily. As a result, other MPs interrupted her—"a rare event."[7]

Overall, the speech was a moderate success. The bill, which she opposed, did not pass. Press reports were flattering and mail response was heavy and positive. Lloyd George was extraordinarily complimentary. He told her, "It's not what you say that counts, but whether you hold your audience. That you did from the start."[8] It was a good beginning for her parliamentary career.

After her maiden speech, Lady Astor proved herself to be a conscientious and industrious parliamentarian. She seldom missed a Commons session or committee meeting. She turned to matters of interest to women, responsive to the appeals they had made in voluminous correspondence to her.[9]

When the Geddes Axe, a drastic cut in government expenditure, threatened to abolish women police by cutting the £27,000 budgeted for them, she vigorously rallied to their defense. She argued that the recommendation of the Geddes committee contradicted earlier reports supporting their retention; she displayed statistical evidence in support of their good works. She ended her speech with a plea for common sense: "Don't let us go in for false economies. Which is cheapest—to have women police and less immorality, or to have no policewomen, but to have more disease and more girls going wrong?"[10]

In May 1920 she pleaded for employment for women in the civil service, asking that they be given equal opportunity and equal pay with men. She also spoke in favor of a measure giving equal guardianship to children and another offering increased pensions for widows.[11]

Members of the House of Commons did not welcome Lady Astor with open arms. Some were appalled by her parliamentary manners and others just could not accept a woman in their midst. What Lady Astor never understood was that Parliament "with its parties, division bells, lobbies, whips . . . is a regimented assembly, whose discipline members must accept if they are to make their mark." Years later, another female MP, Shirley Williams, said it was also "a deeply masculine place," clublike and intimate, and any outsider was viewed as an intruder.[12]

Nancy's problem was that she did not bother to learn the rules and thus adapt to her new audience of MPs in their setting. She interrupted frequently, not only with verbal interjections but also with many other disrupting signs as well. She shook her fist, pointed her finger, wagged her head, made faces, and on at least one occasion, whistled.[13]

She talked while others were talking. Halperin says, "She continuously infuriated her colleagues by her audible running commentary during speeches." Collis, another biographer, reported that one fellow MP once was so exasperated with her comments that he turned to her and shouted, "Mind your manners!" Quickly she replied, "I won't."[14]

She addressed members directly, refusing to bother with the established procedure that required that members refer to each other in the third person and always address remarks to the Speaker. Thus he had to frequently call her to order: "I must ask the honourable member to bear in mind that in this House it is not in order to say you, you, across the floor of the House."[15]

She squabbled over her seat. When she first entered the House of Commons, she sat in the place normally occupied by Sir William Joynson Hicks, who was absent. When he returned, she refused to move, and Hicks had to appeal to the Speaker who readily ruled in his favor. She later conceded that she had been "treated as a male legislator would have been."[16]

When she did speak, she forgot the brevity that had been her strength in her campaign. She often "went on too long, got off the subject and came to a lame ending." At other times, she harped on pet themes over and over. Arthur Baker, longtime parliamentary reporter for the *London Times*, said that she was extremely difficult to follow, "inclined to make so many points that it was impossible to decide which was the most important."[17]

Because she failed to obey the rules, her colleagues in Commons came to view her as Lady Dis-Astor, their *enfant terrible*, about "as welcome as an attack of gout." The only one amused by Astor's parliamentary antics was George Bernard Shaw, who made an attempt to meet her after he had read she had commented on a colleague's speech by shouting "Rats."[18]

The MP who disliked her the most was Winston Churchill. Nancy claimed that though they were social acquaintances, Churchill did not speak to her during her first two years in the House of Commons. When she asked him about his icy reception, he candidly stated, "We thought if we could freeze you out, we could get rid of the lot."[19]

Another who did not like her was Horatio Bottomley, fellow MP and editor of *John Bull*, who discredited her following the debate over divorce reform in April 1920. The proposed legislation would expand the grounds for divorce beyond adultery to include "desertion after three years, cruelty, habitual drunkenness, incurable insanity and imprisonment for life." Lady Astor, rationalizing her decision on religious grounds, opposed the bill, saying, "I am not convinced that making divorce very easy really makes marriages more happy or makes happy marriages more possible." Bottomley was angered, thinking her action, in light of her own previous marriage and divorce, to be extremely hypocritical. He also noted that her position riled other women, especially those in the working classes whose access to divorce was more limited than hers had been.[20]

In an article titled "Lady Astor's Divorce—A Hypocrite of the First Water" published in *John Bull* on 8 May 1920, Bottomley took Astor to task for her inconsistent position on divorce reform. Furthermore, he chastised her for telling *Who's Who, Burkes's Peerage,* and *Whitaker's Peerage* that she was the widow of Robert Shaw. He advertised his edition by placarding London with advertisements announcing in huge letters, "Lady Astor's Divorce," misleading the public into believing that she was leaving Waldorf. Even when Bottomley's readers discovered that they had been deceived by *Bull's* headlines, they still believed that Astor's actions in opposing divorce reform were "irreconcilable with what she herself had done."[21]

At first Lady Astor was not sure how to reply to Bottomley's charges. She "bore herself as if she cared not a fig for his slanders and libels," hiding the fact that she had been hurt. Several months later, she disclosed the unfortunate aspects of her past to a meeting of the Conservative Association in Plymouth. In the conclusion to her speech, she spoke from the heart and evoked a nautical metaphor: "This is the story of these painful occurrences, which is all that requires to be told. I have told you fully of the sorrows of my early life. I knew that when I set out from Plymouth I would encounter foul weather and be tossed by storms." Members of the Conservative Association gave her a complete vote of confidence, and then rose to their feet and cheered her "lustily." Collis remarked that "the line she took of a public refutation, made in person to the audience most

concerned and which the audience publicly accepted, stultified Bottom-ley's malice."[22]

Aware that holding her own within House of Commons was a formi-dable task to face alone, Lady Astor turned to the women of the country for assistance, asking them to elect others to join her, to join local government, and to strive in other ways for women's causes. In an interview after her first six months in office, she said, "I feel more strongly every day the urgent need for women in the House of Commons." She felt that they could provide "the human side" in dealing with a number of postwar issues.[23]

In June, she made her debut on the international stage, speaking in Geneva at the Eighth Congress of the International Woman's Suffrage Alliance. In a most uplifting address, she told her compatriots to strive for equality, to humanize politics, to promote moral progress, and to uphold the ideals of love and brotherhood. She then cautioned them to "avoid being aggressive" in their dealings with men: "If they bluster, it is no good blustering back." She added that viewing men as "monsters of iniquity" was useless and that women, instead, must work with them with "patience, understanding and self-control."[24]

Later in the same summer, she went on a speaking tour to the north of England, making visits to Hull, Leeds, and York. She spoke on a variety of topics: local option, female membership in trades unions, improved working conditions for women, social reforms, and Christianity. Everywhere she went, she urged women to become active citizens and pleaded for their assistance in the House of Commons. At the Town Hall in Leeds on 16 July, she concluded her speech, "Equal Citizenship," by remarking, "I could talk all night—and empty the hall—about the need for women in Parliament."[25]

In the spring months of 1921, she organized 60 leading women's groups into a mass federation of several million women and chaired a consultative committee of their representatives, welcoming them to her home in St. James Square. Later she urged them to send a "Black Hand notice" to MPs who opposed the reforms women wanted with the words: "All right, my man, your time's up." She sponsored a number of evening receptions bringing together women's representatives with MPs so they could talk about matters informally. Her good friend Mrs. Lyttelton said, "Lady Astor has a strong feeling about the value of personal contact between M.P.s and women who really know what is in women's minds and what they want."[26]

In spring 1922, Nancy accepted an invitation to speak at the Pan-American Conference for Women in Baltimore and another meeting sponsored by the English Speaking Union. She also planned a family visit to Virginia. When others in the States heard of her return, they bombarded

her on shipboard with additional requests "to speak, appear, lunch or banquet in every part of the country." She also received numerous requests from Canadians, many of them appreciative of the Astors' wartime work. Consequently, she rearranged her schedule so that she could accept engagements in New York, Washington, D.C., Philadelphia, Chicago, and Toronto, Montreal, and Ottawa in Canada.[27] At the same time she kept her commitment to return to Virginia where a number of celebrations were held in her honor. As a result, her home visit turned into a marathon of nearly 40 speeches

Nancy was adored in Virginia. Crowds in Richmond, Danville, Scottsville, and Charlottesville swarmed to get a glimpse of their favorite daughter. Wherever she went, a carnival atmosphere prevailed. Bands played "Carry Me Back to Old Virginia," "Dixie," and "Home Sweet Home." Children, excused from school, romped and pushed and shoved. Relatives told tales, and Nancy buried her face in bouquets of flowers and fought back tears when she spoke.[28]

Danville, her birthplace, pulled out all the stops. City fathers bestowed the freedom of the city, a loving cup, and a Confederate flag and renamed her home street, "Lady Astor Street." Before she spoke to a crowd of 5,000 from the porch of her old home, Harry C. Ficklen, a childhood playmate, introduced her as the "sweetheart of two nations." He then rhapsodized that Lady Astor was an "angel with a flaming sword cutting the right of way for the mothers of men, dove of war and eagle of peace . . . the first woman in the world ever to sit in the British Parliament and last woman in the world ever to forget the sacred soil of Virginia that bore her." Ficklen's flourishes were too much for Astor. She opened her speech with the quip: "Orators are like politicians, you can't believe them!"[29]

In Scottsville, Mayor Jackson Beal, totally enraptured by Lady Astor's charms, declared his hope that she would return to Virginia and become the Democratic candidate for the presidency.[30]

Throughout her tour, Lady Astor used her speaking opportunities to present some of her favorite themes: women must participate in government, ties between Britain and the United States needed to be strengthened, and the United States should join the League of Nations. Seeking U.S. participation in the League of Nations was a sticky matter as the United States Senate, failing to support President Wilson's grand effort in the Treaty of Versailles, had refused to ratify it. She was thus asking an isolationist nation to become involved in world affairs. She argued that "American interests are not entirely independent of or isolated from Europe. American influence is needed to help put things right." She pleaded with her home country to

change its policy: "You needn't call it a League of Nations; you can call it what you like—give it a new name every week—but for God's sake, give it a chance!" She later suggested that the League of Nations be called the League for Peace.[31]

With considerable rhetorical skill, she wove her themes into a single unified vision of a better world. This world encompassed a community of nations, a league of peace, where men, inspired by women, would live as brothers, doing unto others as they would have done unto them. It was a dream, she said, that had come to her during World War I "while soldiers were convalescing in her home." A mystical moment, it had brought her "to a sense of responsibility in working for an end of all war." Astor believed that within this community of nations, Britain and America would provide moral leadership. In particular, like the biblical Good Samaritan, Britain and America would reach out to bind the wounds of Europe, torn apart by World War I and the devastating economic circumstances of its aftermath. Such a humane and unselfish act, she thought, would be brought about by the efforts of women in both countries. Women, whom she saw as both capable of "the narrow way and the broad view" and as reflectors of God's love, would lead men to their better destiny, life in a world without war.[32]

As a speaker, Lady Astor reinforced her worldview by presenting a formidable persona, a variation of the one so popular in Plymouth. For her American tour, she draped "Pilgrim Mother" in the garb of the Good Samaritan, creating a nurturing and caring figure offering hope and healing. A Virginia reporter thought she embodied mother love, writing that "mother love was the theme that ran like a golden thread through her speeches."[33] As in her first campaign, the motherly persona helped overcome many of the rhetorical obstacles that came her way.

Her United States tour was a triumph, probably the high point during her first term and a significant rhetorical achievement. A Virginia critic commented:

> There are depths of seriousness in her talks, sparkling epigrams in which great truths are concentrated, and then suddenly a playful mood develops, eliciting laughter and relieving any tendency to heaviness. An accomplished and highly trained orator could hardly frame an address to a general audience with finer effect.[34]

As the trip neared its end, Astor received numerous other accolades. The highest came from the *New York Telegraph*: "Her gifts are remarkable; her faculty for saying the right thing at the right time amounts to genius." Indeed,

she had been "a touch of romance in a busy world."[35] She later collected and published her speeches in a volume called *My Two Countries*, which came out in 1923.

SUBSEQUENT YEARS (1922-1945)

In her 1919 campaign, Lady Astor said that she would plod along in Parliament standing up "for British men and women." She did much more than that. Brian Harrison said that her contribution to parliamentary debates was record-breaking: "65,494 lines in *Hansard*, 12 percent of all that was said by women in the period." He added that "her speeches, for all their defects, familiarized politicians and the public with women's new parliamentary role and prepared the way for successors whose quality surpassed her quantity."[36]

In 1923, Lady Astor was finally able to make an impact on drink regulation. She presented a private member's bill, the Intoxicating Liquor Bill, designed to raise the drinking age from 16 to18. Ironically, Mr. Edwin Scrymgeour, a radical prohibitionist who wanted to make England completely dry, aided her attempt. In contrast to the measures he proposed, Lady Astor's bill was a moderate alternative and thus received support from many other MPs and the new Conservative government.[37]

However, it was also strongly opposed by some and as a result did not go smoothly through the House. Over a six-month period, it prompted long debates, and after the second reading it was referred to a committee that added amendments and amendments to amendments. Sir Banbury tried to kill it by talking it out, irritating Lady Astor so much that she pulled on his coattails in order to get him to sit down. On the third reading, 13 July 1923, the bill passed by a majority of 247. Waldorf, in the House of Lords, steered the bill's passage there.[38] It was to be the only successful piece of legislation to Lady Astor's credit. Today, every pub in England bears notice that those under 18 will not be served.

Welfare issues were her chief interest, a matter that often brought her into conflict with members of her own party who thought she had a great liberal bent. She tried to convert them to her own point of view, and when that failed, she went her own way, abandoning party in favor of cause. Her own social conscience and a desire to have the moral upper hand over those in the rival Labour party guided her to promote legislation favoring women's employment, family allowances, equal pay, housing expansion, increased health care, extended education, reduced working hours, and unemployment benefits.[39]

She constantly sought to expand the franchise for women, allowing those 21 years old to vote, thus lowering the requirement from age 30. Although she had hoped such a measure would come into law during her first term of office, she did not see success until May 1928.[40]

Spurred on by the example of Margaret Macmillan's outstanding work with children, Nancy became a leading advocate for the establishment of nursery schools.[41] She thought that they could forestall many future problems in matters of health, poverty, and education. She did not make much progress on the national level during the years she worked on this issue. Ironically, what seemed unusual in her time is more commonplace today, especially in the United States with its successful Head Start programs and abundance of day care centers.

She continued to urge women to take part in the political arena, reaching out to those she described as "real women—the real old-fashioned, courageous, sensible, solid cup-of-tea women." However, she did not find them joining her in significant numbers. From the time of her first election until 1945, only 38 women served in the House of Commons, the most at one time was 15. Other female candidates still had to contend with "the underlying difficulty: the widespread and tenacious belief in reserving public life to men and family life to women."[42]

With those few who did enter the House of Commons, whatever their party, Lady Astor tried to establish common ground in order to pass legislation favorable to women and children. She became close friends with Margaret Wintringham, the second woman elected to the House of Commons, who joined Nancy after a 1921 by-election for her deceased husband's Liberal seat. Margaret came to Plymouth to support Nancy in the 1923 election, and Nancy was furious the following year when Conservatives failed to support Wintringham's re-election bid in her constituency at Louth. Nancy felt that Mrs. Wintringham's presence had stabilized women's place in the House, making others recognize that women were to be expected and accepted.[43]

In 1929, after 14 women had been elected to the House, she tried to organize them as women's group, but was not very successful. Nine were Labourites who preferred party affiliation to feminist alliance. Nevertheless, in spite of party differences and lack of formal organization, they did band together in support of several issues pertinent to women.[44]

From the time of her 1922 speaking tour and even before that, Lady Astor saw "herself a symbol and embodiment of Anglo-American unity."[45] She continually strove to bring her two countries together. Her manner was most often informal. Using her skills as a political hostess, she would bring

visiting Americans of rank together with those in power in Great Britain. Often during frequent postwar visits to the United States, she would speak with Americans about closer ties with Britain. In this arena, she often served as an ambassadoress of good will, rarely doing any significant harm.

However, when she looked to Europe and beyond, she failed miserably because she was often blunt, tactless, and wrong-headed. One writer, John Halperin, said, "She never was cut out for politics at the highest level . . . that she was altogether too ignorant." Another, John Grigg, commented that she was just "out of her depth."[46] Perhaps they are right.

In summer 1931, her friend, G. B. Shaw, well-known and loved socialist playwright, was invited to tour Russia by Madame Litvinoff, wife of commissar of foreign affairs, Maxim Litvinoff. Shaw invited the Astors and some of their friends along, an ironic gesture as the Astors were just as much Russophobes as Shaw was a Russophile. While riding on the train to Moscow, Nancy turned to Maxim Litvinov, who was returning home from Geneva, and inquired, "Now tell me honestly, wouldn't you rather not have had the revolution at all?"[47]

The group visited Communist and historic sites in Moscow and Leningrad and also a model collective farm, the Communa Lenin in Krishnavo. They also attended festivities staged by the Russians in honor of Shaw's seventy-fifth birthday.[48]

Shortly before they were to leave Moscow, the touring party received word that Stalin wished to see Shaw privately. Shaw, in accepting Stalin's invitation asked to bring the Astors and Philip Lothian along, agreeing that what transpired at the meeting would not be publicly disclosed. They met for several hours around a table in Stalin's study. Lady Astor shocked the translator by asking Stalin why he had "slaughtered so many Russians." When he refused to translate the question, Stalin insisted on hearing it and gave a somewhat evasive and oblique reply, referring to a specific case justifying the conviction of some alleged saboteurs. He then turned to British politics and asked about Churchill. Nancy this time replied, "Oh, he's finished!" and predicted that Neville Chamberlain would be "the coming man."[49]

Upon their return to Britain, Shaw praised the Russians. Lady Astor, though not as profuse, echoed Shaw's sentiments by saying that Russia was "wonderful and remarkable" and expressing the hope that the Five Year Plan would succeed. Churchill, who was far from finished, rebuked both Shaw and Lady Astor, for "saying nothing . . . about tyranny and lack of free speech in the Soviet Union or such atrocities as forced labor and death camps." Lady Astor, who had indeed challenged Stalin in their private meeting, could say

nothing in her own defense. She had to bear Churchill's allegations that she was "perhaps a disciple of Stalin and his system" in uncomfortable silence.[50]

Although aware of Stalin's ruthlessness, Lady Astor appeared to have blinders on when it came to Hitler. Like many of her countrymen, she did not fully recognize the dangers inherent in Hitler's rise to power, feeling that "Germany had been hard used in the treaty of 1919," and thus she was willing to give him the benefit of the doubt. Furthermore, she seemed to judge Hitler, as she did others, by his personal habits and was impressed by the fact that he did not drink or smoke.[51]

Placing faith in the League of Nations far too long and genuinely longing for a peaceful world, she, unlike Churchill, failed to see the gathering storm. In the 1930s "she approved of every measure . . . which might prevent or postpone war." In the 1935 election, she stood with Stanley Baldwin, who said, "There will be no great armaments." The next year, she changed her tune and favored rearmament: "I think it is a woman's job to be always on the side of peace, but I believe this time that a strong England means world peace." When Neville Chamberlain became prime minister in May 1937, she gave him her wholehearted support and, like the majority in her country, she endorsed his policy of appeasement. Indeed, she was accused as being responsible for it, a matter that later led to glaring publicity and great loss of face.[52]

In late fall 1937, the gifted Communist journalist Claud Cockburn rebuked the Astors for, in his opinion, favorable views toward Germany and credited them with a role much more influential than the one they actually played. In The Week on 17 November 1937, he told of a meeting that allegedly had taken place at Cliveden the weekend of 23-24 October. He charged that those present had hatched the plan to send Lord Halifax to Berlin to offer a proposal to Hitler. In essence, the proposal was an exchange. In return for an Anglo-German truce, Great Britain would not intervene with Germany's expansion in the East. The plan, Cockburn said, was conceived without the knowledge of Foreign Secretary Anthony Eden.[53]

Cockburn had failed to check his facts. Halifax, the messenger to Hitler, had not been at Cliveden on the October weekend, but Eden had. The following week, on 24 November, Cockburn had to revise his story. He repeated the charge but said that Eden had been brought in order to seem part of the intrigue going on behind his back. Cockburn's second article did not seem to provoke much of a response, probably because his "argument was too involved, sophisticated and improbable." Later he said, "Absolutely nothing happened. It made about as loud a bang as a crumpet falling on a carpet."[54]

Cockburn made a third attempt in *The Week* on 22 December 1937, this time sharpening the tone of his expose and putting "a little devil in it." In addition, he topped the article with the headline, "The Cliveden Set." He charged that those in the group who often gathered around Lady Astor's dinner table were indeed formulating pro-Nazi policies and plotting Britain's downfall. Specifically he associated these "friends of the Third Reich" with a letter writing campaign advocating the return of Germany's former colonies. He further claimed that Cliveden had become a second and more powerful Foreign Office, one that would "be brought very powerfully to bear on the Prime Minister."[55]

In Cockburn's journalistic invention, Lady Astor was the ringleader and her co-conspirators included nearly a dirty dozen: Sir Neville Henderson, Britain's ambassador to Germany; Lord Lothian (Philip Kerr), longtime friend and associate; Lord Londonderry, chief of the Conservative Party; Geoffrey Dawson, editor of the *Times*; Barrington Ward, his assistant; Sir Samuel Hoare, the Home Secretary; Sir John Simon, Chancellor of the Exchequer; Lord Halifax; the Aga Khan; Lady Astor's husband, Waldorf; their son, Bill; and "a whole string of satellites." He stated that they hoped, by siding with Germany, Bolshevism would be stopped.[56]

Cockburn's story, and especially the phrase "Cliveden Set," resonated throughout the world. Indeed, as Cockburn recalled, "The thing went off like a rocket." He said," . . . within a couple of weeks it had been printed in dozens of newspapers, and within six had been used in almost every leading paper in the Western world." Capitalizing on his success, Cockburn brought out six more articles on "The Set." He repeated his original charges and expanded his attacks to include other incidents and other conspirators; most notably, he charged that the Astors had also been instrumental in forcing the resignation of Anthony Eden. The story, in one version or another, appeared in print for the next 18 months. In time, as Cockburn himself stated, "However it started, it presently became a myth."[57]

Many in Great Britain and the United States believed Cockburn, and in turn they chastised Nancy both publicly and privately. She was called "Nazi," "Fascist," "arch-appeaser," "traitor." In Parliament, her colleagues referred to her as "the honourable member for Berlin." Reporters and photographers swarmed her wherever she went. Always fascinated by her "rich and aristocratic lifestyle" and amused by her quips, members of the press were as intent on capturing her fall as they were her rise.[58]

At first, Lady Astor did not pay too much attention to Cockburn's accusation although she did mention to Lord Lothian that "people really seem to believe it." When reporters questioned her about the matter, she

dismissed them by saying it was "nothin' but a lot of nonsense." But for the most part, both she and Lord Astor treated the matter in silence as if it were not worthy of notice.[59]

Six months later, Waldorf decided it was time to respond and discussed the matter with the Conservative Central Office. He was advised to write a letter to the *Times*. He did so on 5 May 1938. On the same day, Nancy penned her remarks to the *Daily Herald*. She said that she had been compelled to write because so many Labourites had asked about the Cliveden Set and her alleged "Fascist leanings." And for their benefit, she wanted to "correct certain absolute untruths." She admitted that "as an individual," she had "supported those who are trying to correct by negotiations the mistakes of the Peace Treaties" and that she had favored attempts to establish "a better atmosphere" between Britain and France on the one side and Germany and Italy on the other. But then she emphatically stated, "I believe in Democracy and in Parliamentary government and am opposed to all forms of dictatorship, whether Fascist, Nazi or Communist." She went on to deny the existence of the Cliveden Set, saying that some of her so-called co-conspirators had never been to Cliveden or, if they had, not in recent years. She said, by contrast, that she and Waldorf had "entertained men and women of all political creeds (including Bolshevik), of all nationalities, of all religious faiths, and of all social interests." She concluded, "The story is a myth."[60]

The Cliveden Set charges died down for a while, but they came back to life after the Munich agreement on 30 September 1938 and Charles Lindbergh's report on European air forces the same fall. The Astors and Lindbergh's association led to the rumor that they both were "fantastically united in the whole Hitler-Chamberlain combination." In December 1938, Frederick Collins wrote an article that implied that Lindbergh and the Astors were cohorts in the Cliveden Set—again repeating and expanding upon the now-popular story. Collins indicated that Lindbergh, dubbed a "hanger-on and lackey of the German fascists" by his Communist detractors, had testified to the superiority of the German air force over the Russian, dispelling the British impression that the Soviet force was the more powerful. As a result, Britain, fearful of a possible disaster, fell in with Germany, and Chamberlain capitulated to Hitler at Munich. Collins implied that Lindbergh may have been "in the employ of Lady Astor and her friends," the "fascist" Cliveden Set. He then turned his attention to "The Set," naming and blaming the same figures as had Cockburn in his attacks. Summing up, he said, "It is obvious that this ascendant group in British public life is hell-set for Hitlerism."[61]

This time, the Astors pulled out all the stops in trying to combat the accusations against them. On the Astors' behalf, G. B. Shaw wrote a reply

to Collins in a later edition of *Liberty*. Other than mentioning that Lindbergh had been only one of the Astors' many guests, he skipped over Collins's charges against the flier and focused his remarks upon the Cliveden Set. Giving himself the credentials of a true insider, Shaw described those who came for the Astors' weekends, matching every Conservative right-winger with someone on the Left, including Ellen Wilkinson, Charlie Chaplin, and himself, "an implacable and vociferous Marxist Communist of nearly sixty years standing." He added that if he could suppress Mr. Collins's list and extend his own, he "could prove that Cliveden is a nest of Bolshevism, or indeed of any other bee in the world's bonnet." He then defended each Astor in turn, describing Nancy as an "eclectic hostess" and Waldorf as one of those who "does public work and gets no credit for it." He dismissed Nancy's alleged Fascist leanings with one sentence: "She has no political philosophy, and dashes at any piece of kindly social work that presents itself." With contemptuous and caustic comment, he said the "Cliveden legend" was "a grotesque invention from the first word to the last." He concluded, "Never has a more senseless fable got into headlines."[62]

In the same month, Nancy wrote her own defense for the *Saturday Evening Post*. She began with a summary of the charges against her, moved on to attack her accusers, denied the specific charges concerning her involvement with Halifax's trip to Germany and Eden's resignation, and then made a further attempt to set the record straight. She wrote, "I want to dispel this outrageous fiction that we are pro-Nazi, or pro-Fascist, or anti-Jew." She described her Cliveden weekends and elaborated upon her political philosophy. As in her letter to the *Daily Herald*, she reaffirmed her faith in democracy: "I am still a Virginian, and still a democrat and an ardent believer in women's rights and social reforms."[63]

When Hitler marched into Czechoslovakia on 15 March 1939, Chamberlain's appeasement policy collapsed and with it, Astor's support. During Question Time in the Commons on the seventeenth, Lady Astor asked, "Will the Prime Minister lose no time in letting the German Government know with what horror this country regards Germany's action?" One of her biographers, Grigg wrote, "Nancy the appeaser was swiftly transformed into Nancy the fighter."[64]

For the most part, the Astors denials were ignored. They were not enough to dispel the rumor Cockburn had created. No new image could restore Plymouth's Pilgrim Mother. She had become the Wicked Witch from the West—worse yet, "Traitress." She continued to be criticized and rebuked, often used as the scapegoat for failures of her government's policies.[65]

The only way Lady Astor could prove her patriotism was through enactment. Now fully aware that Chamberlain's policy of appeasement had been the worst of follies, she turned her back on him. On 8 May 1940, she joined with Labourites and other dissenting Conservatives in voting no confidence in Chamberlain's government.[66] She then gave her support to her longtime antagonist, Winston Churchill.

As war intensified, she and Waldorf again turned Cliveden over to the Canadian Red Cross for a hospital. They also opened it as a home for evacuated children, taking in 83 infants and their mothers. However, she spent most of her time in Plymouth. She assisted Waldorf in his duties as Lord Mayor of Plymouth, often filling in for him when illness kept him away.[67]

She worked continuously, both in civil defense matters and nursing. When Plymouth was blitzed in 1940 and even more horribly in 1941, she spent her days and nights with her constituents even when her own home was damaged and there was danger to her. With pluck and cheerfulness, she strove to keep morale high. She organized dances on the Hoe, often leading them herself. She visited shelters, amusing both adults and children by turning cartwheels and somersaults and quipping, "We are not downhearted, are we?" From February 1940 until February 1944, she supported the North Road Canteen, which served hot food 24 hours a day.[68]

In behind-the-scenes activities and later in the House of Commons, she constantly pleaded for better fire-fighting equipment for bombed communities. When Churchill visited the ruins that had been Plymouth, he wept. Unsympathetic to his tears, she chided him for not providing the equipment she had asked for, "It's all very well to cry, Winston, but you've got to do somethin'." Her efforts eventually led to the establishment of a national fire-fighting service.[69]

She never gave up. "Blitzes," she said, "don't break our spirits, but only our hearts." She vowed to build Plymouth again. For the few who noticed, it, too, was her finest hour.[70]

Later she was one of the few former supporters of appeasement and disarmament who publicly admitted that she was wrong. In September 1942 at Cheltenham, she said, "After the last war we were all striving for peace. The trouble was that we did not understand Europe or the world as admirals and generals did. I am afraid that I was against those who did not want us to disarm."[71]

During the war she commuted back and forth from Plymouth to Parliament for House debates. And again she was not well-received by her colleagues. Like others, they still saw her as the archfiend of the Cliveden Set and paid her little attention. Not only that, she seemed to have lost her

ability to capture their attention in a positive way. As early as 1938, Bevan had complained that she had "a mind like a ragbag," speaking "by free association, giving utterance to any ideas that come into her head." Again she rambled, got off the subject, this time betraying signs of frayed nerves, a not uncommon malady for those who had been under siege for a prolonged time. Furthermore, she irritated her fellow MPs by a number of inappropriate and tactless remarks, exhibiting prejudices, especially against Catholics, that were out of keeping with the times and her more tolerant nature. She was certainly not her best self. At war's end and before the coming 1945 election, Waldorf and other family members urged her to retire.[72]

Oblivious to her own increasing ineptness and failing to fathom the changing political climate in Britain, she balked at first, then reluctantly agreed to Waldorf's wishes, blaming him for her unhappiness thereafter. Holding back tears she announced her retirement on 1 December 1944. Few objected or noticed. Ironically, *John Bull*, the paper that had maligned her so maliciously during the debate on divorce reform, was kind: "The House will lose its most historic figure." Percy Cater, parliamentary correspondent for the *Daily Mail*, reflected, "Maybe there will never be another quite like her."[73]

When the actual moment of her retirement came, she seemed to take it in stride, making farewell remarks that were both philosophical and eloquent. She said:

> I am broken-hearted about going, and I shall miss the House. But the House won't miss me. It never misses anybody. I've seen them all go— Lloyd George, Asquith, Baldwin, Snowden, MacDonald and the rest— and not one of them was missed. The House is like the sea, and the M.P.s like little ships that sail across it and disappear over the horizon. Some of them carry a light and others don't. That's the only difference."[74]

Lady Astor probably thought that she was one of those "little ships" that did not carry a light. She would have downplayed the praise for her accomplishments that was to come later. She would have expressed surprise at the eulogies that poured forth after her death in 1964. Throughout her parliamentary career, she had often said, "I'm only an ordin'ry woman after all." She would have argued that she had done what other ordinary women could do. She would have claimed that she had been only a symbol for their potential: "I don't say that women will change the world, but I do say they can if they want to."[75]

NOTES

PREFACE

1. John M. Murphy, "Knowing the President: The Dialogic Evolution of the Campaign History," *Quarterly Journal of Speech* 84 (1998): 24.
2. Kathleen J. Turner, "Rhetorical History as Social Construction" (paper presented at the Southern States Communication Association Convention, Tampa, Fla., April 1991), 4; Robert L. Scott, conversation with seminar, University of Minnesota, Minneapolis, Minn., 4 Oct. 1985; Martin J. Medhurst, "Public Address and Significant Scholarship: Four Challenges to the Rhetorical Renaissance," in *Texts in Context*, eds. M. C. Leff and F. J. Kauffeld (Davis, Calif.: Hermagoras Press, 1989), 38.
3. See "thickening narratives" in Peter Burke, "History of Events and the Revival of Narrative," in *New Perspectives on Historical Writing*, ed. P. Burke (University Park, Pa.: Pennsylvania State UP, 1992), 240-245; Golo Mann, Forward to the English translation of *Wallenstein* by C. Kessler (London, 1976), quoted in Burke, "History of Events and the Revival of Narrative," 239.
4. Ronald H. Carpenter, "In Not-So-Trivial Pursuit of Rhetorical Wedgies: An Historical Approach to Lincoln's Second Inaugural Address," *Communication Reports* 1 (Winter 1988): 24.
5. Stephen E. Lucas, "The Schism in Rhetorical Scholarship," *Quarterly Journal of Speech* 67 (1981): 18.
6. Medhurst, "Public Address and Significant Scholarship," 36; Karlyn Kohrs Campbell, *Critiques of Contemporary Rhetoric* (Belmont, Calif.: Wadsworth, 1972), 2; J. Axtell, "History as Imagination," *Historian* 49 (August 1987): 454.
7. Joan Scott, "Women's History," in *New Perspectives on Historical Writing*, ed. P. Burke (University Park, Pa.: Pennsylvania State UP, 1992), 58.
8. Karlyn Kohrs Campbell, *Man Cannot Speak for Her*, Vol. 1, *A Critical Study of Early Feminist Rhetoric* (New York: Praeger, 1989), 9.
9. Ibid., 3.
10. Giovanni Levi, "On Microhistory," in *New Perspectives on Historical Writing*, ed. P. Burke (University Park, Pa.: Pennsylvania State UP, 1992), 109; John F. Cragan and Donald C. Shields, *Applied Communication Research: A Dramatistic Approach* (Prospect Heights, Ill.: Waveland, 1981). For symbolic convergence theory, see the following selected works: Ernest G. Bormann, "The Symbolic Convergence Theory of Communication and the Creation, Raising and Sustaining of Public Consciousness," in *The Jensen Lectures: Contemporary Communication Studies*, ed. John I. Sisco (Tampa: Department of Communication,

University of South Florida, 1983), 71-90; *The Force of Fantasy* (Carbondale: Southern Illinois UP, 1985), 1-25, and "Symbolic convergence theory: a communication formulation based on *homo narrans*," *Journal of Communication* 35 (Autumn 1985): 128-138.

INTRODUCTION

1. American newspaper editors called her "Lady Nancy Astor" or "Nancy Astor," but "Lady Astor" or possibly "Nancy, Lady Astor" is the proper form; Ray Strachey, *The Cause: A Short History of the Women's Movement in Great Britain* (London: G. Bell & Sons, 1928), 378.

2. The first woman elected to the House of Commons was Constance Markievicz, who won in the December 1918 election. A Sinn Feiner, she joined 72 other members of her party in refusing to come to England, choosing instead to "set themselves up as the Dail, or parliament of the Irish republic" (A. J. P. Taylor, *English History 1914-1945* [New York: Oxford UP, 1965; reprint, London: Penguin Books, 1975]), 175 (page reference is to reprint edition). There were two elections in 1910; Waldorf won the second. (Alfred F. Havighurst, *Britain in Transition*, 3d ed. [Chicago: University of Chicago Press, 1979], 98-100).

3. Unless otherwise noted, family biographical information for Lady Astor's pre-Parliament years comes from her standard biography, Christopher Sykes, *Nancy* (Chicago: Academy Chicago, 1984). Page references include 12-13, 18, 21, 29, 32, 34, 37-38, 45-53, 55-67, 74, 87-91, 96-97, 99, 103, 107-108, 112-113, 132-133, 140-143, 147, 150-159, 173-175, 183-184, and 197-198. Direct quotations from Sykes are cited.

4. Ibid., 75.

5. Neva Fane, London, to Lady Astor, Plymouth, ANS, 29 Nov. 1919, MS1416/1/1/1721, Astor papers, Archives and Manuscripts, University of Reading, Reading, England; note also she was a "Virginian first and last" (A. L. Rowse, "Nancy Astor," in *Memories of Men and Women American and British* [Lanham, Md.: University Press of America, 1983], 27).

6. Emory M. Thomas, *The Confederate Nation 1861-1865* (New York: Harper & Row, 1979), 300-301; Elizabeth Langhorne, *Nancy Astor and Her Friends* (New York: Praeger, 1974), 4; see also Robert Becker, *Nancy Lancaster: Her Life, Her World, Her Art* (New York: Alfred A. Knopf, 1996), 18; Langhorne, *Nancy Astor*, 10.

7. Alice Winn, *Always a Virginian* (U.S.A.: privately published, 1973), 7.

8. "Mirador" means "resting place on the side of a mountain." Becker, *Nancy Lancaster*, 47.

9. Ibid., 25, 38; see also Winn, *Always a Virginian*, 15.

10. Sykes, *Nancy*, 21; Langhorne, *Nancy Astor*, 9; see also John Grigg, *Nancy Astor, A Lady Unashamed* (Boston: Little, Brown, 1980), 61.

11. Maurice Collis, *Nancy Astor: An Informal Biography* (New York: E. P. Dutton, 1960), 22; Nancy Astor, *As I See It*, BBCX/21102, 1937, sound recording, British Library National Sound Archive, London.

12. M.P.s of the 1918-1922 House of Commons are well described in Auditor Tantum [pseud.], "A Look Round the Back Benches," *Fortnightly Review*, July 1921, 41-53.

13. Nancy Astor, 1951 autobiographical draft, quoted in Sykes, *Nancy*, 30. Her son Michael said that her dislike for numbers continued: "How she loathed accountancy in her hey-day" (Michael Astor, *Tribal Feeling* [London: J. Murray, 1963], 205).

14. Grigg, *Nancy Astor*, 26.

15. Sykes, *Nancy*, 199.

16. By the turn of the century, divorce was "regarded as a regrettable but permissible way of solving marital errors" (Harvey O'Connor, *The Astors* [New York: Alfred Knopf, 1941], 228).

17. Grigg, *Nancy Astor*, 26; Nancy Astor, 1951 autobiographical draft, quoted in Sykes, *Nancy*, 60.

18. Grigg, *Nancy Astor*, 27. In her 1951 autobiographical draft, Nancy said, "the entire family were in favor of the marriage" (Sykes, *Nancy*, 61). Elizabeth Langhorne stated that, according to family tradition, Chillie had approved the match. (Langhorne, *Nancy Astor*, 16).

19. Rowse, "Nancy Astor," 28; Langhorne, *Nancy Astor*, 16, 17.

20. The other woman, whom Shaw later married, was Mrs. Converse, an English actress. (O'Connor, *Astors*, 399).

21. Nancy Astor, 1951 autobiographical draft, quoted in Sykes, *Nancy*, 64-65. Grigg (*Nancy Astor*, 27) gives the date as October 1901.

22. Ava Willing Astor was the first wife of John Jacob Astor IV and a leader of the Anglo-American social set in London. (O'Connor, *Astors*, 273).

23. Nancy Astor, 1951 autobiographical draft, quoted in Sykes, *Nancy*, 67; Becker, *Nancy Lancaster*, 24; Nancy Astor, 1951 autobiographical draft, quoted in Sykes, *Nancy*, 72.

24. Langhorne, *Nancy Astor*, 23.

25. Sykes, *Nancy*, 75.

26. Langhorne, *Nancy Astor*, 25.

27. Ibid.; 27; Grigg (*Nancy Astor*, 41) states that Nancy's Danville birth certificate indicates that she was born May 17, 1879, thus making her two days older than Waldorf.

28. After her marriage to Waldorf, Nancy referred to her father-in-law as "Old Moneybags" ("The Ginger Woman," *Time*, 8 May 1964, 35); William Waldorf's career is described in O'Connor, *Astors*, 158, 188, 365. William Waldorf changed the political viewpoint of the *Pall Mall Gazette* overnight, from Liberal to Conservative.

29. Grigg, *Nancy Astor*, 40-41; O'Connor, *Astors*, 398; Winn, *Always a Virginian*, 123, and Langhorne, *Nancy Astor*, 38.

30. Grigg, *Nancy Astor*, 41.

31. Ibid., 45. Langhorne (*Nancy Astor*, 34) says they went to Paris.

32. *Cliveden* (guidebook) (U. K.: The National Trust, 1988); also Lawrence Rich, "Cliveden, Buckinghamshire," *British Heritage*, Dec./Jan. 1985-86, 62-73, 80.

33. Grigg, *Nancy Astor*, 51.

34. *Cliveden*, 36; see also Becker, *Nancy Lancaster*, 36; Collis, *Nancy Astor*, 38.

35. Collis, *Nancy Astor*, 40; Joyce Grenfell, "Mostly About Aunt Nancy," in *Joyce Grenfell Requests the Pleasure* (London: Macmillan, 1976; London: Futura Publications, 1986), 100 (page reference is to the reprint edition); Julian Grenfell, en route to India, to Lady Astor, Cliveden, 11 Nov. 1910, quoted in Sykes, *Nancy*, 115.

36. Sykes, *Nancy*, 108; Harold Macmillan, *The Past Masters: Politics and Politicians 1906-1939* (London: Macmillan, 1975), 215.

37. Grigg, *Nancy Astor*, 53; Genevieve Parkhurst, "Lady Astor, M.P.," *Ladies Home Journal*, March 1920, 15. "The role of mother in an upper-class British nursery was a highly restricted one" (Langhorne, *Nancy Astor*, 58).

38. "The Noble Lady, the Member from Plymouth," *Literary Digest*, 13 Dec. 1919, 23.

39. Taylor, *English History*, 159; "Plymouth Prophets," *Evening Standard* (London), 15 Nov. 1919, MS1416/1/7/32, Astor papers, 72.

40. "The term 'suffragist'" applied "to any campaigner for women's suffrage, and 'suffragette' to any woman active in the militant sub-section of the suffragist category" (Brian Harrison, "Introduction," in *Prudent Revolutionaries: Portraits of British Feminists between the Wars* [Oxford: Clarendon Press, 1987], 7).

41. Havighurst, *Britain in Transition*, 140.

42. John Halperin, "Lady of the House: Nancy Astor," in *Eminent Georgians* (New York: St. Martin's Press, 1995), 184.

43. Langhorne, *Nancy Astor*, 53-54.

44. Grigg, *Nancy Astor*, 69; Martin Pugh, *Lloyd George*, Profiles in Power Series, ed. Keith Robbins (London: Longman, 1988), 104; Havighurst, *Britain in Transition*, 147-151; Halperin, "Lady," 186; Pugh, *Lloyd George*, 127; see also J.M. McEwen, "The Coupon Election of 1918 and the Unionist Members of Parliament," *Journal of Modern History* 34 (Sept. 1962): 294-306.

45. Langhorne, *Nancy Astor*, 47.

46. H. V. Hodson, "Looking Back: The Founders," *The Round Table*, July 1990, 254-256; Grigg, *Nancy Astor*, 101, 108.

47. Ernest Thurtle, *Time's Winged Chariot* (London: Chaterson, 1945), 117-118. "The Langhorne women never drank because the men went on sprees" (Becker, *Nancy Lancaster*, 25).

48. Brian Harrison, "Publicist and Communicator Nancy Astor," in *Prudent Revolutionaries*, 85.

49. Michael Astor, *Tribal Feeling*, 27.

50. Nancy Astor, *This I Believe*, 19390, 1953, sound recording.

51. Langhorne, *Nancy Astor*, 14.

52. Nancy Astor, 1951 autobiographical draft, quoted in Sykes, *Nancy*, 159.

53. Grigg (*Nancy Astor*, 180) said she liked the Wednesday service because "it gave her a chance to get up and speak in church"; Roy Jenkins, *Gallery of 20th Century Portraits* (London: David & Charles, 1988), 28.

54. "Plymouth Election," *Daily Telegraph* (London), 6 Nov. 1919, MS1416/1/7/31, Astor papers, 83.

55. Collis, *Nancy Astor*, 57; Parkhurst, "Lady Astor, M. P.," 210.

56. Nancy Astor, *As I See It.*

57. Nancy Astor, 1951 autobiographical draft, quoted in Sykes, *Nancy*, 184-185.

58. Grigg, *Nancy Astor*, 69; Sykes, *Nancy*, 200.

59. Nancy Astor, 1951 autobiographic draft, quoted in Sykes, *Nancy*, 105.

60. Ibid., 106.

61. Grigg, *Nancy Astor*, 34. Langhorne (*Nancy Astor*, 46) comments that it was a time of international marriages. See also Maureen E. Montgomery, *Gilded 'Prostitution': Status, Money, and Transatlantic Marriages, 1870-1914* (London: Routledge, 1989).

62. Consuelo Vanderbilt Balsan, *The Glitter and the Gold* (New York: Harpers, 1952), 204-205.

63. Michael Astor, *Tribal Feeling*, 69.

64. Ibid., 75-77; also Becker, *Nancy Lancaster*, 79, and Langhorne, *Nancy Astor*, 52; Lord Riddell, *Lord Riddell's Intimate Diary of the Peace Conference and After 1918-1923* (London: Victor Gollancz, 1933), 135.

65. Grigg, *Nancy Astor*, 156.

66. Langhorne, *Nancy Astor*, 42; Nancy Astor, 1951 autobiographical draft, quoted in Sykes, *Nancy*, 126.

CHAPTER ONE

1. William Waldorf Astor was named a baron in the New Year's honors list for 1916. The following year, when Lloyd George was prime minister, he was made a viscount. For a revealing character sketch, see John D. Gates, *The Astor Family* (Garden City, NY: Doubleday, 1981), 206-216; for his attire, see "Bright and Breezy," *Daily Sketch* (London), 29 Oct. 1919, in MS 1416/1/7/31, Astor papers, Archives and Manuscripts, University of Reading, Reading, England, 32.

2. "Three Candidates for Plymouth," *Western Daily Mercury* (Plymouth), 4 Nov. 1919, in MS 1416/1/7/31, Astor papers, 51; an appointment to the Chiltern Hundreds formally vacates the seat. ("End of Truce," *Western Morning News* [Plymouth], 1 Nov. 1919, in MS 1416/1/7/31, Astor papers, 34).

3. *Western Daily Mercury* (Plymouth), 21 Oct. 1919, in MS 1416/1/7/31, Astor papers, 10-11. Shortly thereafter, he did make such a challenge. See "Viscount Astor's Bill," *Western Morning News* (Plymouth), 13 Nov. 1919, in MS 1416/1/7/31, Astor papers, 60. In 1895 when Lord Selborne wanted to keep both his Commons seat and his title, the Leader of the House, Sir William Harcourt, "enunciated the principle that an English peer by patent became a Peer of the

Realm and automatically a Lord of Parliament—even if he did not apply for a writ or summons" ("Astor Peerage," *Daily News* [London], 27 Oct. 1919, in MS 1416/1/7/31, Astor papers, 18); "Sutton Election," *Western Morning News* (Plymouth), 28 Oct. 1919, in MS 1416/1/7/31, Astor papers, 27.

4. Sykes, *Nancy*, 178; for Qualification of Women Bill, see *Daily News* (London), 22 Oct. 1919, in MS 1416/1/7/31, Astor papers, 11; R. K. Webb, *Modern England*, 2d ed., (New York: Harper & Row, 1980), 630-636, and "Is Lady Astor's Election Valid?" *Saturday Review*, 10 Jan. 1920, 28. For a thorough discussion of the selection procedure, see Elizabeth Vallance, *Women in the House* (London: Athlone Press, 1979), 43-52. For Jacobs as candidate, see *Scotsman* (Edinburgh), 21 Oct. 1919, MS 1416/1/7/31, Astor papers, 10; for Waldorf's decision, see *Evening News* (London), 22 Oct. 1919, in MS 1416/1/7/31, Astor papers, 11.

5. William T. Gay had opposed Waldorf Astor in the 1918 general election and had accepted an invitation to stand for Labour again—before it was known that a by-election would be called. ("Peer's Wife Enters," *Daily Herald* [London], 27 Oct. 1919, MS 1416/1/7/31, Astor papers, 21); *Evening News* (London), 22 Oct. 1919, MS 1416/1/7/31, Astor papers, 11; *Western Daily Mercury* (Plymouth), 21 Oct. 1919, MS 1416/1/7/31, Astor papers, 10-11. See also "Colston Day and Parties," *Scotsman* (Edinburgh), 12 Nov. 1919, MS 1416/1/7/32, Astor papers, 57, for a probing analysis of party affairs during this time, including a discussion of the approaching split in the Labour party between the moderates and the revolutionaries.

6. "Death of Lord Astor," *Times* (London), 20 Oct. 1919, sec. A, 16, and "Funerals," *Times* (London), 21 Oct. 1919, sec. C, 15; *Evening News* (London), 22 Oct. 1919, MS 1416/1/7/31, Astor papers, 11. The paper refers to Waldorf Astor as "Major," his wartime rank; *Evening Standard* (London), 25 Oct. 1919, MS 1416/1/7/31, Astor papers, 15.

7. "'Pussyfoot' Woman M. P.?" *Daily Express* (London), 25 Oct. 1919, MS 1416/1/7/31, Astor papers, 15; *Sunday Herald* (London), 26 Oct. 1919, MS 1416/1/7/31, Astor papers, 17. The "truce" entailed a ban on public propaganda which was defined as 1) no opening of committee rooms, 2) no canvassing, and 3) no outside meetings. Regular party work, such as the adoption meeting, was permitted. ("Lady Astor," *Western Daily Mercury* [Plymouth], 28 Oct. 1919, MS 1416/1/7/31, Astor papers, 26).

8. Other by-elections were scheduled for South Croyden, Chester-le-Street, and the Isle of Thanet. See "Other By-Elections," *Common Sense*, 25 Oct. 1919, MS 1416/1/7/31, Astor papers, 16. "'Our Nancy' for Plymouth," *Sunday Express* (London), 27 Oct. 1919, MS 1416/1/7/31, Astor papers, 17; "Lady Astor," *Western Daily Mercury* (Plymouth), 28 Oct. 1919, MS 1416/1/7/31, Astor papers, 26.

9. "Sutton Election," *Western Morning News* (Plymouth), 28 Oct. 1919, MS 1416/1/7/31, Astor papers, 27.

10. "Dux Femina Fecit," *Morning Post* (London), 28 Oct. 1919, MS 1416/1/7/31, Astor papers, 24. One writer lamented, "the first woman member really should

be a native of the kingdom." ("Nancy Astor," *Sunday Evening Telegram* [London], 26 Oct. 1919, MS 1416/1/7/31, Astor papers, 17). The legality of Lady Astor's right to sit in the Parliament was also challenged by the writer of "Is Lady Astor's Election Valid?" *Saturday Review*, 28. Apparently the latest Naturalization Act (1918) did not touch the point. "Lady Astor and Plymouth," *Western Morning News* (Plymouth), 27 Oct. 1919, in MS 1416/1/7/31, Astor papers, 21.

11. Please note that initial references to personas are capitalized and enclosed in quotation marks. Caps will signal subsequent references.

12. Tom Tierney, *Gibson Girl Paper Dolls in Full Color* (Mineola, NY: Dover, 1985), front cover. See also Lois W. Banner, "The Gibson Girl," in *American Beauty* (New York: Alfred A. Knopf, 1983), 154-174.

13. Irene was an important model but not the original as Gibson did not meet her until after the Gibson Girl was already popular. (Banner, 158). Lady Astor, M. P.?" *Liverpool Post*, 25 Oct. 1919, MS 1416/1/7/31, Astor papers, 16, and "A Gibson Girl M. P.?" *Lloyd's News*, 26 Oct. 1919, MS 1416/1/7/31, Astor papers, 16. Actually, there were five Langhorne sisters: Elizabeth (Lizzie), Irene, Nancy, Phyllis, and Nora. The eldest, Lizzie, married Thomas Moncure Perkins and for the most part remained in Virginia. She did not lead as glamorous a life as her younger sisters and as a result did not capture the attention they did. (Sykes, *Nancy*, 25-29, 36; also Alice Winn, *Always a Virginian*). For additional information on the sporty behavior of the turn-of-the-century female, see Strachey, *The Cause*, 386-390.

14. Banner (*American Beauty*, 166) contends that the flapper was in vogue as early as 1913. At the time of Lady Astor's campaign, her oldest child, Bobbie, had seen wartime service in France, and her youngest, Jakie, was not yet two. (Sykes, *Nancy*, 205-206).

15. The Anti-Saloon League of America is viewed by some as "the most effective pressure group in American political history." As momentum for prohibition developed, "there were then 20,000 ASL speakers in the field, preaching in every part of the country" (Norman H. Clark, *Deliver Us From Evil: An Interpretation of American Prohibition* [New York: Norton, 1976], 92-117). "'Pussyfoot' Woman M. P." *Daily Express* (London), 25 Oct. 1919, MS 1416/1/7/31, Astor papers, 15. Pussyfoot's speaking tour is covered in "'Pussyfoot's' Pilgrim's Progress," *Literary Digest*, 29 Nov. 1919, 22, and "Our 'Pussyfoot,' England's Hero and Pest" with "'Pussyfoot' Nosey Parker from Across the Sea" (Cartoon), *Literary Digest*, 6 Dec. 1919, 47, 51. For the Astors as moderates, see "Best Wishes," *Pall Mall Gazette* (London), 27 Oct. 1919, MS 1416/1/7/31, Astor papers, 18. Most of the important press in Britain was "wet" except for the London *Daily News*, *Westminster Gazette* (London), and the Manchester *Guardian*.

16. "Lady Astor's Chances," *Evening Standard* (London), 1 Nov. 1919, MS 1416/1/7/31, Astor papers, 37, and *South Wales Daily News* (Cardiff), 27 Oct. 1919, MS 1416/1/7/31, Astor papers, 23; Jessica Gerard, "Lady Bountiful: Women of the Landed Classes and Rural Philanthropy," *Victorian Studies* 30 (Winter 1987): 183-210. For a discussion of Lady Astor's early benevolent activities, see Sykes, *Nancy*, 46-47. For women's work in local government, see Patricia Hollis, *Ladies*

Elect: Women in English Local Government 1865-1914 (Oxford: Clarendon Press, 1987), 1-68; Gerard, 189, 196-200; Hollis, 422-460.

17. "Viscountess as Candidate," *Daily Chronicle* (London), 25 Oct. 1919, MS 1416/ 1/7/31, Astor papers, 14; "Lady Astor," *Western Daily Mercury* (Plymouth), 28 Oct. 1919, MS 1416/1/7/31, Astor papers, 26, and "Lady Astor and Plymouth," *Western Morning News* (Plymouth), 27 Oct. 1919, MS 1416/1/7/31, Astor papers, 21. A thorough discussion, albeit contemporary, of the MP's constituent role can be found in Lisanne Radice, Elizabeth Vallance, and Virginia Willis, "The Job Outside the House," in *Member of Parliament: Job of a Backbencher* (London: Macmillan Press, 1987; reprint, 1988), 102-121. (page references are to reprint edition).

18. "Lady Astor and Plymouth," *Times* (London), 25 Oct. 1919, MS 1416/1/7/31, Astor papers, 15; "Vigorous Election Campaign," *Observer* (London), 2 Nov. 1919, MS 1416/1/7/31, Astor papers, 41; "Lady Astor," *Western Daily Mercury*, 26. A thorough account of the Astor war hospital at Cliveden is given in Sykes, *Nancy*, 173-207.

19. Hollis, 11-14; also Gerard, 203-204; "By-Election Issues," *Daily Herald* London), 4 Nov. 1919, MS 1416/1/7/31, Astor papers, 54; "The Plymouth Vacancy," *Daily Telegraph* (London), 27 Oct. 1919, MS 1416/1/7/31, Astor papers, 18; "Lady Astor and Plymouth," *Western Morning News*, 21.

20. "Sutton Election," *Western Morning News* (Plymouth), 28 Oct. 1919, MS 1416/ 1/7/31, Astor papers, 27.

21. *South Wales Daily News* (Cardiff), 27 Oct. 1919, MS 1416/1/7/31, Astor papers, 23. A candidate's conduct during a campaign, especially in initial acts, is often perceived as indicative of what is to come; that is, political surfacing implies a future dimension. See, for example, Judith S. Trent, "Presidential Surfacing: The Ritualistic and Crucial First Act," *Communication Monographs* 45 (Nov. 1978): 285.

22. The term *hustler* for Lady Astor's electioneering persona is derived from "The new Viscountess Astor . . . will introduce some real American 'hustle' methods into the contest" ("Viscountess Astor, M. P.?" *Daily Graphic* [London], 25 Oct. 1919, MS 1416/1/7/31, Astor papers, 16). At the time of the 1918 general election, Waldorf was parliamentary secretary to the Ministry of Food. ("Lady Astor and Plymouth," *Times* [London], 25 Oct. 1919, MS 1416/1/7/31, Astor papers, 15). For Waldorf's victory, see "Plymouth Election," *Daily Telegraph* (London), 4 Nov. 1919, MS 1416/1/7/31, Astor papers, 52. Astor's campaign style, as remembered by reporters prior to her own campaign, bears a strong resemblance to London's outdoor oratory described by J. Vernon Jensen as "a conversational confrontation entered into with earnestness, frankness, freedom, lack of organization, and an abundance of good humor" ("London's Outdoor Oratory," *Today's Speech* 15 [Feb. 1967]: 5).

23. "Lady Astor," *Western Daily Mercury*, 26; "Lady Astor Begins Her Fight," *Newcastle Illustrated*, 1 Nov. 1919, MS 1416/1/7/31, Astor papers, 37.

24. "A Gibson Girl M. P.?" *Lloyd's News*, 16; "'Our Nancy' for Plymouth," *Sunday Express* (London), 26 Oct. 1919, MS 1416/1/7/31, Astor papers, 17.

25. "Lady Astor and Plymouth," *Western Morning News*, 21.

26. *Daily Mail*, 25 Oct. 1919, MS1416/1/7/31, Astor papers, 14; "Lady Astor," *Daily Mail* (London), 27 Oct. 1919, MS 1416/1/7/31, Astor papers, 18; "Lady Astor, M.P.?" *Liverpool Post*, 16; "Lady Astor as Candidate," *Pall Mall Gazette*, 27 Oct. 1919, MS 1416/1/7/31, Astor papers, 20. Historian Josef Altholz has frequently commented, "The purpose of politics is to amuse the people" (Personal observations).

27. "Mr. Isaac Foot," *Western Morning News* (Plymouth), 28 Oct. 1919, MS 1416/1/7/31, Astor papers, 26; *Western Morning News* (Plymouth), 31 Oct. 1919, MS 1416/1/7/31, Astor papers, 33.

28. "Consciousness creating communication accounts for the innovation of the founding fantasies and ultimately for the development of the rhetorical vision. Consciousness raising communication enables the participants to attract and convert newcomers." (Bormann, "The Symbolic Convergence Theory," 76). In this essay (77-79) Bormann speaks of "breaking up the old foundations and pouring in the truth" in terms of group consciousness, but does not preclude its application to individual endeavor. For a series of studies which discuss the application of symbolic convergence theory to analyze and manage political campaigns, see Cragan and Shields, *Applied Communication Research*, 115-213. Rhetorical artifacts examined include Lady Astor's press release responding to the Pussyfoot charge, her first interview with the press (29 Oct. 1919), her second interview (1 Nov. 1919), a special interview with the *Observer* (1 Nov. 1919), her address to the electors, and her Adoption Day speech (3 Nov. 1919).

29. "No Pussyfoot," *Evening Standard* (London), 28 Oct. 1919, MS 1416/1/7/31, Astor papers, 25; "Lady Astor's Chance," *Eastern Daily Press*, 31 Oct. 1919, MS 1416/1/7/31, Astor papers, 33.

30. "Vigorous Election Campaign," *Observer* (London), 2 Nov. 1919, MS 1416/1/7/31, Astor papers, 41. For a brief discussion of British restrictions on drink during the war, see Clark, 137-138.

31. "The By-Elections," *Morning Post* (London), 13 Nov. 1919, MS 1416/1/7/31, Astor papers, 62. See also "Three Candidates for Plymouth," *Western Daily Mercury* (Plymouth), 4 Nov. 1919, MS 1416/1/7/31, Astor papers, 52.

32. One reporter noted that after she said she was "not coming as a warming pan," she gave "a sly look at Lord Astor" ("Lady 'Astorisms'," *Manchester Evening Chronicle*, 4 Nov. 1919, MS 1416/1/7/31, Astor papers, 47).

33. Ibid.; "Lady Astor," *Western Morning News* (Plymouth), 29 Oct. 1919, MS 1416/1/7/31, Astor papers, 30. Hollis (*Ladies Elect*, 472-473) defines "separate spheres" as "the work that only women could do for women" and describes it as "a language in which level-headed local government women talked about their practical and relevant experiences and not in some more mystical way about their essential nature." She said that "it was a supportive language" that "valued women's domestic background and showed how it could strengthen civic life." She also acknowledged that "it also carried a radical cutting edge" and pointed out that women entering the public arena "were refusing to accept

male definitions of what was central and what was marginal, that they were asserting that women's needs counted for as much as men's. The language of separate spheres helped give them the public space to say so." For additional commentary relating to the assumptions of "separate spheres," see Susan Kingsley Kent, "Gender Reconstruction After the First World War," in *British Feminism in the Twentieth Century*, ed. Harold L. Smith (Amherst: U of Mass. Press, 1990), 66-83, and Smith's own essay, "British Feminism in the 1920's," in the same work, 47-63.

34. "Vigorous Election Campaign," *Observer*, 41.

35. As man's world is often not open to woman, neither is woman's world open to man—a view that feminists in both Astor's day and in the modern era sometimes overlook.

36. *Daily Mail* correspondent as quoted in *Literary Digest*, 6 Dec. 1919, 51.

37. "Lady Astor," *Western Morning News*, 30.

38. "Sutton Election," *Western Evening Herald* (Plymouth), 4 Nov. 1919, MS 1416/1/7/31, Astor papers, 49. For a penetrating historical overview of acceptable/unacceptable stylistic patterns for both men and women, see Kathleen Hall Jamieson, "The 'Effeminate' Style," in *Eloquence in an Electronic Age: The Transformation of Political Speechmaking* (New York: Oxford UP, 1988), 67-89.

39. "Lady Astor," *Western Morning News*, 30; "Lady 'Astorisms'," *Manchester Evening Chronicle*, 47. For a brief description of the visit to France, see Winn, *Always a Virginian*, 131-132.

40. For a discussion of rhetorical character as agent, see Roderick P. Hart, *Modern Rhetorical Criticism* (Glenview, Ill.: Scott, Foresman/Little Brown Higher Education, 1990), 285-287. See also John Adams, "The Familial Image in Rhetoric," *Communication Quarterly* 31 (Winter 1983): 56-61.

41. "Lady 'Astorisms'," *Manchester Evening Chronicle*, 47.

42. Ibid.

43. "Notes of the Day," *Western Evening Herald* (Plymouth), 24 Oct. 1919, MS 1416/1/7/31, Astor papers, 14; Hart, *Modern Rhetorical Criticism*, 351. Hart's discussion of transcendence as "an incorporative device" stems from his understanding and interpretation of Kenneth Burke's "dramatism."

44. "Lady Astor," *Western Morning News*, 30; note also that in Astor's time, and even today, such a strong competitive nature is seen as a male attribute.

45. Ibid.; "Lady Astor's Ambition," *Evening Standard* (London), 1 Nov. 1919, MS 1416/1/7/31, Astor papers, 36; Nancy Astor, Plymouth, to the Electors of the Sutton Division of Plymouth, 3 Nov. 1919, MS 1416/1/1/1731, Astor papers; "Three Candidates for Plymouth," *Western Daily Mercury*, 52.

46. The distinctions between the serious and humorous modes of discourse are thoroughly discussed in Michael Mulkay, *On Humour* (Cambridge, England: Polity Press, 1988), 22-37. Signals indicating that a shift is being made from one mode to another are discussed in pages 39-56. "The name of the game is vote-getting" (Dan F. Hahn and Ruth M. Gonchar, "Political Myth: The Image and the Issue," *Today's Speech* 20 [Summer 1972]: 60); Mulkay, 22.

47. "Lady Astor," *Western Morning News*, 30. Although sometimes masked as "the returning Virginian," the persona of "returning pilgrim" continued on in Astor's career. See, for example, "So it's really not surprising that Virginians should be venturesome, and that one should come home" (Nancy Astor, *As I See It*); "Three Candidates for Plymouth," *Western Daily Mercury*, 52.

48. "Lady Astor," *Western Morning News*, 30-31.

49. The advantages of the incumbent are discussed in Larry Powell and Annette Shelby, "A Strategy of Assumed Incumbency," *Southern States Communication Journal* 46 (Winter 1981): 105-115; "Three Candidates for Plymouth," *Western Daily Mercury*, 52.

50. "Three Candidates for Plymouth," *Western Daily Mercury*, 52. For Drake, see also David Harris Willson, *A History of England*, 2d ed. (New York: Holt, Rinehart & Winston, 1972), 301-302.

51. "Tommy" comes from "Tommy Atkins," a generic name for a private in the British army. "Jack tar" is a colloquial term for a sailor. (*Chambers English Dictionary*, 1988 ed.). See also Rudyard Kipling, "Tommy," in *Kipling: A Selection of His Stories and Poems*, ed. John Beecroft (Garden City, NJ: Doubleday, 1956) 2: 491-492. "Going over the top," an expression from World War I, meant "to go over the front of a trench and attack the enemy" (*Chambers English Dictionary*, 1988 ed.). "Three Candidates for Plymouth," *Western Daily Mercury*, 52; "Bright and Breezy," *Daily Sketch*, 32.

52. "Plymouth Election," *Daily Telegraph* (London), 5 Nov. 1919, MS 1416/1/7/31, Astor papers, 62.

53. "Lady Astor's Election Campaign," *Evening Standard* (London), 4 Nov. 1919, MS 1416/1/7/31, Astor papers, 54.

54. "Three Candidates for Plymouth," *Western Daily Mercury*, 52.

CHAPTER TWO

1. Sykes, *Nancy*, 209-210; Frank Hawker, Plymouth, to the men and women of the Conservative and Unionist Association, Plymouth, TLS, 1 Nov. 1919, MS 1066/1/532, Waldorf Astor papers, Archives and Manuscripts, University of Reading Library, Reading, England; "Astorisms," *Express and Echo* (Exeter), 12 Nov. 1919 in MS 1416/1/7/32, Astor papers, 35. A contemporary analysis and discussion of the disturbances in the laboring classes, both those affiliated with the trade unions and with the Independent Labour Party who supported the doctrines of Socialism can be found in C. F. G. Masterman, "Social Unrest in Great Britain," *Atlantic Monthly*, Aug. 1919, 255-266. Masterman (257) summarizes the situation by stating, "The history of Labour during the four years of conflict is the history of a passage from high hopes and keen patriotic emotion at the beginning, to one at the end of disillusionment, class-hatred, and bitter distrust of government."

2. "The Final Week," *Daily Telegraph* (London), 11 Nov. 1919, MS 1416/1/7/32, Astor papers, 34; Arthur Henderson, Labour, had just won a by-election in

Widnes, a constituency that had had the reputation of being strongly Conservative. Plymouth also had a Conservative tradition, but political analysts felt that "anything may happen in these constituencies" ("Parliament This Week," *Times* [London], 20 Oct. 1919, 12); "By-Election Issues," *Daily Herald*, 54.

3. "Plymouth Prophets," *Evening Standard* (London), 15 Nov. 1919, MS 1416/1/7/ 32, Astor papers, 72; "Lady Astor and a Sailor," *Daily Chronicle*, (London), 5 Nov. 1919, MS 1416/1/7/31, Astor papers, 64.

4. "Lady Astor and Plymouth," *Times*, 15; "Lady Astor's Bet," *Daily Herald* (London), 11 Nov. 1919, MS 1416/1/7/32, Astor papers, 34; "A New Issue at Plymouth," *Times* (London), 14 Nov. 1919, MS 1416/1/7/32, Astor papers, 76; "Astorisms," *Express and Echo*, 35. "Wypers" was the English pronunciation of Ypres, a Belgian city that British and Canadian troops tried to protect during World War I. Three major battles were fought there—each with an overwhelming number of casualties, but a quarter of a million in the last battle. By the end of the war, Ypres came to be known as "an eerie, fog-shrouded wasteland populated chiefly with ghosts"(James L. Stokesbury, *A Short History of World War I* [New York: William Morrow, 1981], 242, 292). In short, "Wypers" meant "a ruined city."

5. "Plymouth Election," *Daily Telegraph* (London), 12 Nov. 1919, MS 1416/1/7/ 32, Astor papers, 41.

6. The purpose of "effective consciousness-raising communication" is "to gain converts who become active workers as well as a large group of people, less dedicated, but nonetheless sharing the group consciousness and willing to provide public support for the activities of the committed" (Bormann, *The Force of Fantasy*, 171).

7. The correspondent for the *Daily Telegraph* commented that scheduling meetings for women was "a wise course which brings her into close touch with the feminine voters. They at least are most determined to exercise the vote, and the choice they make will largely decide the election" ("The Final Week," *Daily Telegraph*, 34); for other meetings, see "Date of Plymouth Poll," *Scotsman* (Edinburgh), 5 Nov. 1919, MS 1416/1/7/31, Astor papers, 57; "Lady Astor Sums Up," *Globe* (London), 15 Nov. 1919, MS 1416/1/7/32, Astor papers, 81; "Lady Astor Makes a Compact," *Daily Chronicle* (London), 6 Nov. 1919, MS 1416/1/7/31, Astor papers, 82.

8. Handbills for women's meetings, 6 Nov. 1919-13 Nov. 1919, MS 1066/1/532, Waldorf Astor papers. Handbills and other campaign paraphernalia for Lady Astor's 1919 campaign were filed among Lord Astor's papers instead of her own; "Lively Questions at Plymouth," *Liverpool Courier*, 7 Nov. 1919, MS 1416/ 1/7/31, Astor papers, 90. Among others, Professor Ann Lowry, College of St. Catherine, St. Paul, Minnesota (interview by author, 13 June 1991, Minneapolis) and Professor Elizabeth Lipscomb, Randolph-Macon Women's College, Lynchburg, Virginia (interview by author, 27 April 1991, Minneapolis) contend that uninhibited discussion is a distinguishing feature of women's classes

in women's colleges today. The absence of men promotes freedom in female speech.

9. For "bawling babies," see "Lady Astor and the Women Voters," *Daily Chronicle* (London), 8 Nov. 1919, MS 1416/1/7/31, Astor papers, 98; for "cheering children," see "The Final Week," *Daily Telegraph*, 34. At the meeting at Laira Green Schools on Thursday, 6 Nov. 1919, one woman asked why they were all packed into a small room. Lady Astor replied, "Because the men arranged it" ("Organized Disorder," *Western Evening Herald* [Plymouth], 7 Nov. 1919, MS 1416/1/7/31, Astor papers, 91). See also "Lady Astor and Her Gaiety," *Evening Standard* (London), 8 Nov. 1919, MS 1416/1/7/31, Astor papers, 91; "Lady Astor and a Sailor," *Daily Chronicle*, 64; "Lady Astor Sums Up," *Globe*, 81; "Women in Politics," *Western Morning News* (Plymouth), 14 Nov. 1919, MS 1416/1/7/32, Astor papers, 76.

10. For example, Mrs. Spender Clay, Waldorf's sister Pauline, spoke at her first meeting and told how women in the division could help with the campaign. ("Date of Plymouth Poll," *Scotsman*, 57). Lyttelton is described in Collis, *Nancy Astor*, 84; Strachey, *The Cause*, 6. Strachey told her daughter, Mary, that she had coached Lady Astor for her meetings and for her maiden speech and that "she is a hopeless speaker" (Ray Strachey to Mary Berenson, 14 Feb. 1920, Mary Berenson Collection, Smith Archives, Oxford, quoted in Johanna Alberti, *Beyond Suffrage* [New York: St. Martin's Press, 1989], 97-98). According to Alberti, Strachey left Astor in the summer of 1920 in order to devote time to her own writing.

11. The analysis of Astor's speeches delivered at women's meetings is based upon those given at Pitt's Memorial Hall (4 Nov. 1919), St. Jude's Church Room (5 Nov. 1919), St. Augustine's Parish Hall (6 Nov. 1919), Laira Green Schools (6 and 7 Nov. 1919), Palace Street Schools (10 Nov. 1919), St. James-the-Less Parish Hall (13 Nov. 1919), and the Plymouth Guildhall (14 Nov. 1919). For a discussion of boundary establishment in the development of group consciousness, see Bormann, " Symbolic Convergence Theory," 77-78.

12. Handbills for meetings (24), 4 Nov. 1919-14 Nov. 1919, in MS 1066/1/532, Waldorf Astor papers.

13. "Organized Disorder," *Western Evening Herald*, 91.

14. "The Final Week," *Daily Telegraph*, 34.

15. "Date of Plymouth Poll," *Scotsman*, 57; "The Final Week," *Daily Telegraph*, 34. For a discussion of the common structural techniques used in persuasion, see Hart, 156-171, especially 162. Note also "Approval of one's own political grouping combined with denigration of other's views and actions appears to be a basic structural principle within political language" (Mulkay, 205).

16. "Date of Plymouth Poll," *Scotsman*, 57; "Plymouth's Triangular Contest," *Scotsman* (Edinburgh), 6 Nov. 1919, MS 1416/1/7/31, Astor papers, 82; for further discussion of the view of women's superiority in spiritual matters, see Karlyn Kohrs Campbell, "Femininity and Feminism: To Be or Not To Be a Woman," *Communication Quarterly* 31 (Spring 1983): 101-102.

17. Gwladys Jones, "Lady Astor Makes a Compact," *Daily Chronicle*, 82.

18. "Partnership Policy," *Western Morning News* (Plymouth), 14 Nov. 1919, MS 1416/1/7/32, Astor papers, 74. Astor discussed her policy in greater depth in statements she prepared for the press. For example, in an interview published as "A Little 'General,'" *Morning Post* (London), 5 Nov. 1919, MS 1416/1/7/31, Astor papers, 64, she discussed the Irish question, the Unionist party, tariff reform, the League of Nations, war profits, prohibition, and the woman's point of view. She discussed her views on prohibition at length for the same paper a few days later. ("Lady Astor's Fight at Plymouth," *Morning Post* [London], 7 Nov. 1919, MS 1416/1/7/31, Astor papers, 86.)

19. "Plymouth's Triangular Contest," *Scotsman*, 82; "The Final Week," *Daily Telegraph*, 34.

20. "Lady Astor's Ideals," *Western Evening Herald* (Plymouth) 5 Nov. 1919, MS 1416/1/7/31, Astor papers, 58. One audience member taunted her with the question, "Why don't you go work in America?" Astor replied, "I left America to better myself. I married a gentleman who is an English citizen" ("Organized Disorder," *Western Evening Herald*, 91).

21. "Date of Plymouth Poll," *Scotsman*, 57. For a discussion of the "active audience" as a characteristic feature of modern rhetoric, see Barry Brummett, "A Justification for the Concept of the 'Active Audience' with Some Implications for Rhetorical Theory" (Ph.D. diss., University of Minnesota, 1978).

22. "Lady Astor's Ideals," *Western Evening Herald*, 58; "Lady Astor's Success," *Western Morning News* (Plymouth), 5 Nov. 1919, MS 1416/1/7/31, Astor papers, 57. Astor's practice seemed to coincide with her notions about public speaking: "But the whole secret of speaking really is, whether you have got something to say. If you've got something in your heart that you feel you simply must say out, it's all right, even if your words aren't perfect. People see you're in earnest and they listen" (Lady Astor, "My First Year in Parliament," interview, *Pearson's Magazine*, June 1921, 464, MS 1416/1/7/45, Astor papers, 47).

23. "Lady Astor and Plymouth," *Western Morning News*, 21. At the Baby Week exhibition, she quieted a crying baby by allowing him to play with her rope of pearls.

24. "Lady Astor and her Gaiety," *Evening Standard*, 97.

25. "Lively Questions at Plymouth," *Liverpool Courier*, 90; "The Final Week," *Daily Telegraph*, 34.

26. "Lady Astor and the Women Voters," *Daily Chronicle*, 98.

27. The relationship between self-disclosure and vulnerability and the relationship between self-disclosure and reciprocity is discussed in Gerald R. Miller and Mark Steinberg, *Between People* (Chicago: Science Research Associates, 1975), 309-325.

28. For an excellent discussion of "situational humour," see Mulkay, 57-72.

29. "Lady Astor and a Sailor," *Daily Chronicle*, 64.

30. Ibid.; in discussing his or her response to Astor's meetings, a reporter for the *Daily Telegraph* commented, "You laugh and participate in the exhilaration that the whole audience shares. I have rarely known meetings which broke up so thoroughly refreshed that all have been having a good time" ("Plymouth

Election," *Daily Telegraph* [London], 6 Nov. 1919, MS 1416/1/7/31, Astor papers, 83).

31. Gwladys Jones, "Lady Astor Makes a Compact," *Daily Chronicle*, 82; "Lady Astor's Success," *Western Morning News*, 57.

32. "Her Winning Way," *Daily Mirror* (London), 7 Nov. 1919, in MS 1416/1/7/31, Astor papers, 93.

33. Ibid.

34. "The Final Week," *Daily Telegraph*, 34. According to Black, "There is a second persona also implied by a discourse, and that persona is its implied auditor" (Edwin Black, "The Second Persona," *Quarterly Journal of Speech* 56 [April 1970]: 111).

35. "Lady Astor and a Sailor," *Daily Chronicle*, 67.

36. "The Final Week," *Daily Telegraph*, 34; "Organized Disorder," *Western Evening Herald*, 91. Astor's part in the development of the Canadian cemetery is discussed in Sykes, *Nancy*, 200-205.

37. *Western Daily Mercury* (Plymouth), 12 Nov. 1919, MS 1416/1/7/32, Astor papers, 46.

38. Robert Blythe, *The Age of Illusion* (London: H. Hamilton, 1963; Oxford: Oxford UP, 1983; reprint, Oxford: Oxford UP, 1986), 7 (page reference is to reprint edition). Blythe (1) himself takes a contrary view: "No more innocent generation was ever destroyed so ignorantly or so thoroughly."

39. John 3:16. Blythe also reports, "A popular print which found its way into thousands of British homes showed a handsome Tommy sprawling at the foot of the Cross. It was called 'The Great Sacrifice' and it invited comparison" (*The Age of Illusion*, 1). The linkage between personae and ideology is discussed and illustrated in Black, "The Second Persona," 112-119.

40. Isaac Foot, especially, thought her speeches were weak. ("Revolt by Stages," *Western Morning News* [Plymouth], 14 Nov. 1919, MS 1416/1/7/32, Astor papers, 72).

41. "Lady Astor's Hecklers," *Daily News* (London), 8 Nov. 1919, MS 1416/1/7/31, Astor papers, 98.

42. "Plymouth Election," *Daily Telegraph*, 83.

43. "Astorisms," *Express and Echo* (Exeter), 12 Nov. 1919, MS 1416/1/7/32, Astor papers, 35. In addition to those who were Gay and Foot supporters, Lady Astor's male opponents also included members of the "Trade" and those Unionists "disposed to abstain from voting for Lady Astor on no better ground than that she is a woman" ("Queries at Plymouth," *Morning Post* [London], 11 Nov. 1919, MS 1416/1/7/32, Astor papers, 34, and "Notes in the West," *Western Morning News* [Plymouth], 14 Nov. 1919, MS 1416/1/7/32, Astor papers, 77).

44. Astor's reaction to the number of pressmen, presswomen and photographers waiting to cover her first constituency tour is covered in "Lady Astor vs. the Press" in chapter 3. Rhetorical artifacts examined include Astor's talks at open-air meetings on 4 November 1919, 6 November 1919, 8 November 1919, 11 November 1919, and 13 November 1919, and indoor appearances on 11

November 1919 (Law Chambers), 12 November 1919 (Marines), and 13 November 1919 (Royal Garrison Artillery).

45. "Heckling Lady Astor," *Leeds Mercury*, 6 Nov. 1919, MS 1416/1/7/31, Astor papers, 73, and "No Courtesies Wasted at Plymouth," *Yorkshire Observer* (Bradford), 6 Nov. 1919, MS 1416/1/7/31, Astor papers, 86. The Associated Press story called Astor's coachman "Churchwood." ("Drives Lady Astor to Win," *Chicago News*, 1 Dec. 1919, MS 1416/1/7/2, Astor papers, 17).

46. "Answers to Hecklers," *Observer* (London), 9 Nov. 1919, MS 1416/1/7/32, Astor papers, 10.

47. Ibid.

48. "Politics Forgotten at Slum Dance," *Daily Express* (London), 10 Nov. 1919, MS 1416/1/7/32, Astor papers, 17. Earlier on Astor had entertained another group of children by mimicking an old-time election address. "Right arm outflung," and speaking in the "solemn cadences of a conventional political speech," she had said, "Electors of Plymouth, when I look into your faces I want to pass a Bill to provide every child in Plymouth over the age of three shall have the vote. Would you vote for me?" (Gwladys Jones, "Lady Astor Makes a Compact," *Daily Chronicle*, 82).

49. "Not Here for a Beano!" *Globe* (London), 12 Nov. 1919, MS 1416/1/7/32, Astor papers, 52; "Plymouth Liberalism," *Morning Post* (London), 12 Nov. 1919, MS 1416/1/7/32, Astor papers, 40.

50. "Partnership Policy," *Western Morning News* (Plymouth), 14 Nov. 1919, MS 1416/1/7/32, Astor papers, 74. The *Liverpool Courier* identified Seddon as "the Labour leader, who, as president of the Trade Union Congress in 1914, had a prominent share in the reunion of the Congress Committee to support the Government in the prosecution of the war" ("Lady Astor's Campaign," 14 Nov. 1919, MS 1416/1/7/32, Astor papers, 76).

51. "Lady Astor's Campaign, *Liverpool Courier*, 76.

52. "Partnership Policy, *Western Morning News*, 74; both Astor and the ex-soldier allude to the remark that Lloyd George made when he launched his 1918 campaign with a program for reconstruction at Wolverhampton on 24 November 1918. He then said that he hoped to "make Britain a fit country for heroes to live in" (Pugh, *Lloyd George*, 127). During the next year, "land fit for heroes" became the symbolic cue referring to both a common hope and the subsequent disillusion when it failed to materialize as some had anticipated. For more on "the symbolic cue phenomenon," see Bormann, *Force of Fantasy*, 6-9.

53. "Lady Astor's Campaign," *Liverpool Courier*, 76; "Fighting Spirit," *Western Morning News* (Plymouth), 15 Nov. 1919, MS 1416/1/7/32, Astor papers, 78. As early as 2 November 1919, the *Observer* had reported that Astor was devoted to the men of the lower deck and their wives and had already received a resolution of support from the Devonport Joint Committee of the Lower Deck Benevolent Association. ("Vigorous Election Campaign," 41).

54. "Lady Astor with the Marines," *Daily Chronicle* (London), 13 Nov. 1919, MS 1416/1/7/32, Astor papers, 56.

55. Ibid.

56. "Lady Astor's Campaign," *Liverpool Courier*, 76. The *Courier* correspondent credits the *Daily Express* (London) for the story of Astor's visit with the marines.

57. Both the *Liverpool Courier* and the *Western Morning News* (Plymouth) briefly covered Astor's visit to the headquarters of the Royal Garrison Artillery. Selborne [Earl], London, to [Viscount] Astor, Plymouth, TLS, 31 Oct. 1919, in MS 1416/2/17, Astor papers; Astor [Viscount], Plymouth, to [Earl] Selborne, London, TLS, 2 Nov. 1919, in MS 1416/2/17, Astor papers. Selborne then returned Lord Astor's letter, writing in "Proud/S" beside Astor's request.

58. Lady Astor, "Lady Astor Tells Story of Election; Announces Stand," *Buffalo Courier*, 1 Dec. 1919, MS 1416/1/7/2, Astor papers, 17; "The Premier's Greeting to Lady Astor," *Yorkshire Observer* (Bradford), 10 Nov. 1919, MS 1416/1/7/32, Astor papers, 18.

59. Astor, like many modern day speakers, found it necessary to play a double role, both as "flesh and blood" speaker and as "image" for dispersal by the media. See, for example, Hart, *Modern Rhetorical Criticism*, 81-82.

60. "The press reached perhaps its highest point of influence during the First World War. Radio was in the future" (A. J. P. Taylor, *English History*, 55). For a thorough discussion of media influences upon political speechmaking, see Jamieson, *Eloquence in an Electronic Age: The Transformation of Political Speechmaking* and Dan Nimmo and James E. Combs, *Mediated Political Realities* (New York: Longman, 1983), especially 162-181. For "Astorisms," note, "She had the gift of speaking in headlines" (Jeanette Eaton, "Nancy Astor: Myth and Woman," *North American Review*, April 1929, 386). Astor's campaign was covered in the newsreel, Hearst News No. 50. ("Lady Astor as She Appeared on Stump," *Chicago News*, 1 Dec. 1919, MS 1416/1/7/2, Astor papers, 18). For *homo narrans*, see Walter R. Fisher, *Human Communication as Narration: Toward a Philosophy of Reason, Value, and Action* (Columbia: University of South Carolina Press, 1987), 62, and Robert L. Scott, "Narrative Theory and Communication Research," *Quarterly Journal of Speech* 70 (May 1984): 197-204. Robert L. Scott suggests that readers of communication research need to "think in terms of narrative *one* and narrative *two*." He describes narrative *one* as the critic's account and narrative *two* as "the social reality constructed by those actors studied." Applied to the present work, narrative *one* would be the author's interpretative account of Astor's daytime meetings; narrative *two* would be what Astor did or said at them to attract audience interest. Scott's suggestion misses the fact that the social reality Astor created was mediated, captured by the press. The author then recommends that narrative theorists consider at least three levels: narrative *one*, the critic's work (storymaster); narrative *two*, the reporter/narrator's work (storyteller); and narrative *three*, the effort/rhetorical act of the actor him/herself (storymaker). Numbers increase as different roles and transformations take place. Readers and writers of rhetorical criticism need to think in terms of multiple narratives.

61. Rhetorical artifacts examined for Astor's evening meetings include speeches and/or remarks given at Mutley Baptist School, 4 November 1919; a League

of Nations meeting at the Guildhall, 6 November 1919; at Prince Rock Schools and Laira Green Schools, 10 November 1919; at Shaftesbury Schools, 11 November 1919; and at St. Jude's Mission Hall, 13 November 13, 1919. Other evening meetings scheduled for Astor's campaign included gatherings at Mount Street Schools and St. James-the-Less Parish Hall, 5 November 1919; at Palace Street Schools and Embankment Road Schools, 6 November 1919; Mosley at Mutley Baptist School and Lower Compton School, 6 November 1919; Mosley at Palace Street Schools, 7 November 1919; at Mutley Baptist School, Cattledown Road Schools, and Lockyer Hall, 12 November 1919. Talks at these latter events were either not reported by the press, or, if so, not kept in the Astor files. Handbills for meetings [24], 4 Nov. 1919-14 Nov. 1919, MS1066/1/532, Waldorf Astor papers; MS1066/1/532. Astor's opponents also scheduled numerous meetings, especially during the second week. One reporter called the campaign a "torrent of oratory" ("Lady Astor's Winning Fight," *Birmingham Post*, 10 Nov. 1919, MS 1416/1/7/32, Astor papers, 12).

62. For an example of Briggs's other activities, see C. G. Briggs, Plymouth, to Lord Astor, Plymouth, TLS, 4 Nov. 1919, MS 1066/1/530, Waldorf Astor papers. Handbills for meetings, 4 Nov. 1919-7 Nov. 1919, MS 1066/1/532, Waldorf Astor papers.

63. Handbills for meetings, 10 Nov. 1919-13 Nov. 1919, in MS 1066/1/532, Waldorf Astor papers. The handbill for the meetings scheduled for 12 November carried, "Put your country above party/Vote for Astor and Lloyd George."

64. "England in Peril," *Western Daily Press* (Bristol), 11 Nov. 1919, MS 1416/1/7/32, Astor papers, 36. Waldorf had arranged Jones's appearance. (Waldorf Astor, Plymouth, to Sir Henry Jones, Glasgow, TLS (copy), 5 Nov. 1919, MS 1066/1/530, Waldorf Astor papers). For Seddon's visit, see "Lady Astor's Campaign," *Liverpool Courier*, 76. Mosley (1896-1980) became a political chameleon, standing in the 1920s as a Conservative, Independent, and a member of the ILP. In the 1930s he founded the New Party and later tried to establish and lead a British Fascist movement, which failed miserably. In 1940, he was arrested and detained for his political views. (Richard Griffiths, "Mosley, Oswald," in *Dictionary of National Biography*. See also Nicolas Mosley, *Rules of the Game: Sir Oswald and Lady Cynthia Mosley 1896-1933* [Secker and Warburg: London, 1982], 10, 25). Waldorf Astor moved to the newly established Ministry of Health in the summer of 1919 to serve as parliamentary secretary to its first chief, Christopher Addison. (Sykes, *Nancy*, 210). See also Waldorf Astor, Plymouth, to Hughes Gibb, London TLS (copy), 2 Nov. 1919, in MS 1066/1/530, Waldorf Astor papers.

65. "Plymouth Election," *Daily Telegraph* (London), 7 Nov. 1919, MS 1416/1/7/31, Astor papers, 85.

66. Ibid. See also W. T. Gay, Plymouth, to the Electors of the Sutton Division of Plymouth, MS 1066/1/532, Waldorf Astor papers. This letter, apparently one

of Gay's official campaign documents, mentions both the "dockyard discharges" and "nationalisation."

67. "Audacious Nancy," *Manchester Chronicle,* 12 Nov. 1919, MS 1416/1/7/32, Astor papers, 35; "Deeds Not Words," Astor campaign leaflet, MS 1066/1/532, Waldorf Astor papers; "Lady Astor's Fight at Plymouth," *Morning Post,* 86.

68. "England in Peril," *Western Daily Press,* 36; "Plymouth Election," *Daily Telegraph,* 41; "Audacious Nancy," *Manchester Chronicle,* 35. In the 1918 election Waldorf's electoral total was 17,091. His majority was 11,757. Lady Astor followed her statement with the afterthought, "Like a lot of other great people, I am a bit sloppy about figures" ("Plymouth Election," *Daily Telegraph,* 85).

69. Hart (*Modern Rhetorical Criticism,* 388) remarks that "all messages are intertwined. No text can be understood unless viewed in the light . . . of its persuasive field, the messages to which the text responds and which respond to it." Earlier in discussing the persuasive field, he stated that "all messages contain the ghosts of other messages."

70. "Plymouth Prophets," *Evening Standard* (London), 14 Nov. 1919, MS1416/1/7/32, Astor papers, 72.

71. Ibid. For an account of Lady Astor's later relationship with her maid Rosina Harrison, see Harrison's *Rose: My Life in Service* (New York: Viking, 1975).

72. "Audacious Nancy," *Manchester Chronicle,* 35.

73. Ibid

74. "Plymouth Election," *Daily Telegraph,* 41.

75. Both William Gay and Isaac Foot had guest speakers working for their election. See, for example, "No Courtesies Wasted at Plymouth," *Yorkshire Observer* (Bradford), 6 Nov. 1919, MS 1416/1/7/31. Astor papers, 86, and "Help for Plymouth/Liberal Speakers Needed for Mr. Foot," *Westminster Gazette* (London), 8 Nov. 1919, MS 1416/1/7/31, Astor papers, 98.

76. "Peace, Progress and Prosperity" was a major slogan in Astor's campaign. (Nancy Astor, Plymouth, to the Electors of the Sutton Division of Plymouth, "First Electioneering Address").

77. Apparently Waldorf did not prompt as often as he wished. According to one correspondent, he "admitted that he is often a little worried on his wife's account, as he never knows what she is going to say or do next. He confesses to desperate attempts to catch her eye, generally unavailing ones" ("No Courtesies Wasted at Plymouth," *Yorkshire Observer,* 86).

78. "Audacious Nancy," *Manchester Chronicle,* 35; "Laughing to Victory," *Evening Standard* (London), 6 Nov. 1919, MS 1416/1/7/31, Astor papers, 70.

79. Critic Kenneth Burke might say this circumstance reflects a universal condition, "the unending conversation" of our lives. Kenneth Burke, *The Philosophy of Literary Form: Studies in Symbolic Action,* 3d ed. (Baton Rouge: Louisiana State UP, 1941; reprint, Berkeley: University of California Press, 1973), 110-111 (page references are to reprint edition), quoted in Sonja K. Foss, Karen A. Foss, and Robert Trapp, *Contemporary Perspectives on Rhetoric* (Prospect Heights, Ill.: Waveland Press, 1985), 241.

80. Nicholas V. Riasanovsky, *A History of Russia*, 4th ed. (New York: Oxford UP, 1984), 477-483; Beryl Williams, *The Russian Revolution 1917-1921*, Publication of the Historical Association, eds. Roger Mettam and James Shields (Oxford: Basil Blackwell, 1987), 68.

81. 81.Williams, *Russian Revolution*, 69; Riasanovsky, *A History of Russia*, 486. On 8 November, Lloyd George had said, "Bolshevism, with its dangerous doctrines, could not be suppressed by the sword" ("After a Year of Peace," *Manchester Guardian*, 10 Nov. 1919, 10).

82. Riasanovsky, *A History of Russia*, 486; Williams, *Russian Revolution*, 68. For a discussion of Churchill's persistent support of the White Russians, see Kenneth Morgan, *Consensus and Disunity: The Lloyd George Coalition Government 1918-1922* (Oxford: Clarendon Press, 1979; reprint, New York: Oxford UP, 1986), 134-135 (page references are to reprint edition) and Pugh, *Lloyd George*, 137. For the viewpoint of the Asquithism Liberals, see "Mr. Foot's Queries," *Western Daily Mercury* (Plymouth), 11 Nov. 1919, MS 1416/1/7/32, Astor papers, 31.

83. "After a Year of Peace," *Manchester Guardian*, 9-10.

84. Ibid.

85. "Premier's Russian Policy," *Manchester Guardian*, 13 Nov. 1919, 6; "The Prime Minister at the Guildhall," *Manchester Guardian*, 10 Nov. 1919, 8; "Mr. Foot's Queries," *Western Daily Mercury*, 31. Gay also remarked that £100,000,000 "would have defrayed the cost of some hundreds of thousands of urgently needed houses" (William Gay, "Letter to the Electors," 3).

86. "Mr. Foot's Queries," *Western Daily Mercury*, 31.

87. "England in Peril, *Western Daily Press*, 36; for capital levy, see F. W. Pethick-Lawrence, *The Capital Levy (How the Labour Party Would Settle the War Debt)* (London: Labour Party, 1918), 3.

88. "Astorisms," *Express and Echo*, 35.

89. "England in Peril," *Western Daily Press*, 36.

90. Kenneth Burke would contend that "the discussion is interminable." (Burke as quoted in Foss, Foss, and Trapp, 241).

CHAPTER THREE

1. Frank Hawker, Plymouth, to Plymouth Men and Women of the Conservative and Unionist Association, 1 Nov. 1919, MS 1066/1/532, Waldorf Astor papers. Hawker and Briggs may have been the men who packed women into a small room and small desks at Laira Green Schools on 6 November. ("Organized Disorder," *Western Evening Herald*, 91). The *New York Times* described the Astors' home as "an information bureau" where Lady Astor received "callers and volunteers" and offered "her help to deputations" ("Lady Astor's Quips Amuse Plymouth," 6 Nov. 1919, 13). For Briggs's efforts, note Waldorf Astor, Plymouth, to Sir Charles A. Hanson, London, TLS (copy), 2 Nov. 1919, MS1066/1/530, Waldorf Astor papers, and C. G. Briggs, Plymouth, to Lord Astor, Plymouth, TLS, 4 Nov. 1919, MS 1066/1/530, Waldorf Astor papers.

For the work of the Primrose League, see "Plymouth Liberalism," *Morning Post* (London), 12 Nov. 1919, MS 1416/1/7/32, Astor papers, 41. The Primrose League was founded in 1883. "Ostensibly in memory of Disraeli, it was a Tory militia,' organized like a lodge, with local chapters, regional and national gatherings, officers with high-flown titles, orders, decorations, a strong appeal to women, and an endless succession of tea parties" (Webb, *Modern England*, 425).

2. "Date of Plymouth Poll," *Scotsman*, 57; "Lady Astor and the Women," *Western Daily Mercury* (Plymouth), 4 Nov. 1919, MS1416/1/7/31, Astor papers, 52.

3. Gates, *Astor Family*, 225-226.

4. *Chambers English Dictionary*, 1988 ed.; Webb, *Modern England*, 497. For more on the "coupon," see Alfred F. Havighurst, *Britain in Transition*, 147-151; Morgan, *Consensus and Disunity*, 26-45; A. J. P. Taylor, *English History*, 171-176; and McEwen, "The Coupon Election," 295. Taylor did not think that the coupon injured the Liberal party, contending that "The coupon was Lloyd George's device to save as many Liberals as he could. Without it the Unionists would have swept the country. As it was, 'more Liberals were elected in 1918 than ever after'" (Taylor, *English History*, 172). For negative views of the Coupon Election, see Havighurst, *Britain in Transition*, 148; Keynes, *Economic Consequences*, 137-148; and "Three Candidates for Plymouth," *Western Daily Mercury*, 51. Isaac Foot told the *Mercury* that the Coupon Election was "one of the biggest frauds in political history."

5. "Mr. Foot's Letter to the Premier," *Manchester Guardian*, 12 Nov. 1919, in MS 1416/1/7/32, Astor papers, 38. Most of Lady Astor's letters of endorsement are placed among her papers (MS1416/2/17) in a file folder labeled "Election—1919/ Letters for Press/ Testimonials.'" Each has a short penciled inscription at the top stating its press destination (usually the Plymouth papers, the *Western Morning News*, the *Western Daily Mercury*, the *Western Evening Herald* and occasionally the Press Association) and the initials "L. E. C." or the request, "Please Return to Miss Cundy." These "testimonials" include statements from Christopher Addison, MP, Minister of Health; Arthur James Balfour, Unionist Prime Minister (1902-1905) and current Lord President of the Council; Lord Robert Cecil, MP; Herbert A. L. Fisher, President of the Board of Education; David Lloyd George, Prime Minister; Walter H. Long, First Lord of the Admiralty; F. B. Mildmay, MP Totnes, Isaac Foot's 1910 (January) opponent; G. H. Roberts, MP, Minister of Food; the Earl of Selborne, formerly First Lord of the Admiralty; and George J. Wardle, MP, Parliamentary Secretary to the Ministry of Labour. Press reports indicate she also received "cordial messages" from Admiral Sir George Egerton, late Commander-in-Chief, Plymouth, and General Sir William Pitcairn Campbell, and a telegram from Bonar Law, leader of the Coalition Unionists ("Lady Astor Going Strong," *Evening Standard*, 10). Waldorf's correspondence also contains a letter for publication from Sir Charles A. Hanson, MP, Isaac Foot's opponent in the 1918 election in Southeast Cornwall.

6. Sykes, *Nancy*, 221.

7. D. Lloyd George, London, to Lady Astor, Plymouth, TLS, 7 Nov. 1919, MS1416/2/17, Astor papers.

8. In 1918, the coupon had been given to Foot's opponent Sir Charles A. Hanson, Conservative, who defeated him by over 3,000 votes. ("Sutton Election," *Western Morning News*, 27). In writing to Lady Astor, Hanson, who was unable to accept a speaking engagement for her, commented, "Nothing on earth would give me greater pleasure than to have a whack at your opponents, particularly my old opponent, Mr. Isaac Foot, who has never found it possible to get away from John Stewart [sic] Mill and Edmund Burke." (Sir Charles A. Hanson, London, to Lady Astor, TLS, 2 Nov. 1919, MS 1066/1/530, Waldorf Astor papers).

9. "Lady Astor's Quips Amuse Plymouth," *New York Times*, 6 Nov. 1919, 13.

10. MS1066/1/530 and MS1066/1/532, Waldorf Astor papers. One two-by-three-foot poster proclaimed "Lloyd George LIBERAL Prime Minister/ Bonar Law UNIONIST Leader/ Geo. J. Wardle LABOUR Party in 1916/ Chairman of the Parliamentary/ ALL ADVISE YOU TO/ VOTE FOR LADY ASTOR." (MS 1066/1/532, Waldorf Astor papers). For LadyAstor's local support, see "Electors!" Astor campaign leaflet, MS1066/1/532, Waldorf Astor papers.

11. MS1066/1/532, Waldorf Astor papers.

12. For a discussion of the social program of the Coalition government at this time, see Morgan, *Consensus and Disunity*, 80-108. For issues of importance to Lady Astor, see "Deeds Not Words," Astor campaign leaflet, MS1066/1/532, Waldorf Astor papers, and "The Dockyards," Astor campaign leaflet, MS1066/1/532, Waldorf Astor papers.

13. Lord Astor, Plymouth, to C. G. Briggs, Plymouth, TLS, 4 Nov. 1919, MS1066/1/530, Waldorf Astor papers.

14. Photo, *Globe* (London), 15 Nov. 1919, MS1416/1/7/32, Astor papers, 86, and Photo, *Daily Mirror* (London), 15 Nov. 1919, MS1416/1/7/32, Astor papers, 87; Lord Astor, Plymouth, to Comrades of the Great War, TLS (copy), 11 Nov. 1919, MS1066/1/531, Waldorf Astor papers; Lord Astor, Plymouth, to Horse Breeders, TLS (copy), MS1066/1/531, Waldorf Astor papers.

15. "A Little 'General,'" *Morning Post* (London), 5 Nov. 1919, MS1416/1/7/31, Astor papers, 64. Later, Waldorf expressed his feelings on the way Nancy appeared in print when he described his role in the preparation of Nancy's speeches during her 1922 North American tour. On Wednesday, 3 May 1922, he complained about Nancy's split infinitives and "other crimes of grammar." (Waldorf Astor, "American Visit Diary," TMS, 3 May 1922, MS1416/2/16, Waldorf Astor papers, 20-21).

16. "A Little "General,'" *Morning Post*, 64.

17. "Lady Astor's Quips Amuse Plymouth," *New York Times*, 13.

18. "Idle Rich," Gay campaign leaflet, MS1066/1/530, Waldorf Astor papers. Other Gay posters and handbills carried the slogans: "95 MILLIONS/ for Russian autocracy/ Unemployment/ for Jack and Tommy/ Vote for Gay/ Sack the Coalition/ or be sacked"; "Sutton Division/ Coalition to Navy Heroes/

You've done your 12/ Get out!/ Vote Labour this time"; and "The 'Dockyardie'/ to stay/if you vote/ for Gay."

19. Memo, TL, MS1066/1/531, Waldorf Astor papers. The memo was filed by a pamphlet, "What is the I.L.P.?" published by the National Unionist Association. The writers of the pamphlet attempt to distinguish between acceptable Labourites, such as Arthur Henderson, and those ILP leaders, Ramsay Mac-Donald, MP, and Philip Snowden, MP, who were disparaged for failing to support conscription during the war. Scouting reports, typed sketches, in MS1066/1/531, Waldorf Astor papers; Sir B. Thomsen, London, to Hughes Gibb, London, TLS, n.d., MS1066/1/531, Waldorf Astor papers; for Basil Thompson, see Morgan, *Consensus and Disunity*, 52-53, and Taylor, *English History*, 331.

20. Bevin was highly praised as a speaker. ("Wind-Up of First Week's Electioneering," *Western Daily Mercury* [Plymouth], 10 Nov. 1919, MS1416/1/7/32, Astor papers, 26). The Gay supporter who did capture press attention was a Mrs. Evans, an American. ("Lady Astor's Bet," *Daily Herald* [London], 34.)

21. "Lady Astor's Quips Amuse Plymouth, " *New York Times*, 13; C. G. Briggs, Plymouth, to Miss Beningfield, Plymouth, TLS, n.d., in MS1066/1/531, Waldorf Astor papers.

22. "Lady Astor's Going Strong," *Evening Standard*, 10; Lord Astor, Plymouth, to Miss Thomas, London, TLS (copy), MS1066/1/530, Waldorf Astor papers.

23. The reporter for the *Guardian* wrote, "The audible prompting with which Lord Astor and others on her platform assist her out of the most elementary difficulties has caused more than one aggrieved questioner to doubt who is the real candidate" ("Polling Today," *Manchester Guardian*, 15 Nov. 1919, MS1416/1/7/32, Astor papers, 89); Gates, *Astor Family*, 238.

24. Ghostwriting, even to this day, may not be as prevalent in Britain as it is in the United States. Unlike the U.S. Congress, where reading into the record is accepted, parliamentary practice requires extemporaneous speaking. As a result, MPs, who may be assisted by staff in preparatory work, deliver their remarks with very few notes. If "ghosts" are employed, they usually assist high-ranking officials who find themselves compelled to speak for the government. (Mr. David R. Beamish, House of Lords Establishment Office, interview by author, 31 October 1988, London.)

25. Remaining speech texts are filed in MS1066/1/530, Waldorf Astor papers. If other notes or texts existed, it is possible that they were destroyed in World War II. When Phyllis Ayers wrote Lady Astor in 1954 for material to use in connection with her "research purpose," Astor replied that "I was so busy living—I never kept a diary. Many papers destroyed in the Blitz." (Phyllis Ayers, "The Public Career of Lady Astor" [Ph.D. diss., University of Pittsburgh, 1958], 150). A speech titled "Lady Astor's Views on the Drink Problem" includes the phrase, "You voted for my husband." MS1066/1/530, Waldorf Astor papers. Another text includes the sarcastic comment that Mr. Foot might want to "give every mother a cannon." (See "England in Peril," *Western Daily Press*, 36). The third relates to Coalition social policies.

26. "No Courtesies Wasted at Plymouth," 86. For empathic communication, see "Scripted and Unscripted Interaction," "Two Modes of Interpersonal Communication," and "Public Speaking" in William S. Howell, *The Empathic Communicator* (Belmont, CA.: Wadsworth, 1982), 4-5, 35-37, 224-226.

27. In his discussion of ghostwriting, Ernest G. Bormann states, "Style is the most personal aspect of speechmaking" and contends that "it is in this area that the ghost's influence is most destructive and subtle" ("Ghostwriting and the Rhetorical Critic," *Quarterly Journal of Speech* 46 [October 1960]: 285). Stylistically, Lady Astor's speeches resembled Lloyd George's more than they did Waldorf's. Lloyd George's speeches, for example, have been described as "informal and homely, with short, digestible sentences and pithy asides, freely punctuated with biblical allusions and pictures painted from nature in which mountains, trees and storms figured prominently. Above all, he wielded the essential weapons of the stump orator—humour and wit." (Pugh, *Lloyd George,* 31-32). The analysis of Waldorf's speeches is based upon texts in MS1066/1/831, Waldorf Astor papers, particularly those prepared for a speaking tour in 1922: "Is War Preventable?" Falmouth Worker's Education Association, 23 Oct. 1922, and another with a religious theme for the Sheffield Church Congress, 13 Oct. 1922.

28. "Mr. Foot was born in the Sutton division—Notte Street, to be precise—thirty nine years ago" ("Mr. Isaac Foot," *Western Morning News,* 27). Simon Hoggart and David Leigh, "Chosen People: The Foot Family," chapter in *Michael Foot: A Portrait* (London: Hodder & Stoughton, 1981), 18.

29. "Mr. Isaac Foot," *Western Morning News,* 26-27; "Sutton Election," *Western Morning News,* 27.

30. Sarah Foot, *My Grandfather Isaac Foot* (Bodmin, Cornwall: Bossiney Books, 1980), 18. The Foot children were Dingle, Hugh, John, Michael, Sally, Jennifer, and Christopher. See also Hoggart and Leigh, "Chosen People," 24-33. Foot's son Michael reports that Isaac "signed the pledge at the age of nine" (Michael Foot, "A Rupert for the Roundheads," *Debts of Honor* [London: Davis-Poynter, 1980], 12). Hoggart and Leigh, ("Chosen People," 22) say that Isaac "was susceptible to pretty women, though far too upright even to flirt." Foot's remark on his resistance to Lady Astor's charms is recorded in "Premier's Message to Plymouth," *Daily Chronicle* (London), 9 Nov. 1919, MS1416/1/7/32, Astor papers, 10; Foot's letter of endorsement from the Bodmin division Liberals is printed in "Mr. Isaac Foot," *Western Morning News,* 26.

31. "Mr. Isaac Foot," *Western Morning News,* 26; "Sturdy Fight at Plymouth," *Daily News* (London), 29 Oct. 1919, MS 1416/1/7/31. Astor papers, 29. One of the circumstances surrounding Foot's loss may be that he had been criticized for defending "conchies" during the war. See Hoggart and Leigh, "Chosen People," 18.

32. "Sutton Election," *Western Morning News,* 27; Sarah Foot, *My Grandfather,* 63; Hoggart and Leigh, "Chosen People," 20-21.

33. "Mr. Isaac Foot," *Western Morning News,* 26; Hoggart and Leigh, "Chosen People," 22; Michael Foot, "A Rupert,"15; "Claims in Plymouth," *Western Morning News* (Plymouth), 7 Nov. 1919, MS1416/1/7/31, Astor papers, 95.

34. Hoggart and Leigh, "Chosen People," 15-22; Michael Foot, "A Rupert," 13. Michael ("A Rupert," 18-19) called his father "a bibliophilial drunkard—with the difference that the taste never palled and he never had a hangover."

35. *Evening News,* 11, and "Opponent for Lady Astor," *Western Mail* (Cardiff), 27 Oct. 1919, MS1416/1/7/31, Astor papers, 23. The *Westminster Gazette* for 4 Nov. 1919 did report that Isaac Foot had caught a cold during the municipal elections. "Mr. Isaac Foot," *Western Morning News,* 26. For a discussion of timing, see Bruce E. Gronbeck, "Rhetorical Timing in Public Communication," *Central States Speech Journal* 25 (1974): 84-94.

36. Although Isaac Foot held back on public Tory-baiting, his son Michael reports that the "1919 Marseillaise" for the Foot family was:

> Who's that knocking at the door?
> Who's that knocking at the door?
> If it's Astor and his wife,
> We'll stab 'em with a knife,
> And they won't be Tories any more.
> (Michael Foot, "A Rupert," 14).

Foot felt that Coalition government opened the way to misrule, and he based his argument upon Edmund Burke's lines in *Thoughts on the Present Discontents:* "For my part I shall be compelled to conclude the principle of Parliament to be totally corrupted and therefore its end entirely defeated when I see . . . a rule of indiscriminate support to all Ministers; because this destroys the very end of Parliament as a control, and is a general previous sanction to misgovernment" ("Why Mr. Lloyd George Supports Lady Astor," *Western Evening Herald* [Plymouth], 12 Nov. 1919, MS 1416/1/7/32, Astor papers, 56). See also Edmund Burke, *Thoughts on the Present Discontents,* in *The Writings and Speeches of Edmund Burke,* ed. Paul Langford, vol. 2, *Party, Parliament, and the American Crisis 1766-1774* (Oxford: Clarendon Press, 1981), 251-323. For Foot's view that the contest was a matter of confidence, see "Three Candidates for Plymouth," *Western Daily Mercury,* 51. For a discussion of the problems of the "shattered" Liberal party after the 1918 election, see Morgan, *Consensus and Disunity,* 192-212.

37. Among other things, the leaflet mentioned improvements in the areas of housing, health, transportation, unemployment pay, and pensions as well as progress toward peace, the abolition of conscription, and establishment of the League of Nations. ("Deeds Not Words," MS 1066/1/532, Waldorf Astor papers). "Mr. Foot's Queries," *Western Daily Mercury,* 31, and "England in Peril," *Western Daily Press,* 36.

38. For Foot's Adoption Day address, see "Three Candidates for Plymouth," *Western Daily Mercury,* 51; for similar views of his, see "Mr. Foot's Queries,"

Western Daily Mercury, 31, and Isaac Foot, Plymouth, Letter to the Electors, 11 Nov. 1919, MS 1066/1/532, Waldorf Astor papers.

39. Hart defines the jeremiad as a "religiously tinged oration calling people back to their solemn duties under God," 192. For further discussion, see Bormann, *Force of Fantasy*, 27 and 227-228; Ronald H. Carpenter, "The Historical Jeremiad as Rhetorical Genre," in *Form and Genre*, eds. Karlyn Kohrs Campbell and Kathleen Hall Jamieson (Falls Church, Va.: SCA, 1976), 103-117; Kurt W. Ritter, "American Political Tradition and the Jeremiad Tradition: Presidential Nomination Acceptance Addresses, 1960-1976," *Central States Speech Journal* 31 (Fall 1980): 153-171. Ritter's "modern jeremiad" linked with American presidential nomination acceptance addresses may have a precedent or parallel in the Adoption Day addresses of British politicians.

40. Shakespeare, *Henry V* 3.1.1 and *Henry V* 3.1.31-32, in *The Complete Oxford Shakespeare*, eds. Stanley Wells et al, vol.1 (Oxford: Oxford UP, 1987). "Three Candidates for Plymouth," *Western Daily Mercury*, 51.

41. "Three Candidates for Plymouth," *Western Daily Mercury*, 51. "'Fight the good fight and keep the faith.' That message was dinned into the Foot children by their father" (Hoggart and Leigh, "Chosen People," 11). See also Michael Foot, "A Rupert," 13.

42. "Lady Astor's Shots Silence Hecklers," *Boston Globe*, 4 Nov. 1919, 4.

43. "Three Candidates for Plymouth," *Western Daily Mercury*, 51. Foot's granddaughter Sarah writes that during this campaign Foot received a letter from Sir Arthur Quiller Couch who stated that Foot was "fighting always with the old sincerity of mind and the old chivalry of conduct," adding later that Foot was "a man who, however provoked, ever fought clean" (Sir Arthur Quiller Couch, Southeast Cornwall, to Isaac Foot, Plymouth, as quoted in Sarah Foot, *My Grandfather*, 47-48).

44. "Dux Femina Fecit," *Morning Post*, 24. Some of the Independent Conservatives went so far as to announce that they resented "very much her Socialist tendencies" ("The By-Elections," *Morning Post*, 62). The author of a "Letter to the Editor," *Western Daily Mercury* (Plymouth), 4 Nov. 1919, MS 1416/1/7/31, Astor papers, 50, stated that Lady Astor was really "a Gladstonian Liberal." For Astor's qualified support for Lloyd George, see "Lady 'Astorisms'," *Manchester Evening Chronicle*, 47; for Astor's independent streak, note "It would be useless to pretend, however, that I am not by nature independent" ("Lady Astor's Ambition," *Evening Standard*, 36). For Foot's lament that Astor had no program, see *Western Morning News*, 82, and "Mr. Foot's Queries," *Western Daily Mercury*, 31. Note that Lady Astor said that she was "not giving a long detailed programme," adding that "for over ten years they knew what she was and what she stood for" ("Sutton Election," *Western Evening Herald*, 49).

45. "Sutton Election," *Western Morning News*, 27. Ironically, it appears that the Astors were not as bereaved at the loss of Waldorf's father as they were at the loss of the Commons' seat. For a discussion of the rift between Waldorf and his father over the latter's pursuit and acceptance of a title, see Sykes, *Nancy*,

193-194 and 214. For more on Foot's moral and spiritual values, see Hoggart and Leigh, "Chosen People," 11-12, and "The By-Elections," *Morning Post,* 62.

46. Hoggart and Leigh, "Chosen People," 14. The phrase, "life's champions of the underdog," is attributed to Foot by Hoggart and Leigh, "Chosen People," 26. Using the dramatistic nomenclature of fantasy theme analysis, one could say Foot and Astor shared the same fantasy type. See, for example, Bormann, *Force of Fantasy,* 7.

47. "Mrs. Lloyd George on the Need for Unity," *Manchester Guardian,* 15 Nov. 1919, 11. See also "Lady Astor," *Daily Mail* (London), 8 Nov. 1919, MS1416/1/7/32, Astor papers, 52; "Premier's Message to Plymouth," *Daily Chronicle,* 10.

48. "Sex Disabilities," *Western Morning News* (Plymouth), 14 Nov. 1919, MS 1416/1/7/32, Astor papers, 77.

49. Hoggart and Leigh, "Chosen People," 17-18. Apparently, Foot was numbered among many old fogeys. The correspondent for the *Daily Telegraph* remarked, "It may be characterised as ridiculous and out of date, this prejudice against a woman—old fogeyism, fossilisation, or what you will—but human nature being what it is, old fogies there are, and I know no reason to assume that Plymouth is entirely free from them" ("Plymouth Election," 52).

50. For "Let the best man win," see Michael Foot, "A Rupert,"14; Hoggart and Leigh, "Chosen People," 23; Sarah Foot, *My Grandfather,* 48; for "Let the best candidate win," see "Three Candidates for Plymouth, *Western Daily Mercury,* 51.

51. "No Courtesies Wasted at Plymouth," *Yorkshire Observer,* 86; "Mr. Foot's Queries," *Western Daily Mercury,* 31; Isaac Foot, Plymouth, Letter to the Electors, 11 Nov. 1919, MS 1066/1/532, Waldorf Astor papers.

52. "Help for Plymouth," *Westminster Gazette,* 98.

53. "Revolt by Stages," *Western Morning News,* 72. Foot's allusion to "Bubbles" is obscure. A likely candidate is Charles Edward Wilson, *Blowing Bubbles,* watercolor, now in the Bridgeman Art Library, Victoria and Albert Museum, London. For women's speech, see Jamieson, *Eloquence,* 77-81.

54. "Vigorous Election Campaign," *Observer,* 41; "Lady Astor's Quips Amuse Plymouth," *New York Times,* 13; "Help for Plymouth," *Westminster Gazette,* 98; "Date of Plymouth Poll," *Scotsman,* 57. For "naming," see Jamieson, *Eloquence,* 70, and Karlyn Kohrs Campbell, *The Rhetorical Act* (Belmont, CA: Wadsworth, 1982), 254-256. For a discussion of the discord between the Astors and the Asquiths, see Sykes, *Nancy,* 134-140, 189-190, 218.

55. "Sutton Election," *Western Evening Herald,* 49.

56. For Astor's cooperative spirit, see "Answers to Hecklers," *Observer,* 10, and "Coupon for Lady Astor," *Manchester Guardian,* 10 Nov. 1919, 16; for Astor's last minute attack on Foot, see "Partnership Policy," *Western Morning News,* 74.

57. "Help for Plymouth," *Westminster Gazette,* 98. The friendly character of their relationship continued—so long in fact that in her eighty-first year, Lady Astor sent greetings to Foot on his eightieth birthday. (Sarah Foot, *My Grandfather,* 45-47, 94, 101; see also Michael Foot, "Lady Astor, " sketch in *Loyalists and Loners* [London: Collins, 1986], 231).

58. "Mr. Isaac Foot," *Western Morning News,* 27.

59. "Peer's Wife Enters," *Daily Herald*, 21. Arthur Henderson was secretary of the National Executive. For resolutions in support of Gay, see "Lady Astor and Plymouth," *Western Morning News*, 21, and "Opening the Fight," *Western Morning News* (Plymouth), 3 Nov. 1919, MS1416/1/7/31, Astor papers, 44. For Gay's announcement, see *Daily Herald* (London) and *Northern Whig* (Belfast), 25 October 1919, MS1416/1/7/31, Astor papers, 15.

60. "Mr. Isaac Foot," *Western Morning News*, 27. For changes in the parties, note "Liberalism . . . is seriously weakened, and Labour is gaining new force every day" (Ernest Hatch, "The Uprising of Labour: An Alternative Government," *Nineteenth Century and After*, Jan. 1920, 22). See also Victor Fisher, "Where is Labour Going?" *Nineteenth Century and After*, May 1920, 916-928. H. M. Hyndman was "the self-appointed apostle of Marx," and the "first prominent Socialist." For further discussion of Hyndman, see Webb, *Modern England*, 393-399, Taylor, *English History*, 192, and Morgan, *Consensus and Disunity*, 220. For a general history of the ILP, see Robert E. Dowse, *Left in the Centre: The Independent Labour Party 1893-1940* (London: Longmans, 1966).

61. "Lady Astor," *Western Daily Mercury*, 26. "Shattered dreams" may have been the dominant vision of the laboring classes. For "rhetorical vision," see Bormann, *Force of Fantasy*, 8.

62. *Western Morning News* (Plymouth), 14 Nov. 1919, MS 1416/1/7/32, Astor papers, 72. Foot expressed similar thoughts concerning "direct action" in his Adoption Day speech. ("Three Candidates for Plymouth," *Western Mercury*, 51). "Direct action" was an "inside cue" (Bormann, *Force of Fantasy*, 6-9) as demonstrated in "new doctrines, such as direct action, have become the rallying ground of the forces of the laboring people" (Hatch, "Uprising of Labour," 18). Shortly thereafter, the term was discussed at length in J. Ramsay MacDonald, *Parliament and Revolution* (New York: Scott and Seltzer, 1920), 103-127.

63. "Lady Astor's Winning Fight," *Birmingham Post*, 12.

64. "Lively Times at Plymouth," *Morning Post* (London), 10 Nov. 1919, MS1416/1/7/32, Astor papers, 20; "Plymouth Fight," *South Wales Echo* (Cardiff), 14 Nov. 1919 (misdated as 12 Nov. 1919), MS1416/1/7/32, Astor papers, 39. The labeling of Labourites as "Bolshevists" is thoroughly discussed by Victor Fisher ("Where is Labour?" 916-928) who, six months later, concluded, "The truth, then, seems to be that by far the largest proportion of the Party is emphatically not Bolshevik."

65. Rhetorical artifacts used in determining Gay's program include those speeches given at the Newton Abbot Labour Club, 27 Oct. 1919, before a gathering of Trade Unionists, 2 Nov. 1919, and at his Adoption Day meeting, 4 Nov. 1919; his Letter to the Electors of the Sutton Division of Plymouth, MS1066/1/532, Waldorf Astor papers, and the "Labour Party's Manifesto" (27 Nov. 1918) as printed in the *Parliamentary Gazette No. 45*, Dec. 1919, 193-194.

66. "Opening the Fight," *Western Morning News*, 44; "Plymouth Election," *Daily Telegraph*, 52; William Gay, "Letter to the Electors," 1; "Plymouth Election," *Daily Telegraph*, 85; campaign poster, MS 1066/1/530, Waldorf Astor papers.

Although nearly 40 percent of the merchant fleet had been sunk in World War I, much of it had already been replaced. (Taylor, *English History*, 167).

67. "Plymouth Election," *Daily Telegraph*, 85; "Plymouth Election," *Daily Telegraph* (London), 12 Nov. 1919, MS1416/1/7/32, Astor papers, 44. At this time, "Bevin had established himself in the trade-union movement as one of the most promising of the younger generation of leaders" (Alan Bullock, *The Life and Times of Ernest Bevin: Trade Union Leader 1881-1940*, vol. 1 [London: Heinemann, 1960], 116).

68. William Gay, "Letter to the Electors," 1-3; "Labour Party's Manifesto (27 Nov. 1918)," in *Parliamentary Gazette No. 45*, ed. and comp. James Howarth (London: Howarth, Dec. 1919), 193-194. In the 1918 Manifesto (194), the Labour Party advocated "equal rights for both sexes, complete adult suffrage, equal pay" in industry, "one trade union movement" for men and women and claimed that "the Labour Party is the Women's Party." Less than a year later, demobilization forced women workers back into bottom place with few champions for their cause. See, for example, Strachey, *The Cause*, 370-374.

69. William Gay, "Letter to the Electors," 1. The first two inside cues, "Hang the Kaiser" and "Make Germany Pay," are most likely hangovers from the 1918 campaign; they refer to the "strong anti-German programme" of the Coalition government. See, for example, Hatch, "Uprising of Labour," 21, and Taylor, *English History*, 173-174.

70. William Gay, "Letter to the Electors," 1-3. For a brief discussion of "Common Structural Techniques in Persuasion," see Hart, *Modern Rhetorical Criticism*, 160-163.

71. William Gay, "Letter to the Electors," cover.

72. "Sutton Campaign," *Western Evening Herald* (Plymouth), 6 Nov. 1919, MS1416/1/7/31, Astor papers, 77.

73. Ibid.

74. Ibid.; "A New Issue at Plymouth," *Times*, 76.

75. "Wind-up of First Week's Electioneering," *Western Daily Mercury*, 26; "The Election Issues," *Western Morning News* (Plymouth), 13 Nov. 1919, MS1416/1/7/32, Astor papers, 60; "Help for Plymouth," *Westminster Gazette*, 98.

76. New on the scene as a Socialist daily, the *Daily Herald* tried to become the "voice" of Labour. It was then edited by George Lansbury. (Taylor, *English History*, 191). See, for example, *Herald* articles (1)"Gay to Victory," 3 Nov. 1919, MS 1416/1/7/31, Astor papers, 44; (2) "By-Election Issues," 4 Nov. 1919, 54; and (3) "Lady Astor's Bet," 11 Nov. 1919, in MS1416/1/7/32, Astor papers, 34; "Peer's Wife Enters," *Daily Herald*, 21.

77. "Vigorous Election Campaign," *Observer*, 41. For a discussion of increased interest in the "women's side" by MPs as an "immediate effect of women's suffrage," see Strachey, *The Cause*, 367-370.

78. "Lady Astor's Election Campaign," *Evening Standard*, 54; "Three Candidates for Plymouth," *Western Daily Mercury*, 52; "Lady 'Astorisms'," *Manchester Evening Chronicle*, 47. For the Coalition's view of Snowden and MacDonald, see Morgan, *Consensus and Disunity*, 213-235. For pacifism, note, "The I.L.P. has

been and is consistently pacifist" (Victor Fisher, "Where is Labour?" 926). See also "The Independent Labour Party and the 1914-1918 War," in Dowse, *Left in the Centre*, 20-34.

79. "Lady Astor's Shots Silence Hecklers," *Boston Globe*, 4.

80. "Lady Astor's Quips Amuse Plymouth," *New York Times*, 13. Ambiguities and generalities are still viewed as rhetorical weaknesses; in contrast, "precision implies that the rhetor is expert" (Campbell, *The Rhetorical Act*, 261). "The typing of women in crude terms has a long history." See Jamieson, *Eloquence*, 67-81.

81. Robert Burns, "To a Mouse," in *The Poetical Works of Burns*, ed. Raymond Bentman (Boston: Houghton Mifflin, 1974), 31-32. "Opening the Fight," *Western Morning News*, 44; "By-Election Issues," *Daily Herald*, 54. On November 12, the *Western Daily Mercury* published a letter from one of the "mothers of the children" denying that Lady Astor had given sixpences to those photographed with her. ("The Photographic Group," MS 1416/1/7/32, Astor papers, 41).

82. "Three Candidates for Plymouth," *Western Daily Mercury*, 52. Gay as a "Bolshevist" and "pacifist" was echoed by Lady Astor in her subsequent remarks.

83. "Conscript Wealth," *Western Morning News* (Plymouth), 5 Nov. 1919, MS1416/1/7/31, Astor papers, 63.

84. "Plymouth Liveliness," *Westminster Gazette* (London), 5 Nov. 1919, MS1416/1/7/31, Astor papers, 56; "Conscript Wealth," *Western Morning News*, 63.

85. "Claims on Plymouth," *Western Morning News* (Plymouth), 7 Nov. 1919, MS1416/1/7/31, Astor papers, 95; "Lady Astor Going Strong," *Evening Standard* (London), 10 Nov. 1919, MS1416/1/7/32, Astor papers, 10.

86. "Date of Plymouth Poll," *Scotsman*, 57; "Plymouth's Triangular Contest," *Scotsman*, 82; Lady Astor's Campaign," *Liverpool Courier*, 76; "The Final Week," *Daily Telegraph*, 34; "Partnership Policy," *Western Morning News*, 74. For a discussion of devil terms/ultimate terms, see Hart, *Modern Rhetorical Criticism*, 236-239. Note also that "Nothing builds cohesiveness better than a good devil figure" (E. G. Bormann, conversation with author, University of Minnesota, Minneapolis, Minnesota).

87. Kerr to Lloyd George, 20 Nov. 1918 (Lloyd George Papers, F89/1/13) in Morgan, *Consensus and Disunity*, 213; and also Morgan, *Consensus and Disunity*, 214.

88. "Raids on 'Bolsheviks' in America," *Manchester Guardian*, 10 Nov. 1919, 9; although the *Guardian* headline attributed the agitations to the Bolsheviks, the article itself said that the organization bearing chief responsibility was the Union of Russian Workers, "described by the U.S. Attorney General as being 'more radical than the Bolsheviks.'"

89. "Date of Plymouth Poll," *Scotsman*, 57; "Lively Questions at Plymouth," *Liverpool Courier*, 90. See also Morgan, *Consensus and Disunity*, 218-219;

90. "Lively Questions at Plymouth," *Liverpool Courier*, 90; "Lady Astor's Bet," *Daily Herald*, 34. J. H. Thomas lived in a cottage on the Astor estate, Cliveden. ("Lady Astor," *Western Daily Mercury*, 26). Sykes (*Nancy*, 289) said that Thomas was

one of Lady Astor's "special friends in the Labour Party." For Astor's attack on
Snowden and MacDonald, see "Sutton Election," *Western Evening Herald,* 49.

91. "Labour and Lady Astor," *Western Daily Mercury* (Plymouth), 6 Nov. 1919,
MS1416/1/7/31, Astor papers, 85.

92. Ibid.

93. "Lively Times at Plymouth," *Morning Post,* 20; "Plymouth Fight," *South Wales
Echo,* 39. J. R. Clynes, Arthur Henderson, and James Wignall were all Labour
MPs who also served on the National Executive of the Labour Party. Bevin
was national organizer for the Dockers as was Wignall. At the time, all were
known national figures within the labor movement.

94. "Lady Astor's Bet," *Daily Herald,* 34; "Lord Astor and Mr. Gay," *Manchester
Guardian,* 10 Nov. 1919, 16; "Wind-up of First Week's Electioneering," *Western
Daily Mercury,* 26.

95. "Lady Astor's Bet," *Daily Herald,* 34; "Labour and Lady Astor," *Western Daily
Mercury,* 85.

96. "Help for Plymouth," *Westminster Gazette,* 98.

97. "Astorisms," *Express and Echo,* 35; "Today's Incidents," *Western Evening Herald*
(Plymouth), 12 Nov. 1919, MS1416/1/7/32, Astor papers, 53. The next day
when visiting the marines, Lady Astor was challenged by one who asked, "Do
you know that Mr. Gay has stated publicly that he does not belong to the
I.L.P.?" She answered, "Mr. Gay will state anything" ("Lady Astor with the
Marines," *Daily Chronicle,* 56).

98. "Lord Robert Cecil's Letter to Lady Astor," *Manchester Guardian,* 6 Nov. 1919,
MS1416/1/7/31. Astor papers, 71. Turner's letter is quoted by Waldorf Astor
in his published letter to Messrs. Bond and Pearce, printed in "Lord Astor and
Mr. Gay," *Manchester Guardian,* 16. The resolution of the Cooperative Society
is printed in "Conscript Wealth," *Western Morning News,* 63.

99. Astor's reply to Turner as quoted in his letter to Messrs. Bond and Pearce,
printed in "Lord Astor and Mr. Gay," *Manchester Guardian,* 16; "Lady Astor's
Thrusts at I.L.P. Hecklers," *Daily Express* (London), 6 Nov. 1919, MS 1416/1/
7/31, Astor papers, 73; "Lady Astor Retorts to Hecklers," *Times* (London), 6
Nov. 1919, 14.

100. Astor's published letter to Messrs. Bond and Pearce, printed in "Lord Astor
and Mr. Gay," *Manchester Guardian,* 16.

101. When appropriately used, an apology incorporating transcendence is an
effective strategy in prompting gaffe "forgiveness." According to Bennett's
model, it is the optimal choice when the gaffe (as Waldorf's was) is unambig-
uous and of considerable magnitude. (W. Lance Bennett, "Assessing Presiden-
tial Character: Degradation Rituals in Political Campaigns," *Quarterly Journal
of Speech* 67 [August 1981]: 317-321).

102. All three hostile wards were workingmen's districts. Laira was a railwaymen's
area; Coxside was near the gasworks; Victoria Wharves were on the east side
of Sutton Harbor. For a map of the time, see Parliament, Cmd. 8758, *Sessional
Papers 1917-1918* (Commons), vol. 13, 425. Hecklers did exhibit "violent
hostility" to J. A. Seddon, Labour MP, who appeared with Lady Astor at an

open-air meeting in Notte Street on 13 November. ("Partnership Policy," *Western Morning News*, 74). Heckling has been part of the British political tradition for a long time. During this campaign, any restrictions upon it would have been set forth in the English Public Meeting Act of 1908. This Act "specified that a violation occurred when a person acted in a disorderly manner for the purpose of preventing the transaction of business for which the meeting was called" (Haig A. Bosmajian, "Freedom of Speech and the Heckler," *Western Speech* 36 [Fall 1972]: 219, 230. See also John Carson, "Freedom of Assembly and the Hostile Audience: A Comparative Examination of the British and American Doctrines," *New York Law Forum* 15 [1969], 801, 815, 833-834).

103. "Lady Astor's Quips Amuse Plymouth," *New York Times*, 13.

104. "Plymouth Fight," *South Wales Echo*, 38; "The By-Elections," *Manchester Guardian*, 12 Nov. 1919, 9; "Claims on Plymouth," *Western Morning News*, 95; "Lady Astor Among the Hecklers," *Devon Express* (probably *South Devon Weekly Express*, Chudleigh), 12 Nov. 1919, MS 1416/1/7/32, Astor papers, 54. The reporter for the *South Wales Echo* said that Foot was heckled for the first time by Labour opponents on Wednesday, 12 November, and commented, "At Mr. Gay's meetings the only questions asked are friendly ones."

105. For questions on economic issues, see "Counted Out," *Daily Herald* (London), 12 Nov. 1919, MS 1416/1/7/32, Astor papers, 48; "England in Peril," *Western Daily Press*, 36; "Astorisms," *Express and Echo*, 35. Astor set herself up for questions on economic matters when she told a reporter, "I am not a political economist, and I don't mean to be. That is not a woman's province." ("A Little General," *Morning Post*, 64). For questions on pub closings and divorce, see "No Courtesies Wasted at Plymouth," *Yorkshire Observer*, 86, and "Lady Astor Among the Hecklers, *Devon Express*, 54. Astor's divorce from her first husband, Robert Shaw, was a highly sensitive matter for her.

106. A small segment of the press also lamented the fact that Lady Astor was not an Englishwoman. (See, for example, "A Criticism of Lady Astor," *Liverpool Post*, 10 Nov. 1919, MS 1416/1/7/32, Astor papers, 22, and (Editorial), *Witness*, 14 Nov. 1919, MS 1416/1/7/32, Astor papers, 76). "Lady Astor's Quips Amuse Plymouth," *New York Times*, 13. The *Times* also remarked that "the candidate is too much respected to have had them [the millions] made much of as campaign material." "Not Here for a Beano," *Globe*, 52.

107. "Lady Astor's Campaign," *Liverpool Courier*, 76.

108. Ibid. Most likely, the woman was referring to the January 1910 election when Waldorf Astor stood as one of the two Conservative candidates, then in opposition to the Liberals, Lloyd George among them.

109. "Lady Astor's Campaign", *Liverpool Courier*, 76. It could be that Astor's heckler had a stereotype in mind. Earlier, one reporter had said that Lady Astor was "no haughty Primrose dame freezing interrupters with chilly silence of aristocratic disapproval." ("A Gibson Girl M.P.?" *Lloyd's News*, 16).

110. "Lady Astor's Campaign," *Liverpool Courier*, 76.

111. Ibid.

112. "Counted Out," *Daily Herald*, 48. Such a bombardment tactic, the employment of an oversophisticated code, has an exclusionary effect. F. G. Bailey says, "It may also be used, as in the case of 'blinding with science' or 'snowing with statistics,' as a form of assertive rhetoric—a type of argument from authority" (F. G. Bailey, *The Tactical Uses of Passion: An Essay on Power, Reason, and Reality* [Ithaca & London, Cornell UP, 1983], 226). "Laughing to Victory," *Evening Standard*, 70; "Plymouth Election," *Daily Telegraph*, 41.

113. See, for example, "breaking up the old foundations" and "pouring on the truth" in Bormann, "Symbolic Convergence Theory," 78-79. The effect of heckling upon the credibility of the speaker has been discussed in P. D. Ware and R. K. Tucker, "Heckling as Distraction: an Experimental Study of the Effect on Source Credibility," *Speech Monographs* (June 1974): 185-186 and Michael J. Beatty and Michael W. Kruger, " The Effects of Heckling on Speaker Credibility and Attitude Change," *Communication Quarterly* 26 (Spring 1978): 46-50.

114. F. G. Bailey, *The Tactical Uses of Passion*, 54. Bailey goes on to say, "He [the person provoked] can exercise reason—by thinking out or recalling a more insulting rejoinder—only if he succeeds in controlling his emotions and ignoring the insults that have been heaped upon him." For a discussion of "the fitting response," see Lloyd F. Bitzer, "The Rhetorical Situation," *Philosophy and Rhetoric* 1 (June 1968): 1-14.

115. Coping with hecklers may be part of the fitness test candidates need to pass in their bid for political office. Note, for example, Bosmajian's comment that in "British political life . . . candidates are sometimes cherished less for their policies than for their repartee" ("Freedom of Speech and the Heckler," 218). For a revival of the Hustler persona, see "'Our Nancy' for Plymouth," *Sunday Express*, 17 and "Viscountess Astor, M.P.?" *Daily Graphic*, 16. Note that Astor had tried to modify the persona by emphasizing her seriousness and downplaying the comic elements. "Laughing to Victory," Evening *Standard*, 70; Grigg, *Nancy Astor*, 76; Michael Astor, *Tribal Feeling*, 52; Grigg, *Nancy Astor*, 77. An Astor supporter also commented that the frosty air moving into Plymouth would also help Astor's campaign effort because it would "ginger them [the electorate] up" (Gwladys Jones, "Lady Astor in an 'Enemy Quarter'," *Daily Chronicle* [London], 12 Nov. 1919, MS 1416/1/7/32, Astor papers, 40).

116. "England in Peril," *Western Daily Press*, 36; "Plymouth Liberalism," *Morning Post*, 40; "Lady Astor in an 'Enemy Quarter'", *Daily Chronicle*, 40; "Plymouth Election," *Daily Telegraph*, 41.

117. In the developing dramatic situation, she attempted to change the story by creating a new role for her antagonist. Without conflict, there is no drama and, in turn, reduced tension. For "second persona," see Black, "Second Persona,"109-119. For the incident at Laira Green Schools, see "Organized Disorder," *Western Evening Herald*, 91. One way for a woman to better her circumstances is to marry well. Although such moves may be subtly masked today, they were acknowledged in the earlier days of the century. (See, for example, Richard Kenin, *Return to Albion* [New York: Holt, Rinehart and

Winston, 1979], 203-210; Hesketh Pearson, *The Marrying Americans* [New York: Coward & McCann], 1961], 246-263).

118. "Lady Astor and a Sailor," *Daily Chronicle*, 64; "Date of Plymouth Poll," *Scotsman*, 57; "Not Here for a Beano," *Globe*, 52.

119. "Audacious Nancy," *Manchester Chronicle*, 35; "Lady Astor's Retort to Hecklers, " *Times* (London), 14. For empathic communication, see Howell, *The Empathic Communicator*, especially 3-4, also 245.

120. "Lady Astor's Retorts," *Daily Express* (London), 12 Nov. 1919, MS 1416/1/7/ 32, Astor papers, 49.

121. "Lively Questions at Plymouth," *Liverpool Courier*, 90; for "prohibition," see "Lady Astor's Quips Amuse Plymouth," *New York Times*, 13; for "cooperative," see "Date of Plymouth Poll," *Scotsman*, 57; for "Socialist," see "Lady Astor's Quips Amuse Plymouth," *New York Times*, 13. "The By-Elections," *Morning Post*, 62.

122. "Coupon for Lady Astor," *Manchester Guardian*, 10 Nov. 1919, 16; "Counted Out," *Daily Herald*, 48.

123. "Lady Astor and a Sailor," *Daily Chronicle*, 64. It is likely that Lady Astor provoked the woman by stating that Gay belonged "to the most poisonous section of the Labour party that ever existed on earth." The giggles may have been a case of nervous tension. The *Chronicle* reporter noted that "the 500 women [were] assembled for the first time in their lives to judge a woman candidate."

124. "Plymouth Election," *Daily Telegraph*, 85.

125. "Lady Astor in an 'Enemy Quarter'," *Daily Chronicle*, 40.

126. "Astorisms," *Express and Echo*, 35; "Lady Astor Among the Hecklers," *Devon Express*, 54. The *Daily Herald*'s account of Lady Astor's evening meetings on the eleventh stated that "her ladyship was decidedly in the tails last night. Lord Astor stood in front of her and prompted her assiduously." ("Counted Out," *Daily Herald*, 48).

127. "Plymouth Election," *Daily Telegraph*, 85.

128. "Plymouth Contest," *Manchester Daily Dispatch*, 7 Nov. 1919, MS 1416/1/7/31, Astor papers, 90. Later on she said that she "felt that it was unfair that fate had given a Virginian the honour [to sit in Commons] which should have been theirs [the British suffragettes]" (Winn, *Always a Virginian*, 125). Sykes (*Nancy*, 190) states that she thought Millicent Fawcett or Christabel Pankhurst deserved to be first.

129. "Plymouth Election," *Daily Telegraph*, 85; "Coupon for Lady Astor," *Manchester Guardian*, 16; "Lady Astor's Retorts to Hecklers," *Times* (London), 14.

130. "Astorisms," *Express and Echo*, 35.

131. "Insults for Lady Astor," *Birmingham Post*, 13 Nov. 1919, in MS 1416/1/7/32, Astor papers, 69.

132. Ibid. Astor's sarcastic remark alludes to "Idle Rich," Gay's campaign leaflet, MS1066/1/530, Waldorf Astor papers.

133. 133."The Week in Retrospect," *Daily Telegraph* (London), 10 Nov. 1919, MS 1416/1/7/32, Astor papers, 19.

134. "Lively Questions at Plymouth," *Liverpool Courier*, 90.

135. "Partnership Policy," *Western Morning News*, 74. Sugar refining and trade had been a government-controlled industry from the early days of the war. (Taylor, *English History*, 30, 98-99). Other government controls, in terms of the ILP's response to them, are described in Benjamin Sacks, "The Independent Labor Party and Social Amelioration in Great Britain During the World War," *University of New Mexico Bulletin* 2, no. 6 (August 1940): 5-37.

136. In referring to Gay and Foot, Lady Astor said, "Both are redhot Prohibitionists" ("A Little 'General'," *Morning Post*, 64). For complaints to the *Post*, see, for example, "Plymouth Unionists Discontent," *Morning Post* (London), 6 Nov. 1919, MS 1416/1/7/31, Astor papers, 85; "Queries at Plymouth," *Morning Post*, 11 Nov. 1919, MS 1416/1/7/32, Astor papers, 34; "The By-Elections," *Morning Post*, 62.

137. "Not Here for a Beano," *Globe*, 52.

138. Collis, *Nancy Astor*, 67.

139. Note that "Assertive rhetoric is a moral rhetoric. It is a rhetoric of belonging, of including in the congregation those who choose to believe and excluding the rest either by ignoring them, ridiculing them, or making them the objects of anger and contempt. Divergent opinions are eliminated in this form of rhetoric by a simple elimination of the non-believers: an insistence that any belief that departs from the orthodox need not be taken into account" (F. G. Bailey, *Tactical Uses of Passion*, 135ff.).

140. "Coupon for Lady Astor," *Manchester Guardian*, 16; "Answers to Hecklers," *Observer*, 10.

141. "Partnership Policy," *Western Morning News*, 74.

142. Ibid.

143. "The serious world is organized to avoid inconsistency and internal contradiction. In contrast, humourous discourse is designed to create these very features" (Mulkay, *On Humour*, 203). For "perspective of incongruity," see Foss, Foss and Trapp, *Contemporary Perspectives*, 155.

144. "No Courtesies Wasted at Plymouth," *Yorkshire Observer*, 86; "England in Peril," *Western Daily Press*, 36; "Lady Astor's Retorts," *Daily Express*, 49.

145. "Lady Astor's Retorts," *Daily Express*, 49. Later Margaret Bondfield became "the first woman to enter the Cabinet (June 1929)" (Taylor, *English History*, 343). See also Margaret Bondfield, *A Life's Work* (London: Hutchinson, 1950).

146. For ordering women's meetings, see "Women Heckle Lady Astor," *Daily Express* (London), 7 Nov. 1919, MS 1416/1/7/31, Astor papers, 90, and "Lady Astor and Her Gaiety," *Evening Standard*, 97; for supporters to the rescue, see "Claims on Plymouth," *Western Morning News*, 95, and "Plymouth Election," *Daily Telegraph*, 41.

147. "Lady Astor's Quips Amuse Plymouth," *New York Times*, 13; "Lady Astor's Gift of Repartee," *Daily Chronicle*, 85; "Astorisms," *Express and Echo*, 35; "Coupon for Lady Astor," *Manchester Guardian*, 16; "Counted Out," *Daily Herald*, 48.

148. "Plymouth Fight," *South Wales Echo*, 38. Family members and friends from/in Virginia called her "Nannie." (Winn, *Always a Virginian*, 121-139). "Partnership

Policy," *Western Morning News*, 74. For Astor's remarks to misbehaving women, see "Women Heckle Lady Astor," *Daily Express*, 90; "Lady Astor's Gift of Repartee," *Daily Chronicle*, 85; and "Organized Disorder," *Western Evening Herald*, 91. "Not Here for a Beano," *Globe*, 52; "Lady Astor in an 'Enemy Quarter'," *Daily Chronicle*, 40.

149. "Coupon for Lady Astor," *Manchester Guardian*, 16. Astor's retort was: "If there were no greed there would be no slums. You cannot make men economically equal, but I would be willing to throw every capitalist off the Plymouth Hoe tomorrow if you could prove to me that under the government of the I.L.P. this would be a better world. I am not interested in my own class merely; I am interested in all classes. If you don't think me honest, capable, and sincere, I implore you not to vote for me."

150. "Three Candidates for Plymouth," *Western Daily Mercury*, 52; "No Courtesies Wasted at Plymouth," *Yorkshire Observer*, 86; Grigg, *Nancy Astor*, 75.

151. "Organized Disorder," *Western Evening Herald*, 91; "Death of Lord Astor," *Times* (London), 20 Oct. 1919. sec. A, 16.

152. Aristotle, "Rhetoric," in *The Rhetoric and the Poetics of Aristotle*, trans. W. Rhys Roberts (Oxford: Clarendon, 1954; reprint, New York: Random House, Modern Library, 1984), 24 (page reference is to reprint edition). "Competence assesses the situation and adapts" (William S. Howell, conversation with author, University of Minnesota, Minneapolis, Minnesota). For "unconscious competence," see Howell, *Empathic Communicator*, 4-5; 31-32; 162-165. "Lady Astor's Gift of Repartee," *Daily Chronicle*, 85.

153. E. G. Bormann, *Discussion and Group Methods*, 2d ed. (New York: Harper & Row, 1975), 228.

154. *Western Daily Mercury* (Plymouth), 29 Oct. 1919, MS 1416/1/7/31, Astor papers, 29; "Drives Lady Astor to Win," *Chicago News*, 17; "Lady Astor's Shots Silence Hecklers," *Boston Globe*, 4; "Lady Astor's Quips Amuse Plymouth," *New York Times*, 13; comments on the British press contingent came from "Help for Plymouth," *Westminster Gazette*, 98 and "No Courtesies Wasted at Plymouth," *Yorkshire Observer*, 86. In her discussion of Gladstone's 1879-1880 Midlothian campaign, Ellen Reid Gold reports that over 80 papers sent reporters and comments that "for important events papers often preferred to send their own reporters" (Ellen Reid Gold, "The Provincial Press and Political Speeches," *Communication Quarterly* 31 [Winter 1983]: 38). One can assume that the practice continued during Lady Astor's first bid for Parliament.

155. The *Birmingham Post*, the *Liverpool Post*, *Manchester Guardian*, and the *Yorkshire Post* (Leeds) in England, the *Scotsman* (Edinburgh) and the *Glasgow Herald* in Scotland, and the Welsh *Western Mail* (Cardiff) were classified as major provincial papers. (Charles L. Mowat, *Great Britain since 1914* [Ithaca, NY: Cornell UP, 1971], 159). For high praise of the *Manchester Guardian* at this time, see Charles H. Grasty, "British and American Newspapers," *Atlantic Monthly*, Nov. 1919, 583. Today the *Guardian* is a national newspaper published simultaneously in London and Manchester. Both the *Birmingham Post* and the *Manchester Guardian*

proclaimed their preferences at the end of the campaign. ("Close of the Fight at Plymouth," *Birmingham Post*, 89; "Polling Today," *Manchester Guardian*, 11).

156. "Lady Astor's Success," *Western Morning News*, 57.

157. "Women in Parliament," *Liverpool Courier*, 5 Nov. 1919, MS 1416/1/7/31, Astor papers, 56. "Catalogue for MS 1416," TMS, 3, Archives and Manuscripts, University of Reading Library, Reading, England. Note especially the listings for MS 1416/1/7/1-17, bound cuttings from American newspapers.

158. As already mentioned, there were three other by-elections in progress: Croydon, Isle of Thanet, and Chester-le-Street (Durham). ("A Little 'General,'" *Morning Post*, 64). The *Manchester Guardian* seemed to cover each in a fair way and remarked that those in Plymouth and the Isle of Thanet were "the more boisterous contests" ("Croyden," *Manchester Guardian*, 10 Nov. 1919, 16). Pack journalism, "a form of groupthink peculiar to the news media," is discussed at length in Dan Nimmo and James E. Combs, "Pack Journalism—Group Mediation of Political News," in *Mediated Political Realities* (New York: Longman's, 1983), 162-181.

159. "Quality press" here means "seeking to provide material that will interest educated readers." (*Chambers English Dictionary*, 1988 ed.). Ralph Negrine, *Politics and the Mass Media in Britain* (London: Routledge, 1989), 50; Grasty, " British and American Newspapers," 578. See also George Boyce, "The Fourth Estate: The Reappraisal of a Concept," in *Newspaper History: from the 17th Century to the Present Day*, ed. George Boyce, James Curran, and Pauline Wingate (London: Constable, 1978), 29.

160. "Lady Astor," *North Star* (Darlington), 27 Oct. 1919, MS 1416/1/7/31, Astor papers, 20.

161. Chris Wrigley, *Lloyd George and the Challenge of Labour: The Post-War Coalition 1918-1922* (New York: Harvester Wheatleaf, 1990), 1-12; "Mr. Lionel Jacobs," *Western Mercury*, 4 Nov. 1919, MS1416/1/7/31, Astor papers, 52.

162. For partisanship of the British press, see Boyce, "The Fourth Estate," 26-29; Grasty, "British and American Newspapers," 580-583; and Negrine, *Politics*, 50-51. Grasty discusses the *Morning Post* at some length, pointing out that its owner was a woman, Lady Bathurst, that it was intended for the ruling class, and that the editorial work of Ian D. Colvin could "be at once pious and interesting." (Grasty, "British and American Newspapers," 580). The purchase of the *Daily Chronicle* is discussed in Boyce, "The Fourth Estate," 32-33, and Morgan, *Consensus and Disunity*, 29. Editorial support from the Sunday *Lloyd's News* argued that 1) it was time for a woman to be elected; 2) Nancy could improve relations with the U.S.; 3) she showed concern for the mass of people and coming generations. (*Lloyd's Weekly News* [London], 2 Nov. 1919, MS1416/1/7/31, Astor papers, 41). "Plymouth Election," *Daily Telegraph*, 52.

163. The phrase "mark on the forest" comes from Barbara Tuchman's *Practicing History* (New York: Ballantine Books, 1982), 26.

164. The best summary of the provisions of the Representation of the People Act (1918) can be found in Note C, Taylor, *English History*, 159-160; for women's part in the 1918 election, see Vallance, *Women in the House*, 24-25.

165. Markievicz defeated William Field of the Irish Party (7835 to 3742 votes), who had held the seat for 26 years. (Anne Haverty, *Constance Markievicz: An Independent Life* [London: Unwin Hyman, Pandora Press, 1988], 182-186). Haverty contends that the "Irish-German intrigue was concocted" by the British as an excuse to detain Irish militants stirred by the notice that conscription would be extended to Ireland (Manpower Bill, April 1918).

166. En route from Holloway to Ireland, Constance did stop by the House of Commons to see her name on the coat peg in the cloakroom.(Haverty, *Constance,* 189).

167. Ibid., 191.

168. Ibid., 194. See also Thomas E. Hachey, Joseph M. Hernon, Jr., and Lawrence J. McCaffrey, *The Irish Experience* (Englewood Cliffs, NJ: Prentice Hall, 1989), 160-162; Havighurst, *Britain in Transition,* 170-172; Webb, *Modern England,* 500-503.

169. "Plymouth Election," *Daily Telegraph,* 52.

170. Alfred Harmsworth, Lord Northcliffe, owned the *Times,* the *Daily Mail,* and the *Evening News.* His brother, Lord Rothermere, owned the *Daily Mirror* and the *Daily Sketch.* Lord Beaverbrook owned the *Daily Express* and the *Sunday Express.* (Mowat, *Great Britain,* 157-158). Sykes, *Nancy,* 200 and 476-477; Boyce, "The Fourth Estate," 29; Negrine, *Politics,* 51.

171. "Americans followed her campaign with intense interest" (Collis, *Nancy Astor,* 64). George Seldes, *Witness to a Century* (New York: Ballantine Books, 1987), 126. Years later, Seldes recalled "the American contingent of about twenty among the total of about a hundred." "Lady Astor, From Virginia," *New York Times,* 16 Nov. 1919, sec. 4, p.1; Genevieve Parkhurst, writing for the *Ladies Home Journal* a few months later, said, "Twenty-eight, one would take her to be; for she has not a line in her face" ("Lady Astor, M.P.," *Ladies Home Journal,* March, 1920, 15). "The Most Conspicuous Woman in England," *Current Opinion,* 290; for Churchward, see "Drives Lady Astor to Win," *Chicago News,* 17, and "Lady Astor's Shots Silence Hecklers," *Boston Globe,* 4.

172. "Lady Astor's Shots Silence Hecklers," *Boston Globe,* 4.

173. "Lady Astor From Virginia, First Woman M.P.," *Literary Digest,* 13 Dec. 1919, 50; "Lady Astor's Campaign," *Outlook,* 26 Nov. 1919, 342; "How a New Member Is Received in the House of Commons," *Outlook,* 17 Dec. 1919, 491; for Astor's loyalty, see "Lady Astor, From Virginia," *New York Times,* 2; "The Most Conspicuous Woman in England," *Current Opinion,* 291; Lady Astor, From Virginia," *New York Times,* 1.

174. "Lady Astor, From Virginia," *New York Times,* 1-2. Nearly three years later, Robert Littell, critically commenting upon Astor's rhetorical gifts during her U.S. tour, conceded, "Lady Astor would be 'one of us' almost wherever she happened to be" ("Lady Astor," *New Republic,* 3 May 1922, 275).

175. "Lady Astor From Virginia, First Woman M.P.," *Literary Digest,* 54; *Cleveland Citizen* as quoted in "Lady Astor From Virginia, First Woman M.P.," *Literary Digest,* 54.

176. Collis, *Nancy Astor,* 62. According to Negrine, the more an event concerns elite people the more likely it is to become news; the more expected the event, that is the more the event is predicted and wanted, the more likely that it will become news; and newspapers use "composition" to give a balance across stories. (Negrine, *Politics,* 139-143).

177. "Lady Astor's Quips Amuse Plymouth," *New York Times,* 13; "The Most Conspicuous Woman in England," *Current Opinion,* 290; Michael Astor, *Tribal Feeling,* 92.

178. Matching the persona type with the amount of press coverage it received revealed that twice as many papers picked up on the Hustler persona than they did on the others. As mentioned in previous sections dealing with Foot, Gay, and the hecklers, Astor also engaged in confrontational episodes—the very stuff of newsworthiness. "Lady Astor's Quips Amuse Plymouth," *New York Times,* 13; "The Most Conspicuous Woman in England," *Current Opinion,* 290.

179. "The Most Conspicuous Woman in England," *Current Opinion,* 290-292.

180. "Plymouth Election," *Daily Telegraph,* 83.

181. Negrine, *Politics,* 141; Winn, *Always a Virginian,* 124; Seldes, *Witness,* 127.

182. "'Pussyfoot' Woman M. P.?" *Daily Express,* 15; *Sunday Herald,* 17; "Lady Astor," *Western Morning News,* 30; Editorial, *Lloyd's Weekly News* (London), 2 Nov. 1919, MS 1416/1/7/31, Astor papers, 41; "Vigorous Election Campaign," *Observer,* 41; "A Little 'General'," *Morning Post,* 64; "Lady Astor's Fight at Plymouth," *Morning Post,* 86.

183. See, for example, "Election—November 1919/ Letters for Press/ 'Testimonials'," MS 1416/2/17, Astor papers, and W. T. Cranfield to Miss A. M. Kindersley, London, TLS, 1 Dec. 1919, 1066/1/530, Waldorf Astor papers. A small, folded piece of brown paper imprinted with "Woolgar and Roberts' Press Cutting, Printing and Advertising Agency . . . London, Paris and New York" and attached to "Lady Astor's Ideas on Drink Problem," *Evening News* (London), 1 Oct. 1920, was found tucked between the pages in MS 1416/1/7/41, Astor papers. Cranfield to Kindersley, 1 Dec. 1919, Waldorf Astor papers; for use of the letters column, see "Lady Astor and the Women," *Western Daily Mercury,* 52, and "The Photographic Group," *Western Daily Mercury,* 41.

184. "Lady Astor's Shots Silence Hecklers," *Boston Globe,* 4; posing for this shot with the fisherman took extra time and effort. Astor had to leave her carriage, walk "across the slimy pavement of the fish mart," board the boat, pose alone, and then pose again with the captain, who had also been asked to cooperate for the photographers.

185. "Women in Parliament," *Liverpool Courier,* 56; "Lady Astor's Election Campaign," *Evening Standard,* 54.

186. "Politicians, as a general rule, seek to influence by shaping the perception of events or by defining the nature of 'reality'" (Negrine, *Politics,* 170). "Lady Astor's Fight at Plymouth," *Morning Post,* 86; "Lady Astor Quotes Eve," *Liverpool Post,* 6 Nov. 1919, MS 1416/1/7/31, Astor papers, 79; "Astorisms," *Express and Echo,* 35.

187. "Help for Plymouth," *Westminster Gazette*, 98. Thursday evening, the day the *Gazette* reported her meetings a "stunt," the *Times* noted "she was in a serious mood [when] she attended a town's meeting in support of the League of Nations and made a very effective speech." ("Lady Astor's Fight," *Times*, 8 Nov. 1919, MS 1416/1/7/31, Astor papers, 98). According to provisions of the Representation of the People Act, each "candidate had to deposit 150 pounds which he forfeited if he polled less than one-eighth of the total votes cast in his constituency," (Taylor, *English History*, 159-160). "Lady Astor Angry," *Star* (London), 7 Nov. 1919, MS 1416/1/7/31, Astor papers, 86; "Labour's Escape at Plymouth," *Morning Post* (London), 8 Nov. 1919, MS 1416/1/7/31, Astor papers, 99.

188. "Lady Astor," *Daily Mail* (London), 8 Nov. 1919 (misdated as 11 Nov. 1919), MS 1416/1/7/32, Astor papers, 52; *South Wales Daily News* (Cardiff), 8 Nov. 1919, MS 1416/1/7/31, Astor papers, 100.

189. "Viscountess Astor's Political Faith," *Lloyd's Weekly News* (London), 9 Nov. 1919, MS 1416/1/7/32, Astor papers, 8.

190. "Lady Astor Amazed," *Western Mail* (Cardiff), 10 Nov. 1919, MS 1416/1/7/32, Astor papers, 22. The *Liverpool Courier* reported that because "she dislikes intensely the notoriety which is attaching to her candidature," she "has had to decline to be further interviewed or photographed" ("Lady Astor and Winkipop," *Liverpool Courier*, 12 Nov. 1919 MS 1416/1/7/32, Astor papers, 41). "Lady Astor's Winning Fight," *Birmingham Post*, 10 Nov. 1919, MS 1416/1/7/32, Astor papers, 12.

191. "Lady Astor Amazed," *Western Mail*, 22.

192. "Lady Astor's Hecklers," *Daily News* (London), 8 Nov. 1919, MS 1416/1/7/31, Astor papers, 98; "Help for Plymouth," *Westminster Gazette*, 98; "A Criticism of Lady Astor," *Liverpool Post*, 10 Nov. 1919, MS 1416/1/7/32, Astor papers, 22; "Labour's Escape at Plymouth," *Morning Post*, 99.

193. "The Final Week," *Daily Telegraph*, 34; "Lady Astor's Fight," *Times*, 98; "Lady Astor's Winning Fight," *Birmingham Post*, 12.

194. "Overtime Candidate," *Daily Herald* (London), 8 Nov. 1919, MS 1416/1/7/31, Astor papers, 99.

CHAPTER FOUR

1. "Claims on Plymouth," *Western Morning News*, 95; "Lady Astor Going Strong," *Evening Standard*, 10; "Plymouth," *Manchester Guardian*, 6; "Plymouth Election," *Daily Telegraph*, 41.

2. Campaigns, as described by journalists, often adhere to dramatic structure. If the campaign does not provide sufficient interest, journalists create it. See, for example, the "melodramatic imperative" in Nimmo and Combs, *Mediated Political Realities*, 14-16. Note also chap. 2, "A Man for all Seasons," 48-70.

3. "League Match Results," *Times* (London), 10 Nov. 1919, 6; "Claims on Plymouth," *Western Morning News* (Plymouth), 7 Nov. 1919, MS1416/1/7/31, Astor

papers, 95; "Wind-up of First Week's Electioneering," *Western Daily Mercury*,
26. The *Telegraph* reporter commented, "How well we march since the war!"
("The Final Week," *Daily Telegraph*, 35).

4. Ernest Bevin served his countrymen for a long time as "trade union leader,
 wartime Labour minister, foreign secretary" (Francis Williams, "Bevin, Ernest,"
 in *Dictionary of National Biography, 1951-1960*, 103-109). "Wind-up for First
 Week's Electioneering," *Western Daily Mercury*, 26; "The Final Week," *Daily
 Telegraph*, 35; "Lady Astor's Winning Fight," *Birmingham Post*, 12; *Northamptonshire
 Evening Telegraph* (Kettering), 11 Nov. 1919, MS1416/1/7/32, Astor papers, 12.

5. "Lord Astor and Mr. Gay," *Manchester Guardian*, 16; "The Final Week," *Daily
 Telegraph*, 34.

6. D. Lloyd George, London, to Lady Astor, Plymouth, TLS, 7 Nov. 1919, in
 MS1416/2/17, Astor papers. Miss Cundy noted that she distributed copies of
 Lloyd George's letter "for Sunday's papers (Press assoc. & Western Indepen-
 dent)" and "W. M. News, W. D. Mercury and Herald" on the 8 November.
 Handwritten notation on D. Lloyd George, London, to Lady Astor, Plymouth,
 TLS, 7 Nov. 1919, MS 1416/2/17, Astor papers. "Tenderness" is not a term
 normally applied to Lady Astor; however, Agnes Chalmers described the same
 characteristic when she told how Lady Astor held a French soldier in her arms
 and sang the "Marseillaise" to him while the doctors at Cliveden amputated
 his foot. (Agnes Chalmers, "Nancy Astor Would Go to Parliament if Yanks
 Had Their Way," *Grand Rapids Herald* [Grand Rapids, Mich.], 23 Nov. 1919,
 MS 1416/1/7/2, Astor papers, n.p.).

7. D. Lloyd George to Lady Astor, 7 Nov. 1919, Astor papers.

8. Lady Astor's scrapbooks include clippings of Foot's letter as it appeared in the
 Aberdeen Free Press, the *Birmingham Gazette*, the *Birmingham Post*, the *Daily Mail*, the
 Liverpool Courier, the *Liverpool Post*, and the *Morning Post*. The writer for the
 Liverpool Post called it the "outstanding feature of the moment" ("The Premier
 and Plymouth," *Liverpool Post*, 12 Nov. 1919, MS 1416/1/7/32, Astor papers,
 40); "The Quickened Pace at Plymouth," *Birmingham Post*, 12 Nov. 1919,
 MS1416/1/7/32, Astor papers, 38.

9. Lloyd George as quoted in "Plymouth," *Manchester Guardian*, 12 Nov. 1919, 9

10. "Plymouth," *Manchester Guardian*, 9.

11. Ibid. Lloyd George was 56; Isaac Foot was 39; Lady Astor was 40. See also
 Robert Browning, "The Lost Leader," in the *The Literature of England*, 3d ed.,
 edited by George B. Woods, Homer A. Watt, and George K. Anderson, Vol.
 2, *Dawn of the Romantic Movement to the Present Day* (Chicago: Scott, Foresman,
 1948), 666.

12. "Plymouth," *Manchester Guardian*, 9; Browning, "The Lost Leader," line 21. The
 editorial writer for the *Scotsman* lamented the division in the Liberal party: "The
 time will come when there will be need for the unity of Liberals of all degrees
 in steering the country between the dangers of reaction on the one hand and
 revolution on the other; hence it would be wise for both Liberals who support
 the Government and those who are frankly in opposition to it to say nothing

that may make future co-operation difficult." ("Colston Day and Parties," *Scotsman*, 56).

13.	"Why Mr. Lloyd George Supports Lady Astor," *Western Evening Herald* (Plymouth), 12 Nov. 1919, MS 1416/1/7/32, Astor papers, 55. The writer for the *Scotsman* also alluded to Lloyd George's reply in an editorial on the twelfth. "The Plymouth Contest," *Times*, (London), 13 Nov. 1919, 14.

14.	"The Plymouth Contest, *Times*, 14.

15.	Ibid.

16.	The *Western Morning News* called Lloyd George's letter to Foot "a crushing reply." ("Partnership Policy," 74).

17.	"Partnership Policy," *Western Morning News*, 74.

18.	Ibid. The Education Act of 1918, brought forth by H. A. L. Fisher is discussed in Havighurst, *Britain in Transition*, 142; Taylor, *English History*, 225, 214-242, and Morgan, *Consensus and Disunity*, 290-294.

19.	"Why Mr. Lloyd George Supports Lady Astor," *Western Evening Herald*, 55-56; those questions Foot had asked were whether or not Lloyd George still regarded himself as a member of the Liberal party and, in the same vein, whether or not he stood with the "younger Liberals."

20.	"Why Mr. Lloyd George Supports Lady Astor," *Western Evening Herald*, 55-56. Charles James Fox (1749-1806), Whig statesman-orator, was a contemporary of Edmund Burke and known for his bitter opposition to Prime Minister William Pitt. See, for example, Willson, *History of England*, 557-560.

21.	"Why Mr. Lloyd George Supports Lady Astor," *Western Evening Herald*, 55-56. Here Foot based his argument upon Edmund Burke's *Thoughts on the Present Discontents* as previously discussed.

22.	"Why Mr. Lloyd George Supports Lady Astor," *Western Evening Herald*, 56.

23.	Mrs. Lloyd George said that both Mr. Lloyd George and herself "were taunted because they were supporting Lady Astor . . . in place of one who was a member of their own party. But this was not a time for party strife. It was a time for unity, so that we might put the affairs of the country right" ("End of Plymouth Campaign," *Times* [London], 15 Nov. 1919, 14).

24.	"Partnership Policy," *Western Morning News*, 74.

25.	"The By-Elections," *Morning Post*, 62. Jacobs' comments prompted a letter to the *Post* from Frank Hawker, chairman of the Plymouth Unionist Association. He stated that Capt. John Jacob Astor "did not want to stand for Plymouth" and that, even though there were "several names brought back from London," the Executive Committee had chosen Lady Astor as the "most likely candidate to defeat the Asquithians and Socialists" ("The Close of Four Campaigns," *Morning Post* [London], 14 Nov. 1919, MS1416/1/7/32, Astor papers, 79).

26.	"Astorisms," *Express and Echo*, 35; "Plymouth Election," *Daily Telegraph*, 41; "Plymouth Contest," *Birmingham Gazette*, 12 Nov. 1919, MS 1416/1/7/32, Astor papers, 41.

27.	Relying upon numerous American campaign studies, E. G. Bormann contends that media providers have developed a series of stock scenarios "that can be used to make sense out of often confusing experiences relating to campaign-

ing." These scenarios, which he labels "fantasy types," often "consist of analogies to races of various sorts," but that "horse races predominate." Identified types include the *front runner*, the candidate who takes the lead in the beginning of a campaign. If the front runner stays ahead, then the "media professionals move to another fantasy type, the *landslide drama* . If, however, the front runner falls behind, either by faltering or failing to keep the pace, then those in the media have at least two optional types from which to choose. Should a challenger overtake the front runner, then a move is made into a *come-from-behind underdog drama*. However, if the front runner manages to maintain a marginal lead, or, in an even more exciting turn of events, lags behind and comes back, then the media turn to a *nose-to-nose battling for the wire* drama" (E. G. Bormann, "Media Fantasies of Political Campaigns" TMS (photocopy), 4-7, Lecture in honor of James L. Golden, Ohio State University, Columbus, Ohio, Fall, 1988).

28. "Astorisms," *Express and Echo*, 35.

29. "Lady Astor's Campaign," *Liverpool Courier*, 76; "Notes in the West," *Western Morning News* (Plymouth), 14 Nov. 1919, in MS 1416/1/7/32, Astor papers, 77.

30. "Lady Astor Sums Up," *Globe*, 81. In their development of a theoretical and methodological model for a modern day political campaign based upon a communication perspective, Cragan and Shields suggest a "one-act, three-scene" format for the political rally. They present a format that encompasses an opening number featuring "the baptizers"; a second scene, which "spotlights the superstar"; and a final scene, which brings on the "chorus." Astor's political rally incorporated many of the elements of Cragan's and Shield's model and could easily serve as the historical exemplar for it. See Donald C. Shields and John F. Cragan, " A Communication Based Political Campaign: A Theoretical and Methodological Perspective," chap. in *Applied Communication Research*, 189-191.

31. "Lady Astor Sums Up," *Globe*, 81. Dr. Mabel Ramsay was affiliated with the Plymouth Citizens' Association, a group concerned with feminist issues such as an equal moral standard, extension of the franchise, equal guardianship of children and equal pay for equal work. ("Sex Disabilities," *Western Morning News* (Plymouth), 14 Nov. 1919, MS1416/1/7/32, Astor papers, 77). See also "Women in Politics," *Western Morning News* (Plymouth), 15 Nov. 1919, MS1416/1/7/32, Astor papers, 77.

32. "Lady Astor Sums Up," *Globe*, 81. Heckling backfires when speakers rally supporting voices. See M. J. Beatty and M. W. Kruger, "The Effects of Heckling on Speaker Credibility and Attitude Change," 50.

33. "Lady Astor Sums Up," *Globe*, 81. The *Globe* reporter could recall no precedent: "Never did women cheer like those Plymouth women at their candidate."

34. Ibid.

35. Ibid. Note repetition of "I am going." The function of anaphora is to "highlight the speaker's mental grasp of a concept by displaying the *completeness* (and hence determination) of his or her thinking." (Hart, *Modern Rhetorical Criticism*, 226).

36. "Women in Politics," *Western Morning News*, 76-77.

37. Ibid., 77. See "differentiation" as a rhetorical strategy in "rebuffing attack." (Hart, *Modern Rhetorical Criticism*, 285; also B. Ware and W. Linkugel, "They Spoke in Defense of Themselves: On the Generic Criticism of Apologia," *Quarterly Journal of Speech* 59 [1973]: 273-283).

38. "Women in Politics," *Western Morning News*, 77. Walter Fisher defines "good reasons" as "those elements that provide warrants for accepting or adhering to the advice fostered by any form of communication that can be considered rhetorical" (*Human Communication as Narration: Toward a Philosophy of Reason, Value and Action*, 107).

39. "Women in Politics," *Western Morning News*, 77. On other occasions, Lady Astor, like Mrs. Lloyd George, used transformation of the second persona as a rhetorical strategy in dealing with hecklers and/or an unfriendly audience.

40. Women in Politics," *Western Morning News*, 77.

41. Ibid. Daymond's expressed hope to see Lady Astor as "the first woman prime minister" was met with "laughter and applause."

42. Both "Lady Astor Sums Up," *Globe*, 81, and "Women in Politics," *Western Morning News*, 77, cover the end of Astor's last women's meeting. In discussing the stock roles available to a candidate during a political rally, Cragan and Shields state that the choice usually lies between that of the "devil slayer" or the "miracle worker" (Cragan and Shields, "Communication Based Campaign," 190). As Lady Astor left her afternoon rally, those there certainly were given a glimpse of her version of the "devil slayer."

43. "Fighting Spirit," *Western Morning News*, 78; "Lady Astor Sums Up," *Globe*, 81.

44. "Lady Astor Sums Up," *Globe*, 81. Lady Cynthia Curzon was the second daughter of Lord Curzon, then foreign secretary in Lloyd George's Coalition cabinet. The following May, she married Oswald Mosley, MP, in the society wedding of the year. "Fighting Spirit," *Western Morning News*, 78.

45. "Lady Astor Sums Up," *Globe*, 81; note nautical metaphor.

46. "Fighting Spirit," *Western Morning News*, 78. A phrase Astor employed here was "in bitter earnest"—again an attempt to strike the serious chord in her campaign.

47. "Fighting Spirit," *Western Morning News*, 78. In late July 1588, Sir Francis Drake helped defeat the Spanish Armada.

48. Ibid.

49. Astor, as mentioned before, often attacked Gay for his lack of military service. She saw him as "a shirker," not "a sailor." W. H. Auden, in describing the romantic view of the sea, said, "The sea is where the decisive events, the moments of eternal choice, of temptation, fall, and redemption occur. The shore life is always trivial" (W. H. Auden, *The Enchanted Flood: The Romantic Iconography of the Sea* [New York: Random House, 1950], 14; quoted in Michael Osborn, "The Evolution of the Archetypal Sea in Rhetoric and Poetic," *Quarterly Journal of Speech* 63 [Dec. 1977]: 351).

50. Osborn, "The Evolution of the Archetypal Sea," 356-357; Auden, *The Enchanted Flood*, 7; quoted in Osborn, "The Evolution of the Archtypal Sea," 348.

51. Auden, *The Enchanted Flood,* 7; quoted in Osborn, "The Evolution of the Archtypal Sea," 349-353, 357.

52. Ibid, 351, 362.

53. "Fighting Spirit," *Western Morning News,* 78. Praying was not a political ploy for Astor but an important part of her Christian Science belief. See Mary Baker Eddy, "Prayer," chapter 1 in *Science and Health* (Boston: By the Trustees under the Will of Mary Baker G. Eddy, 1922), 1-17. Note also "She goes to no meeting, and makes no speech, without inward prayer" (Mrs. Alfred Lyttelton, "The First Woman Member," *National Enquirer,* 5 Feb. 1920, MS1416/1/7/2, Astor papers, 93). Religious references and statements of avowed purpose indicate that here Astor opted for the "miracle worker" wherein "the scenario is for the crippled to be healed and the blind to see" (Cragan and Shields, "Communication Based Political Campaign," 190).

54. "Fighting Spirit," *Western Morning News,* 78. Renunciation of peerages became possible in 1963. (Webb, *Modern England,* 634). Like Waldorf who called Lady Astor "Pilgrim Mother," Mrs. Alfred Lyttelton had "said it was right that Plymouth, associated as it was with the Pilgrim Fathers, should be a pioneer in sending women to Parliament" ("End of Plymouth Campaign," *Times,* 14).

55. "Fighting Spirit," *Western Morning News,* 78. The purpose of a consciousness-sustaining event is "to revitalize the individual's commitment to the vision" (Bormann, "The Symbolic Convergence Theory," 87). "Hierarchy argues that people can get more; transcendence argues that they can become better" (Hart, *Modern Rhetorical Criticism,* 351).

56. "Fighting Spirit," *Western Morning News,* 78. The focus on "right" also struck a transcendent note and broke through the ideological constraints of party division.

57. The linking of symbolic dramas to compelling here and now moments lies at the heart of symbolic convergence theory. If there were to be any moment in which Astor's audience could be caught up, this final rally was it. See Bormann, "Symbolic Convergence Theory: A Communication Formulation," 132; Cragan and Shields, "Communication Based Political Campaign,"191.

58. "A Busy Saturday," *Manchester Guardian,* 17 Nov. 1919, 7; "Lady Astor's Vote," *Daily Express* (London), 17 Nov. 1919, MS1416/1/7/32, Astor papers, 100. Lord Astor did not vote because "peers have no vote for members of the House of Commons" (Webb, *Modern England,* 631). "Pilgrim Mother of Parliament," *Daily Express* (London), 17 Nov. 1919, MS1416/1/7/32, Astor papers, 99; "Lady Astor's Vote," *Daily Chronicle* (London), 17 Nov. 1919 (misdated 14 Nov. 1919), MS1416/1/7/32, Astor papers, 77; "Heavy Poll at Plymouth," *Times,* 9.

59. "Lady Astor's Vote," *Daily Chronicle,* 77; "A Busy Saturday," *Manchester Guardian,* 7.

60. "Lady Astor's Vote," *Daily Chronicle,* 77; "Pilgrim Mother of Parliament," *Daily Express,* 99; "A Busy Saturday," *Manchester Guardian,* 7; "Heavy Poll at Plymouth," *Times,* 9.

61. "Heavy Poll at Plymouth," *Times*, 9; "Pilgrim Mother of Parliament," *Daily Express*, 99; "Plymouth Records Its Vote," *Yorkshire Observer* (Bradford), 17 Nov. 1919, MS1416/1/7/32, Astor papers, 101.

62. "Idle Rich," Gay's campaign leaflet, MS1066/1/530, Waldorf Astor papers.

63. "The By-Elections," *Morning Post*, 62; "Astorisms," *Express and Echo*, 35.

64. "An Election Day Epigram," *London Mail*, 15 Nov. 1919 (dateline), MS 1416/1/7/32, Astor papers, 80.

65. The writ, received in Plymouth, 4 November, fixed nominations for 7 November, polling for 15 November, and counting on 28 November. ("Lady Astor's Election Campaign," *Evening Standard*, 54). "Polling Today in Two By-Elections," *Manchester Guardian*, 15 Nov. 1919, 11-12. For a general discussion of the electoral law applicable at this time, see Frederic A. Ogg, "Foreign Governments and Politics," *American Political Science Review* 13 (Feb. 1919): 108-115. For the delay, see Sykes, *Nancy*, 226. Of the 4,518 eligible absentee voters in the Plymouth Sutton division, many were servicemen still overseas. ("Plymouth Prophets," *Evening Standard*, 72).

66. T. H. Scott, "If the Woman Wins," *Daily Sketch* (London), 15 Nov. 1919, MS 1416/1/7/32, Astor papers, 85; for a discussion of the "women's cause" in the post World War I era, see Susan Kingsley Kent, "The Politics of Sexual Difference: World War I and the Demise of British Feminism," *Journal of British Studies* 27 (July 1988): 232-253.

67. T. H. Scott, "If the Woman Wins," *Daily Sketch*, 85.

68. Ibid.

69. "Plymouth Polling," *Daily Telegraph* (London), 17 Nov. 1919, MS1416/1/7/32, Astor papers, 99, and Lord Hugh Cecil, M.P., "Women in Parliament," *Pall Mall Gazette* (London) 5 Dec. 1919, MS 1416/1/7/35, Astor papers, 42. Winston Churchill told Lady Astor that he found "a woman's intrusion into the House of Commons as embarrassing as if she burst into my bedroom when I had nothing with which to defend myself, not even a sponge" (Sykes, *Nancy*, 240). Fears of other MPs are mentioned in the *Weekly Dispatch* (London), 9 Nov. 1919, MS 1416/1/7/32, Astor papers, 8. The King's opening became "My lords and members" ("Lady Astor Causes a Change," *Louisville Herald* as reprinted in *Chicago Post*, 5 Jan. 1920, MS 1416/1/7/2, Astor papers, 79). For Lord Cecil's comment, see Sykes, *Nancy*, 240. A survey of British oratory is given by Robert T. Oliver in *The Influence of Rhetoric in the Shaping of Great Britain* (Newark: University of Delaware Press, 1986) and in *Public Speaking in the Reshaping of Great Britain* (Newark: University of Delaware Press, 1987).

70. "Origin of Custom of Wearing Hats," *Boston Post*, 21 Nov. 1919, MS 1416/1/7/2, Astor papers, 9. The hat was brought up in the opening days of the campaign as well as after polling day. (*Dundee Advertiser* [Dundee]), 5 Nov. 1919, MS 1416/1/7/31, Astor papers, 69).

71. Hayden Church, "Bumps Against the Complicated Etiquette of House," *Buffalo Express* (Buffalo NY), 4 Jan. 1920, MS 1416/1/7/2, Astor papers, 79; "Origin of Custom of Wearing Hats," *Boston Post*, 9.

72. "Origin of Custom of Wearing Hats," *Boston Post*, 9.

73. Sykes, *Nancy*, 233; "Bumps Against the Complicated Etiquette of the House," *Buffalo Express*, 79.

74. "Viscount Astor's Bill," *Western Morning News*, 60. Earlier comments were noted in "Astor Peerage," *Daily News*, 27 Oct. 1919, 18; "Lady Astor and Plymouth," *Western Morning News*, 27 Oct. 1919, 21; and "Lady Astor," *Western Daily Mercury*, 28 Oct. 1919, 26; "Three Candidates for Plymouth," *Western Daily Mercury*, 51; "Lord Astor's Peerage," *Daily News* (London), 11 Nov. 1919, in MS 1416/1/7/32, Astor papers, 33. Foot's allusion is to Shakespeare's *Twelfth Night*, 2. 5. 119-120.

75. "Viscount Astor's Bill," *Western Morning News*, 60; for the Astor-Thomas relationship, see "Lady Astor," *Western Daily Mercury*, 26. Several interesting figures have rented cottages at Cliveden. The most notorious was Stephen Ward, whose playmate Christine Keeler met Secretary of State for War John Profumo there on 8 July 1961 and started "one of the most talked-about scandals of the century" ("Faultless Towers," *Telegraph Sunday Magazine* [London], 9 Feb. 1986, 16-17); see also Christine Keeler, *Scandal* (New York: St. Martin's Press, 1985).

76. J. H. Thomas, Speech to the House of Commons (Peerage Bill), 26 Nov. 1919, *Parliamentary Debates* (Commons), 5th ser., vol. 121 (1919), cols. 1802-1803. The significant ruling was that "No peer of the realm can drown or extinguish his honor (but that it descends to his descendents) neither by surrender, grant, fines nor any other conveyance to the King" (Earl de Ruthyn case, 1640). ("Electricity Bill," *Times* [London], 27 Nov. 1919, 14). For more on Selborne's case, see "A Busy Week in Parliament," *Times* (London), 24 Nov. 1919, 15.

77. J. H. Thomas, *Parliamentary Debates*, cols. 1803-1804.

78. E. Wood, Speech to the House of Commons (Peerage Bill), 26 Nov. 1919, *Parliamentary Debates*, col. 1805. Wood could sit in Commons as the son of a living peer.

79. E. Wood, *Parliamentary Debates*, cols. 1806-1808. The *Times* thought the Bill should have "gone to a second reading" ("Electricity Bill," 14).

80. Sykes, *Nancy*, 228. Bill, born in 1907, was the eldest child of Lady Astor's marriage with Waldorf. The child of her first marriage, Bobbie Shaw, was now over 20.

81. "Lady Astor The First Woman M.P.," *Daily Express* (London), 29 Nov. 1919, MS1416/1/7/33, Astor papers, 100.

82. Ibid.; also Sykes, *Nancy*, 228.

83. "Lady Astor The First Woman M.P." *Daily Express*, 100.

84. Ibid.

85. J. C. T., "Lady Astor: A Memory of 25 Years," *Observer* (London), 3 Dec. 1944, MS 1416/1/7/83, Astor papers, 77; photo caption, "Lady Astor The First Woman M.P.," *Daily Express*, 100.

86. The Unionist Club was just behind the Guildhall. (Sykes, *Nancy*, 229). "Lady Astor The First Woman M.P., *Daily Express*, 100. Collis, (*Nancy Astor*, 70) said she delivered these remarks from the balcony. Sykes (*Nancy*, 230) said she gave them "in the big hall of the club." Bill's remarks were recorded in "Lady

Astor The First Woman M.P.," *Daily Express*, 100. In 1935, Bill Astor was elected MP from East Fulham and served for ten years. In 1961-1963, he played a "peripheral" part in the Profumo scandal, but nevertheless served as a target for the press. (Sykes, *Nancy*, 422-423; 610-611. Christine Keeler, in her memoir *Scandal*, tells another story, 97-98; 143-144; 230-231; 235).

87. "Lady Astor The First Woman M.P.," *Daily Express*, 100. Lady Astor kept her "uniform" all the time she served. Those who came after chose different options. (Vallance, *Women in the House*, 38-40). In her 1937 broadcast, *As I See It*, she recalled Balfour with fondness: "Now some men, of course, had vision. Some—I don't say all—but some of them had it. And the late Arthur James Balfour was one of them. He believed in women as citizens and helped them in every way."

88. "Lady Astor, M.P.," *Sunday National News* (London), 30 Nov. 1919, in MS 1416/1/7/33, Astor papers, 101.

89. Sykes, *Nancy*, 230. At Paddington, Bill took another train and went back to prep school. (Collis, *Nancy Astor*, 71). Collis, *Nancy Astor*, 70; when Lady Astor died, Mary Stocks, in her tribute to her, said she became "the fiercest feminist of them all" (*Observer Weekend Review*, 3 May 1964, 23). In her 1937 *As I See It* broadcast, Astor said that women's struggle for political recognition began with women reformers in the nineteenth century: "They protested against the wrongs of humanity in the subjection of women. It was their fight that made it possible for me to become that venturesome and troublesome thing—the first woman in the British House of Commons."

90. Collis, *Nancy Astor*, 71.

91. "Lady Astor To Take Her Seat Today," *Buffalo Commercial* (Buffalo, N.Y.), 30 Nov. 1919, MS1416/1/7/2, Astor papers, 7; "Lady Astor's Reception," *Manchester Guardian*, 2 Dec. 1919, 9. Recall that after the 1918 election, 73 Sinn Feiners set up their own government in Dublin. (Taylor, *English History*, 175).

92. "Lady Astor's Reception," *Manchester Guardian*, 9; also "Women in the Press Gallery," *Manchester Guardian*, 2 Dec. 1919, 8; Collis, *Nancy Astor*, 75; Sykes, *Nancy*, 232.

93. "Lady Astor's Reception," *Manchester Guardian*, 9. Three hundred sixty MPs were on hand for a later division. ("Essence of Parliament," *Punch*, 10 Dec. 1919, 493). For more on premium bonds, see Collis, *Nancy Astor*, 73, and Sykes, *Nancy*, 237; note also that when Astor was asked for her view on premium bonds during the campaign, she equivocated. ("Astorisms," *Express and Echo*, 35). In the end the bill was defeated.

94. "In the House," *Manchester Guardian*, 2 Dec. 1919, 8; Sykes, *Nancy*, 231.

95. "Lady Astor's Arrival," *Manchester Guardian*, 2 Dec. 1919, 8. Astor's attire is described by Sykes, *Nancy*, 233, 237; Collis, *Nancy Astor*, 72; and Parkhurst, "Lady Astor M. P.," 15. For the cartoon figure, see "Essence of Parliament," *Punch*, 493.

96. "Lady Astor's Arrival," *Manchester Guardian*, 8; Sykes, *Nancy*, 232-233. "When more than one member takes his seat, the order is inalienably determined by the time the official report is received" (Sykes, *Nancy*, 234).

97. Sykes, *Nancy*, 233; "Lady Astor's Reception," *Manchester Guardian*, 9; Collis, *Nancy Astor*, 72. According to parliamentary custom, those approaching the Speaker should bow "three times to the Chair"—first, from the door on entering; second, halfway; and finally, on reaching the table. ("How a New Member Is Received in the House of Commons," *The Outlook*, 17 Dec. 1919, 491).

98. "Lady Astor's Reception," *Manchester Guardian*, 9. Parliamentary etiquette does not permit MPs "to applaud, or to give indication of any emotion, except by the traditional method of exclaiming, "Hear! Hear!" ("Bumps Against the Complicated Etiquette of House," *Buffalo Express*, 79).

99. Sykes, *Nancy*, 235; "Lady Astor's Reception," *Manchester Guardian*, 9.

100. "Sir Courtney was seventy-eight and took a little longer to find the page and place and pen than a younger man would have done" (Sykes, *Nancy*, 235). "Lady Astor's Reception," *Manchester Guardian*, 9; Sykes (*Nancy*, 234) identified the shouting Labour member as Will Thorne. Collis, *Nancy Astor*, 56, 73.

101. "Lady Astor's Reception," *Manchester Guardian*, 9. Astor's seat "was in a part of the House on the Opposition side where the overflow from the government supporters used to sit, mostly younger members" (Sykes, *Nancy*, 231). For William J. Hicks, see Ronald Blythe, "The Salutary Tale of Jix," chapter in *The Age of Illusion*, 15-42. Lloyd George, Mrs., London, to [Lady] Astor, London, ANS, 1 Dec. 1919, MS 1416/1/1/1732, Astor papers.

102. "Lady Astor's Reception," *Manchester Guardian*, 9. Lady Astor's visiting, at this point in the day's proceedings, was not so unusual. An American reporter who observed the daily scene in the House of Commons commented, " . . . they loll on the benches in more or less graceful attitudes, and unless a very important debate is going on, appear to pay little attention to the member speaking. It is common for half the members to be reading the morning papers during a speech" ("Origin of Custom of Wearing Hats," *Boston Post*, 9). Sykes, (*Nancy*, 237) comments on Astor's premium bond vote.

103. Collis, *Nancy Astor*, 75; Sykes, *Nancy*, 238.

104. For the effects of World War I, note "Afterward there was no turning back" (Barbara Tuchman, *The Guns of August* [New York: Macmillan, 1962; Bantam Books, 1980], 489). See also Havighurst, *Britain in Transition*, 145-175, Taylor, *English History*, 165-179, Webb, *Modern England*, 495-506, 511-517. For Astor's mail, see "What is Expected of a Woman M.P.," *Daily Mirror* (London), 11 Feb. 1920, MS1416/1/7/36, Astor papers, 57; "More Women M.P.s Wanted," *Daily News*, 57.

105. "Women's Growing Demands," *Evening Standard* (London), 9 Feb. 1920, MS1416/1/7/36, Astor papers, 52.

106. "More Women M.P.s Wanted," *Daily News*, 57. Even though Lady Astor thought men the weaker sex, she did add that "men had qualities finer than women have. They stuck together, and did not go back on one another, even in the House of Commons. They wanted women to try to get that quality."

107. Lady Astor's mail, from "all classes of people from every part of the land," was already running heavy during the last week of the campaign. ("Lady Astor Going Strong," *Evening Standard*, 10).

108. "A Little 'General'," *Morning Post*, 64; Lady Astor, "Lady Astor Tells Story of Election; Announces Stand," *Buffalo Courier* (Buffalo N.Y.), 1 Dec. 1919, MS 1416/1/7/2, Astor papers, 17-18.

109. "Lady Astor Tells Story of Election; Announces Stand," *Buffalo Courier*, 17-18.

110. Ibid.

111. Mrs. Alfred Lyttelton, "The First Woman Member," *National Enquirer* (U.S.), 5 Feb. 1920, MS 1416/1/7/2, Astor papers, 93. It is not exactly clear what Astor did for those on the lower deck. There was a rumor that she had made a special trip to see Lloyd George to plea for an increase in sailor's pay. ("Lady Astor with the Marines," *Daily Chronicle*, 56). A copy of the *Jerram Report*, Cmd. 270 (1919), dealing with Navy pay, allowances, and pensions was filed in MS 1066/1/530, Waldorf Astor papers.

112. Lyttelton, "The First Member," 93.

113. Ibid.

114. Lady Astor received a massive amount of correspondence that was later filed in two main groups, General and/or Personal Correspondence and Political Correspondence. Letters relating to Astor's parliamentary entrance, from her campaign to her maiden speech, were included in "Political Correspondence." "Reading University Catalogue for MS 1416," TMS, Astor papers, Archives and Manuscripts, University of Reading Library, 3. Those letters selected for the above discussion were chosen from MS 1416/1/1/1721 and MS 1416/1/1/1722. Not all envelopes were kept. Some letters may have been sent to Astor in Plymouth; others may have been sent to her London address. Unless specifically noted otherwise, citations give "Plymouth" as Astor's address.

The discussion of Astor's congratulatory mail is based upon a thorough analysis of 79 letters chosen from among the many Lady Astor received. The methodological approach involved an exploration of the persona-second persona links created by Astor and her respondents: 1) when Astor spoke to her audiences, she created a first persona (her political self) and a second persona (audience as she perceived them); 2) however, when members of her audience wrote back to her at the end of the campaign, a reversal took place. The correspondents, in identifying themselves, became the first persona, and Astor, the second persona. Correspondences, "matches," between the two indicated that identification had taken place—or, in the simplest of terms, there had been "a meeting of the minds—or hearts." The methodology used was informed by Black, "The Second Persona," 109-119; Bormann, "fantasy theme analysis" as discussed in "Fantasy and Rhetorical Vision: The Rhetorical Criticism of Social Reality," *Quarterly Journal of Speech* 58 (1972); 396-407; "Fantasy and Rhetorical Vision: Ten Years Later," *Quarterly Journal of Speech* 68 (1982): 288-305; Donald S. Shields and John F. Cragan, "A Communication Based Political Campaign: A Theoretical and Methodological Perspective,"

Applied Communication Research, 177-196; Hart, "I-Statements," *Modern Rhetorical Criticism,* 295-301.

"Content analysis of letters is also developing as a current trend in mass media audience studies" (Professor David Rarick, "Audience analysis," discussion with author, 12 April 1993, University of Minnesota, Minneapolis). See also S. Elizabeth Bird, *For Enquiring Minds: A Cultural Study of Supermarket Tabloids* (Knoxville: University of Tennessee Press, 1990), 112-113.

115. Letters chosen can be classified as a convenience sample. Choices were heavily influenced by the fact that, after many years, paper rots and ink fades. Selected from alphabetically arranged files, the letters chosen were both readable and sturdy. C. R. Davis to Lady Astor, Plymouth, ANS, 26 May, MS1416/1/1/1721, Astor papers [filed with other letters bearing November-December 1919 dates]; S. Annie Evans (née Coggins) to Lady Astor, Plymouth, ALS, 6 Dec. 1919, MS1416/1/1/1721. Astor papers.

116. Ruth D. Hansard, Kew, to Lady Astor, M.P., Plymouth, ALS, MS1416/1/1/1722, Astor papers. For more on "Hansard" the printer of debates in Parliament until 1889, see G. Jack Gravlee, "Reporting Proceedings and Debates in the British House of Commons," *Central States Speech Journal* 32 (Summer 1981): 85-99.

117. Mary G. Collins, Hampstead, to Lady Astor, Plymouth, ALS, 29 Nov. 1919, MS 1416/1/1/1721, Astor papers.

118. Ibid.

119. The Fathers, Argus Printing Company, London, to Lady Astor, Plymouth, TLS, 29 Nov. 1919, MS 1416/1/1/1721, Astor papers. "The Fathers," a shortened form of "The Fathers of the Compositors' and Readers' Chapels," is an "expression used to identify the shop stewards of printing unions" (Josef Altholz, historian, discussion with author, 12 April 1993, University of Minnesota, Minneapolis). Amy Goddard, Newcastle-on-Tyne, to Lady Astor, Plymouth, ANS, 29 Nov. 1919, MS 1416/1/1/1722, Astor papers.

120. The terms for suffrage workers seem to be used interchangeably.

121. Mrs. Letherbrow, Moorbeck Buxton, to Lady Astor, Plymouth. ALS, 3 Dec. 1919, MS 1416/1/1/1722, Astor papers; Lady Astor also heard from younger suffrage workers, Elsie M. Arnold, for example, said she had waited "for this to happen for the past 12 years ever since I was 15" (Elsie M. Arnold, East Putney, to Lady Astor, Plymouth, ALS, 6 Dec. 1919, MS 1416/1/1/1721, Astor papers).

122. Astor and her correspondents were identified as Christian in approximately eight percent of the letters surveyed . About 11 percent positively responded to her Hustler persona. Mrs. L. Clibborn, Eastwood, to Lady Astor, Plymouth, ANS, 29 Nov. 1919, MS 1416/1/1/1721, Astor papers; Florence Bateman, Plymouth, to Lady Astor, Plymouth, ANS, 28 Nov. 1919, MS 1416/1/1/1721, Astor papers; Arthur J. Lisk, Plymouth, to Lady Astor, Plymouth, ALS, 28 Nov. 1919, MS 1416/1/1/1722, Astor papers.

123. Mary C. Davidson, London, to Lady Astor, Plymouth, ALS, 1 Dec. 1919, MS 1416/1/1/1721, Astor papers; Fane to Astor, 29 Nov. 1919.

124. By "vision" here, one means "rhetorical vision" as used in fantasy-theme analysis in reference to "a unified putting together of the various scripts which give the participants a broader view of things" (Bormann, *The Force of Fantasy*, 8.)

125. Lady Astor, "Lady Astor Tells Story of Election; Announces Stand," *Buffalo Courier*, 18.

CONCLUSION

1. *Winning Post*, 8 Nov. 1919, MS1416/1/7/31, Astor papers, 104.

2. Harrison, "Publicist," 79.

3. "Women of England and the League of Nations," *Daily Telegraph* (London), 31 Jan. 1920, MS1416/1/7/36, Astor papers, 52; "What Is Expected of a Woman M.P.," *Daily Mirror* (London), 11 Feb. 1920, MS1416/1/7/36, Astor papers, 57; Lady Astor, "Primrose League Banquet—February 16th," MS1416/1/6/12, Astor papers, 5; see also "She was always an independent critic" (Harrison, "Women in a Men's House," 651).

4. Collis (*Nancy Astor*, 79) notes that she later said, "I was warned not to touch the temperance question, but I was not anxious about my future."

5. Sykes, *Nancy*, 244; see also "Lady Astor's Maiden Speech," *Daily Mail* (London) 24 Feb. 1920, MS1416/1/7/36, Astor papers, 74.

6. Collis, *Nancy Astor*, 81; see also "Lady Astor's Maiden Speech," 74.

7. Sykes, *Nancy*, 244-245; Harrison, "Publicist," 92.

8. Collis, *Nancy Astor*, 81-82.

9. In addition to her parliamentary duties, she managed her various households, looked after her six children, entertained, supported her charities, and dealt with a great deal of correspondence. (Collis, *Nancy Astor*, 89; Sykes, *Nancy*, 261); Harrison said that by 1922 she received "between 1500 to 2000 letters a week, many of them on the difficult personal problems of women not her constituents" ("Women in a Men's House," 630).

10. Lady Astor, "Two Tribunals," MS1416/1/6/33, 1-5; see also Harrison, "Publicist," 77, and Sykes, *Nancy*, 290; for "Geddes Axe," see Taylor, *English History*, 240-241.

11. Sykes, *Nancy*, 263; Collis, *Nancy Astor*, 89.

12. Collis, *Nancy Astor*, 75; Shirley Williams as quoted in Harrison, "Women in a Men's House," 629. Nancy Astor later commented that the male members of the House "bore their shock with dauntless decency" ("Address to New York League of Women Voters," 19 April 1922, MS1416/1/6/15, Astor papers, 2-3).

13. Harrison, "Publicist, 94; see also Collis, *Nancy Astor*, 92.

14. Halperin, "Lady," 192; Collis, *Nancy Astor*, 110; see also Gilbert Campion, "Viewed Impartially" as quoted in Sykes, *Nancy*, 320.

15. Collis, Nancy Astor, 84-85; see also Grigg, *Nancy Astor*, 85. Grigg says "more often than not out of order."

16. Sykes, *Nancy*, 249-254; "Lonely in the House," *Sunday Chronicle* (London), 31 Oct. 1920, MS1416/1/7/42, Astor papers, 87.

17. Halperin, "Lady," 195; Arthur Baker, *The House Is Sitting* (London: Blandford Press, 1958), 205.

18. Rose E. Feld, "Lady Astor's Ways in Parliament and Out," *New York Times*, 16 April 1922, sec. 7, 4; also "Personal Forces of the Period," *Everyman*, 19 June 1920, MS1416/1/7/42, Astor papers, 8; for Shaw's comment, see Halperin, "Lady," 202.

19. The discord between Lady Astor and Winston Churchill is remembered by many. For selected references, see Harrison, "Women in a Men's House," 628; Sykes, *Nancy*, 240; Grigg, *Nancy Astor*, 87, 141; Nancy Astor, *As I See It*, BBCX/21102, 1937, sound recording; Harrison, "Publicist," 90; see also R. C. Feld, "Political Opinions of Lady Astor, M. P.," *New York Times Book Review and Magazine*, 11 Dec. 1921, 3.

20. Bottomley expressed his dislike directly: "But I have seen the lady M.P., and, charming and fascinating as I am sure she is in private life, I don't like her at all" ("Have Women Gone Too Far?" *Sunday Illustrated* [London], 24 July 1921, MS1416/1/7/45, Astor papers, 90). Sykes, *Nancy*, 250; Lady Astor, "Divorce," 14 April 1920, MS1416/1/6/31, Astor papers, 1. Recall that Lady Astor's divorce was on grounds of adultery. She did not apply for a divorce until she knew Shaw had illegally married another. His drunkenness led to separation, not divorce. Note also that Lady Astor's first vote in Parliament was against Bottomley's bill on premium bonds; she also proved to be a rival as the "Soldier's Friend." (Sykes, *Nancy*, 240-241). Collis, *Nancy Astor*, 86.

21. "Lady Astor's Divorce," *John Bull*, 8 May 1920, 12-13; "Lady Astor, M.P.," *Western Morning News* (Plymouth) 10 July 1920, 5; Collis, *Nancy Astor*, 87.

22. Sykes, *Nancy*, 258; "Early Sorrows of Lady Astor," *Daily Chronicle* (London), 10 July 1920, MS1416/1/7/42, Astor papers, 22; "Lady Astor, M.P.," 5. Collis, *Nancy Astor*, 88; see also William Benoit, *Accounts, Excuses and Apologies* (Albany: State University of New York Press, 1995) for a thorough but succinct discussion of the theory of image restoration.

23. Viscountess Astor, M.P., "Six Months in Parliament," *The Woman's Supplement*, June 1920, MS1416/1/7/42, Astor papers, 19.

24. Lady Astor, "Geneva," 7 June 1920, MS1416/1/6/12, Astor papers, 1-9.

25. "Lady Astor on Tour," *Daily Sketch* (London) 14 July 1920, MS1416/1/7/42, Astor papers, 21; "Lady Astor, M.P.," *Yorkshire Evening News* (Leeds), 17 July 1920, MS1416/1/7/42, Astor papers, 29.

26. "Too Many Women," *Daily News* (London), 28 July 1921, MS1416/1/7/45, Astor papers, 92; "Fair for the Brave," *Leeds Mercury* (Leeds), 10 March 1921, MS1416/1/7/43, Astor papers, 56; "Teaching the M.P.s," *Daily News* (London), 15 March 1921, MS1416/1/7/43, Astor papers, 59; "Women's Societies and M.P.s," *Observer* (London), 17 April 1921, MS1416/1/7/43, Astor papers, 80.

27. Lady Astor, "America and World Politics," (draft of article for *Headway*), 9 June 1922, MS1416/1/6/62, Astor papers, 1; "Lady Astor Brings 'Pram' with her Variegated Luggage," *Baltimore Sun*, 14 April 1922, sec. 1, 18; for Canadian

requests, see entries for 17 May-19 May, Waldorf Astor, "American Visit Diary," 38-41. Waldorf and some hastily hired secretaries assisted her. A detailed account of their activities is given in Waldorf Astor's diary.

28. Waldrof said, "It's the personal individual feeling of affection and admiration that is so moving in Virginia" (Entry for 4 May 1922, Waldorf Astor, "American Visit Diary," 22). Danville "Astor Day" program included in Waldorf Astor, "American Visit Diary," 26; "Thousands Crowd Broad Street Station to Greet Visitor," *Richmond Times-Dispatch*, 3 May 1922, 1-2; see also "I never cry in public. If a woman cries in public, people exclaim, 'how weak'; if a man cries in public, 'how magnificent'" ("Lady Astor Wins the Affection of the People of Danville for All Time," *The Register* [Danville, Va.], 6 May 1922, 2).

29. "Lady Astor and Party Will Reach Danville Tonight," *The Register* (Danville, Va.), 4 May 1922, 3; also "Lady Astor Wins the Affection," 1-2, and "Astor Party Leaves for New Conquests," *The Register* (Danville, Va.), 7 May 1922, 3.

30. "Lady Astor is Welcomed Home," *The Daily Progress* (Charlottesville, Va.), 10 May 1922, 1.

31. Lady Astor summarized her themes in "Speech for English Speaking Union Dinner," Savoy Hotel (London), 12 June 1922, MS1416/1/6/14, Astor papers, 1. Astor's comment on U.S. failure to support the League of Nations was: "That's where we dropped the molasses jug" ("Lady Astor is Welcomed Home," 1). "Lady Astor Calm in Gale of Queries," *New York Times*, 20 April 1922, sec. 1, 8; "Join the League, Lady Astor's Plea," *New York Times*, 21 April 1922, sec. 1, 1; "Lady Astor Calls Men Weaker Sex," *New York Times*, 29 April 1922, sec. 1, 1.

32. "Tells War Blinded They Prove League," *New York Times*, 28 April 1922, sec. 17, 3. On moral leadership, Lady Astor had said, "My two countries must go hand in hand" (Hon. Edith S. Lyttelton, "Lady Astor as Seen by a Woman Friend, *New York Times*, 20 April 1922, sec. 1, 8). Lady Astor's call to aid Europe is recorded in "Lady Astor's Adieu A Plea for Europe," *New York Times*, 23 May 1922, sec. 1, 6; see also J. L. Garvin, "Notes for League of Women Voters—New York," MS1416/1/6/15, Astor papers, 1-9, and J. M. Keynes, *Economic Consequences of the Peace* (New York: Harcourt Brace & Howe, 1920); her call to women was given in Lady Nancy Astor, "VII (New York farewell)," *My Two Countries*, 75.

33. "Lady Astor Wins the Affection," 1-2.

34. "The Triumph of Lady Astor," editorial in *New York Times*, 23 May 1922, sec. 1, 16; "Lady Nancy," *The Register* (Danville, Va.), 6 May 1922, 4.

35. *New York Telegraph* as quoted in Collis, *Nancy Astor*, 103; President Alderman, University of Virginia, said she was " a touch of romance." "Lady Astor at University," *The Daily Progress* (Charlottesville, Va.), 12 May 1922, 1.

36. Collis, *Nancy Astor*, 62; Harrison, "Women in a Men's House," 632, and "Publicist," 96.

37. Collis, *Nancy Astor*, 111-113. Edwin Scrymgeour, MP from Dundee, had defeated Winston Churchill in the 1922 election. Churchill had lost popular support because he had supported intervention in Russia. (Sykes, *Nancy*, 297).

38. Sykes, *Nancy*, 300-304, 306, 309; Collis, *Nancy Astor*, 114-115.

39. Harrison, "Women in a Men's House," 645, and "Publicist," 82.

40. Sykes, *Nancy*, 347; see also Lady Astor, "Reform of the Franchise," in *Selected Speeches on the Constitution*, ed. Cecil S. Emden (London: Oxford UP, 1939), 2: 200-201.

41. Harrison, "Publicist," 88; see also Sykes, *Nancy*, 328-330, 420.

42. Harrison, "Publicist," 80, and "Women in a Men's House," 623-625.

43. Sykes, *Nancy*, 267; Harrison, "Women in a Men's House," 634, and "Publicist," 85; R. C. Feld, "Political Opinions of Lady Astor, M.P.," *New York Times Book Review and Magazine*, 11 Dec. 1921, 3.

44. Sykes, *Nancy*, 352-354; Elliseva Sayers, "Women M.P.s Have Done a Grand Job," *Evening News* (London), 21 Nov. 1944, MS1416/1/7/83, Astor papers, 72.

45. Grigg, *Nancy Astor*, 138.

46. Halperin, "Lady," 212; Grigg, *Nancy Astor*, 152.

47. Sykes, *Nancy*, 379-381; Halperin, "Lady," 203, 207.

48. Sykes, *Nancy*, 384-394.

49. Sykes, *Nancy*, 395-397; Waldorf Astor's Diary as quoted in Sykes, *Nancy*, 395; Grigg says Stalin replied that "many people had to die before a Communist state could be firmly established" (*Nancy Astor*, 141); Rowse, "Nancy Astor," 39.

50. Halperin, "Lady," 209-210; see also Sykes, *Nancy*, 399-402.

51. Sykes, *Nancy*, 414; O'Connor, *Astors*, 451; *Time and Tide*, 1936, quoted in Halperin, "Lady," 216. See also A. Lentin, *Lloyd George, Woodrow Wilson and the Guilt of Germany* (Leicester: Leicester UP, 1984).

52. As early as 1922, she had said, "It's hopeless trying to go forward when you are looking backward. We have had enough of hate and I for one am not prepared to hate, not even the Germans, any longer" ("Join the League," 1). Halperin, "Lady," 212, 215; HC Deb., 4 May 1936, c. 1429 as quoted in Harrison, "Publicist," 90. "Astor had long admired Chamberlain for his social reforms" (Harrison, "Women in a Men's House," 648). Harrison (653) also commented, "Her support for appeasement in 1938, far from reflecting fascist values, embodied (however misguidedly) their opposite: a hatred of war, a respect for women, and a down-to-earth preparedness to face realities and seek a middle way." Grigg commented that "Nancy's blind support for Chamberlainite appeasement was the worst political mistake of her career" (*Nancy Astor*, 146). Note also that Chamberlain "alone was arbiter of British policy" (Langhorne, *Nancy Astor*, 180).

53. Claud Cockburn, "Britain's 'Cliveden Set' An Informal but Powerful Pro-German Group Constitutes a Second British Foreign Office," *Current History* 48 (Feb. 1938), 32-33; Cockburn attributed the Astors' power and influence to their wealth and newspaper connections, the *Observer* and the *Times*, grossly underestimating the power of their independent editors. Sykes, *Nancy*, 428. Before he left for Germany Halifax had contacted both Neville Chamberlain and Anthony Eden; Churchill also knew about the trip. (Sykes, *Nancy*, 434, and Winston Churchill, *The Gathering Storm* [New York: Bantam Books, 1961], 224).

54. Grigg, *Nancy Astor*, 147-148; Sykes, *Nancy*, 430; Claud Cockburn, *Crossing the Line* (New York: Monthly Review Press, 1960), 19.

55. Cockburn, *Crossing the Line*, 19-21; Sykes, *Nancy*, 431. Collis, in contrast to Cockburn, noted that from Lady Astor's early political days, "there was not a trace of the intriguer in her nature" (*Nancy Astor*, 69); on another matter, Sykes said, "Nancy was far too open, candid and honest a person to follow any conspirational line of conduct" (*Nancy*, 314). For the letter-writing campaign, see Sykes, *Nancy*, 431; for Cliveden as a second Foreign Office, see Cockburn, "Britain's 'Cliveden Set'," 32. Note that according to Churchill's account, the Second Foreign Office was the Prime Minister's because Chamberlain frequently disagreed with his Foreign Secretary, Anthony Eden. (*Gathering Storm*, 215-231).

56. Cockburn, "Britain's 'Cliveden Set'," 33; later Cockburn (*Crossing the Line*, 21) stated, "I am prepared to believe that a lot of people I had cast as principal figures were really mere cat's paws. But then a cat's paw is a cat's paw and must expect to be treated as part of the cat." For stopping Bolshevism, see Cockburn, "Britain's 'Cliveden Set'," 31; also Halperin, "Lady," 217, and Raymond J. Sontag, *A Broken World* (New York: Harper Torchbooks, 1972), 377.

57. Cockburn, *Crossing the Line*, 19-20; Sykes, *Nancy*, 432, 435. The "Cliveden Set" story has all the earmarkings of a fantasy chain event, especially the "symbolic cue phenomenon." See E. G. Bormann, *Force of Fantasy*, 6-7. Note also that Cockburn himself said that he had been interested by "the journalistic detail— the way in which a phrase can 'trigger' to explosion a lot of facts which, for the most part, were already known to hundreds of people, but remained, as it were inert" (*Crossing the Line*, 21).

58. Sykes, *Nancy*, 435; Halperin, "Lady," 218-219. Lady Astor ("Lady Astor Interviews Herself," *Saturday Evening Post*, 4 March 1939, 5) said, "They say that my family and friends ought all to be taken out and shot." Harrison ("Publicist," 95) talks about her continuous press following.

59. Letter from Nancy Astor to Lord Lothian, 12 Dec. 1937, as quoted in Sykes, *Nancy*, 453; Sykes, *Nancy*, 456-457; she also called the Cliveden Set charges "mischievous rubbish" and a "monstrous tale" (Viscountess Astor, "Lady Astor Interviews Herself," 5). Also note: "And throughout it all the members of the Cliveden Set, furiously, wearily or derisively, maintained that they were not members because there simply was not any Cliveden Set to be a member of. It was a myth" (Cockburn, *Crossing the Line*, 20).

60. On Waldorf's decision to respond, note: "When our image is threatened, we feel compelled to offer explanations, defenses, justification, rationalizations, apologies or excuses for our behavior"(Benoit, *Accounts*, 2). Sykes, *Nancy*, 457; Waldorf Astor, "The 'Cliveden Set'," *Times* (London), 5 May 1938. Lady Astor chose the *Daily Herald*, the Labour paper, because it had not circulated the Cliveden Set rumor as other papers had done. The *Daily Herald* allowed her to reach an audience different from those reached by Waldorf's letter to the *Times*. (O'Connor, *Astors*, 451). All references to the *Daily Herald* letter come from O'Connor's account, 450-452. She made similar comments to her *Daily*

Herald letter in a personal letter to Felix Frankfurter. (Langhorne, *Nancy Astor*, 182-184).

61. Sykes, *Nancy*, 467; Frederick L. Collins, "Why Did Hitler Give Lindbergh a Medal?" *Liberty*, 17 Dec. 1938, 6-8.

62. George B. Shaw, "Bernard Shaw Answers Frederick Collins about Lady Astor," *Liberty*, 11 March 1939, 7-8. Collins's attack and Shaw's reply are an excellent example of *kategoria* and *apologia*. (Benoit, *Accounts*, 20).

63. Viscountess Astor, "Lady Astor Interviews Herself," 5-6; see also Viscountess Astor, "I Hate Fascism," *The Forum*, April 1939, 237-238.

64. Langhorne, *Nancy Astor*, 203; Sykes, *Nancy*, 472; Sykes adds that before the Prime Minister could reply, another MP shouted at Astor, "You caused it yourself"; Grigg, *Nancy Astor*, 152.

65. Note Benoit, *Accounts*, 72: "The longer or more widespread the negative effects, the greater the damage to the actor's reputation." Though many perceived Astor to be a "Traitress," Hitler never saw her as an ally. When the Nazi Black Book was discovered in 1940, Lady Astor's name was among the 2,300 residents to be executed when the Germans invaded England. (Halperin, "Lady," 224). 'Cliveden Set' had become the "symbol of appeasement" and the "failure to evaluate the world situation as it really was" (Langhorne, *Nancy Astor*, 240).

66. As early as 23 August 1939, Chamberlain admitted failure: "I have done everything I can think of and it seems as if all my work has come to naught" (Sontag, *A Broken World*, 379). On Astor's vote, see Harrison, "Women in a Men's House," 649.

67. Sykes, *Nancy*, 486. Waldorf had been elected Lord Mayor in November 1939, and he served until 1944. (Langhorne, *Nancy Astor*, 216).

68. By mid-March 1941, Plymouth had had 37 bombing raids, 59 by the end of the war. (Sykes, *Nancy*, 507, 549); Nancy later said she had been through all the blitzes in Plymouth. (Grace Conway, "I Like People and Social Work," *Catholic Herald*, 24 Nov. 1945, MS1416/1/7/83, Astor papers, 72). For dances and visits, see Rowse, "Nancy Astor," 32; Grigg, *Nancy Astor*, 164; Langhorne, *Nancy Astor*, 230.

69. At first, she did not speak in public about the need for fire-fighting equipment because there was a fear that by doing so she had be giving information to the enemy. (Sykes, *Nancy*, 507); Grigg, *Nancy Astor*, 164; Sykes, *Nancy*, 514.

70. Langhorne, *Nancy Astor*, 231-233. Her finest hour also had some awful moments. She argued with Waldorf over chocolates sent to the people of Plymouth. (Sykes, *Nancy*, 520-521). She was fined £50 for ordering rationed clothing items from the United States. Her son Jakie told G. B. Shaw that she should spend time in the clink. (Langhorne, *Nancy Astor*, 235; see also Grigg, *Nancy Astor*, 166, and Sykes, *Nancy*, 542-544).

71. Halperin, "Lady," 222.

72. For Bevan's comment, see *Tribune*, 2 Dec. 1938, as quoted in Harrison, "Publicist," 93. Sykes, *Nancy*, 516, 525-526, 538. At war's end Waldorf himself was stepping down as Lord Mayor of Plymouth. (Sykes, *Nancy*, 554).

73. Harrison said she was one of those who "fell in love with the House" ("Women in a Men's House," 629); Halperin, "Lady," 223; Percy Cater, "The Petticoat in Politics Has Made Good," *Daily Mail* (London) 2 Dec. 1944, MS1416/1/7/83, Astor papers, 77.

74. "Lady Astor Almost in Tears on Last Day In Commons," *News Chronicle* (London), 15 June 1945, MS1416/1/7/83, Astor papers, 101.

75. "Decision for Future Peace," *Lynchburg News*, 5 May 1922, 1. Speech before League of Women Voters, New York, 19 April 1922, typescript in Astor papers, MS1416/1/6/15, 7.

BIBLIOGRAPHY

MANUSCRIPT COLLECTION

Astor papers, Archives and Manuscripts, University of Reading Library, Reading, England.

MS 1066 (Correspondence and other papers of Waldorf Astor 1902-1950)

MS 1416 (Correspondence and other papers of Lady Astor 1900-1964)

MS 1416/1/1 (Political correspondence 1919-1945)

MS 1416/1/2 (General correspondence 1900-1964)

MS 1416/1/6 (Sundry papers)

MS 1416/1/7/1-17 (American press cuttings 1919-1940)

MS 1416/1/7/18-89 (British press cuttings 1908-1964)

MS1416/2/16 (Waldorf Astor "American Visit" Diary)

MS 1416/2/17 (Election 1919: letters of encouragement, congratulations and "testimonials")

OFFICIAL PAPERS

U.K. Parliament. Comd 8758. *Sessional Papers 1917-1918* (Commons)

U.K. *Parliamentary Debates* (Commons). 5th ser., vol. 121 (1919)

PERIODICALS (CONTEMPORARY)

Astor, Lady. "My First Year in Parliament." *Pearson's Magazine*, June 1921, 464.

Astor, Viscountess, M.P. "What Women Can Do in Politics That Men Cannot Do." *Woman's Home Companion*, Sept. 1920, 7-8.

Astor, Viscountess. "Lady Astor Interviews Herself." *Saturday Evening Post*, 4 March 1939, 5-6.

Astor, Viscountess. "I Hate Fascism." *The Forum*, April 1939, 237-238.

Collins, Frederick L. "Why Did Hitler Give Lindbergh a Medal? *Liberty*, 17 Dec. 1938, 6-8.

Eaton, Jeanette. "Nancy Astor: Myth and Woman." *North American Review*, Apr. 1929, 385-391.

"Essence of Parliament." *Punch*, 10 Dec. 1919, 493.

Fisher, Victor. "Where is Labour Going?" *Nineteenth Century and After*, May 1920, 916-928.

Grasty, Charles H. "British and American Newspapers." *Atlantic Monthly*, November 1919, 577-591.

Hatch, Ernest. "The Uprising of Labour." *Nineteenth Century and After*, Jan. 1920, 17-26.

"How a New Member Is Received in the House of Commons." *Outlook*, 17 Dec. 1919, 491.

"Is Lady Astor's Election Valid?" *Saturday Review*, 10 Jan. 1920, 28.

"Lady Astor." *Outlook*, 3 May 1922, 10-12.

"Lady Astor, from Virginia, First Woman M. P." *Literary Digest*, 13 Dec. 1919, 50-54.

"Lady Astor, M. P." *The Conservative Woman* (Leeds), Nov. 1921, 2-3.

"Lady Astor's Campaign." *Outlook*, 26 Nov. 1919, 342.

"Lady Astor's Triumph." *Outlook*, 17 Dec. 1919, 491.

Littell, Robert. "Lady Astor." *New Republic*, 3 May 1922, 274-275.

Masterman, C. F. G. "Social Unrest in Great Britain." *Atlantic Monthly*, August 1919, 255-266.

"Most Conspicuous Woman in England." *Current Opinion*, Dec. 1919, 290-292.

"Noble Lady, The Member from Plymouth." *Literary Digest*, 13 Dec. 1919, 23.

Ogg, Frederic A. "Foreign Governments and Politics." *American Political Science Review* (Feb. 1919): 108-115.

"Our 'Pussyfoot,' England's Hero and Pest." *Literary Digest*, 6 Dec. 1919, 47-56.

Parkhurst, Genevieve. "Lady Astor, M. P." *Ladies Home Journal*, Mar. 1920, 14-15.

"'Pussyfoot's' Pilgrim's Progress." *Literary Digest*, 29 Nov. 1919, 22-24.

"The 'Rooseveltian' Lady Astor." *Literary Digest*, 6 May 1922, 59-61.

Tantum, Auditor (pseud.). "A Look Round the Back Benches." *Fortnightly Review*, July 1921, 41-52.

"Virginia Viscountess." *Ladies Home Journal*, Apr. 1920, 32.

NEWSPAPERS

Most newspapers cited are in MS1416/1/7/1-17 (American press cuttings) and MS1416/1/7/18-19 (British press cuttings), Astor papers. Papers utilized from other sources are listed as follows:

British Newspapers

Daily Telegraph Sunday Magazine (London) Feb. 1986.

John Bull (London) May 1920.

Manchester Guardian (Manchester) Nov. 1919-Feb. 1920.

The Times (London) Oct. 1919-Feb. 1920.

Western Morning News (Plymouth) July 1920.

American Newspapers

Baltimore Sun (Baltimore, Md.) April 1922.

Daily Progress (Charlottesville, Va.) May 1922.

Lynchburg News (Lynchburg, Va.) May 1922.

Minneapolis Morning Tribune (Minneapolis, Minn.) Dec. 1919.

New York Times (New York, N. Y.) Nov.-Dec. 1919; April-May 1922.

New York Times Book Review and Magazine (New York, N. Y.) Dec. 1921.

Richmond Times Dispatch (Richmond, Va.) May 1922.

The Register (Danville, Va.) May 1922.

OTHER REFERENCES

Adams, John. "The Familial Image in Rhetoric." *Communication Quarterly* 31 (Winter 1983): 56-61.

Alberti, Johanna. *Beyond Suffrage.* New York: St. Martin's Press, 1985.

Allen, Frederick Lewis. *Only Yesterday: An Informal History of the 1920's.* New York: Harper, 1959; Perennial Library, 1964.

Altholz, Josef. Conversation with author, 23 Jan. 1993, University of Minnesota, Minneapolis.

Aristotle. "Rhetoric" in *The Rhetoric and the Poetics of Aristotle.* Translated by W. Rhys Roberts. Oxford: Clarendon, 1954; reprint, New York: Random House, Modern Library, 1984.

Astor, Lady. *My Two Countries.* Garden City, NJ: Doubleday, Page, 1923.

———"Women in Politics." In *Modern Eloquence,* ed. Ashley Thorndike, New York: Modern Eloquence, 1923, 7:36-40.

———*As I See It,* BBC X/21102, 1937. Sound recording. London: British Library National Sound Archives.

————"Reform of the Franchise." In *Selected Speeches on the Constitution*, ed. Cecil S. Emden, London: Oxford UP, 1939, 2:199-201.

————*This I Believe*, BBC 19390, 1953. Sound recording. London. British Library National Sound Archives.

Astor, Michael. *Tribal Feeling*. London: J. Murray, 1963.

Attlee, Lord. "She Made Things Hum." (Obituary) *Observer Weekend Review*, 3 May 1964, 23.

Axtell, J. "History as Imagination." *Historian* 49 (August 1987): 451-462.

Ayers, Phyllis Laverne. "The Public Career of Lady Astor." Ph.D. diss., University of Pittsburgh, 1958.

Bailey, F. G. *The Tactical Uses of Passion: An Essay on Power, Reason, and Reality*. Ithaca: Cornell UP, 1983.

Bailey, Thomas A. *Woodrow Wilson and the Great Betrayal*. New York: Macmillan, 1945; Chicago: Quadrangle Books, 1963.

Baker, Arthur. *The House Is Sitting*. London: Blandford Press, 1958.

Balsan, Consuelo Vanderbilt. *The Glitter and the Gold*. New York: Harpers, 1952.

Banner, Lois W. *American Beauty*. New York: Alfred A. Knopf, 1983.

Beamish, David R., Clerk, House of Lords, and "BBC Mastermind" (Astor expert). Interview by author, 31 Oct. 1988, House of Lords Establishment Office, London.

Beatty, Michael J., and Michael W. Kruger. "The Effects of Heckling on Speaker Credibility and Attitude Change." *Communication Quarterly* 26 (Spring 1978): 46-50.

Becker, Robert. *Nancy Lancaster: Her Life, Her World, Her Art*. New York: Alfred A. Knopf, 1996.

Bennett, W. Lance. "Assessing Presidential Character: Degradation Rituals in Political Campaigns." *Quarterly Journal of Speech* 67 (August 1981): 310-321.

Benoit, William L. *Accounts, Excuses, and Apologies*. Albany: State University of New York Press, 1995.

Bird, S. Elizabeth. *For Enquiring Minds: A Cultural Study of Supermarket Tabloids*. Knoxville: University of Tennessee Press, 1990.

Bitzer, Lloyd F. "The Rhetorical Situation." *Philosophy and Rhetoric* 1 (June 1968): 1-14.

Black, Edwin. "The Second Persona." *Quarterly Journal of Speech* 56 (April 1970): 109-119.

————*Rhetorical Criticism*. Madison: University of Wisconsin Press, 1978.

Blythe, Ronald. *The Age of Illusion*. London: Hamish Hamilton, 1963; reprint. Oxford: Oxford UP, 1963.

Bondfield, Margaret. *A Life's Work*. London: Hutchinson, 1950.

Bormann, Ernest G. "Ghostwriting and the Rhetorical Critic." *Quarterly Journal of Speech* 46 (Oct. 1960): 284-288.

————"Fantasy and Rhetorical Vision: The Rhetorical Criticism of Social Reality." *Quarterly Journal of Speech* 58 (1972): 396-407.

————*Discussion and Group Methods.* 2d ed. New York: Harper & Row, 1975.

————"Fetching Good Out of Evil: A Rhetorical Use of Calamity." *Quarterly Journal of Speech* 63 (Apr.1977): 130-139.

————*Communication Theory.* New York: Holt, Rinehart & Winston, 1980.

————"Fantasy and Rhetorical Vision: Ten Years Later." *Quarterly Journal of Speech* 68(1982): 288-305.

————"The Symbolic Convergence Theory of Communication and the Creation, Raising and Sustaining of Public Consciousness." In *The Jensen Lectures: Contemporary Communication Studies.* Ed. John I. Sisco, 71-90. Tampa: Department of Communication, Univ. of South Florida, 1983.

————*The Force of Fantasy.* Carbondale: Southern Illinois UP, 1985.

————"Symbolic Convergence Theory: A Communication Formulation Based on Homo Narrans." *Journal of Communication* 35 (Autumn 1985): 128-138.

————"Media Fantasies of Political Campaigns" TMS (photocopy). Lecture in honor of James L. Golden, Ohio State University, Fall, 1988.

————"Rhetorical Criticism and Significant Form: A Humanistic Approach." In *Form and Genre: Shaping Rhetorical Action,* ed. Karlyn Kohrs Campbell and Kathleen Hall Jamieson, 165-187. Falls Church, VA: SCA, n.d.

Bormann, E. G., John F. Cragan, and Donald S. Shields. "In Defense of Symbolic Convergence Theory: A Look at the Theory and Its Criticisms after Two Decades." *Communication Theory* 4 (1994): 259-294.

Bosmajian, Haig A. "Freedom of Speech and the Heckler." *Western Speech* 36 (Fall 1972): 218-232.

Bottigheimer, Karl S. *Ireland and the Irish.* New York: Columbia UP, 1982.

Boyce, George. "The Fourth Estate: The Reappraisal of a Concept." In *Newspaper History: from the 17th Century to the Present Day,* ed. George Boyce, James Curran and Pauline Wingate. London: Constable, 1978.

Braden, Waldo W. "Contemporary Debating in the House of Commons." *Southern States Communication Journal* 27 (Summer 1962): 261-272.

————"How Borah Handled Senatorial Heckling." *Southern Speech Journal* 12 (Jan. 1947): 58-61.

Brake, Robert J. "The Porch and the Stump: Campaign Strategies in the 1920 Presidential Election." *Quarterly Journal of Speech* 55(Oct. 1969): 256-267.

Brake, Robert J., and Robert B. Neuleib. "Famous Women Orators: An Opinion Survey." *Today's Speech* 21 (Fall 1973): 33-37.

Brock, Bernard L. and Robert L. Scott, eds. *Methods of Rhetorical Criticism*. 2d ed. Detroit: Wayne State UP, 1980.

Browning, Robert. "The Lost Leader." In *The Literature of England*. 3d ed. Edited by George B. Woods, Homer A. Watt, and George K. Anderson. Vol. 2, *Dawn of the Romantic Movement to the Present Day*. Chicago: Scott Foresman, 1948, 666.

Brummett, Barry. "A Justification for the Concept of the 'Active Audience' with Some Implications for Rhetorical Theory." Ph.D. diss., University of Minnesota, 1978.

———"Burkean Scapegoating, Mortification, and Transcendence in Presidential Campaign Rhetoric." *Central States Speech Journal* 32 (Winter 1981): 254-264.

Bullock, Alan. *The Life and Times of Ernest Bevin: Trade Union Leader 1881-1940*. Vol. 1. London: Heinemann, 1960.

Burke, Edmund. *The Writings and Speeches of Edmund Burke*. Edited by Paul Langford. Vol. 2., *Party, Parliament, and the American Crisis 1766-1774*. Oxford: Clarendon Press, 1981.

Burke, Kenneth. *A Grammar of Motives*. Berkeley: University of California Press, 1945.

———*A Rhetoric of Motives*. Berkeley: University of California Press, 1950.

———*The Rhetoric of Religion: Studies in Logology*. Boston: Beacon, 1961.

———"Dramatism." In *International Encyclopedia of the Social Sciences*," ed. David L. Sills. New York: Macmillan, 1968-1979, 7: 445-451.

Burke, Peter. "History of Events and the Revival of Narrative." In *New Perspectives on Historical Writing*, ed. P. Burke. 233-248. University Park: Pennsylvania State UP, 1992.

Burns, Robert. "To A Mouse." In *The Poetical Works of Burns*. Edited by Raymond Bentman. Boston: Houghton Mifflin, 1974.

Butler, Jessie Haver. *Time to Speak Up: A Speaker's Handbook for Women*. With a Forward by Nancy Astor. New York: Harper, 1946.

Butler, J. R. M. *Lord Lothian*. London: Macmillan, 1960.

By-Elections in British Politics, ed. Chris Cook and John Ramsden. London: Macmillan, 1973.

Campbell, Karlyn Kohrs. *Critiques of Contemporary Rhetoric*. Belmont, CA: Wadsworth, 1972.

———*The Rhetorical Act*. Belmont, CA: Wadsworth, 1982.

———"Femininity and Feminism: To Be or Not To Be A Woman." *Communication Quarterly* 31 (Spring 1983): 101-108.

———"Style and Content in the Rhetoric of Early Afro-American Feminists." *Quarterly Journal of Speech* 72 (Nov.1986): 434-443.

———*Man Cannot Speak for Her*. Vol. 1, *A Critical Study of Early Feminist Rhetoric*. New York: Praeger, 1989.

Campbell, Karlyn Kohrs, and E. Claire Jerry. "Woman and Speaker: A Conflict in Roles." In *Seeing Female: Social Roles and Personal Lives*, ed. Sharon S. Behm, 123-133. New York: Greenwood Press, 1988.

Carpenter, Ronald H. "The Historical Jeremiad as Rhetorical Genre." In *Form and Genre*, ed. Karlyn Kohrs Campbell and Kathleen Hall Jamieson, 103-117. Falls Church, Va. SCA, 1976.

Carpenter, Ron. "In Not-So-Trivial Pursuit of Rhetorical Wedgies: An Historical Approach to Lincoln's Second Inaugural Address." *Communication Reports* 1 (Winter 1988): 20-25.

Carson, John. "Freedom of Assembly and the Hostile Audience: A Comparative Examination of the British and American Doctrines." *New York Law Forum* 15 (1969): 798-834.

Cathcart, Robert. Review of *The Force of Fantasy: Restoring the American Dream*, by Ernest G. Bormann. In *Quarterly Journal of Speech* 72 (Feb. 1986): 108-110.

Churchill, Winston S. *The Gathering Storm*. New York: Bantam Books, 1961.

Clark, Norman H. *Deliver Us From Evil: An Interpretation of American Prohibition*. New York: Norton, 1976.

Cliveden (guidebook) U.K.: The National Trust, 1988.

Cockburn, Claud. "Britain's 'Cliveden Set' An Informal but Powerful Pro-German Group Constitutes a Second British Foreign Office." *Current History* 48 (Feb. 1938): 31-34.

———*Crossing the Line*. New York: Monthly Review Press, 1960.

Cole, G. D. H. *History of the Labour Party from 1914*. London: Routledge, 1948.

Collis, Maurice. *Nancy Astor: An Informal Biography*. New York: Dutton, 1960.

Cragan, John F., and Craig W. Cutbirth. "A Revisionist Perspective on Political *Ad Hominem* Argument: A Case Study." *Central States Speech Journal* 35 (Winter 1984): 228-237.

Cragan, John F., and Donald C. Shields. *Applied Communication Research: A Dramatistic Approach*. Prospect Heights, IL: Waveland Press, 1981.

Donaldson, A. "Women emerge as political speakers." *Speech Monographs* 18 (1951): 54-61.

Dowse, Robert E. *Left in the Centre*. London: Longmans, 1966.

Eddy, Mary Baker. *Science and Health with Key to the Scriptures*. Boston: By the trustees under the will of Mary Baker Eddy, 1922.

Einhorn, Lois J. "The Ghosts Unmasked: A Review of Literature on Speechwriting." *Communication Quarterly* 30 (Winter 1981): 41-47.

Fischer, David Hackett. *Albion's Seed: Four British Folkways in America*. New York: Oxford UP, 1989.

Fisher, Walter R. *Human Communication as Narration: Toward a Philosophy of Reason, Value, and Action*. Columbia, SC: University of South Carolina Press, 1987.

Foot, Michael. "A Rupert for the Roundheads." Chap. in *Debts of Honour*. London: Davis-Poynter, 1980, 11-22.

——— "Lady Astor." Sketch in *Loyalists and Loners*. London: Collins, 1986, 229-233.

Foot, Sarah. *My Grandfather Isaac Foot*. Bodmin, Cornwall: Bossiney Books, 1980.

Foss, Karen A., and Sonja K. Foss. "The Status of Research on Women and Communication." *Communication Quarterly* 31 (Summer 1983): 195-204.

Foss, Sonja K. *Rhetorical Criticism: Exploration and Practice*. Prospect Heights, Ill.: Waveland Press, 1989.

Foss, Sonja K., Karen A. Foss, and Robert Trapp. *Contemporary Perspectives on Rhetoric*. Prospect Heights, Ill.: Waveland Press, 1985.

Gates, John D. *The Astor Family*. Garden City, New York: Doubleday, 1981.

Gerard, Jessica. "Lady Bountiful: Women of the Landed Classes and Rural Philanthropy." *Victorian Studies* 30 (Winter 1987): 183-210.

Gilbert, Bentley Brinkerhoff. Review of *Lloyd George and the Challenge of Labour: The Post-War Coaliton, 1918-1922*, by Chris Wrigley. In *Albion* 23 (Winter 1991): 804-805.

"Ginger Woman." (Obituary) *Time*, 8 May 1964, 35.

Gold, Ellen Reid. "Political Apologia: The Ritual of Self-Defense." *Communication Monographs* 45 (Nov. 1978): 306-316.

———"The Provincial Press and Political Speeches." *Communication Quarterly* 31 (Winter 1983): 37-42.

Golden, James, Goodwin F. Berquist and William E. Coleman, eds. *The Rhetoric of Western Thought*. 3d ed. Dubuque, Iowa: Kendall/Hunt, 1983.

Gravlee, G. Jack. "Reporting Proceedings and Debates in the British House of Commons." *Central States Speech Journal* 32 (Summer 1981): 85-99.

Grenfell, Joyce. *Joyce Grenfell Requests the Pleasure*. London: Macmillan, 1976; Futura Publications, 1977; reprint, 1986.

Grigg, John. *Nancy Astor, A Lady Unashamed*. Boston: Little, Brown, 1980.

Gronbeck, Bruce E. "Rhetorical Timing in Public Communication." *Central States Speech Journal* 25 (1974): 84-94.

Hachey, Thomas E., Joseph M. Hernon, Jr., and Lawrence J. McCaffrey. *The Irish Experience*. Englewood Cliffs, NJ: Prentice Hall, 1989.

Hagan, Martha. "The Antisuffragists' Rhetorical Dilemma: Reconciling the Private and Public Spheres." *Communication Reports* 5 (Summer 1992): 73-81.

Hahn, Dan. F., and Ruth M. Gonchar. "Political Myth: The Image and the Issue." *Communication Quarterly* 20 (Summer 1972): 57-65.

Halperin, John. *Eminent Georgians*. New York: St. Martin's Press, 1995.

Harrison, Brian. "Women in a Men's House: The Women M.P.s, 1919-1945." *Historical Journal* 29, 3 (Sept. 1986): 623-654.

————*Prudent Revolutionaries: Portraits of British Feminists between the Wars.* Oxford: Clarendon Press, 1987.

Harrison, Rosina. *Rose: My Life in Service.* New York: Viking, 1975.

Hart, Roderick P. *Modern Rhetorical Criticism.* Glenview, Ill.: Scott, Foresman/Little Brown Higher Education, 1990.

Haverty, Anne. *Constance Markievicz: An Independent Life.* London: Unwin, Pandora Press, 1988.

Havighurst, Alfred F. *Britain in Transition.* 4th ed. Chicago: University of Chicago Press, 1985.

Hoban, James L. "Rhetorical Rituals of Rebirth." *Quarterly Journal of Speech* 66 (Oct. 1980): 275-288.

Hodson, Harry V. "Looking Back: The Founders." *The Round Table* (July 1990): 254-256.

Hoggart, Simon and David Leigh. *Michael Foot: A Portrait.* London: Hodder and Stoughton,1981.

Hollis, Patricia. *Ladies Elect: Women in English Local Government 1865-1914.* Oxford: Clarendon Press, 1987.

Howell, William S. *The Empathic Communicator.* Belmont, Calif.: Wadsworth, 1982.

Hufton, Olwen, et al. "What is women's history?" *History Today* 35 (June 1985): 38-48.

Jamieson, Kathleen Hall. *Eloquence in an Electronic Age: The Transformation of Political Speechmaking.* New York: Oxford UP, 1988.

Jenkins, Roy. *Gallery of 20th Century Portraits.* London: David & Charles, 1988.

Jensen, J. Vernon. "London's Outdoor Oratory." *Today's Speech* 15 (Feb. 1967): 3-6.

Kavaler, Lucy. *The Astors: An American Legend.* New York: Dodd, Mead, 1968.

Keeler, Christine. *Scandal.* New York: St. Martin's Press, 1989.

Kendle, John Edward. *The Round Table Movement and Imperial Union.* Toronto/Buffalo: University of Toronto Press, 1975.

Kenin, Richard. *Return to Albion: Americans in England 1760-1940.* New York: Holt, Rinehart& Winston, 1979.

Kennan, George F. *Russia and the West.* Boston: Little, Brown, 1960, Mentor Books, 1961.

Kent, Susan Kingsley. "The Politics of Sexual Difference: World War I and the Demise of British Feminism." *Journal of British Studies* 27 (July 1988): 232-253.

————"Gender Reconstruction after the First World War." In *British Feminism in the Twentieth Century,* ed. Harold L. Smith, 66-83. Amherst: U of Mass. Press, 1990.

Keylor, William R. *The Twentieth Century World: An International History.* New York: Oxford UP, 1984.

Keynes, John Maynard. *Economic Consequences of the Peace.* New York: Harcourt Brace and Howe, 1920.

Kipling, Rudyard. "Tommy." In *Kipling: A Selection of His Stories and Poems,* ed. John Beecroft. Garden City, NJ: Doubleday, 1956, 2:491-492.

"Labour Party's Manifesto (27 Nov. 1918)." In *Parliamentary Gazette No. 45,* ed. and comp. James Howarth, 193-194. London: Howarth, Dec. 1919.

"Lady Astor, 1st Woman in Commons, Dies." (Obituary) *Minneapolis Sunday Tribune,* 3 May 1964, 19.

Langhorne, Elizabeth. *Nancy Astor and Her Friends.* New York: Praeger Publishers, 1974.

Lee, Ronald. "Moralizing and Ideologizing: An Analysis of Political Illocutions." *Western Journal of Speech Communication* 52 (Fall 1988): 291-307.

Lentin, A. *Lloyd George, Woodrow Wilson and the Guilt of Germany.* Leicester: Leicester UP, 1984.

Levi, Giovanni. "On Microhistory." In *New Perspectives on Historical Writing,* ed. P. Burke, 93-113. University Park: Pennsylvania State UP, 1992.

Lipscomb, Elizabeth. Randolph Macon Women's College, Lynchburg, Va. Interview by author, 27 April 1991.

Low, D. A. "What Happened to Milner's Young Men: What of Their Successors?" *The Round Table* (July 1990): 257-267.

Lowry, Ann. College of St. Catherine, St. Paul, Minn. Interview by author, 27 April 1991.

Lucas, Stephen "The Schism in Rhetorical Scholarship." *Quarterly Journal of Speech* 67 (1981): 1-20.

————"The Renaissance of American Public Address: Text and Context in Rhetorical Criticism." *Quarterly Journal of Speech* 74 (May 1988): 241-260.

MacDonald, J. Ramsay. *Parliament and Revolution.* New York: Scott & Seltzer, 1920.

Macmillan, Harold. *The Past Masters: Politics and Politicians 1906-1939.* London: Macmillan, 1975.

Marcus, Geoffrey. *Before the Lamps Went Out.* London: George Allen and Unwin, 1965.

Marquand, David. "Must Parliament Remain a Male-Dominated Preserve?" *Listener,* 10 April 1980, 460-461.

Marwick, Arthur. "British Life and Leisure and the First World War," *History Today* 15 (June 1965): 409-419.

McEwen, J. M. "The Coupon Election of 1918 and Unionist Members of Parliament." *Journal of Modern History* 34 (Sept. 1962): 294-306.

Medhurst, Martin J. "Public Address and Significant Scholarship: Four Challenges to the Rhetorical Renaissance." In *Texts in Context,* eds. M. C. Leff and F. J. Kauffeld, 29-42, Davis, Calif.: Hermagoras Press, 1989.

Miller, Gerald R. and Mark Steinberg. *Between People.* Chicago: Science Research Associates, 1975.

Montgomery, Maureen E. *Gilded 'Prostitution': Status, Money, and Transatlantic Marriages, 1870-1914.* London: Routledge, 1989.

Morgan, Kenneth O. *Consensus and Disunity: The Lloyd George Coalition Government 1918-1922.* Oxford: Clarendon Press, 1979.

Morgan, K. S. "Parliamentary Reporting at Westminster." *Parliamentarian* 61 (July 1980): 147-152

Mosley, Nicolas. *Rules of the Game: Sir Oswald and Lady Cynthia Mosley 1896-1933.* Secker and Warburg: London, 1982.

Mowat, Charles L. *Britain between the Wars 1918-1940.* Chicago:University of Chicago Press, 1955.

———*Great Britain Since 1914.* Ithaca: Cornell UP, 1971.

Mulkay, Michael. *On Humour.* Cambridge, England: Polity Press, 1988.

Murphy, John. "Knowing the President: The Dialogic Evolution of the Campaign History." *Quarterly Journal of Speech* 84 (1998): 23-40.

Murphy, R. "Walter Long, the Unionist Ministers and the Formation of Lloyd George's Government in December 1916." *Historical Journal* 29 (Sept. 1986): 735-745.

Negrine, Ralph. *Politics and the Mass Media in Britain.* London. Routledge, 1989.

Nimmo, Dan and James E. Combs. *Mediated Political Realities.* New York: Longmans, 1983.

Nimocks, Walter. *Milner's Young Men: The 'Kindergarten' in Edwardian Imperial Affairs.* Durham: Duke UP, 1968.

O'Connor, Harvey. *The Astors.* New York: Alfred A. Knopf, 1941.

O'Halpin, E. "British Government and Society in the 20th Century." *Historical Journal* 28 (Sept. 1985): 751-762.

Oliver, Robert T. *The Influence of Rhetoric in the Shaping of Great Britain.* Newark: University of Delaware Press, 1986.

———*Public Speaking in the Reshaping of Great Britain.* Newark: University of Delaware Press, 1987.

Osborn, Michael. "The Evolution of the Archetypal Sea in Rhetoric and Poetic." *Quarterly Journal of Speech* 63 (Dec. 1977): 347-363.

Pearson, Hesketh. *The Marrying Americans.* New York: Covard & McCann, 1961.

Peterson, Owen. "The Role of Public Speaking in the Early Years of the British Labour Party." *Quarterly Journal of Speech* 48 (Oct. 1962): 254-260.

Pethick-Lawrence, F. W. *The Capital Levy (How the Labour Party Would Settle the War Debt).* London: Labour Party, 1918.

Powell, Larry and Annette Shelby. "A Strategy of Assumed Incumbency." *Southern States Communication Journal* 46 (Winter 1981): 105-123.

Pugh, Martin. *Lloyd George*. Profiles in Power Series, ed. Keith Robbins. London: Longman, 1988.

Radice, Lisanne, Elizabeth Vallance, and Virginia Willis. *Member of Parliament*. London: Macmillan, 1987; reprint, 1988.

Rarick, David. "Audience Analysis." Discussion with author, 12 April 1993, University of Minnesota, Minneapolis

Reid, Gwendoline L. "Winston S. Churchill's Theory of Public Speaking as Compared to His Practice." Ph.D. diss., University of Minnesota, 1987.

Remak, Joachim. *The Origins of World War I 1871-1914*. New York: Holt, Rinehart & Winston, 1967.

Remarque, Erich Maria. *All Quiet on the Western Front*. Little, Brown & Co. 1929; reprint, New York: Fawcett Crest, 1969.

Riasanovsky, Nicholas V. *A History of Russia*. 4th ed. New York: Oxford UP, 1984.

Rich, Lawrence. "Cliveden, Buckinghamshire." *British Heritage*, Dec.1985-Jan. 1986, 62-73, 80.

Riddell, Lord. *Lord Riddell's Intimate Diary of the Peace Conference and After 1918-1923*. London: Victor Gollancz, 1933.

Rowse, A. L. "Nancy Astor." In *Memories of Men and Women American and British*. Lanham, Md. University Press of America, 1983.

Ryan, Halford Ross, ed. *Oratorical Encounters: Selected Studies and Sources of Twentieth Century Political Accusations and Apologies*. New York: Greenwood Press, 1988.

Sacks, Benjamin. "The Independent Labor Party and Social Amelioration in Great Britain during the World War." *University of New Mexico Bulletin* 2, no. 6 (Aug. 1940): 5-37.

————"Relations between the Independent Labor Party and the British Labor Party during the World War." *University of New Mexico Bulletin* 2, no. 5 (Sept. 1938): 3-19.

Schmidt, Ralph N. "The Importance of Being Earnest." *Communication Quarterly* 7 (Nov. 1960): 23-24.

Scott, Ann Firor. *Making the Invisible Woman Visible*, Urbana: University of Illinois Press, 1984.

Scott, Joan. "Women's History." In *New Perspective on Historical Writing*, ed. P. Burke, 42-66. University Park: Pennsylvania State UP, 1992.

Scott, Robert L. "Narrative Theory and Communication Research." *Quarterly Journal of Speech* 70 (May 1984): 197-204.

————Conversation with seminar, 4 October 1985, University of Minnesota, Minneapolis.

Seldes, George. *Witness to a Century*. New York: Ballantine Books, 1987.

Shakespeare, William. *The Complete Oxford Shakespeare*. Eds. Stanley Wells et al. Oxford: Oxford University Press, 1987.

Shrapnel, Norman. *The Performers: Politics as Theatre*. London: Constable, 1978.

Simons, Herbert W. "In Praise of Muddleheaded Anecdotalism." *Western Journal of Speech Communication* 42 (Winter 1978): 21-28.

Smith, H. L. "Sex vs. Class: British Feminists and the Labour Movement, 1919-1929." *Historian* 47 (Nov. 1984): 19-37.

————"British Feminism in the 1920's." In *British Feminism in the Twentieth Century*. Ed. Harold L. Smith, 47-63. Amherst: University of Mass. Press, 1990.

Sontag, Raymond J. *A Broken World 1919-1939*. New York: Harper & Row, 1971; Harper Torchbooks, 1972.

Spitzack, Carole and Kathryn Carter. "Women in Communication Studies: A Typology for Revision." *Quarterly Journal of Speech* 73 (Nov. 1987): 401-423.

Stevenson, D. "Reading History, the Treaty of Versailles." *History Today* 36 (Oct. 1986): 50-52.

Stevenson, John. *British Society 1914-1945*. Harmondsworth, England: Penguin, 1984; reprint, 1986.

Stobaugh, Beverly Parker. *Women and Parliament 1918-1970*. Hicksville, NY: Exposition Press, 1978.

Stocks, Mary. "The Fiercest Feminist of All." (Obituary) *Observer Weekend Review*, 3 May 1964, 23.

Stoessinger, John G. *Why Nations Go to War*. 3rd ed. New York: St. Martin's Press, 1982.

Stokesbury, James L. *A Short History of World War I*. New York: William Morrow, 1981.

Strachey, Ray. *"The Cause": A Short History of the Women's Movement in Great Britain*. London: G. Bell & Sons, 1928.

Stubbs, John. "Appearance and Reality: A Case Study of *The Observer* and J. L. Garvin, 1914-42." In *Newspaper History: from the 17th Century to the Present Day*, ed. George Boyce, James Curran, and Pauline Wingate, 320-338. London: Constable, 1978.

Sykes, Christopher. *Nancy*. New York: Harper & Row, 1972.

Taylor, A. J. P. *Illustrated History of the First World War*. London: H. Hamilton, 1963.

————"Moving Towards War: 1914: Events in Britain." *Listener*, 16 July 1964, 79-82.

————*English History 1914-1945*. London: Oxford UP, 1965; reprint, Penguin Books, 1975.

Thompson, J. A. "Woodrow Wilson and World War I: A Reappraisal." *Journal of American Studies* 19 (Dec. 1985): 325-348.

Thomson, David, with additional material by Geoffrey Warner. *England in the Twentieth Century*. 2d ed. Pelican History of England, ed. J. E. Morpurgo, no. 9. Harmondsworth, England: Penguin, 1981.

Thurtle, Ernest. *Time's Winged Chariot.* London: Chaterson, 1945.

Tierney, Tom. *Gibson Girl Paper Dolls in Full Color.* Mineola, N.Y.: Dover, 1985.

Trent, Judith S. "A Synthesis of Methodologies Used in Studying Political Communication." *Central States Speech Journal* 26 (Winter 1975): 287-298.

————"Presidential Surfacing: The Ritualistic and Crucial First Act." *Communication Monographs* 45 (Nov. 1978): 281-292.

Tuchman, Barbara W. *The Guns of August.* New York: Macmillan, 1962.

————*Practicing History: Selected Essays.* New York: Ballantine Books, 1982.

Turner, John. "State Purchase of the Liquor Trade in the First World War." *Historical Journal* 23 (Sept. 1980) 589-615.

Turner, Kathleen J. "Rhetorical History as Social Construction." Paper presented at the Southern States Communication Association Convention, Tampa, Fla., April 1991.

Vallance, Elizabeth. *Women in the House.* London: Athlone Press, 1979.

Ware, B. L., and W. Linkgugel. "They Spoke in Defense of Themselves: On the Generic Criticism of Apologia." *Quarterly Journal of Speech* 59 (1973): 273-283.

Ware, P. D., and R. K. Tucker. "Heckling as distraction: An Experimental Study of Its Effects on Source Credibility." *Speech Monographs* (June 1974): 185-186.

Webb, R. K. *Modern England.* 2d ed. New York: Harper & Row, 1980.

Williams, Beryl. *The Russian Revolution 1917-1921.* Publication of the Historical Association, eds. Roger Mettam and James Shields. Oxford: Basil Blackwell, 1987.

Williams, Shirley. "House Bound." *Guardian,* 30 Oct. 1979, 8.

Willson, David Harris. *A History of England,* 2d ed. New York: Holt, Rinehart & Winston, 1972.

Windes, Russell R. Jr. "A Study in Effective and Ineffective Presidential Campaign Speaking." *Communication Monographs.* (March 1961): 39-49.

Winn, Alice. *Always a Virginian.* U.S.A. Privately printed 1973.

Wrigley, C. J. *Lloyd George and the Challenge of Labour.* New York: Harvester Wheatsheaf, 1990.

Zacharis, J. C. "Emmeline Pankhurst: An English Suffragette Influences America." *Communication Monographs* 38 (1971): 198-206.

Zimmeck, M. "Strategies and Stratagems for the Employment of Women in the British Civil Service, 1919-1939." *Historical Journal* 27 (Dec. 1984): 901-924.

INDEX

DATE DUE

MAR 26 1999	

UPI 261-2505 G PRINTED IN U.S.A.